Art in China

Oxford History of Art

Craig Clunas has worked as a curator of Chinese art at the Victoria and Albert Museum, and taught at Sussex University and the School of Oriental and African Studies, London University. He was appointed Professor of the History of Art, University of Oxford in 2007, where he is the first holder of the chair to specialise in art from Asia.

Oxford History of Art

Titles in the Oxford History of Art series are up-to-date, fully illustrated introductions to a wide variety of subjects written by leading experts in their field. They will appear regularly, building into an interlocking and comprehensive series. In the list below, published titles appear in bold.

Oxford History of Art

Art in China

SECOND EDITION

Craig Clunas

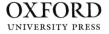

OXFORD
UNIVERSITY PRESS

OXFORD
UNIVERSITY PRESS

Great Clarendon Street, Oxford OX2 6DP

Oxford University Press is a department of the University of Oxford.
It furthers the University's objective of excellence in research, scholarship,
and education by publishing worldwide in

Oxford New York

Auckland Cape Town Dar es Salaam Hong Kong Karachi
Kuala Lumpur Madrid Melbourne Mexico City Nairobi
New Delhi Shanghai Taipei Toronto

With offices in

Argentina Austria Brazil Chile Czech Republic France Greece
Guatemala Hungary Italy Japan Poland Portugal Singapore
South Korea Switzerland Thailand Turkey Ukraine Vietnam

Oxford is a registered trade mark of Oxford University Press
in the UK and in certain other countries

Published in the United States
by Oxford University Press Inc., New York

British Library Cataloguing in Publication Data
Data available

Library of Congress Cataloging in Publication Data
Data available ·

Typeset by SPI Publisher Services, Pondicherry, India
Printed and bound by CPI Group (UK) Ltd, Croydon, CR0 4YY

ISBN 978-0-19-921734-2

7 9 10 8

Contents

Introduction

'Chinese art' is quite a recent invention, not much more than a hundred years old. Although the textiles, pieces of calligraphy, paintings, sculptures, ceramics, and other works of art shown in this book date from a period of 5,000 years, the idea of grouping this body of material together and calling it 'Chinese art' has a much shorter history. No one in China before the nineteenth century saw all these objects as constituting part of the same field of enquiry, despite the existence of a long and sophisticated tradition of writing about art, collecting art, and showing and consuming art by successive élites within that country. Rather it was in nineteenth-century Europe and North America that 'Chinese art' was created. It still exists in the West as an object of study contrasted with an unqualified 'art', usually in practice the European tradition, with its extensions into America and other parts of the world. The 'National Gallery' in London and the 'National Gallery of Art' in Washington, DC, despite the implicit claims to comprehensiveness made in their titles, do not contain work from China.

The creation of 'Chinese art' in the nineteenth century allowed statements to be made about, and values to be ascribed to, a range of types of objects. These statements are all to a greater or lesser extent statements about 'China' itself. The ideas of the nineteenth-century German thinker Hegel, who saw art as the soul of a people, here met with the orientalist notion of China as a homogeneous totality whose essence could be known and described only by those who were not themselves Chinese, to produce a particular way of writing 'Chinese art'. This often stresses continuity at the expense of change, harmony at the expense of contested uses of the same thing, and essential homogeneity at the expense of difference. Or rather, difference *between* China and 'the Western artistic tradition' is stressed, while difference *within* the field of practice across time and place in China is under-played. Yet China is a physically immense country, covering numerous climatic zones and ecological environments, where social and religious ideas, the ethnic composition of the ruling élite, the geographical locations of political power and of the major centres of population, have all undergone many changes over the period covered here.

Detail of 62

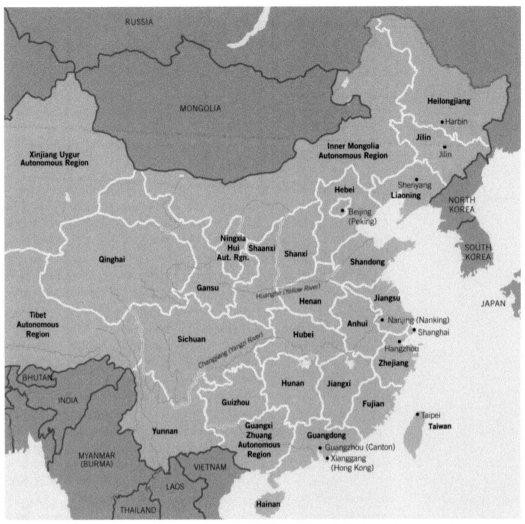

Administrative Divisions of Modern China

This book is very deliberately called *Art in China*, and not *Chinese Art*, because it is written out of a distrust of the existence of any unifying principles or essences linking such a wide range of made things, things of very different types, having very different dates, very different materials, and very different makers, audiences, and contexts of use. Yet the choices of what to put in and what to leave out of a book remain contingent, since the number of illustrations and of words is limited by the author's energy, the reader's patience, and the economics of publishing. The question 'What is art in China?' could really be rephrased as 'What has historically been called art in China, by whom and when?' That is one of the problems the book sets out to pose, if not to answer fully. For even a quick examination of the existing literature shows that there are so many anomalies and inner contradictions in any definition of 'Chinese art' that it can never be grasped as a stable or unchanging entity, and can only be approached at all if we take into

Dates

Dates are given in this book in the forms 'Before the Common Era' (BCE) and 'Common Era' (CE), in preference to BC and AD. There are also references to 'dynasties', the successive imperial ruling houses which have always been used to structure time within the Chinese historical record. Dynastic names are not the personal names of the imperial family—the emperors of the Tang dynasty were surnamed Li, for example. Most early dynastic names are geographical ones, often the names of titles held by a family before they reached the imperial throne. The names of the last three imperial dynasties are symbolic attributes; Yuan, Ming, and Qing mean 'Primal', 'Bright', and 'Clear' respectively. Charts of dynastic dates, including those found in this book, give an unrealistically tidy impression of historical progress, with each dynasty following its predecessor without any gap. Nor do they accurately represent periods when political power was divided between rival ruling houses. A given emperor's reign could contain a number of 'eras', each of which carried an auspicious name. From the Ming dynasty (1368–1644) there was only one era per emperor, and this is sometimes used loosely to identify individual rulers,

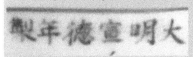

Detail of 31

Detail of 37

Detail of 40

as in 'the Qianlong emperor' (r. 1736–95 CE). These reign names are the chief way of describing a year, prior to the twentieth century. Thus the inscription on **31** reads 'Made in the Xuande era of the Great Ming', equivalent to 1425-36 CE. Xuande, which means something like 'Proclaiming Virtue', is the name of an era, not of a person. Beginning as it did with the first day of the lunar year, each era is not exactly coterminous with dates in the Western calendar. The inscription on **37** is dated 'First year of the Yongzheng era', given here by convention as equivalent to 1723 CE, even though in reality it covered only part of 1737 and the very early part of 1738. The dating of **40** uses yet another system, of combining one set of ten and one set of twelve characters to give a sixty-year repeating cycle. It reads 'In the *dingyou* year of the Guangxu era, middle ten day period of the middle month of spring, done by the imperial brush'. This gives a date equivalent to 1897 CE.

Names

The Chinese language is rendered here in the Pinyin system of romanization. It should be borne in mind that this conveys contemporary standard pronunciation of the written characters, and that these were spoken very differently in the past. Chinese personal names give the surname first: *Mi* Youren was the son of *Mi* Fu. Male members of the upper classes had many personal names, used according to the social context (a custom also followed by some upper-class women). Artists can thus be known by several names, but only the most formal is generally recorded in this book. Buddhist and Daoist monks have special names assumed by them at ordination. Emperors prior to the Ming are referred to here by their 'temple names', titles assumed only after death, such as 'Taizong', or 'Grand Ancestor'. Ming and Qing emperors are called by their 'era-names', such as 'Qianlong emperor'. Place names are usually given in their modern forms, or if an earlier form is given, with the modern equivalent.

account who is doing the categorizing and from what standpoint. For example, Chinese élite definitions of 'art' over the last thousand years have always given first place to calligraphy, though English-language surveys often tend to devote less space to this than they do to sculpture, which is validated as a 'fine art' in the Western post-Renaissance tradition. Yet sculpture itself is a contested area. The French scholar Victor Segalen (1878–1922), author of a pioneering work called *The Great Statuary of China*, refused to deal at all with Buddhist sculpture in China (which forms the bulk of the surviving work in all media), on the grounds that it was 'not really Chinese', but rather an 'alien' import from India, and one which had had a wholly deleterious effect on the purely native work which he claimed to admire so much.[1]

Similarly abrupt decisions have been made in this text, and it would be curious if they were not challenged by readers. For example, there is no discussion of buildings in what follows. Before the present century there is no discourse of 'architecture' as one of the fine arts in China, but that does not mean that buildings were not the objects of just as much aesthetic consideration as were other (equally under-theorized) areas which are included here. Decisions as to what to put in and what to leave out are conditioned by the format of publication, but they are not explained by it.

The reader should not therefore think that the hundred and twenty or so things illustrated in this book represent some time-honoured canon of masterpieces, or an agreed list of approved art treasures. Rather they represent a variety of different life histories. Some were considered as works of art in the place and time where they were made, and have continued to seem significant in all subsequent accounts down to the present, while others have had that status thrust upon them only in our own century. Some of them, well outside the traditional canon of 'important' works of art, might be challenged as

failing to meet the standards of quality necessary for an introductory work of this kind. The principle I am using in selecting them is that they should be capable of sustaining discourse about the contexts of what we now consider to be art in China from the very earliest times to the present. Many of them have been the subject of recent innovative scholarship in English, which is detailed in the notes and bibliography. They are a starting-point, not a neutral sample. Most Chinese art of the vast span covered by this book is lost, but even so a standard modern reference book lists over 13,000 named painters alone.[2] I have tried to give weight to what was articulated as art at the time of its production, which means privileging calligraphy and painting up to a point, but I have also recognized that, within China as much as elsewhere, 'Chinese art' now includes categories of material about which no such articulation was made, but where the conscious manipulation of aesthetic effects is of major importance. This justifies the inclusion of both secular and religious sculpture in stone, where we in fact have almost nothing of the views of its patrons, and nothing at all of the views of its makers, beyond what we can construct out of the surviving physical evidence.

The structure of this book requires some explanation, being neither fully chronological nor fully thematic, but it does not require an apology. No frame of reference occurs naturally. The one deployed here is scarcely more or less sustainable than any other. It takes as its point of departure contexts of use, the social and material circumstances in which objects of art were created and used. One of the arguments for this is that it is an area which has received scant attention in surveys of Chinese art until quite recently. In fact, in both the Chinese and Western intellectual traditions, 'art' and questions of function have been mutually exclusive categories until quite recently; since the nineteenth century, a work of art has been something without a function, or something considered in the light of the removal or concealment of its function.

The following chapters deal with the contexts of the tomb as an artistic site, the courts of rulers, the temples and altars of religious observance, the social life and interaction of the upper classes, and finally with the idea of the market-place. These are not viewed as mutually exclusive: many works could have been discussed under several of the headings, and a number of them are in fact referred to more than once. It has also been a priority to show how constructions of meaning in a given object have changed over time. Its presence in this book as a 'work of art' may perhaps be only the latest of a series of such categories to which any given item has been subject.

有虞帝舜

舜二妃娥皇女英

舜父瞽叟

周太姜

周太任

周太姒

Art in the Tomb

1

Neolithic to Bronze Age: 2500–200 BCE

The way in which different meanings have been read into Chinese art objects at different periods is brought out very precisely in a jade tablet, now preserved in the National Palace Museum on Taiwan [1]. The stone is ivory yellow, with grey and ochre natural inclusions altered by great age, and has been worked into a thin trapezoid shape, with a hole bored in the narrower end. In delicate low relief, one side is worked with the clearly defined figure of a plunging bird of prey, while the other bears a more enigmatic stylized face, with prominent eyes. The evidence of archaeology would now enable us to say that it was probably made between about 2500 and 2000 BCE, and would categorize it as the product of a culture, the Longshan culture (*c*.3000–1700 BCE), which flourished at that period in what is now China's province of Shandong, near the mouth of the Yellow River. Its makers predated the use of metal, but jade was clearly of great importance to them as a material for making tools and weapons, and for manifesting the prestige of some over others in what was already a stratified society. On the tablet is an inscription dated 1786 CE, written by a Chinese emperor in whose vast collection of antiquities the piece had by that date found itself. He provides a fanciful explanation for the two-sided decoration, understood by him as representing an eagle and a bear, as a sort of ancient award for bravery, and assigns the tablet to two of China's earliest historical dynasties, the Shang (*c*.1500–1050 BCE) or the Zhou (1050–221 BCE).

At this point a facile connection could be made with 'the Chinese love of antiquity', depicting a people somehow uniquely obsessed with interpreting their own long, illustrious past, a past conceived of as unbroken to a degree paralleled by no other civilization. I would prefer to stress the creative appropriation of this ancient object (much more ancient than the inscribing emperor could possibly know), and its insertion into what is effectively a *new* context, that of the imperial collection, and imperial claims to legitimacy through the deployment of ancient symbols of prestige, in a way which has no essential difference from the way many other cultures have deployed prestigious architectural forms, art works, or collected treasures of the past to

Detail of 13

support what are basically current projects. The location of the jade tablet in the National Palace Museum, indeed its presence between the covers of this book as an example of 'art in China', similarly represent new contexts, new meanings inscribed on it, as surely as do the poetic effusions of the Qianlong emperor. We can try to interpret how the object was originally conceived, but we cannot know what it 'really means'.

Jade, or more precisely nephrite, was first used by one of the cultures of the Chinese neolithic between 6000 and 5000 BCE. A mineral of extreme hardness, it cannot be carved with a metal blade, but must be worked with abrasive sand in a procedure of slicing and drilling which involves great expenditure of time and skill. Therefore, at a very early period, it became associated with power: temporal power, in the sense of control over resources, and by extension with spiritual power. By the time the Longshan people were making their highly advanced jade objects over 4,000 years ago, exploiting nearby sources of the stone, there was already a long and very disparate history of jade-working in parts of what is now China. The extent to which all these cultures were 'Chinese', or ancestors of the Chinese of today, remains a matter of speculation, coloured by political presumptions. None of them left any written record, and it is a highly dubious practice, though one too seldom resisted, to use Chinese texts written several millennia later to explicate the meanings and purposes of such early objects. This is particularly so with the case of 'ritual jades' like the illustrated tablet. It is one of a number of shapes found in Chinese neolithic graves and is without any immediate apparent function. Perhaps the most distinctive objects of this type are found in sites of the earlier and more southerly Liangzhu culture (c.3300–2250 BCE). These are flat disks, varying greatly in size, and segmented hollow columnar objects, the angled corners of which are worked with what are among the earliest representations of the human form in that part of the world. These are not counterparts of everyday tools, and it has been argued that they may refer to the realm of the 'other', to powers beyond the mundane. Their presence in graves (which may contain over 100 jade objects) suggests some connection with the marking of differentiated status in life, but much further we cannot go. There are names for these (the disks are now called *bi* and the tubes *cong*) in Chinese ritual manuals of much later date, together with explanations of their role in the worship of Heaven and Earth, and as markers of hierarchical ranks on an aristocratic ladder, but the relevance of these texts to the neolithic context is surely minimal. Instead of trying to make the evidence of material culture fit the (very much later) written evidence, it is preferable to accept the limits of interpretation in relation to objects of such antiquity.

What is worth noting is that these neolithic jades, which must

Time Chart of Periods and Dynasties Mentioned in this Chapter	
NEOLITHIC CULTURES	
Liangzhu (Zhejiang/Jiangsu)	c.3300–c.2250 BCE
Longshan (Shandong)	c.3000–c.1700
XIA DYNASTY (disputed, traditional dates)	2205–1818
SHANG DYNASTY	c.1500–c.1050
ZHOU DYNASTY	
Western Zhou	c.1050–770
Spring and Autumn Annals period	770–475
Warring States period	475–221
QIN DYNASTY	221–207
HAN DYNASTY	
Western Han dynasty	206 BCE–8 CE
(Usurpation of Wang Mang)	9–23
Eastern Han dynasty	25–220
PERIOD OF DISUNITY	220–589
Three Kingdoms period	220–280
Six Dynasties (in south)	265–589
Western Jin	265–316
Eastern Jin	317–420
Song	420–79
Southern Qi	479–502
Liang	502–57
Chen	557–89
Sixteen Kingdoms (in north)	316–589
Northern Wei	386–535
Eastern Wei	534–50
Western Wei	535–57
Northern Qi	550–77
Northern Zhou	557–81
SUI DYNASTY	581–618
TANG DYNASTY	618–906

constantly have come to light in the course of agriculture and other earth-moving activities across a wide area of China, have often been construed as significant objects, as bearers of meaning. What has changed is that actual meaning, to which as often as not the prestigious written sources have provided enigmatic and endlessly fascinating guides.

The textual record, which has been unbroken since the early first millenium BCE, and which has always had prestige as a source of cultural and political legitimacy, came to be read as containing a clear picture of the course of early Chinese history. First came a number of individual culture-hero sovereigns, benefactors of humanity like Yu the Great who tamed the unruly waters of China's great rivers, while

others invented the necessities of civilized life (clothing, housing, agriculture, but also importantly writing). In this scheme, the first dynasty, or ruling house, of Chinese history was the Xia (traditionally 2205–1818 BCE), who were overthrown by the Shang (c.1500–c.1050 BCE), who were in turn overthrown by the Zhou (c.1050–256 BCE). It was under the Zhou, and in order to legitimize their rule, that the relevant texts were written. Scepticism about this account was becoming widespread in the early part of this century, until it was revitalized by the discovery of the archaeological remains of the late Shang royal capital of Anyang. Here were found inscriptions in which the divine powers were interrogated by the Shang kings, kings whose names matched those of the now vindicated ancient historical sources. Anyang remains the only early site to have produced a large body of inscriptions in the earliest form of the Chinese language, carved on the turtle shells and animal bones which acted as physical points of entry to the numinous world. Further, very brief, inscriptions are found too on bronze containers from the same site.

The beginning of the making of objects in bronze, an alloy of copper and tin, is still taken by some archaeologists to represent a founding moment of Chinese culture, and it is undoubtedly true that vessels and weapons in this expensive material, made by a technique involving skilled, possibly hereditary, groups of specialists show an expansion in the types of resources which could be mobilized by early rulers and their families. In the model advanced by the American scholar Robert Bagley, bronze-working technology was first developed in the North China plain, the area watered by the Yellow River and its tributaries, around 1500–1300 BCE.[1] Early Shang political power spread it out from there towards the south. Shang political control weakened at the beginning of the Anyang period, 1300–1000 BCE, and was reduced to its core in Henan. Southern bronzes, often in the form of animals such as tigers and elephants, do not depend on Anyang, but on independent developments of southern appropriations from the north during the earlier phase of interaction.

The picture of an early Chinese polity which was geographically and culturally united, with a strong and prosperous centre extending its influence outwards to an ever-larger area, emerged from excavations sponsored by the Republican government at the Anyang site from 1928, and carried out by the first-generation of professional Chinese archaeologists. It was an ancient China which suited the needs of the new and often fragile Republic for a usable past. Above all, it supported the account of early history given in the earliest written Chinese texts, and allowed a certain resolution of the tension between the desire for 'modernity', expressed as the scientific discourse of which archaeology formed part, and the unwillingness to jettison the written heritage of many centuries. Nowadays a picture of a much more disparate,

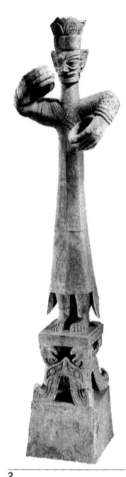

2

Bronze standing figure from Sanxingdui, over life-size, *c.*1200 BCE. Excavated in 1986, the figure had been deliberately broken and dumped in a pit probably containing the remains of sacrificial animals.

heterogeneous, and less ethnically pure ancient China is forming around the extraordinary finds from excavations which reveal cultures of undoubted antiquity and sophistication far from any of the traditionally understood heartlands of Chinese culture. For many, this multi-centred ancient China speaks to current needs more eloquently than the cohesive monolith of older accounts.

None of these excavations is more potentially disruptive of the standard accounts than those at Guanghan Sanxingdui, in Sichuan province, near the modern city of Chengdu. Discovered in 1986, this upset all previous models of early Chinese culture, archaeology, and art. Here, outside a city wall made of rammed earth, and contemporary with the Shang city of Anyang, two pits were located. The first dates from *c.*1300–1200 BCE, the second from a few decades later. Among a mass of burnt animal bones archaeologists found gold, bronze, jade stone, and pottery objects of a totally unknown type, of which the most spectacular to modern eyes are a group of life-sized bronze heads from the earlier pit and a huge single bronze statue 262 cm. high from the later [2]. Technically these bronzes are on a par with, or even surpass, anything done at Anyang, long thought to be the 'cradle of Chinese civilization'. However, the aesthetic is strikingly different; the reaction of many scholars, seeing these for the first time, was that they looked 'un-Chinese'. In other words, they did not look like the things that had been used to construct an idea of 'Chineseness'. Any representation of the human figure on this scale at this date was previously unknown, let alone the distinctive huge, staring eyes and sharply ridged noses of the Guanghan heads, or the tensed posture of the standing figure, with its arms made to hold some now lost object in wood or ivory.

No written text refers to this culture at the time of its flourishing. We do not know who they conceived themselves to be, or what their relations were with other contemporary state formations in other parts of what is now China. They were clearly in touch with bronze-using cultures further down the Yangtze river, and may have imported vessels from there. We do not know how, where, or by whom the Guanghan bronze figure was used. These pits are not the tombs of human beings, nor do they contain the human sacrifices found at Anyang. The scale of the operation involved in casting bronzes and working jade suggests rulers of power and wealth. They were not part of a 'periphery' of which Anyang was the 'core', and in studying the ways in which the culture differs from that of the Shang (no making of bronze vessels or bells, the prominence of the human figure), it is important not to think of the Shang as the norm from which the Guanghan culture deviates.

At Anyang itself recent excavation has also considerably broadened and complicated the earlier picture of the Shang and their culture. In particular, it has provided for interpretation objects in materials other than the bronze and jade which dominated initial interpretations.

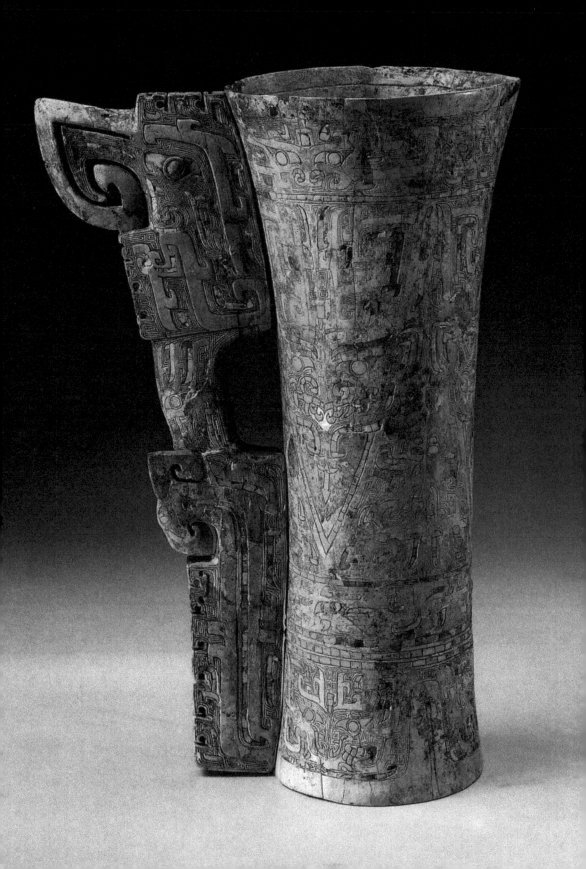

Fragments of white plaster walls, painted in red and black, have even been recovered, to hint at the visual culture surrounding the Shang rulers in their lifetimes. However most of the evidence still comes from the goods surrounding the dead. The undisturbed tomb of the Shang royal lady Fu Hao, wife of King Wu Ding, was discovered in 1976, and dates from *c.*1200 BCE. We have no way of approaching the personality or life of this woman, other than through the contents of her tomb. This took the form of a single great pit, possibly with a built superstructure to protect it, provide a theatre for ongoing sacrifices, and announce its presence in the royal mausoleum. Among its profusion of over 200 bronze vessels, plus weapons and more than 700 jade items for ritual use and personal adornment, is a unique beaker of ivory [3], an elegant concave tube inlaid with turquoise, the form and decoration of which bear some relation to bronze objects but which does not exactly copy any known example. The durability of bronze has put it right at the centre of all historical and modern understandings of early art in China, but this beaker shows what is lost in wood or other perishable materials, whose possibly equal value to their original owners will never now be known to us. Bronzes were made in sets, with objects of similar form differing in size and elaboration of decoration due to the differing status of their owners, and the extent to which they are comprehensible as single objects rather than as integral parts of those sets, used in royal feasting, sacrifices to ancestors, and in the context of funerals, is limited. Single luxury objects may have borne more personal meanings for their owners, and this particular case may have been a piece of exotica. Ivory was a local luxury (the climate of China was warmer 3,000 years ago, and elephants lived much further to the north than they do now), but the turquoise was an import from far away. As such it was only one of a number of exotic pieces in Fu Hao's collection of possessions, which also contained 'antiques', in particular jade objects, products of the neolithic cultures discussed above which were already ancient by her time, as well as contemporary facsimiles of ancient objects.

The beaker has a handle in the form of a bird, and is decorated with monstrous faces. These are one of the most common motifs on Shang bronze vessels, and are sometimes known anachronistically by the later Chinese name of *taotie*, which means something like 'glutton' in the language of the last few hundred years. These faces are horned, with staring prominent eyes, and typically have two bodies, one stretching out horizontally from each side. The interpretation of this and other motifs has in recent years become a matter of renewed and vigorous controversy among scholars. Some have argued that it can be read as indicative of Shang mythology and culture, that it represents beliefs whose primary locus was elsewhere, in the oral or written literature and ritual of the period about which we are almost entirely ignorant. Using

the methodology of structuralism (in which very disparate phenomena are reflections of an underlying structure of meanings), they have attempted to reconstruct this system of belief from the evidence of surviving bronzes. Others, associated with the art-historical tradition known for convenience as 'formalism', have maintained that any discussion of features external to the objects themselves should be rigorously excluded, and that it is purely technical features of the process of casting, together with intrinsic laws of stylistic development, which govern the distribution of this and other motifs across the body of the material evidence. While not arguing that these motifs have no meaning, those who incline towards this approach maintain that we cannot read vanished beliefs from visible features of formal decoration. They thus accept that we are never likely to understand how a royal owner such as Fu Hao may have conceptualized the decoration on something like this ivory vessel, as opposed to how she may have thought about the messages of power and prestige embodied in the fact of its possession.

Bronze vessels of the Shang period have been preserved largely due to the fact that they were buried in the tombs of the great of both sexes. Their primary use at the time of their manufacture was in banquets in temples at which sacrifices of food were offered to the royal ancestors. They were buried with their owners in order that they could continue to sacrifice to higher powers even after they themselves had died and become ancestors in their turn. The vessels were evidence of power, an aspect which became even more sharply focused after the Zhou, a people from west of the Shang kingdom, destroyed that kingdom around 1050 BCE. Zhou kings used gifts of bronzes, and of the metal necessary to make bronzes, as rewards to their followers, events which increasingly from this date are recorded in inscriptions cast on the pieces themselves. Here bronzes were no different from jades, weapons, and chariot fittings, all the accoutrements of an aristocratic lifestyle, as carriers of rank, and of the continuation of rank through family. The earliest bronze inscriptions stress the fact that these 'precious vessels' are to be 'treasured forever by sons and grandsons'. Such inscriptions may transcribe formulae uttered during the ritual banquets in which food was offered to the ancestors. Such early Zhou inscriptions are *inside* the vessels, where they would be covered when in use, and it may therefore be that they were intended for the eyes of the ancestors as much as to impress the living participants.

We can construct something of how these bronze vessels of the Shang and Zhou élites were understood by their owners, and we can say quite a lot too about how they were made. About their makers we are much more ignorant. The vessels never carry the names of individual makers or of workshop organizations, and while we can argue by analogy from later sources that they were made by a hereditary

4

Bronze vessel for wine, dated 964 or 962 BCE. Part of a hoard of bronzes made for four generations of the same aristocratic family. This included both vessels in current use and those no longer deployed in ritual, but presumably preserved for their associations with previous generations.

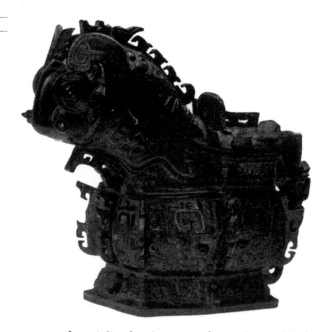

group of specialized artisans, we do not know this for sure. We might guess, given the sacred nature of the vessels, and the particular status of metalworkers in a number of analogous cultures, that there may have been something of the priest or the shaman about those who could produce objects so central to the key concerns of the rulers, but the sources again are silent. Nor do we know how the workshops in which they were made were organized, for example whether they practised any form of division of labour, with different craftsmen responsible for different stages of the process. What is better understood is the very complex casting process by which early bronzes were produced. This involved the working in clay of a negative model of the finished vessel, made in sections which then had to be fitted together with extreme care (even so, external 'seams' on the metal show where the sections were joined). A clay core was then fitted into the mould, and the molten metal was poured into the space between this and the external sections to form the vessel. Finally, the external sections were dismantled, surplus metal was filed off and the object was complete. When brand new, Shang and Zhou bronzes would have shone brightly, without the green oxidization patina which is now part of their aesthetic appeal. Although this procedure would theoretically allow for the reuse of moulds, there is perhaps surprisingly no evidence that this was ever done.

Certain similarities in form and decorative motifs between Shang and Zhou bronzes have acted until recently to mask significant differences in the way they were used, and thus most probably in the way they were understood by their users. This amounted to what has been described as a 'ritual revolution' taking place in the years around

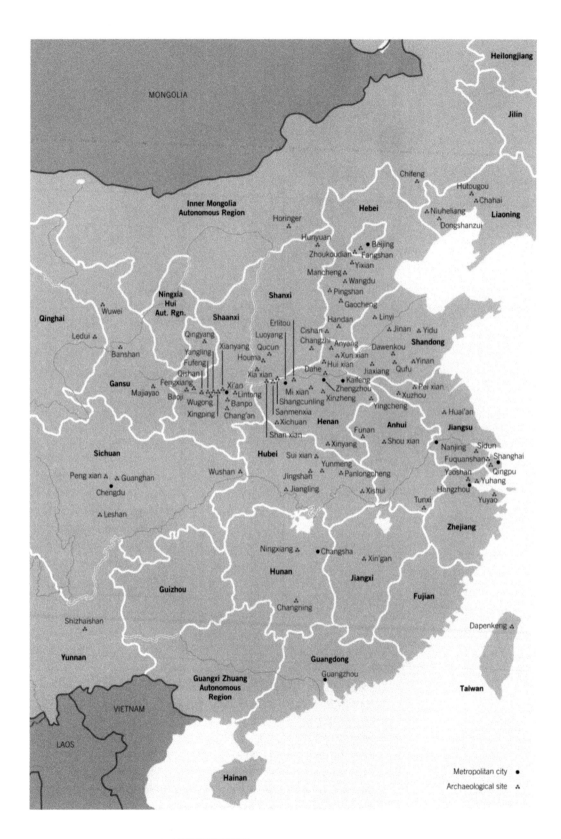

900 BCE. Bronzes became plainer in decoration and more extensively inscribed (sometimes now on the outside), as explicit wording replaced elaboration as the chief marker of the owner's power and prestige. Several shapes of bronzes went out of use altogether. Sets of bronzes were still buried in tombs, but they also became the subject of a different kind of deposit, the hoard, in which no human burial was involved, and the objects present were heterogeneous, rather than part of a ritually specified set. The large bronze vessel for wine shown [4] is part of the largest such hoard to be excavated, 103 pieces found in 1976 at Fufeng Zhuangbai, in Shaanxi province. A pit contained the precious heirlooms of a family of court scribes, that of Lord Xing of Wei, buried c.900–800 BCE to preserve them from danger at a time of political instability and never recovered. As the vessels from their ancestral altars, the hoard comprised a set of recently made pieces for current use, plus others of particular importance to the family from an earlier period. This wine vessel was such an antique, inscribed as having been made in the nineteenth year of the Zhou king Zhao, equivalent to 964 or 962 BCE by the traditional reckoning. It was thus some hundred years old when it was buried. The extent to which purely aesthetic appreciation, apart from its associations with a revered ancestor, mandated its preservation, is doubtful, but this does not mean that awareness of such issues was entirely lacking. Clearly some bronzes were better made, grander, more fulsomely inscribed, or more highly decorated than others. They were almost certainly understood as being so, with consequent meanings attached, and in this type of discrimination we have the beginnings of the conditions necessary for the concept of art.

As the archaeological record gets richer in the course of the first millennium BCE, it provides evidence for the progressive uncoupling of bronze vessels from religious observance, as they become associated instead with a realm of display and luxury consumption. In later Chinese historical periodization, the shift from the era of the 'Spring and Autumn Annals' (770–476 BCE) to that of the 'Warring States' (475–221 BCE), which take their names from chronicles of the period, is marked by the decline of any respect for the central, sacral authority of the Zhou kings, and its replacement by a regime of vicious and permanent conflict between numerous contending political entities of varying sizes. This culture of competition extended to the material realm, as lavish display at the large number of regional courts became one of the means by which a ruler's prestige was asserted and maintained in the face of both friends and rivals.

Something of this court culture can be reconstructed from the contents of the tomb of Yi, Marquis of Zeng, a small state in modern Hupei province, who died around 433 BCE ('Marquis' is used, like 'Duke' and other titles, as equivalents of a Chinese hierarchy of rank).

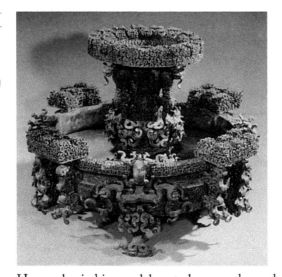

Bronze jar and basin, c.430 BCE, from the tomb of Yi, Marquis of Zeng. Decorative details made by the lost-wax technique have been fastened to the main body of the object, cast in a removable piece-mould. These vessels may be for wine, or may have been used for ceremonial washing.

He was buried in an elaborate lacquered wood nest of coffins, with a lavish array of bronze vessels, weapons, a set of bronze bells, objects such as musical instruments and furniture in lacquered wood, plus items of gold and jade. The survival of the objects in perishable materials gives a much better sense of how bronze, still the major metal of this culture, fits into the total scheme of things, now as merely one kind of luxury among others, and not, as in the Shang and Western Zhou periods, as a uniquely privileged bearer of cultural meanings and prestige. The example shown from Marquis Yi's death-hoard is a set of a bronze jar and basin, both virtuoso pieces of casting, the surfaces of which appear to writhe with dragons and tigers among a forest of tightly packed scrolls [5]. This is an aesthetic of excess, of 'more *is* more', made possible partly by the introduction of the technique of 'lost-wax' casting. This is a more practical way of making small, three-dimensional forms in metal, where the intricacy and degree of undercutting make the removal of the traditional sectional clay mould difficult or impossible. In the lost-wax method, first attested archaeologically in the sixth century BCE, the form of the object to be made is first modelled in wax, which is covered in clay to form the mould. When hot metal is poured in, the wax melts and is lost (hence the name); the mould is then broken to remove the metal piece and cannot be reused. In the Warring States period there is evidence that bronzes were becoming luxury commodities, things which could be purchased from independent workshops, which were no longer so tightly controlled by the court of the ruler, and which could service a wider clientele. For example, the excavation of a bronze foundry site at Houma in southern Shanxi province, capital in the sixth and fifth centuries BCE of the state of Jin, shows that a wide range of quality of objects was produced at the same place over the same time span.[2] Technical features in the way bronzes were made point to steps taken

to maximize production in the service of this broad market, with increasing use of shortcuts and reuse of mould pattern blocks to improve efficiency.

Given the probable absolute increase in the number of metal vessels being put into circulation, bronzes of this period *have* to shout to be noticed; they have to be exceptionally large (the biggest piece in Marquis Yi's tomb is 126 cm., or about 4′, high and contains 327.5 kg of metal), or else they have to resort to devices such as inlay with copper, gold, or silver wire and other precious materials, since the meaning of bronze itself has undergone a transformation. Objects in that material now had to contend with highly coloured lacquers and textiles as the prime sites of conspicuous display. The tripod vessels known as *ding*, still necessary for sacrificial purposes, which are found in the tomb, are now rather plain and insignificant, while it is objects for explicitly secular use, for feasting and display, which are most lavishly decorated.

The Marquis Yi bronzes were part of the contents of a tomb, and hence experienced prior to their excavation in 1978 two distinct contexts of use. The presence of the objects in the tomb sustains in death the status enjoyed by their owner in life, and in that sense there is a degree of continuity between the two states. Although the practice of burying large quantities of grave goods with members of the upper classes was continuous in China from the very earliest times, the contents of élite tombs underwent a considerable change in the fifth–fourth centuries BCE. In particular, the slaughtering of human and animal followers to accompany their master or mistress in death, which had been a feature of the great royal Shang tombs, gradually died out. Marquis Yi was accompanied by eighteen women, probably musicians, but this was by his time becoming less usual. Substitutes now began to be provided in the form of facsimiles of people, animals, and things in clay or wood. These changes were accompanied by changes in the religious beliefs of the upper classes, reflected in the physical layout of tombs. The royal tombs of the Shang, such as that of Fu Hao, were single pits, often of great depth. Marquis Yi, on the other hand, is provided in death with a multi-roomed dwelling, with doors allowing passage from one space to another, and the objects disposed in those rooms as they would have been in life. A tomb is now a dwelling, and for the next millennium or even longer steps are consistently taken to make a tomb ever more like the dwelling inhabited by the person in life, and multiply the representations it contains of every last detail of daily life. This is done equally through pictures of things, models of things, and things themselves.

However, it is at the same time a door to an afterlife which is much more precisely imagined in the literature of the period from around 500 BCE, populated by never-dying, spiritually powerful beings who can interact with the living and the dead. Representation of these immortal

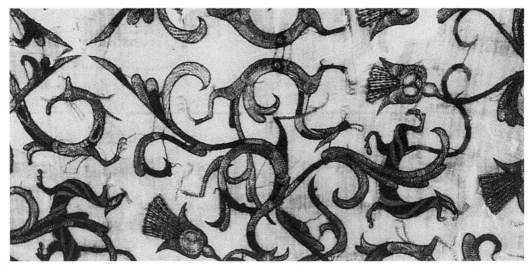

6

Detail of an embroidered silk shroud, *c*.300 BCE, from Mashan, Hubei province. The embroidery is carried out in chain-stitch, only one of a number of textile techniques represented on the Mashan finds, and which include complex patterned weaves.

beings, which take animal and quasi-human form, and who are importantly *not* understood as the ancestors of the deceased, but as independent if entreatable spiritual powers, becomes consequently more important from this period also. Their presence in tombs marks a clear shift in belief, which did not supersede the paying of ritual respects to ancestors, but instead added to it a new way of understanding the world, the other world, and the mysterious workings of both.

These new beliefs are seen not so much on bronze vessels, whose sacral purposes may have encouraged a conservatism in their design, as they are on newly prominent forms of craft, principally, lacquered wood and silk textiles. It may simply be that the better rate of survival of these objects makes them seem more important. We know that silk was woven and wood was carved and lacquered at the Shang court, but we do not know what such objects looked like, or even if they shared an aesthetic and a design vocabulary with the bronzes and jades (although the analogy of the close relationship between bronzes and the ivory beaker makes it a strong possibility). On balance it does seem likely that changes did take place in the hierarchy of esteem enjoyed by what we would now categorize as different 'art forms', and that one of the key beneficiaries of this was textiles.

The techniques of rearing the silk worm, of unravelling, spinning, and weaving its cocoons, had been perfected in China in the neolithic period, at least from the third millennium BCE. As a machine for making and more importantly for *repeatedly* making a pattern, the importance of the loom to any conscious aesthetic cannot be overemphasized, but again lack of evidence leaves room only for speculation as to what the earliest textiles in China looked like. Surviving fragments from the Shang and early Zhou tell us that techniques were by then available to make quite sophisticated self-patterned silks, and that embroidery was already practised as a means

of creating freer pictorial designs. But it is only from the third century BCE, and only in very recent years, that we have any body of complete objects on which to begin the analysis of the role of textiles at that time.

The evidence all comes from tombs, and so cannot be relied on as a source for how the upper classes were dressed in life. The patterns we see on, for example, one of the thirty-five complete blankets and garments recovered from a tomb of around 300 BCE at Mashan in Hubei province [6] may perhaps be part of a specialized visual culture of death (although the possibility also exists that garments worn in life have been recut to make shrouds). An unknown upper-class woman of about 40, the Lady of Mashan may even herself have acted as a shaman, a powerful religious practitioner able to journey in spirit to realms beyond the mundane, and to facilitate communication between below and above. The interlaced tigers, dragons, and marvellous birds are the fauna of the realms to which the tomb's occupant is going, rather than a representation of where she has been in life.

As with bronzes, it is reasonable to postulate the existence of specialized weaving workshops which may have had relationships with courts but which increasingly may not have been under their immediate control. Whether these workshops were segregated on gender lines it is impossible to know, and it may or may not turn out to be significant that excavated men's tombs of the period have yielded bronze vessels but fewer textiles, while this single woman's tomb is packed with textiles but holds no bronzes.

Weaving and embroidery, though now categorized together as 'textiles', are in fact two very different processes, a difference which is clear in their relationship to drawn or painted representation. In China as elsewhere in the world, weaving has been largely independent of drawing until very recently, and it is probable that there never were any 'designs' for the woven textiles at Mashan. With the embroideries the possibility of a relationship to representations in other forms should at least be raised, though not in any sense implying that drawing or painting were necessarily of a higher status in China at this time. Patterns could be drawn directly on the silk prior to stitching, or else could be held under the thin gauze, still visible enough to guide the needle.

The First Empires: 221 BCE–220 CE

Until the excavations of the 1970s, which laid open some of the contents of his tomb to an astonished world, the First Emperor of Qin (in Chinese, *Qin shi huang di*, r. 221–210 BCE) was renowned as much for what he destroyed as for what he caused to be created. Familiar to generations of schoolchildren as the ogre who 'burnt the books and buried the scholars', his image was of a brutal warlord whose armies

View of Pit no. 1, part of the
'Terracotta Army' surrounding
the tomb-mound of the First
Emperor of Qin, d. 210 BCE.
There may in total be as
many as 7,000 life-size clay
figures on this site, of which
only 1,000 have so far been
uncovered.

put an end to the Warring States period by destroying all his rivals, ushering in an age of centralized imperial rule (he was the first man to bear the title 'imperial sovereign') which standardized weights, measures, and writing systems, and linked disparate defensive systems into what became known as the Great Wall. 'Qin dynasty art' would have seemed a contradiction in terms.

All this changed with one of the few Chinese archaeological finds to capture the popular imagination in recent years, the so-called 'Terracotta Army' [7], at Lintong, near the modern city of Xi'an in Shaanxi province. This, on a massive scale, replicated the pattern of tomb-building and grave goods which had become standard for the wealthy and powerful over the preceding 500 years. A ruler in death should inhabit a palace, and he should be accompanied in this case by models of the military forces which had sustained the career cut short in 210 BCE. What is distinctive about the excavated portion of his tomb is the number and size of the clay figures of warriors which formed the military escort to the corpse.

Rulers of the past had controlled luxury materials such as bronze and jade, and had been buried with goods which marked their status. But only an emperor able to mobilize resources on a totally new scale could have brought about the making of this formidable assembly. It is not the material which is precious or reserved (the clay from which the figures are made is simply the abundant soil of the North China plain), but the scale of the operation. This must have involved literally tons of firewood, to fire the figures at between 950 and 1,000 degrees, the construction of massive and numerous kilns, and the deployment of an army of workers, to parallel the army under construction. Although attention has focused on the lifelike nature of the soldiers, what is at least as striking is the use of techniques of mass production, what has been called a modular system of the reuse of prefabricated parts, which must have required a complex organization to achieve.[3] The army is a triumph of bureaucracy as much as of art.

Each of the standing figures, which vary between 180 and 190 cm. in height, is composed of a number of sections: a plinth, legs, torso, two separate arms, two hands, and head. These all exist in a repertoire of limited types, with three plinths, two types of leg sets, eight types of torso and of heads, which were further customized by individual modelling of features and hair. Moulds were used to increase the production rate of some of these elements, particularly hands, themselves composed of smaller prefabricated elements. It is the manipulation and combination of these elements which gives the appearance of almost infinite variety. The similar manipulation of the possibilities of basic paint schemes for components added to this effect. The aim was not purely aesthetic, as these figures were never intended for contemplation by any living eye. The verisimilitude

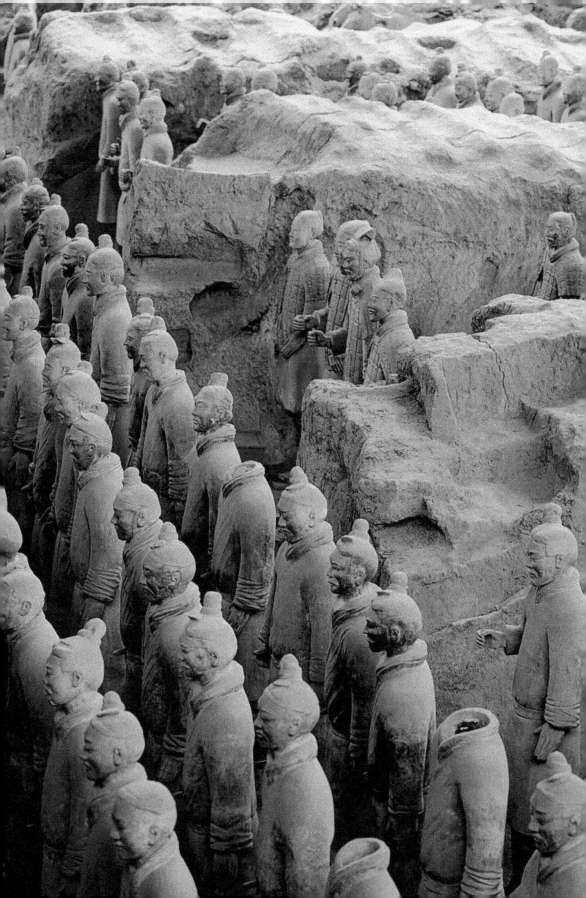

Funeral banner from Tomb
no. 1, Mawangdui, c.168 BCE.
The painting on silk is done
with six pigments; the
minerals cinnabar, red ochre,
and powdered silver, indigo
and ink from vegetable soot,
and white from powdered
clamshells.

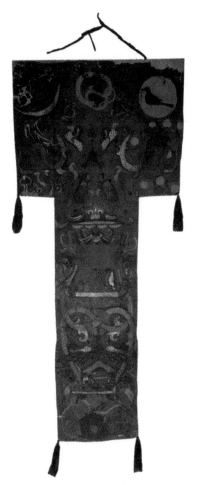

which delights today was sought in the interests of effectiveness of the
figures' basic function; the more lifelike they were, the better they
fulfilled the role of guarding their master in the nether world. The
'realism' which has been so admired in Qin period art was marshalled
in a practical and religious, not an artistic, cause.

Similar grounds of religious need drove the creation of what is today
one of the most famous as well as the most controversial of early
Chinese objects, the painted silk banner excavated in 1972 from a tomb
at Mawangdui, just outside the city of Changsha in Hunan province,
dating from c.168 BCE [8]. Interpretations of the meaning of this
enigmatic object have been numerous and contradictory. Some have
seen it as a symbolic garment, used in the ritual of 'summoning the
soul' after death, some as a banner carried in procession as part of
the funeral rites, before their installation in the tomb. Another
interpretation has described it more convincingly as a 'name banner',
the focus of veneration by the bereaved during the mourning cere-
monies.[4] Controversy often centres on the relationship of the icono-
graphy, of what is actually shown, to the rites and religious beliefs

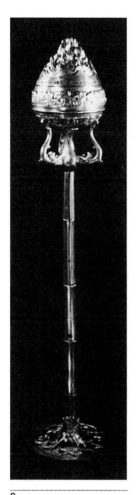

9
Incense burner of gilt silver, the property of the Han dynasty imperial princess Yangxin, c.153–106 BCE. The inscription around the top identifies the owner.

described in Chinese texts of the period. All are more or less agreed that four levels can be made out, commencing at the top with the heavens, where the moon and the sun are represented by their symbols of a toad and a raven respectively, while dragons and immortal beings cavort in the sky. Below are two levels of the earthly realm, where the occupant of the tomb is shown as an old woman, leaning on her staff and surrounded by servants, and where sacrificial vessels are set out before her shrouded corpse. At the very bottom is the underworld. The aim of the banner's painter(s) is clearly not to depict observed phenomena accurately, but it may well be that fidelity to a precise iconographical programme, whether shared widely or idiosyncratic to the lady herself, here drives the representation. Furthermore, it is certainly necessary to see the banner *not* as an isolated 'work of art' but as a part of the elaborate rituals of aristocratic burial, rituals of which the tomb itself and its contents are only the visible part.

Although the Mawangdui banner has been perhaps more intensively discussed than any other recently excavated piece of early Chinese art, it is far from the only object to shed light on the way in which the art of the period serviced notions of the afterlife. Finds from the tombs of the emperors of the second unified imperial dynasty, the Western Han (206 BCE–8 CE) have produced lavish goods like an incense burner of gilded silver, inscribed as being from the palace of Princess Yangxin, sister of the Han emperor Wudi, who reigned 140–87 BCE [9]. The shaft is cast in the form of a bamboo pole, but the body it supports is a miniature model of a mountain, pierced with holes to allow smoke to wreath it when incense is lit inside. This is not a real mountain, but a paradise where the princess's soul might dwell after death, in the company of magical beasts and immortals. The company she might keep in such a paradise is shown by another object from a Han imperial tomb, a small carving in pure white jade of an immortal rider on a prancing white horse [10]. Such a figure is related to the immortals, often dressed in feathers, who cavort, freed from mundane cares, on the Mawangdui coffins, on textiles from Mashan, and on numerous other pieces of Han funeral art. Both of these objects, produced for specific purposes to do with the rituals of death, contain images which were increasingly to penetrate the culture of the upper classes. The representation of paradise scenes in particular, it has been argued, paved the way for the interest in landscape representations which was to be one of the central strands of art in China over subsequent centuries (see p. 55).[5]

Prior to the discovery of Mawangdui and the excavation in recent years of a number of Han imperial and princely graves, the key monuments of early tomb art in the Han period were the low-relief carvings found at a number of sites in the north. There has been renewed interest in these in recent years, and they have been the focus

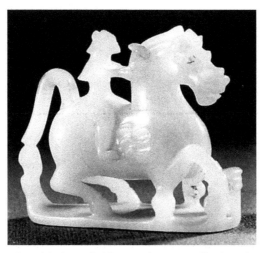

of sophisticated, if sometimes conflicting, interpretations. The most intensively studied has been the group of carvings related to the so-called Shrine of Wu Liang, built in 151 CE for an upper-class male of that name. This is one of a complex of shrines where offerings were made to deceased males of the Wu family, at Jiaxing in the south-west of modern Shandong province. It is not a tomb and Wu Liang himself was never buried there. But its carvers shared the concerns of makers of tomb art of the period (the same craftsmen were employed) and it can be considered as the same type of representation.

In the first century CE, important changes in burial practice and religious belief were consolidated. The focus of worship, on the part of the imperial household and the wider élite, shifted from ancestral temples, which had been so important in the Shang and Zhou periods, to the tomb itself. It was now at the tomb, or at nearby shrines, that sacrifices were held. Significantly, these shrines (like that of Wu Liang) were conceived as public sites, open to visitors. This consciousness of an audience must have affected the types of scenes depicted on shrine walls, as well as perhaps hastening the change to the more durable medium of stone.

Individual scenes carved in very low relief on the walls of the stone slabs which make up the various chambers of the Wu Liang Shrine, have been intensively researched as to their meaning, in China and the West, for at least a hundred years. Scholars have often concentrated on the most visually impressive scenes, such as the so-called 'Battle on the Bridge' [11], a slab probably from the associated shrine of an earlier member of the same family named Wu Ban (d. 147 CE). Many of the slabs are accompanied by short texts identifying the figures. Often these can be identified as characters referred to in the classic texts, including those associated with the name of the historical philosopher Master Kong or Confucius (551–479 BCE). The writings of Confucius and his followers were given a central role in the ideology of the state by

the Han emperors, and what might be called 'Confucian' themes in art begin to appear at this time. The most comprehensive study of the site by the modern scholar Wu Hung stresses the importance of reading the entire complex as a whole, rather than as a set of unrelated 'pictures'.⁶ The battle scene, for example, is not unique to this shrine, but appears in tombs in other parts of north China at this period (indeed it appears more than once at the Wu Liang site itself). Many of the characters shown in the shrine stem from philosophical or spiritual traditions which are very different from that of the followers of Confucius, and it may be wrong to try and introduce too much ideological conformity into the diversity it contains. Wu Hung's interpretation therefore centres on the role of the shrine's decoration in linking ideas of the soul and the afterlife to an ideal social order on earth, with elements of both cosmic and human history given equal prominence, and Wu Liang himself shown as in harmony with both.

The Wu Liang Shrine's use of stone, a material not found extensively in earlier phases of civilization in China but which was accorded a new prominence in the Han dynasty (220 BCE–206 CE), reflects ideas about permanence and permanent commemoration which are linked to changed ideas about the afterlife and the place of the individual in it. Although it is true that the style of the Wu Liang carvings is probably related to that of now-lost wall-paintings used in the palaces and dwellings of the rich at this same period, the fact that the material used is *not* painted plaster or wood but the much more durable material of stone gives these scenes a very particular meaning.

North and South: 220 CE–589 CE

A different relationship between the decoration of a tomb and the art enjoyed by the living is shown on the brick walls of the elaborate grave of an upper-class couple of the Eastern Jin dynasty, buried near Nanjing in the late fourth–early fifth century CE [12]. Nanjing was the capital of a series of dynasties who ruled in the southern half of China after the collapse of the Han, while the north was ruled by another sequence of ruling houses, many of whom were not ethnically from the Han Chinese majority. At these Nanjing courts, many of the cultural forms which were to dominate the whole of China for centuries were first developed. It was there, for example, that the first famous named painters worked, including Gu Kaizhi who was probably still active as a painter of figures at the time this tomb was built.

The walls of the tomb in question, discovered in 1960, are decorated with an elaborate scene of aristocratic figures, known as 'The Seven Sages of the Bamboo Grove and Rong Qiqi'. These are not spiritual guides to the tomb's occupant, not figures from another world, but real historical characters, famed for their poetic talent and for embodying an idealized upper-class lifestyle of elegance and cultured leisure. The

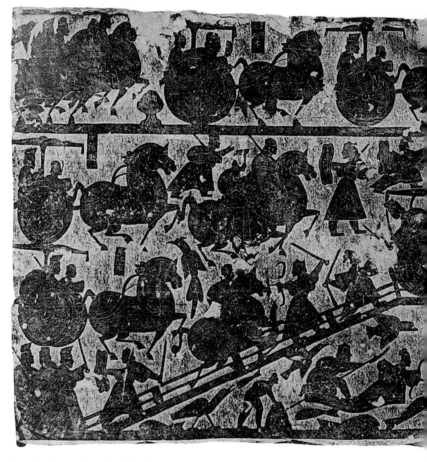

11

Stone slab from the Shrine of Wu Ban, *c.* 147 CE. This may show a scene from human history, a legend from the Wu family's past, a representation of a ritual performance of the soul's journey, or else a purely symbolic clash between the forces of chaos and order, over the dead man's soul.

kind of people the dead pair were in life is indicated by the lofty company they keep in death. The presence of the same group of figures on the walls of at least three royal tombs built nearly a century later suggests that clients wanted this subject-matter in particular, for its associations of cultural eminence and refinement.

The manner of depiction is rather different from that of the Wu Liang Shrine stone slab. The figures are much larger, there are fewer of them, and they are shown as inhabiting a less-flattened space. The depiction, however, does not emphasize space, but the individualized depiction of the character of each man through pose, dress, and, to a lesser extent, facial expression. While there is clearly a close relationship between these two brick walls and the paintings enjoyed in their daily lives by the aristocracy, they do not handle three-dimensional space in the way associated with the earliest surviving Chinese scroll paintings. These developments are seen on two objects from tombs dating to around a hundred years later.

The first comes from the tomb of Sima Jinlong, who died in 484 CE, ten years after his wife Yichen, a member of the Tuoba ethnic minority which formed the ruling group in the north Chinese state of Wei. The

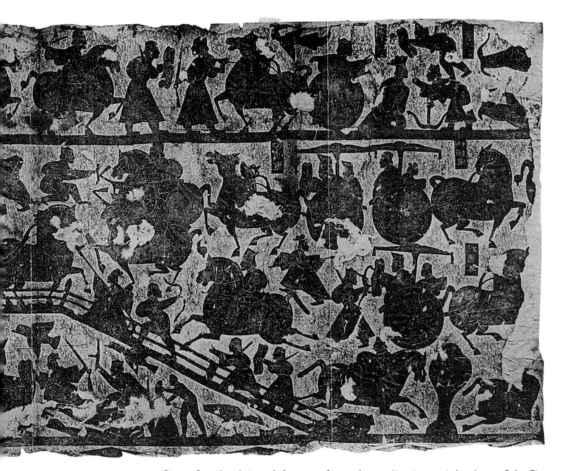

Sima family claimed descent from the earlier imperial rulers of the Jin dynasty at Nanjing, but had risen high in the service of the Tuoba. The ethnically diverse and culturally hybrid upper class of north China at this period is reflected in the contents of Sima Jinlong's tomb, which was excavated in 1965. Large numbers of ceramic figures of warriors and civilian attendants of both sexes are present, but the finds which have attracted most attention are the fragments of one or more wooden screens painted on both sides in lacquer, which originally stood in front of the coffin platform [13]. These screens were perhaps not specially manufactured grave goods, but part of the furnishing of the palace of the dead man and woman.

The surface of the panel shown is divided into four equal registers, painted in lacquer with texts and subjects mostly drawn from a book of the first century BCE, the *Lienü zhuan* (Biographies of Exemplary Women) written by Liu Xiang. These biographies had themselves originally been painted on screens at the imperial court, and they also formed appropriate subject-matter for the walls of aristocratic tombs (for example, appearing in the Wu Liang Shrine). The subjects shown are, from top to bottom: three scenes from the life of the ancient sage-

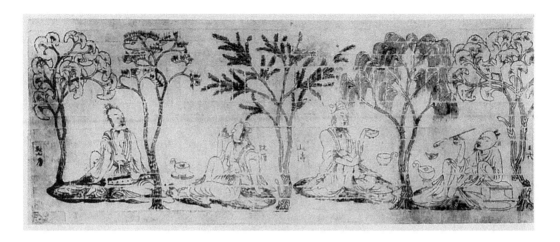

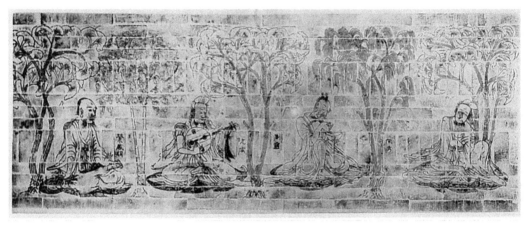

12

Rubbing of tomb walls
c.380–420 CE, from
Xishanqiao, near Nanjing. The
walls were decorated by
drawing the design in ink on a
wood surface, then cutting
this up and carving each
section into a mould. This was
then used to stamp the clay
bricks, which were individually
fired and reassembled.

emperor Shun (now held to be mythical but not at the time the screen was made), three exemplary mothers of the Zhou dynasty, a model woman teacher of the state of Lu named Chun Qiang, and the story of how Concubine Ban refused to share a sedan chair with her lord, on the grounds that grave councillors of state would be more fitting companions for a good ruler. So these are historical stories, taken from a text widely disseminated among the upper classes, and the selection concentrates on virtuous *royal* women, virtuous principally in their submission to men, their modesty and chastity, and their role as mothers and defenders of the élite cultural heritage.

The screen was immediately recognized on its excavation as bearing comparison with some of the earliest surviving pictures on silk in the horizontal scroll format, a format which the screen would resemble if the four registers were continuous instead of on top of one another. These include the so-called 'Admonitions of the Court Instructress' scroll, now in the British Museum, and the Beijing Palace Museum's 'Portraits of Exemplary Women Known for their Kindness and Wisdom'. Both are attributed to the artist Gu Kaizhi (c.345–c.406 CE), subsequently revered as a founding figure of Chinese painting.

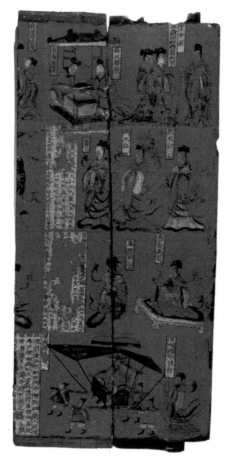

Though now held to be a later copy, possibly of the sixth–eighth centuries CE, the venerable and frequently reproduced 'Admonitions' scroll in particular was put in a new context by the Sima Jinlong screen, and the plausibility of it as an accurate reflection of a fourth-century style of painting was strengthened.[7] Even more significant is the congruence of subject-matter, underlining the didactic uses of much picture-making at this time, in placing before the eyes of women and men models of ideal deportment for both sexes, whether in the form of screen panels, wall-paintings, or scrolls. This congruence becomes all the more striking on considering that Gu Kaizhi was working at the capital of one of the southern Chinese states, self-conscious heirs of Han civilization in the face of 'barbarian' control of the north, where the Tuoba relatives of Lady Yichen ruled. Earlier models of a complete cultural split between north and south at this period are giving way to an appreciation of the hybridity and interchange which characterized the visual, religious, and literary cultures of the age of the 'Northern and Southern Dynasties'.

An even more sophisticated testimony to a continuum in artistic patronage between north and south comes from a limestone coffin,

Limestone coffin of Lady Yuan, d. 522 CE. The incised decoration shows exemplary cases of service to parents, a moral value on which the teachings of Confucius placed great emphasis. Such paragons of virtue were a frequent didactic subject in early pictorial art.

probably that of a certain Lady Yuan, who was buried near Luoyang in 522 CE [14]. This is decorated in low relief, with scenes showing men renowned for the devotion with which they served their parents. The subject was certainly one portrayed by painters, including the famous Gu Kaizhi. Painting and sculpture also certainly shared certain conventions of representation, including what has been called 'binary' imagery, where both sides of a scene are presented to the viewer within the same frame. Two sides of an object or a figure cannot of course in reality be seen at the same time. At this time, the first theorists of representation were writing their treatises, in which they showed disdain for any picture which merely transcribed what the eye could see (see p. 46). This, they argued, was not art. Only the addition of elements from the artist's mind, what we might call 'imagining', could make a picture art. These relatively new and advanced aesthetic theories fit the practice of the makers of Lady Yuan's coffin. We should not necessarily assume that texts came first and practice followed. Perhaps the aesthetic theorists of the Northern and Southern Dynasties were rather putting down in words a rationalization for the kinds of pictorial surface they were beginning to see around them. These practices may have been generated first not by élite court painters, but by the anonymous makers of such objects.

Tomb Sculpture: 400–650 CE

What is clear is that by about 500 CE the tomb was no longer a totally distinct artistic space, with its own subject-matter and styles, never seen in the land of the living. Tombs did not decline in importance, but

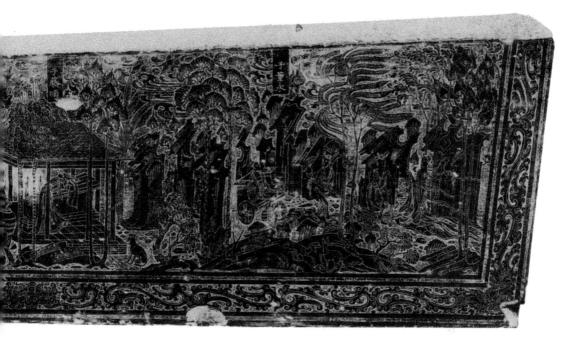

the goods they contained less visibly formed part of a distinctive artistic agenda. One area in which art surrounding the tomb was to be permanently affected by the changes of the Han period was that of large-scale stone sculpture. This had been unknown in earlier periods. The First Emperor's warriors [7] were underground, not above it. Starting in the first century CE, the mimicking by grand tombs of palace precincts had been accompanied by the first stone sculpture in China. This was often arranged in 'spirit roads', ceremonial axes which led up to a new style of tomb mounds. The later example shown [15] is a mythical beast called a *qilin*, a protector against evil influences, from the tomb of the southern ruler of the Song dynasty, Wendi (r. 424–53). The use of such stone beasts was restricted to the imperial family, with individual animals being allocated strictly according to rank—only emperors were allowed the bearded, winged *qilin* figures. Such beasts are descended from the representations of fantastical creatures seen in Han tombs such as Mawangdui, but their sheer scale here gives them a different meaning as attributes of royal power. The southern emperors were enthusiastic patrons of Buddhism, but their realms did not for various reasons produce the massive religious sculpture in stone of their northern contemporaries (see p. 92). The anonymous sculptors of these images must have worked on other projects now lost to us, since it is unlikely that imperial tombs alone could maintain a sculptural tradition of this degree of sophistication.

The tomb-sculpture tradition was maintained in China down to the twentieth century, though it never achieved the status of an art form in the eyes of aesthetic theorists. This does not mean that there

An anecdote found in a text associated with the name of the nobleman and political thinker Han Fei (d. 233 BCE) tells how the king of the state of Qi asked a painter in his retinue which were the most difficult subjects. He was told that dogs and horses were hardest, while demons and goblins were easiest. His justification for this was: 'Since dogs and horses are things known by man, visible before us the day through, they cannot be completely simulated and thus are difficult. Demons and goblins are without form, and not visible before us, hence they are easy.' (Translated in S. Bush and Hsio-yen Shih, *Early Chinese Texts on Painting* (Cambridge, Mass., and London, 1985), 24.) Apart from

Detail of 6

telling us that kings in the third century BCE had painters in their retinues, which is interesting in itself, this passage, which has by now the status of a foundational myth of Chinese art history, opens up problems of representation in early China, of the relationship of things to depictions, of perception and imagination, in a way which suggests these were beginning to become concerns of the élite at some level.

Concerns with representation, broadly defined, were also located in one of the most ancient, prestigious, and arcane of Chinese written texts, now known generally in Chinese as the *Yi jing*

(Classic of Change) or *Zhou yi* (Changes of Zhou), and often in English as the 'Book of Changes'. This divination text is much more than a guide to the future; it is the main theoretical explanation of early Chinese views of the cosmos. Although sections of this may go back to around 1000 BCE, it reached something like the form in which we now have it in the years 200–100 BCE. Extremely hard to interpret, sections of the *Changes*, and in particular the 'Commentary on the Attached Verbalizations', nevertheless provided Chinese thinkers in later times with a core technical vocabulary of words like *tu* ('diagram' or 'picture') and *xiang* (variously translated as 'image', 'representation', 'form', or 'figure'), which enabled later thinkers to elaborate theories of the visual wedded to some of the most powerful and enduring investigative tools of Chinese philosophical practice. Later writers would cite again and again the story, told in the 'Commentary', of how the mythical culture-hero Fuxi (or Paoxi) 'ruled over all-under-heaven. Looking up he observed figures in the heavens. Looking down he observed models on the earth. He observed the markings of the birds and beasts and their suitability on the earth. Close by he drew from his own body. Further away he drew from things. Therewith he invented the eight trigrams in order to comprehend the potency of what is numinous and what is luminous, and in order to categorize the actual circumstances of the ten thousand things.' (W. J. Peterson, 'Making Connections', *Harvard Journal of Asiatic Studies*, 42 (1982), 67–116, (at p. 111.)

A passage like this is to the tradition of writing about art in China over the subsequent 2,000 years what the shadows in Plato's cave or a word like *mimesis* are to another geographically specific tradition. The relationship of theory to practice is, needless to say, also similarly fraught.

A mythical protective beast (qilin) guarding the tomb of the Liu Song dynasty emperor Wendi, d. 453 CE. Over thirty tombs of the rulers of the Southern Dynasties have been identified in the region of modern Nanjing, though in most cases only the monumental stone statuary survives.

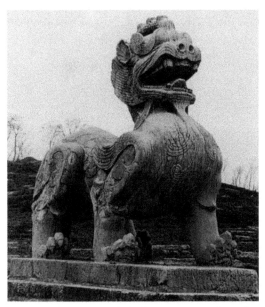

16

One of the six war horses of the Tang dynasty emperor Taizong, d. 649 CE, carved in stone for his tomb. The slabs were installed in covered terraces, at the sides of a courtyard, in front of the sacrificial hall which stood at the tomb mound.

were never connections between tomb sculpture and more esteemed arts such as painting. Among the sculptures where such a link can be made are the famous carvings of the six favourite horses of the emperor Tang Taizong (r. 627–49) [16]. As the second emperor of the great Tang dynasty (618–906), when Chinese military power extended deeper into Asia than ever before, Taizong spent much of his adult life in military campaigning. To him and his courtiers (men and women equally), horses were important as symbols of vigour and strength, and as possessions which defined their owner's status and personality. They were a focus of artistic creativity also, and Taizong is known to have commissioned the court artist Yan Liben (d. 673) to paint his favourite war horses, a painting which, like the rest of Yan's output, no longer survives. These paintings (which may have been murals, rather than movable) are traditionally supposed to have been the models for the slabs. The example shown is of a horse called Saluzi, who stands calmly while one of Taizong's favourite generals, Qiu Xinggong, draws an arrow from his flank. These beasts are not protectors, like the *qilin* on an earlier emperor's tomb. Nor are they simple symbols of rank, like the Terracotta Army of a still more ancient ruler. Rather they are reminders of incidents in an individual's biography, treasured possessions on a par with the art works Taizong also chose to have buried with him (see p. 136). The concept of the tomb as a dwelling place was now firmly established, but it was seen as the dwelling place of an individual, whose individual tastes would endure into the existence beyond this one.

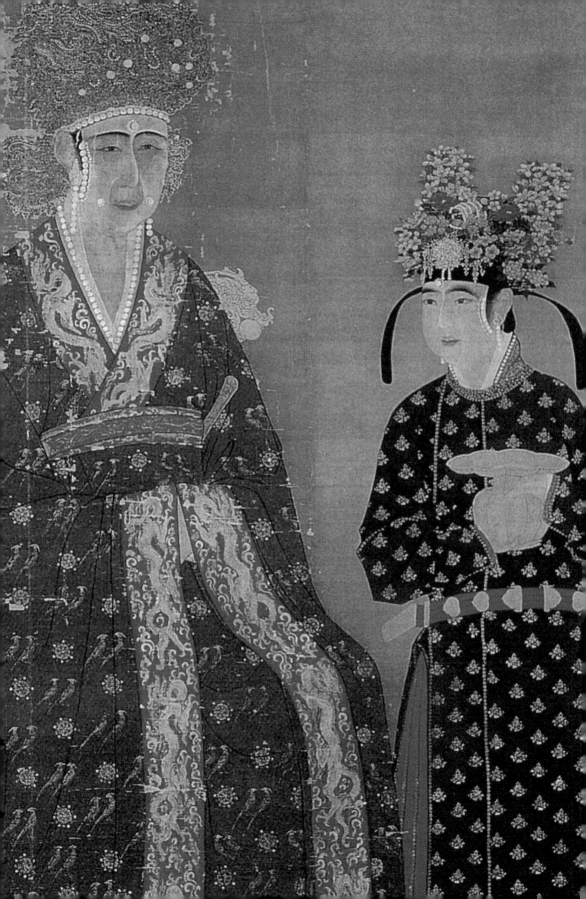

Art at Court

2

Tang to early Song: 618–960 CE

As centres of artistic production, the courts of China's rulers were of major importance from earliest times. Rulers had the resources, in personnel and finances, to carry out large-scale artistic projects. They needed ideological justification and support for their rule, needs which the symbolic resources of works of art could often satisfy. And they had around them the intellectual talent to interpret these programmes, as well as to record and classify artists and their achievements. There were few, if any, alternative centres of patronage of non-religious art on a large scale. Before the Tang dynasty (618–906 CE), there is very little written evidence for art in China which is not in some way related to the milieu of the court.

In the Tang period itself, the court at Chang'an (the modern city of Xi'an) remained the magnet which drew artistic talent to it from all over an expanded empire. Records remain of a number of individual artists, records which are rich enough to tell us something of the conditions in which they worked, and the ideals to which they aspired, even if their output is entirely lost. *Li dai ming hua ji* (Records of Famous Paintings of All the Dynasties), which was completed in 847 by Zhang Yanyuan (*c*.815–after 875), lists more than 370 painters active over the previous 500 or so years, giving biographical anecdotes about them, characterizations of their subject-matter and style, and ranking them according to their talents.

Although not the first writer to rank artists in this way, Zhang, by adapting hierarchical principles used in the ranking of personnel for government service, underscored the close links which were already in his day developing between social status and the artistic esteem in which an individual was held. He also defined a canon of 'great artists', of 'founding fathers', who remained of major significance to all subsequent painters in China, even when their work was long lost. It is for example to Zhang Yanyuan that we owe the prominence in later art-historical writing of the third-century painter Gu Kaizhi (see p. 38), whose writings on art are preserved only through quotation in *Li dai ming hua ji*. This book transmitted major theoretical formations by earlier writers. The most important of these was a text called *Gu hua*

pin lu (Classification of Ancient Painters) by Xie He (active c.500–35) (see above).

Zhang was spurred to write by the destruction, in his own lifetime, of what he perceived as the finest painting of the early Tang. This came about in the short-lived persecution of Buddhism in 845 CE, which saw monasteries despoiled, their images broken or melted down, and their great mural programmes wiped out. Wall-painting remained the focus of activity for most famous early Tang artists—Yan Liben (see p. 138), Li Sixun (651–716/18), Wang Wei (699–759), Wu Daozi (active c.710–60), Zhou Fang (c.730–c.800) among others. Figure-painting, whether religious or secular, was also the subject-matter for which these men were renowned.

Numerous copies of their work, of a greater or lesser plausibility, continued to circulate. In later centuries, everyone 'knew' what a work by Wu Daozi or Yan Liben was meant to look like, even when no authentic work survived (see p. 181). As well as these later copies, another method of approaching the art of the Tang court painters is through surviving work by less prominent artists which is either religious (see p. 110), or which survives in tombs. An example from the tomb of the Tang prince Li Zhongrun (682–701) is particularly valuable as it is unfinished, and therefore shows something of the technical process by which large-scale paintings on plaster walls were executed at the time [17]. The artist or team of artists has first carried out a fairly sketchy underdrawing of the outlines on prepared dry plaster, finished with white paint and a sealant of lime and glue, before areas of colour have been blocked in. It is known that, for court connoisseurs, the drawing of the line was deemed more 'artistic' than the laying on of colour, and that the subsidiary artists who did the latter were already at this date considered of lower status.

During the course of the Tang, the position of wall-painting

17

Detail of the unfinished murals from the entrance passage of the tomb of Li Zhongrun, Prince Yide, c.700 CE. The subject is two elegant maids of honour, part of a scene of aristocratic life, including hunting and sports, which are typical of Tang imperial tombs.

'Ladies Wearing Flowers in their Hair', hand scroll on silk once attributed to Zhou Fang (*c*.730–*c*.800 CE), but probably tenth century CE. This picture may once have existed as a screen, with sections mounted above one another as in [13], before being remounted in its present form.

declined, in favour of work done in the format of the vertical or horizontal scroll. This was work which was not designed to be permanently displayed, and which therefore was destined for a much smaller and more select audience. The rise in popularity of these only occasionally viewed formats of painting was of major significance for the subsequent history of art in China, conditioning the entire relationship between artist, viewer, and patron. From the very end of the Tang period, and from the period of political confusion which followed (known as the Five Dynasties, 907–60), actual surviving scroll paintings attest to the type of picture court audiences could now expect to see. Such is the horizontal scroll, showing court ladies amusing themselves with various pet animals and birds [18]. Although the picture is not signed, Chinese connoisseurs believed this to be by the Tang court artist Zhou Fang (active late eighth–early ninth century), praised by the literary records as the greatest master of this kind of subject. Some still hold to this attribution, but in recent years it has been the subject of renewed controversy. It has been demonstrated that the subject is quite a specific one, being the springtime festival of 'Flower Morning', when ladies wore outsize artificial flowers of paper or silk in their hair, chased butterflies with their fans, and when outdoor picnics were held in scenic spots.[1] The costume of the ladies is distinctive too, being in the fashion of the tenth century. It was probably painted at one of the short-lived courts of the Five Dynasties, the literary and visual culture of which was suffused with nostalgia for the vanished splendours of the Tang. Harder to gauge is the very basic question of who looked at such a picture, and on what occasions. Was it viewed only on the occasion of the annual festival it represented? Did it

represent women to themselves, providing models of ideal deportment and physical beauty? Or was it a representation of women to a male gaze, in a social context where segregation between respectable men and women was becoming more strictly enforced, and where real palace beauties were less and less exposed to view? Such questions are now beginning to be posed, but cannot as yet be answered with any confidence.

Another painting of a woman, which was similarly restricted in the audience who might have viewed it, is an effigy of one of the four successive empresses of the Song dynasty emperor Renzong (r. 1023–63) [19]. The painter is unknown. The aim is not to represent the personality of the individual, but her role. The painter or painters paid meticulous attention to the details of robes and crowns, showing the empress on a larger scale than her two standing attendants. This is probably a convention derived from religious painting, where the empress fills the role of a Buddhist deity, and the servants who flank her look like the donors whose images crowd into the bottom corners of Buddhist painting of a slightly earlier period (see p. 108). The three-quarter view is a convention not of religious painting but of a lost tradition of court portraiture which goes back at least to the Han period, and which was at this time being replaced by the full-frontal view. The realism of such images was beginning to seem suspect to aesthetic theorists of the Song, the stiffness of the images viewed as lacking in the vital spark which made art rather than effigies. However, the ritual aspects of these types of paintings ensured the survival of formal portraiture at court right down to the end of the imperial period.

The Formats of Chinese Painting

In order of their appearance, the major formats of traditional Chinese painting are: wall-painting (from *c.*1100 BCE), screen (from *c.*100 CE), hand or horizontal scroll (from *c.*100 CE), hanging or vertical scroll (after 600 CE), round fan or rectangular album leaf (both from *c.*1100 CE), and folding fan (from *c.*1450 CE). Painting in oil on canvas dates from *c.*1780 CE. Rolled hand scrolls were wrapped in cloth and kept safe from insects in wooden boxes. Larger scrolls were sometimes stored upright in ceramic jars.

a. Handscroll
b. Hanging Scroll
c. Roller
d. Semi-circular wooden stave
e. Protective Wrapper
f. Title sheet
g. Inscription panel
h. End roll
i. Double-leaf album painting
j. Paired single-leaf album paintings
k. Paired single-leaf album paintings, 'butterfly' mounting
l. Screen fan
m. Folding fan

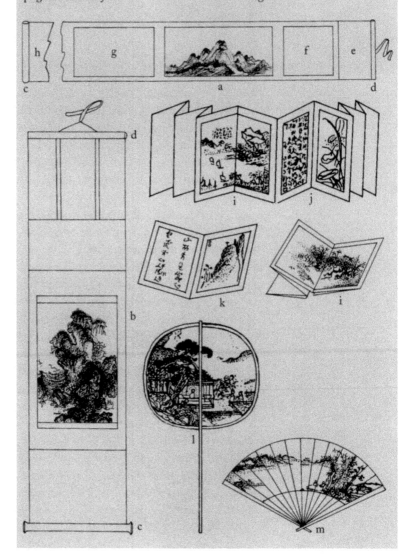

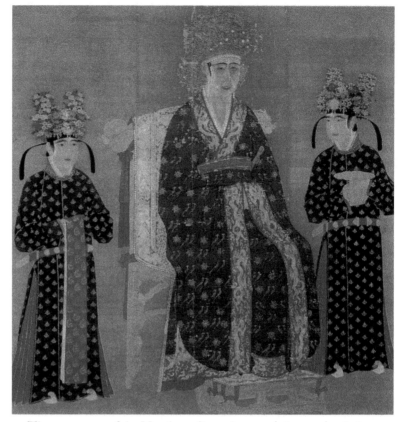

'Empress Cao, Consort of Song Renzong', anonymous hanging scroll on silk, *c.*1040–60 CE. The picture forms part of a set of imperial portraits which remained in the hands of successive ruling houses for 900 years. It was probably originally created for use in the cult of ancestors within the palace.

The emperors of the Northern Song dynasty (960–1127) ruled over a state in which profound cultural and social changes, dating back into the late Tang, were being consolidated. Although scholars today may debate the nature of these changes, most agree that the status of women within upper-class society, and their access to political power, was declining. (The custom of mutilating women's feet by binding them in childhood was coming into currency at this time.) Definitions of 'culture' itself were changing. Importantly, in the early Northern Song, the visual arts were for the first time seen as part of this broader category. The Song dynastic founder, Taizu (r. 960–76) based his claim to rule on his embodiment and propagation of 'this culture of ours' (*si wen*), a concept which ultimately went back to Confucius himself. He patronized the spread of written texts, Daoist and Buddhist as well as Confucian, through the new medium of printing, and built up an imperial library on an unprecedented scale. He also, in 977 and 981, issued orders for the collection of specimens and rubbings of calligraphy (for example, **70**), and for the collection of paintings. These became for the first time part of the larger project of preserving a cultural tradition from decline. At the same time, upper-class understanding of 'this culture of ours' was beginning to change from one in which it was the task of the rulers to maintain a literary and

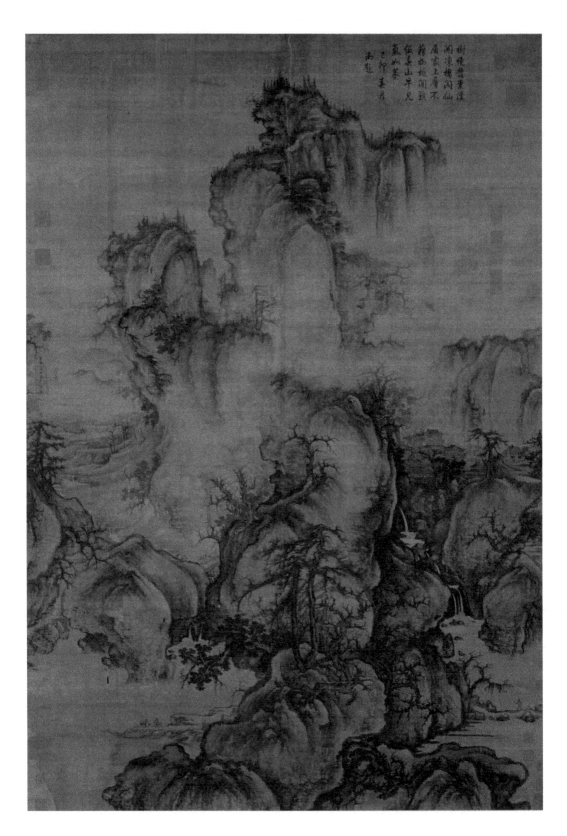

樹幾雙叢溪
澗凍横岡仙
居家上層不
辦松根閒致
似真山早見
氣如簑
乙印春月
淘臨

'Early Spring', by Guo Xi (after 1000–c.1090 CE), dated 1072. Painted on silk, it is one of the earliest surviving paintings done in ink alone, without other colours. This technique is known from written sources to have begun in the 8th century CE (facing page).

This anonymous landscape hanging scroll painted on silk was excavated from the tomb of a woman aristocrat alive in the second half of the 10th century CE. It is important new evidence for the origins, and social role, of landscape painting in China (this page).

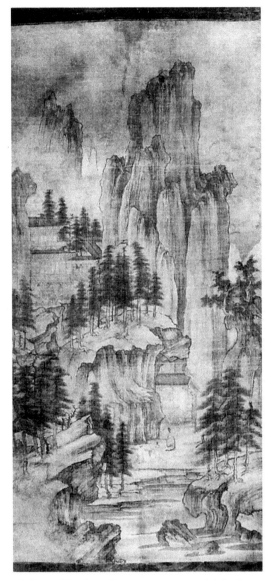

philosophical tradition, to one in which they were supposed to actively inculcate morality. This had implications for the understanding of visual as well as written 'culture', which will be discussed in Chapter 4.

Northern Song Court Art: 960–1127 CE

Art produced at the Northern Song court came in later times to be seen as central to the entire Chinese cultural tradition. Types of composition, and the conventions of brushwork used to represent rocks, trees, and other natural objects, were all immensely influential in later centuries. As a work produced in this context, the painting 'Early Spring' by Guo Xi (after 1000–c.1090) has been important for centuries, and appears in almost all modern surveys of Chinese art,

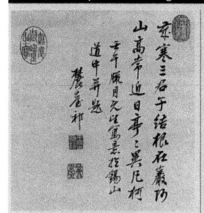

Detail of 35

The earliest paintings in China often included texts identifying the figures portrayed [13]. Written records suggest that by the eighth century CE some murals may have had lengthier inscriptions by their artists, but it was only in the eleventh century that poems and pictures were first created as integral wholes. One of the earliest surviving examples is by Mi Youren (see **25** for an uninscribed work by him). By the thirteenth century, the practice was widespread among educated artists, **57** being one example. Qian Xuan (*c*.1235–*c*.1300) is credited with developing the practice to a still greater degree.

Mi Youren was also one of the first artists to regularly inscribe a work with the place and date of composition. Only in the early fourteenth century did the further practice of specifying on the picture the precise circumstances of its composition and the person for whom it was made become widespread. The earliest surviving example may be a scroll dated 1302 by Zhao Mengfu. Another early example by his wife is **75**.

The practice of adding 'colophons', inscriptions by later viewers or owners of the picture, was widespread by the Ming period (1368–1644). Hand (horizontal scrolls) could be considerably extended by the addition of further sections of paper or silk, to make room for more colophons.

Seals, usually impressed in red, began to be added to pictures in the seventh century as a mark of ownership. From the eleventh century, seals could be placed on

Detail of 26

the surface by the artist at the time of creation, or by subsequent connoisseurs and owners of a picture.

from whatever point of view they are written [**20**]. The painting is dated 1072, when Guo Xi served in one of the court institutions devoted to painting and calligraphy, often known in English as the 'Academy'. The Song court had considerably more formal structures for the employment of painters than did its predecessors, and although these structures were frequently changed, and were enmeshed in factional intrigue within the bureaucracy, it is more reasonable to speak of a 'court painter' at this time than in any previous period.

The origins and early stages of landscape representation in Chinese art have received more attention than almost any other subject, given the privileged nature of this type of painting in later centuries. Scholarship in this field has been hampered by the low survival rate of early landscape painting, causing a reliance on the landscape elements of the Buddhist paintings from Dunhuang (see p. 96), and on later copies (how late is a matter of dispute) of all work prior to about 1000 CE. This makes the recovery by archaeologists of a painting like **21** all

the more important. It comes from the tomb of a woman who lived under the Liao dynasty (907–1125), a non-Han Chinese ruling house, and who was buried at some point in the second half of the tenth century. It is painted on silk, and is not signed. Interpreters of this rare survival tend to think it represents, not a real landscape, but a Daoist paradise inhabited by immortals, and that it was hung in the tomb of the dead woman to represent wishes for her safe passage in the afterlife.[2] It provides important evidence in thinking about how a much more monumental and famous landscape image like Guo Xi's 'Early Spring' might have been understood at the time it was created.

Although it is now mounted as a vertical, or hanging, scroll, 'Early Spring' may have been painted to form the central panel of a screen, permanently mounted in a wooden framework. Guo also painted murals for palaces and for temples in the Song capital of Kaifeng, as had his predecessors in the Tang. A measure of the esteem in which such an artist was held at court is the fact that the picture is visibly signed, sealed, and dated by him (halfway down the left-hand edge, the inscription at top-right being a later addition).

One of the things which separates Guo Xi from Tang artists is his subject-matter. Virtually all Tang artists painted at least some figure subjects, whether religious or secular. But we have no evidence that Guo Xi painted anything other than landscapes. Patrons and painters in China never stopped wanting paintings of people and gods in certain contexts, but the rise of landscape painting to a dominant position of esteem was obvious to critics in the eleventh century, when Guo and other court landscape painters were active.

Guo is also distinguished from his Tang predecessors by leaving writings on art, which deepen the possibilities for interpreting his very few surviving works. In his treatise, *Lin quan gao zhi* (Lofty Ambition in Forests and Streams), he stresses the free inspiration of the artist as heroic creator, and newly current ideas about the artist's character as the defining factor in the making of the great work of art. The picture came not from an observation of external phenomena (although Guo is supposed to have sketched from nature in his youth), but from within the heart/mind of the artist. He also played a part in the creation of a technical vocabulary of painting criticism, for example with his idea of 'three types of distance' ('high', 'deep', and 'level'), used into modern times in discussing composition. These ideas (which are in no sense unique to Guo Xi, but form part of more general Song attitudes to painting) were massively influential in later centuries, giving rise to the ideal of the artist as a romantic free spirit. What must be remembered is that these important ideals must be studied as such, and not as descriptions of what actually happened. For example, a study of Guo's writings would suggest that he painted what and when

22

'Auspicious Cranes', a hand scroll on silk attributed to the Song emperor Huizong (1082–1135, r. 1101–26 CE) and dated 1112 CE. Probably originally part of a set of some hundreds of images of representations of prodigies, mounted in albums.

he felt like, whereas his position as a member of the imperial court may well have constrained him in all sorts of ways.

The same sort of gap between ideal and reality may operate when studying the subject-matter of a painting like 'Early Spring'. Rather than an expression of the painter's love of nature in the abstract, it may have been understood by contemporary audiences at court as showing, not real nature, but the ideal landscape of a Daoist paradise. Guo Xi is known to have been a devotee of Daoist mystical practices, and it has been suggested that his manner of depicting mountains is distantly descended from the kind of magic mountain seen in precious metal in [9]. An alternative interpretation sees the great central peak as an image of imperial centrality and sovereignty. (This would be strengthened if we accepted the view of one scholar that the centre of this scroll has been extensively repainted in later centuries, giving an effect of writhing spatial instability which may not be original.[3]) Rather than an exercise in the realistic depiction of three-dimensional space, Guo Xi may have been attempting to produce a cosmological image, where it is the precise season of 'spring' which is the main subject. Seasonal change, seen as part of the larger pattern of changes driving the universe, was certainly of great importance to Guo, as it was to his imperial patrons, and he is known to have painted sets of seasonal landscapes. 'Early Spring' may not appear today as a 'religious' work of art, and it was not so considered by later Chinese critics, for

whom it was one of the major early monuments of the landscape-painting tradition, but a spiritual element may well have been present for both the artist and his original audiences.

This was certainly the case with a much smaller painting produced at court, and attributed to one of the Song emperors in person, the great collector and aesthete Huizong (r. 1101–1125). Huizong is supposed to have disliked the work of Guo Xi, and to have consigned most of it to storage, perhaps on account of its scale, or perhaps because he felt its subject-matter was insufficiently meaningful or symbolic. The surviving paintings supposedly executed by the emperor himself are all small-scale, often highly coloured images, such as 'Auspicious Cranes', painted to commemorate an occasion in 1112 when twenty white cranes suddenly appeared over the main gate of the palace, in the course of one of the great festivals during which the splendours of the palace were thrown open to a wider public [22]. Whether the picture is actually by Huizong or not is less important than its probable context as one of a vast series of images of 'auspicious responses', marvellous signs that the cosmic powers approved of and blessed Huizong's rule. These could be signs observed in the skys, strange animals or grains, or wonderful rocks. The original paintings were presumably only seen by the emperor and his closest counsellors, but the same images were flown on banners on special occasions, displaying them proudly to a wider audience. Cranes are a particularly powerful symbol of Heaven's blessing, and they are shown here wheeling in the sky to the accompaniment of a new type of imperial music, literally in tune with cosmic harmonies.

The use of visual means to bolster imperial legitimacy perhaps reached a new intensity at the court of Huizong, in that the Song empire was by this time under constant pressure from the Liao state, to the north. This portion of north China and Mongolia was under the control of a non-Han Chinese ruling élite, who in turn were replaced in 1125 by another people, the Jurcen, whose state was known in Chinese as Jin. In 1126 the Jin, having destroyed Liao, were to capture Kaifeng and carry Huizong off into captivity. During his reign, therefore, signs of Heaven's favour were particularly welcome, and symbolic as well as military means were eagerly sought to support the Song empire. In addition to the creation of images like 'Auspicious Cranes', the court of Huizong was the site of major cataloguing projects based around the now vast imperial art collections. These had an important effect on art in China during later centuries by fixing a canon of great works, to the ownership of which other rulers or collectors might aspire. Another such project was the cataloguing of the imperial collection of bronze age vessels, objects like **4**, which Huizong owned in great quantities, and which he eagerly acquired as proofs that he possessed what was coming to be understood as the

cultural heritage of antiquity. Possession of ancient things stood for an equivalence with the wise rulers of ancient times. Huizong's bronzes catalogue, entitled *Xuan he bo gu tu lu* (Illustrated Catalogue of the Conspectus of Antiquities of the Xuanhe Era), by its incorporation of woodblock-printed pictures of these treasures also helped to shape the understanding of the past for many hundreds of years.

As well as painters and antiquarians, the court of Huizong patronized various luxury crafts, and there begin to survive from this period objects made for the court which have been preserved not through burial, but by transmission from owner to owner above ground. Most highly prized in later centuries were certain of the ceramics made to order at kilns situated near the capital, and known to later connoisseurs as 'Ru ware' [23]. Production took place only over a forty-year period, and ceased with the disaster of 1126, making these undecorated but subtly coloured vessels extremely rare, and consequently of immense value in later times. Fewer than a hundred complete pieces survive today. The status of such ceramics at court at the time of their manufacture is harder to discern, and they may have stood fairly low on a hierarchy of objects, but they are at the beginning of an important, if sometimes sporadic, tradition of court interest in and patronage of ceramic production which continued to the end of the imperial period.

Southern Song Court Art: 1127–1279 CE

After the relocation of the court south of the Yangtze River to the city of Hangzhou, questions of legitimacy loomed even larger for the emperors of the diminished Southern Song (1127–1279). The vast ancestral collection of paintings and antiquities was lost when the court fled south, although ritually important images like the imperial portraits [19] were removed to the new capital. The emperor Gaozong (r. 1127–62), although credited with saving something of the dynasty from total defeat, was under great pressure after conceding what many

saw as a humiliating treaty of peace with the Jin state in 1141. During his long reign, artistic and cultural projects were vigorously pursued, one aim being to convince the political élite of his fitness to rule. One of these projects, which has been studied in particular detail, was the production by a court workshop of a large series of illustrations to the 'Book of Odes' (*Shi jing*, an ancient and highly prestigious collection of poetry dating from the Zhou period (probably written about 1000–600 BCE) [**24**]. These poems had long been seen as a crucial guide to correct moral actions. This project was only one of a number in which images were provided by court artists for the central texts of the cultural heritage, or for historical incidents, marshalling them behind the dynasty's interpretations of the past and present, and supporting its claim to be the main bulwark in the defence of that heritage.

The calligraphy of the texts was traditionally claimed to be in the hand of the emperor Gaozong himself, while the pictures were attributed to the court artist Ma Hezhi (active mid-twelfth century). It has been shown that they are not all from the same hand, and that it is less helpful to think about them as the products of individual artistic creation than as an 'edition' of multiple versions. This was perhaps based on the imperial handwriting and on sketches made on paper by Ma Hezhi, but actually made by anonymous painters in a court workshop. The project may never have been completed, and if this is indeed the case then the death of its designer is the most likely cause.

24

Detail of a hand scroll on silk illustrating one of the 'Odes of Chen', a section of the 'Book of Odes', *c.*1150 CE, from original designs by Ma Hezhi (*c.*1130–90 CE). Today, twenty scrolls survive in various museums, between them containing the texts and illustrations for over one-third of the 305 poems in the ancient 'Odes'.

The picture shown illustrates a poem called 'Zhu Forest' and figures the evil Duke Ling of Chen, a bad example to the rulers of the present. Any supposed audience for the scrolls knew all these poems by heart, as well as the traditional interpretations which enabled them to be fitted to current circumstances. While this is state imagery of a kind, it is not public in the wider sense, being directed only towards a court élite. It is possible that Gaozong intended to use the scrolls as gifts, since presents of calligraphy from the imperial hand were a singular mark of favour and much appreciated by government and court officials.

Gaozong is known to have made a practice of giving as presents the

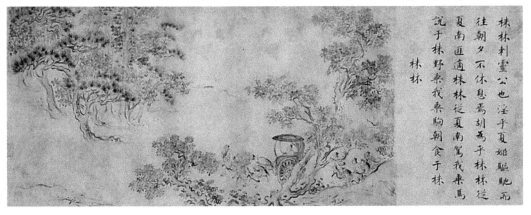

25

'Cloudy Mountains', hand scroll on paper by Mi Youren (1074–1151 CE), painted in the 1140s. The use of paper, a much more absorbent material than silk, was understood as signifying a more spontaneous, 'scholarly' type of art.

paintings of another artist active at court, the painter and official Mi Youren (1074–1151) [**25**]. He acted as a sort of curator of the imperial art collection, as well as producing work in a distinctive manner associated with the name of his father Mi Fu (1052–1107). Part of Mi Youren's job was to guarantee the authenticity of the paintings and calligraphy by his father, held in high esteem by the emperor. The older Mi was closely associated with the development of what came to be called 'scholar-official painting' (see p. 141), a term which described the social status of the artist as much as the formal style which he followed. In later Chinese histories of art, Mi Youren was very much categorized as one of these 'scholar' artists, men remote from worldly cares, never painting to the order of anyone, but only as inspiration moved them. However, all the contemporary evidence points to Mi as essentially a 'court' artist, working within the nexus of imperial patronage and imperial gift-giving. His scholarly status was awarded retrospectively. The artist's slightly ambiguous position attests to the fluid nature of the boundaries between court art and non-court art at this period, boundaries which in later centuries were very much more rigorously enforced.

One of the markers of a 'scholarly' style in 'Cloudy Mountains' (along with the intimate scale of the picture and its use of paper, not silk, as a surface) is the absence of any human figures at all. It is therefore among the first purely landscape representations in Chinese painting. Even so, a broadly political or symbolic message may be conveyed by this subject, the distant cloud-wreathed peaks being read by informed audiences as yet another image of the good and stable government which both the imperial court and the wider ruling élite wished to see established. The cultural prestige of the court was enhanced by having in it a personality like Mi Youren. What he provided was not programmatic work with a clear message, like Ma Hezhi, but a guarantee that the court understood and appreciated the most

advanced aesthetic values of the day, valuing painting as product of the cultivated mind, not merely the skilful hand. Art at the Southern Song court embraced a spectrum of types of work, visually quite different, but all contributing to the lustre of the dynasty and its ruling house.

The idea of an 'Academy' of painting in the service of the court was recreated in the Southern Song capital of Hangzhou, and painters continued to receive ranks within this bureaucratic organization, as well as special marks of imperial favour such as golden belts and other insignia. Service within this institution often seems to have been hereditary, with sons succeeding fathers in the family profession, and presumably being trained by them in distinctive family styles and subject-matters. The most successful such lineage of painters was that belonging to a family surnamed Ma (not related to Ma Hezhi), five generations of which are known to have produced work for the court over a period from about 1100 (before the move south) until after 1250. The most famous member of this lineage, in later years at least, was Ma Yuan (active c.1190–after 1225). Also successful was the group of artists from the family of Ma Yuan's contemporary Xia Gui (active c.1195–1230). It is a mark of the relatively low social status of these court artists that almost no biographical material is preserved about them in Song dynasty literature, nor did they leave behind any writings of their own.

Subsequent critics tended to speak of a 'Ma-Xia' school as a distinctive entity, and they do share common features. The work of these artists is usually painted on silk, not paper. Much of it is in the formats of the vertical hanging scroll, small album leaves, or of paintings on round fans. Horizontal scrolls are rarer. The pictures are

26

'Moments of the Flowering Plum: A Fine Moon' (left) and 'A Rosy Sunset' (right), album leaves by Ma Yuan (active c.1190–1225 CE). Painted on silk, the preferred surface for court artists of the Song period.

27

Embroidered silk fan, c.1250
CE. Making textiles, whether
woven or embroidered, which
imitated paintings of this type
was an innovation of the
Southern Song period,
although religious icons had
been embroidered some
centuries before.

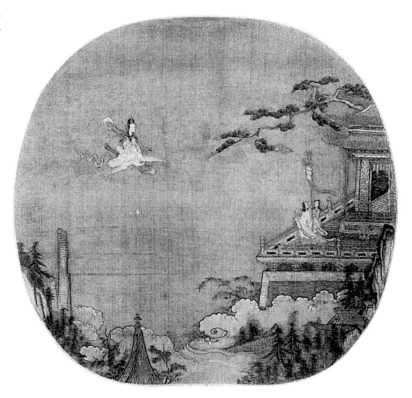

not extensively inscribed, usually carrying only a simple signature and date, if anything.

The range of subject-matter is very wide. These artists painted to order, representing a range of subjects of interest to the men and women of the imperial house. Empress Yang (1162–1232), herself a prolific calligrapher and poet, is known to have been a particular patron of Ma Yuan.[4] Ma family artists painted for the court landscapes, historical and religious scenes (particularly incidents associated with the Chan school of Buddhism), and bird and flower subjects. An album of ten tiny pictures (probably from a larger set) by Ma Yuan depicts the subject 'Moments of the Flowering Plum' [26]. These are not nature sketches, but may be meant to accompany a set of poetic couplets about the blossom, written by the aristocrat and official Zhang Zi (1153–after 1211). The Song upper classes used the plum blossom in literature to symbolize both female beauty and the aloof state of the idealized scholar. As with the Mi Youren landscape [25], this subject-matter was developed not at court but by artists of a different social class from Ma Yuan (see p. 152), and the album represents an appropriation by court culture of ideals which had their first expression elsewhere. The agenda for art was being set less and less at court, even if the court remained the major centre of artistic patronage.

It is hard to reconstruct the original context in which such an album

would have been painted, and even more in which it would have been looked at. Records speak of Academy artists painting literally 'in the presence' of the emperor, and it may be that the production of some paintings did take place as a form of imperial entertainment. The Southern Song emperors held large quantities of paintings in the palace, but they also gave away the work of their artists to favoured courtiers, relatives, and officials. These gift pictures could be painted, or could be in the form of pictorial textiles, a new development of the later twelfth–thirteenth centuries [27]. The embroidery shown, although it is now mounted in an album as a collector's item, was originally a fan, having a vertical stick in bamboo or ivory or some other material. The subject shows a Daoist immortal approaching a heavenly terrace, imagery associated by this time with congratulatory wishes on the occasion of a birthday. The very asymmetrical composition, with most of the stitching concentrated in the bottom-right corner and large areas of open space, is one associated, at least by later connoisseurs, with the artists of the so-called 'Ma-Xia school' of court painters. It is highly likely that the provision of cartoons for embroidery and for woven silk tapestry was among the duties of the Academy painters, if not of its leading members. The relative values placed on painting and embroidery at this time are hard to discern, but we should not automatically assume that painting enjoyed the higher status. Nor should we make any assumptions about the gender of those who either produced or consumed such work. Women of the upper class were certainly trained in needlework, but an exclusive association of embroidery with women (while explaining its neglect in later male-centred art history) may be too restrictive.

Yuan Court Art: 1279–1368 CE

Although most subsequent scholarship has concentrated on the Song court art of south China, the contemporary rulers in the north also required artistic support for their claims to legitimacy. The Liao (907–1125) and Jin (1115–1234) courts were the setting for artistic projects which were not totally cut off from the south (and which had access to the captured Northern Song imperial art collection), but which nevertheless addressed the specific requirements of the ruling ethnic groups. Certain subject-matters were developed in the north, including some connected with seasonal hunting rituals which were of great importance to court culture. One of these involved the hunting of geese or swans with falcons, which became a subject of painting, jade-carving, textile-weaving, and other art forms in the course of the twelfth century [28].[5] This subject entered the repertoire of court painting workshops (including those in the Southern Song capital), and remained there after the specific rituals it referred to had ceased to be practised. This happened when another northern people, the

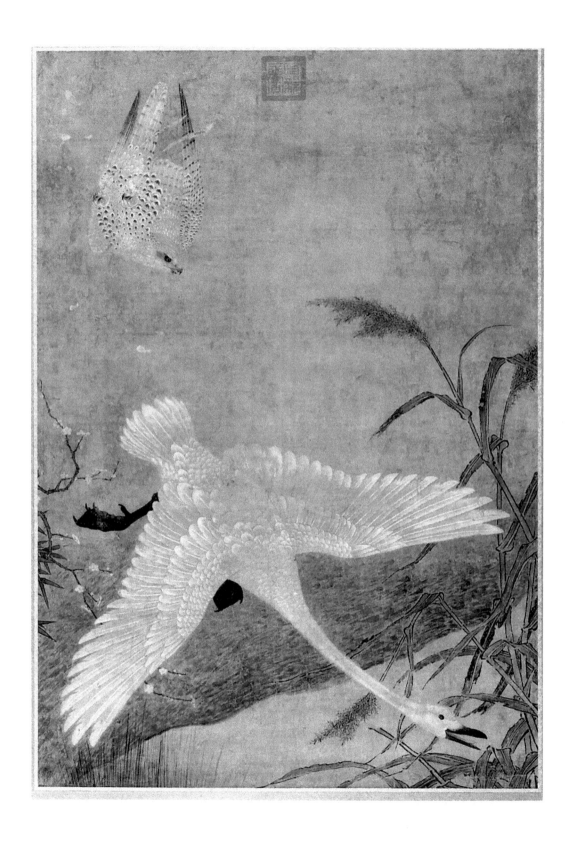

28
'Hunting Falcon attacking a Swan', an anonymous hanging scroll of the 13th–14th centuries CE. This subject is drawn from the 'spring mountains' hunting ritual of the 12th–13th century court of the Jin dynasty. It was also a subject for textile decoration and jade-carving.

Mongols, destroyed the Jin state in north China in 1234, and went on to unify China by conquering the Southern Song in 1279.

The idea of the Mongol emperors of the Yuan dynasty as artistic patrons used to be thought of as far-fetched, but this prejudice has recently been fundamentally reassessed. It is now clear that, despite the lack of a formalized painting academy, the Yuan court in what is now Beijing saw the production of both religious and secular art on a large scale. This included not simply painting, but crafts like ceramics and textiles, for which the Mongols imported skilled weavers from the western parts of their huge empire (modern Iran and Afghanistan). Major Buddhist projects were initiated (see p. 121), ritual portraits similar to **19** were painted, styles and subjects of the Song academy continued to be produced to an extent, and images of auspicious omens, on a par with **22**, were produced to order even by a 'scholar' artist like Zhao Mengfu (see p. 145). Wall-painting was at this point still important, and major court mural projects, now all disappeared, are known to have been created. The subjects of these often proclaimed the court's support of traditional imperial values, for example the encouragement of agriculture, in an attempt to maintain the support of the Chinese ruling class for their new (and occasionally alien-seeming) emperors. Yuan rulers were very skilled at deploying radically different kinds of art when legitimizing themselves in the eyes of different sections of their huge, ethnically various, subject population.

Some Mongol aristocrats, most notably Princess Sengge Ragi, sister of the emperor Renzong (r. 1312–20) built up extensive collections of earlier art (she owned, for example, **72**), as well as patronizing arts based in the capital. In doing so, she behaved exactly as a native Chinese lady of imperial stock. One of the most successful Yuan court artists was Wang Zhenpeng (active c.1280–1329), whose post in the imperial archives brought him into contact with the art collections stored there. He was able to study works of art which are now long-lost, including Northern Song court painting which stressed meticulous and detailed line-drawing in ink. At least some of these monochrome scrolls may originally have been cartoons for full-scale murals. This monochrome manner was used by Wang for a scroll entitled, 'Vimalakirti and the Doctrine of Non-Duality' [**29**], painted in 1308 on the orders of the future Renzong, and based on an earlier treatment of the same subject by a little-known Jin dynasty painter called Ma Yunqing (active c.1230).

The theme is taken from Buddhist scripture, and is made explicit in a lengthy inscription by the artist. He shows the doctrinal debate between the pious and learned layman Vimalakirti (*Weimojie* in Chinese) on the right, and the bodhisattva Manjusri on the left. Between them stand one of the Buddha's disciples, and a flower-

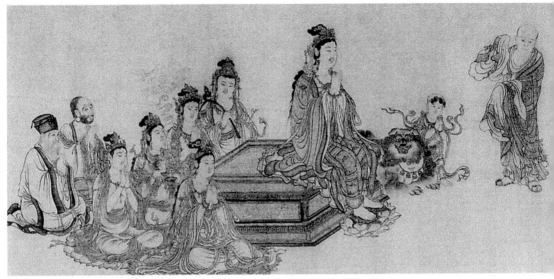

29

'Vimalakirti and the Doctrine of Non-Duality', by Wang Zhenpeng (c.1280–1329 CE), detail of a hand scroll in ink on silk, dated 1308 CE. Although illustrating a Buddhist text, it was not used in worship. It is part of a tradition in which certain religious scenes became secularized and used as subjects for a display of familiarity with prestigious styles of the past.

bearing goddess, who in the course of the discussion switch bodies to demonstrate the Buddhist doctrine that dual categories like 'male' and 'female' are illusions. This subject was associated with many famous painters, including Gu Kaizhi (see p. 38), Wu Daozi and Wang Wei in the Tang, and Li Gonglin (1045–1105/6). The latter in particular was renowned for his figure-drawing in ink alone, and was an artist with an immense reputation by the Yuan period. Possessing works by him, and employing artists who could create contemporary works in styles derived from him, placed the Mongol emperors in a great tradition of patronage, parallel to their patronage of other forms of image. Plates **29** and **60** are both 'Buddhist' pictures, produced at court and very close to one another in time, but they address different audiences.

Ming Court Art: 1368–1644 CE

In 1368, after a prolonged and confused period of civil war, a native Chinese dynasty named the Ming took power in the southern city of Nanjing, which it made its capital until 1420, when the dynasty's third emperor moved his capital north to Beijing. Immense building projects were put in hand in the city and its surrounding areas, including the decoration and furnishing of numerous Buddhist temples. Craft workshops were established again under the court's immediate supervision. One of the most significant of these was named the Orchard Factory, which produced furniture and other objects in lacquered wood for court use.

A unique survival of the full-scale furniture produced by this factory is a table with drawers, made in the Xuande reign (1426–35), and sumptuously decorated with carved layers of lacquer, in a pattern of dragons and phoenixes [**30**]. The technique of building up enough layers of lacquer to make carving possible was developed in the

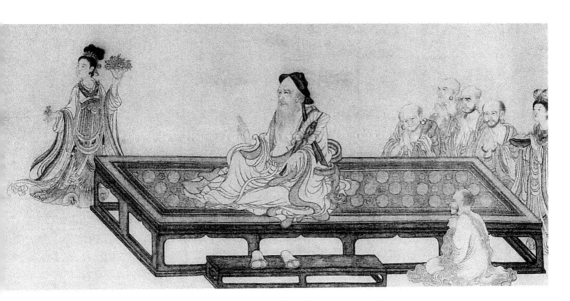

thirteenth century under the Southern Song, and was practised not in the north but in the commercially prosperous regions around the mouth of the Yangtze River. Its transfer to Beijing, by simply ordering craftsmen to work for the court there, was a testimony to the Ming court's intention to be a centre of luxury manufactures in its own right, and not simply to consume those made elsewhere.

By the early Ming the ceramic industry was firmly concentrated in the relatively remote southern town of Jingdezhen, and was necessarily tied there by the supply of the raw materials needed to make fine porcelain. This did not stop the court controlling part of the production, specifying designs needed for both ritual and everyday use, and ordering sets of objects, often in vast numbers. The New Year imagery of the 'Three Friends of the Cold Season' is just one of the distinctive themes manufactured for the court, here seen on a bowl decorated in the underglaze cobalt-blue technique which had been one of the most important technical innovations of the fourteenth-century ceramics industry [31]. Craftsmen working for the Ming court successfully blended decorative motifs from a great number of sources into a coherent visual language which was to carry associations of imperial power down to the end of the monarchical system in the twentieth century. For example, although dragons in various forms were used from very ancient times, only in the Ming do they become so ubiquitous on everything from textiles to jade-carving, and only in the Ming would they be combined with stylized flowers which are part of the legacy of Tibetan style taken over from the numerous foreign craftsmen working in China in the fourteenth century.

Both the lacquer table and the porcelain bowl (the latter very visibly so) are marked with inscriptions specifying the imperial reign of the Ming dynasty in which they were made. This type of marking, which

30

Table of carved red lacquer on a wood core, made in the Xuande reign of the Ming dynasty (1426–35 CE). The red pigment mixed with the clear lacquer sap is mercuric sulphide, sometimes called 'cinnabar'.

appears first on court workshop objects, and is hardly seen at all before the Ming, spread throughout craft production of all kinds over the next 500 years. It may be a transference from the realm of court painting, but it suggests changed attitudes on the part of those ordering these objects to the whole question of defining time and objects within time, attitudes which have scarcely been investigated at all.

Like their Yuan predecessors the Ming emperors had no formal academy structure for painters. Several of them were themselves accomplished painters, however, and work survives which claims to be from the hands of the rulers of the Xuande (1425–36), Hongzhi (1488–1505), and Zhengde (1506–21) eras. In addition, and from as early as the Xuande reign, they employed artists at court. These men were often given nominal posts in the imperial bodyguard, as was the case with Shang Xi (active early 15th century), who was responsible for the huge hanging scroll, once perhaps a screen panel, entitled 'Guan Yu Captures an Enemy General' [32]. The theme is historical, and taken from the confused warfare of the third century CE, the 'Three Kingdoms' period which in the Yuan and early Ming provided the material for one of China's first great prose novels, the 'Romance of the Three Kingdoms'. The way Shang Xi has painted the figures, particularly the contrast between the straining muscles of the prisoner and the impassive general in his magnificent armour, is close to that

used in religious murals of the Yuan and early Ming, and has absorbed some of the stylistic features introduced to the Beijing region by Tibetan artists under the Mongols. The flat colours of the armour are painted very differently from the rocks, trees, and bamboo, done in ink alone. These take over the style of the Ma-Xia school of artists, which was kept alive in Hangzhou after the fall of the Southern Song.

From the seventeenth century until very recently, this type of Ming court painting was held in very low esteem by artistic theorists in China. Many Ming court paintings were provided with spurious signatures, usually of Southern Song artists, and sold on the open art market. Scholars have only in the past decade come to appreciate this art, and research on understanding how it was created and consumed is only just beginning. An artist like Shang Xi, about whose life practically nothing is known, is only now being written into the history of art in China. The same is true even of his more famous contemporaries and successors at the Ming court, painters such as Dai Jin (1388–1462), Lin Liang (active 1450s–1460s), Bian Wenjin (active c.1400–30), and Lü Ji (active c.1490–1510).

This scholarly neglect has been even more pronounced in the case of Ming court art from after about 1500. Later Ming emperors were not avid collectors of art, but seem instead to have been content to allow a certain number of disposals from the imperial collection, now managed by eunuchs under the Directorate of Ceremonial. They continued to support Buddhist temples on a lavish scale down to the early seventeenth century, but in general imperial taste seems to have parted company with that of the upper classes of the lower Yangtze delta, a region of China which was not only economically dominant but which increasingly claimed to exercise a cultural hegemony over the whole empire. Art history has traditionally had nothing to say about a work like the huge scroll showing the Jiajing emperor

31
Porcelain bowl, made for the Ming imperial court in the Xuande reign (1426–35 CE), decorated with the 'Three Friends of the Cold Season': pine, bamboo, and flowering plum. Such a piece was made to be used as a food vessel in the immense establishment of the new court in Beijing.

32

'Guan Yu Captures an Enemy General', hanging scroll on silk by Shang Xi (active early fifteenth century CE). The historical warrior Guan Yu was the subject of a religious cult particularly supported by the Ming court.

(r. 1522–66) in his state barge, surrounded with a massive retinue—the more than 98´ of the silk scroll contains 915 figures [**33**].⁶ This is partly to do with the fact that the picture is unsigned. By the sixteenth century any picture with pretensions to artistic status had to carry a signature, which apart from everything else assured its value in the increasingly commercialized art market. As with the Shang Xi painting, there is a difference between the way the figures are painted and that used for the landscape through which they are made to process. Although the scroll is anonymous, the likelihood is that more than one specialist painter was employed.

Images of imperial processions were produced in China from at least the Tang dynasty down to the early twentieth century (examples survive from the Southern Song), and must once have formed a significant part of the output of court workshops. These are not public images of the imperial countenance, for dissemination to a wide public. The facial features of the ruler formed no part of the imagery of rulership, and for example the coinage of the imperial period carried only text, never the ruler's head. The Jiajing emperor's procession

The Materials of Chinese Painting

The principal surfaces for painting in China, in the order of their appearance were: plastered walls (from 1200 BCE), silk (from about 300 BCE), paper (from about 1000 CE), and canvas (eighteenth century CE). Bamboo, wood, and other surfaces were known in early times. Silk and paper had to be sized with alum before use, and washes of alum were used to fix layers of water-based ink or pigment. The brushes still used by painters differ hardly at all from those used for writing the Chinese script. They have a bamboo or wooden tube, holding layers of differentially absorbent animal hairs tapered to a point. Such brushes were first used around 1200 BCE. Ink was made from animal or vegetable soot, moulded into a cake with glue, and rubbed on a stone with water to produce liquid ink as required. Painters used a range of water-based pigments from mineral and vegetable sources, which often required laborious preparation. Ready-made colours were only commercially available from the mid-eighteenth century CE.

Detail of 99

scrolls may well have been gazed on solely by the emperor himself, and perhaps by his immediate family and personal attendants. It is still possible that a precise aim drove the emperor to commission this scroll, which shows his return to the capital by water, and its companion piece showing him travelling on horseback in military armour. By convention, motion outwards is shown by figures travelling from right to left, and return by travel across the pictorial surface from left to right.

The scrolls commemorate a series of visits made sometime between 1536 and 1538, when the emperor was in his early thirties, to the tombs of his ancestors at Zhengdian in Hubei province. These were controversial acts, in the context of court politics. The Jiajing emperor was not the son of the previous Ming emperor, who had died childless, but from a collateral branch of the ruling family. On his accession, he was adopted into the main line. Disputes between the emperor and his bureaucrats over the nature of the titles and rituals used respectively for his adoptive and biological parents were fierce and prolonged, and the emperor may therefore have been particularly eager to have his pious series of visits to his (real) father's grave represented in visual form, with minute attention to the details of regalia, ceremonial costumes, armour, fans, carriages, and hats which were of such importance to the Ming imperial self-image. He himself is shown on a larger scale than his attendants, and in the full-face posture which from the fifteenth century was standard for formal imperial portraits. Although the most

Detail of hand scroll on silk
showing the Jiajing emperor of
the Ming dynasty (r. 1522–66
CE) in his state barge, painted
by an anonymous group of
court painters, c.1536–8.

artistically assertive of the emperor's subjects might scorn the merely recording abilities of picture-making, there were contexts, and the Ming court was one of them, where such abilities retained some of the esteem they had had in earlier centuries.

Early Qing Court Art: 1644 – c.1735 CE

Court patronage in all its forms other than the support of Buddhist religious establishments genuinely seems to have declined in quantity from c.1600. Certainly there are fewer named court artists at this time, and the amount of ceramics ordered from the kilns of Jingdezhen was drastically reduced due to economic crisis. The transition after 1644 from the Ming period to the succeeding ruling house of the Manchu Qing dynasty (1644–1911) may have been artistically fruitful in a number of other ways (see p. 162), but not in court patronage of the arts. Only with the consolidation of Qing rule in the 1680s, under the Kangxi emperor (r. 1662–1722), did the new court (which had retained Beijing as the capital) become interested in commissioning works of art.

The craft and art organizations coming under the Qing Imperial Household Department formed an enormous, if constantly fluctuating, body of hundreds of artists in all sorts of media. The records and account books of these workshops survive in some quantities, and enable us today to understand the world of court artistic

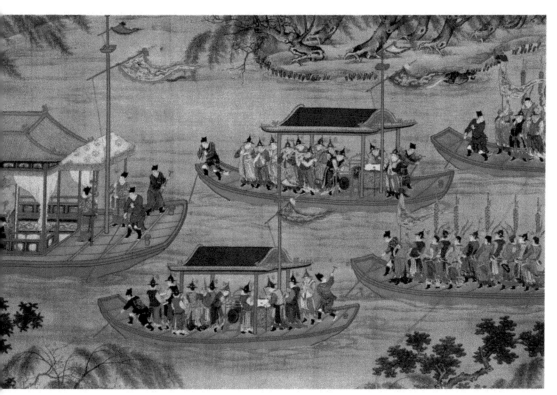

production with a level of detail impossible for any earlier dynasty. Relatively few craftsmen (there are no records of women being employed as artists until the very end of the dynasty in the early twentieth century) were permanently on duty in Beijing, although it is likely that some professional painters were continuously available. Workers in materials like ivory, jade, and precious metals would instead be summoned to court for periods of service, afterwards returning to their own cities and their own commercial businesses. By the seventeenth century, the commercialization of the arts and crafts had proceeded to the degree where the court was to an extent parasitic on the larger market-driven world of artistic production.

One of the earliest identifiable projects of the Qing court was the pictorial record of the second of a series of six trips which the Kangxi emperor made in 1689 to the cultural heartland of China in the south [34]. This was the region where opposition to the Manchu conquest, both overt and in the form of passive resistance and 'internal emigration', had been most intense and prolonged, and the trips were designed to show the imperial countenance to large numbers of subjects, as well as give the emperor the chance to influence people through acts of patronage and beneficence. Teams of craftsmen and artists would be assembled for specific projects, and the set of twelve scrolls (only nine survive) showing the Kangxi emperor's 'Southern Tour' was one of the largest and most complex of these. It was

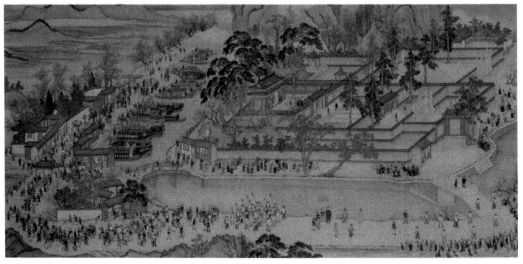

34

Detail of hand scroll on silk, showing the 'Southern Tour' of the Kangxi emperor of the Qing dynasty in 1689 CE. This crowded urban scene, painted in bright mineral colours by a team of artists headed by Wang Hui (1632–1717 CE), retains features of earlier imperial procession scrolls [33], for example showing the emperor on a slightly larger scale than everyone else.

nominally under the direction of a painter named Wang Hui (1632–1717), a man from an upper-class south Chinese family who had already enjoyed an extremely successful career as a painter of landscapes in his native lower Yangtze region. He was seen there as the guarantor and continuation of the artistic lineage represented by Dong Qichang (see p. 160), and as a figure who had successfully blended all pre-existing artistic styles of landscape depiction into a single 'great synthesis'. He was thus an immensely prestigious cultural figure by the time he arrived in Beijing in 1690, and was recommended to the court in the following year by personal contacts in the higher reaches of the bureaucracy. Wang Hui, in directing the work of a large team of artists (specialists in depicting figures, architecture, horses, landscape, and other elements) was working directly for the court on this project, and there is no evidence that he did not consider this a great honour and a valuable commission. However, the ideal of the 'scholar-painter' meant it was an important part of retaining his prestige that he should *not* appear to be a 'hired artisan'. (It should be stressed here that Wang Hui *was* a professional painter, who had all his life accepted commissions and cash payments for his work.) His value to the court would be lost if he appeared to be merely a 'court artist'. Significantly, he did not lodge in the part of the palace compound where the picture was worked on, but stayed as a guest with one of the high officials in charge of the project.

Contemporary sources speak of Wang merely 'adding a few brush-strokes' to the scrolls, which are certainly very different in appearance from the landscapes he painted and signed himself. They are painted on silk, which Wang Hui, in common with all artists aspiring to the more prestigious 'scholar-amateur' status, very rarely used. The scale of the project is immense, with well over 700′ of painting in the original twelve scrolls. Most of the artists are (as with the Ming scrolls)

Dynastic Rule

1. Qin and Han 221BCE-220CE

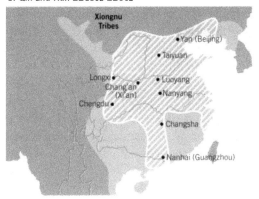

Han Extent of Qin Dynasty 221–207 BC

2. Three Kingdoms 220CE-280CE

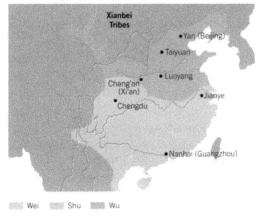

Wei Shu Wu

3. Tang 618CE-906CE

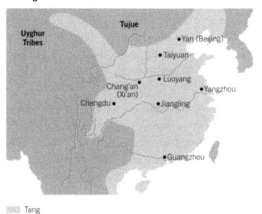

Tang

4. Song 960CE-1279CE

Northern boundary of Southern Song AD 1127–1279

5. Yuan 1279CE-1368CE

Yuan

6. Ming 1368CE-1644CE

Ming

anonymous. Those whose names are known are, significantly, not the court professionals responsible for the detailed depiction of the figures and architecture, but personal pupils of Wang Hui's (like Yang Jin (1644–c.1726) and Gu Fang (active 1700)) who did the landscape sections.

The scroll illustrated [34] is the ninth of the series, and shows the emperor's visit in March 1689 to the Shrine of Yu the Great, outside the city of Shaoxing. The (mythical) early emperor Yu the Great (traditional dates 2205–2197 BCE) was believed to have been the first to tame the waters of China's great rivers, making the land habitable for the first time. As the ostensible purpose of the tour was to inspect water-management projects, one of the imperial state's most important functions, it was appropriate that this visit should be prominently featured. The emperor himself may well have taken an interest in the choice of subjects for inclusion in the scrolls, and (as with the Ming examples) he was almost the sole audience for what are among the largest and most complex pictorial compositions produced anywhere in the world.

If Wang Hui was not a 'court artist', but an artist whose prestige was capable of being appropriated in certain circumstances by the court, the same is even more strongly the case with his younger contemporary Wang Yuanqi (1642–1715). The two men were not related by blood (Wang is a very common Chinese surname), although Wang Yuanqi, as the grandson of Wang Hui's painting tutor Wang Shimin, stood in a relationship to Wang Hui which was almost as important. They were certainly grouped together by Qing writers as part of the connoisseurly category of the 'Four Wangs'. Unlike Wang Hui, Wang Yuanqi had a successful bureaucratic career in tandem with his activities as an artist, and was a prominent figure in Beijing politics from the 1690s until his death in 1715. He was a personal favourite of the Kangxi emperor, and acted (like Guo Xi and Mi Youren before him [20] and [25]) as a sort of overseer of the imperial art collections, authenticating pictures held there, and supervising the publication in 1708 of a massive collection of written sources on the history of painting and calligraphy. This book, the *Peiwenzhai shu hua pu* (Album on Painting and Calligraphy in the Peiwen Studio), was a form of official canon of art-historical writing, and has defined the parameters of the subject to an extent down to the present day.

Wang Yuanqi also acted as supervisor and manager on a painting project very different from his own signed work, namely a series of scrolls depicting the emperor's sixtieth-birthday celebrations in 1713, painted in the meticulous descriptive manner on silk. He himself was famous in his own day for landscapes, and for pictures painted in ink on paper which manipulate and develop the style, based on that of Dong Qichang, which was taking on the character of an 'orthodox', almost

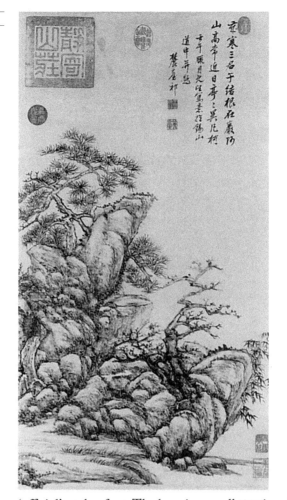

35

'Three Friends of the Cold Season', hanging scroll done in ink on paper by Wang Yuanqi (1642–1715 CE), dated 1702. The design of pine, plum, and bamboo in combination had associations with the New Year festival, for which this picture was painted.

'official', style of art. The hanging scroll [35] is painted with the 'Three Friends of the Cold Season', and was indeed done in the couple of weeks prior to the New Year of 1702, when Wang was travelling south to the city of Wuxi. This is likely to have been painted as a New Year's gift, or to repay an obligation of hospitality. It was probably not painted 'for' the emperor (although it was in the imperial collection by 1800). Given the prevalence of the subject on artefacts produced for the court and Wang Yuanqi's particular position at court during the period when it was painted, it is interesting to juxtapose it with the 'Southern Tour' scroll as an example of the range of pictorial forms and manners within the Qing court milieu. One of the points of comparison, which probably placed the two pictures in rather different visual registers for contemporary audiences, is the absence on the 'Southern Tour' of any writing. The 'Three Friends' scroll on the other hand has the artist's inscription of the circumstances of composition, something no 'scholarly' picture could now be without.

The reign of the Kangxi emperor had seen a re-engagement of the

Porcelain teapot, decorated in enamel colours and underglaze blue with a design of the 'Three Friends of the Cold Season'. Yongzheng reign of the Qing dynasty (1723–35 CE). The combination of decoration over and under the glaze is known as *doucai*, 'interlocking colours', and is technically very difficult to achieve successfully.

court's attention with artistic and craft production after the political and economic troubles of the mid-seventeenth century. This was particularly true of the court's contacts with the ceramic factories of Jingdezhen, where in 1683 an official was sent to revitalize the ceramic industry. This continued, on an even greater scale, in the relatively brief reign of the Yongzheng emperor (1723–35), when kilns in the south expanded the production, to imperial order, of objects elaborately painted in enamel over the glaze [**36**]. This development, associated with the official Tang Ying who took charge at Jingdezhen in 1729, not only brought porcelain decoration closer to painting, but was a conscious attempt to recapture the technical levels of early Ming imperial porcelain, and hence surpass visibly an era which remained a model of achievement for the Qing court. This expansion of patronage took place in a number of other crafts as well. For example, it was under the Yongzheng emperor that skilled ivory-carvers from the southern port city of Guangzhou (Canton) were first summoned to the court to exercise their skills.

One type of artist at the Qing imperial court which has fascinated Western scholarship, perhaps to a disproportionate extent, is the occasional European Catholic missionary assimilated into the milieu of the imperial workshops. The most famous of these men is the Italian Jesuit lay brother Giuseppe Castiglione (1688–1766), whose long career spanned the three reigns of the Kangxi, Yongzheng, and Qianlong eras. He had been deliberately trained by the order as a painter of religious subjects, before being sent to China. First presented at court in 1715, when a few Jesuits were tolerated as experts in mathematics and other sciences, he was still active fifty years later, as a painter of enamelled metalwork, a mural decorator, painter in oils, on silk and

paper, and even as a designer of European-style gardens. He was the most successful, if not the only, European missionary to develop a manner of painting which was pleasing to the imperial taste, in its adaptation of Western conventions of shading and depiction of volume and space to courtly subject-matter. He painted imperial portraits, parts of the procession scrolls which continued to be major imperial workshop commissions, battle scenes, horses, dogs, and architectural scenes. By working on layered paper, he was able to replicate in part the effects of oil-painting on canvas.

Western illusionistic techniques of representation were of some interest to the seventeenth- and eighteenth-century Chinese élite, and were available for appropriation by Chinese artists in specific contexts. A number of comments on Castiglione's work by his major patron, the Qianlong emperor (r. 1736–95), are recorded (often on the works themselves), and show that he enjoyed the feeling of possession of the foreign afforded to him by employing artists from an alien tradition, while he was confident of that tradition's essential inferiority to real painting, to the expression of self and personality through the visible 'traces of the brush'.

This painting on silk is one of Castiglione's earliest datable works [37]. It was painted in 1723, the accession year of the Yongzheng emperor, who was less impressed by the Jesuits than either his father had been or his son would be. It shows a lucky omen appropriate for the start of the new reign, in the form of divided or doubled ears of rice. Such omens were included centuries before in Song Huizong's collection of auspicious phenomena [22], and recorded in paintings which would have been available in the imperial collection both to the emperor and his artists. The rice is combined with other flowers and leaves which form a sort of elaborate visual/verbal pun. The word for 'vase' sounds similar to that for 'peace' (both *ping*, though written with different characters), that for 'rice' (*dao sui*) puns on 'year' (*sui*), while the word for 'lotus' (*lian*) sounds like 'in succession' (*lian*). Such elaborate iconological conceits were surely not within the grasp of an immigrant Italian of five years' standing, and suggest the role of some other court artist in laying out the programme for Castiglione's work at this time. In the Qing period such punning uses of motifs, predominantly botanical motifs, were quite common in certain specific contexts, such as congratulatory New Year and birthday pictures.

The Qianlong Reign: 1736–1795 CE

The very long reign of the Qianlong emperor (1736–95), whose interest in the artistic projects carried out in his name was close and persistent, exercises a considerable grip on the study of all Chinese art. It was during this period that the imperial collections grew to their largest size, acquiring by gift or by confiscation large quantities of earlier art of

37

'Assembled Auspicious
Objects', hanging scroll on silk
by Giuseppe Castiglione
(known in China as Lang
Shining, 1688–1766 CE),
dated 1715. Castiglione went
on to train a small group of
court artists in oil technique
and perspective drawing in
the European manner.

all types. It has even been argued that the removal from circulation of so much work, depriving artists other than those at court of the chance of seeing a painting by Guo Xi or Huang Gongwang [20] or [77], exercised a baleful effect on the subsequent course of Chinese painting. One certain effect is that the imperial collection, which subsequently formed the core of the Palace Museum, Beijing, and the National Palace Museum, Taipei, created a canon of 'major' works which it is hard today to escape. Our ability to understand art in China is filtered to a great extent through the sensibilities which governed the formation of the court collection in the eighteenth century. Artists thought significant then are still the major artists in the textbooks today. Those excluded from this collection are harder to study. A considerable proportion of the paintings and many of the other objects in this book were in the imperial collection in the eighteenth century (1, 18, 19, 20, 22, 23, 24, 25, 26, 31, 32, 33, 34, 37, 38, 68, 71, 72, 73, 75, 77, all have this provenance). Objects from the neolithic jade blade [1] to a painting like Mi Youren's 'Cloudy Mountains' [25] carry the seals of the Qianlong emperor, often in great number, as if to put the fact of imperial possession beyond any possible doubt. On more than one occasion, the emperor added a piece from his own brush to accompany a work of art in his collection, either in the form of a written inscription (e.g. on 20) or more rarely as a small picture (like the small tree and rock to the left of the Wang Xun calligraphy scroll, 68).

As well as the acquisition of works of art on an unprecedented scale, and the creation by court artists of great quantities of new work, which often in its turn adapted earlier pieces in the collections [67], vast cataloguing projects were carried out to parallel the sponsored scholarship in a number of other disciplines.[7] Religious art was catalogued first. Importantly, and at odds with earlier imperial collections such as those of Song Huizong (see p. 57), religious subjects were listed separately in a catalogue of Buddhist and Daoist art completed in the summer of 1744 and called *Bi dian zhu lin* (Forest of Pearls in the Secret Palaces). The first version of the catalogue of other paintings and calligraphy in the emperor's various Beijing palaces took over a year to complete, and was finished under the name of *Shi qu bao ji* (Records of Treasures at the Stone Canal), in the autumn of 1745. Supplements to both these catalogues were created in 1793. Another distinct category was made for imperial portraits (including things like [19], which were stored in a separate palace and listed in 1749. Finally, a catalogue of the imperial collection of ancient bronze vessels, the first since the twelfth century, was finished in 1749, and this *Xi qing gu jian* (Imperially Ordained Mirror of Antiquities prepared in the Xiqing Hall) in turn became a pattern book for the manufacture of new art objects of all kinds in ancient styles.

The decisions made in these cataloguing projects continue to affect art history today. Quite simply, it is the works of calligraphy and painting contained in the *Shi qu bao ji* catalogues which have received most attention as 'Chinese art'. Only now is attention being directed towards the material contained in the separate catalogues of religious art and portraiture, which were almost certainly held separately at the time because of their *importance*, not because of their lack of it.

The interplay between the imperial art collections, the court workshops, and the Qianlong emperor's close personal interest in visual forms of acclaim for his rule can be drawn out by an example [**38**]. This is a jade-carving, the largest in existence, which is extremely well documented in the surviving archives, with the names of all involved and the dates on which decisions were taken meticulously recorded.[8] The boulder from which it is made, 2.24 m. high, and weighing around 5,330 kg, was discovered in the late 1770s in the far west of the empire, near the city of Khotan, the main source of jade in Qing times. Its availability to the court underlined the political conquest by the Qing dynasty of the Khotan region, only definitively achieved some twenty years earlier. The precious rock was transported to Beijing over a period of three years, drawn on a huge wagon by a hundred horses with a thousand labourers assigned to assist with road and bridge construction. The emperor then selected the subject to be carved on it, picking an anonymous Song painting from the *Shi qu bao ji* catalogue, which depicts the emperor Yu the Great taming the flood waters in antiquity. The prestige of this sage-king, whose temple the emperor's grandfather had visited in 1689 [**34**], was thus associated with the reigning house.

Following the selection of the subject, artists of the imperial household department sketched all four sides of the boulder, and these were used to create a full-size wax model of the finished carving. The emperor personally viewed and approved this in the summer of 1781. He felt that the jade-workers in the Beijing workshop could not cope

with such a major project, and so the boulder was sent south by boat to the city of Yangzhou, where luxury crafts of all kinds existed to serve a wealthy clientele. Lest the wax model melt in Yangzhou's famously fierce summer heat, a second model of wood was dispatched southwards. A team of jade craftsmen took seven years and eight months to complete the massive job, a total of 150,000 working days. In the meantime, the wooden model was sent back to Beijing so it could be tried out in various locations until the emperor was satisfied. The actual jade returned to Beijing in 1787, where it took a palace craftsman another year to inscribe the lengthy text in the emperor's handwriting. This eulogizes Yu the Great, and the prodigious piece of jade, and associates both with the splendours of the reigning Qianlong emperor. The jade still stands in the spot he finally chose. The prodigious resources taken up in its manufacture, and the logistic complexity of co-ordinating painters, modellers, jade workers, and transport to create it, are a powerful testimony to the importance attached to such projects at this period of unprecedented imperial extension and cultural hegemony.

Late Qing Court Art: 1796–1911 CE

The splendours of the Qianlong reign used to be seen not so long ago as the 'end' of Chinese art, and the court culture of the nineteenth century viewed (if it was viewed at all) as an embarrassing era of 'decline'. Consequently, very little work has been done on court patronage of the arts in the Qing dynasty's final hundred years. But activity did not stop suddenly with the abdication of the emperor Qianlong in 1795 (or his death in 1799). In 1816, under his son and successor the Jiaqing emperor (r. 1796–1820), when a further supplement was made to both the *Bi dian zhu lin* and *Shi qu bao ji* calligraphy and painting catalogues, 2,000 items were found to have been added to the latter category of non-religious art since 1793. It was economic weakness and direct political attack on the dynasty, both by Chinese rebellions and foreign imperialist assault, which reduced the court's ability to support a large artistic establishment. It remained a patron of the arts in the larger sense; for example, it was in the nineteenth century that court interest in the theatre enabled the drama form known in English as 'Peking opera' to rise to the prominence it continues to enjoy today.

The creation of images of the ruler for court consumption continued to be in the hands of often anonymous court painters. A team of such artists produced to order the scroll showing the Daoguang emperor (r. 1821–50) in the company of his children [**39**]. In doing so, they sustained a tradition of blending one manner of figure-painting with another manner of landscape depiction which went back at least to the early Ming court [**32**, **33**, **34**]. Such sentimental pictures

40

Hanging scroll on paper, 'Pine and Auspicious Fungus', by Dowager Empress Cixi (1835–1908 CE), dated 1897 CE.

of family life at court may have been derived by court artists from Western conventions of portraiture—Castiglione was commanded to paint more than one image of the Qianlong emperor with his children. They continued to be made in the early nineteenth century, and seem to have been popular with the Manchu aristocracy in particular, as visual images of a culture of emotional sensibility which finds its most famous expression in the great novel *Hong lou meng* (Dream of the Red Chamber), first published in 1791. Two princesses are painted to the right of the emperor, who sits alone practising the élite art of calligraphy, while five of his sons are painted to his left, the three younger ones playing with kites. The figure second from the extreme

left was to succeed to the throne as the Xianfeng emperor (r. 1851–62), his fully frontal pose expressing a status higher than that of his brother Yixin, Prince Gong (1833–98), a man who was to dominate China's foreign policy in the late nineteenth century. This is a new kind of imperial portrait. The format of a large horizontal rectangle is perhaps an adaptation of imported European pictorial types. More importantly, the relationships represented by the inclusion in the same pictorial space of the 65-year-old emperor and his teenage children (the crown prince was aged around 16 at the time) are relatively new artistic subjects, at any rate to the repertoire of court artists.

To the very end of the dynasty, visual art was created to adorn and celebrate the court. Its status in the eyes of Chinese theorists and connoisseurs was so low as to place it beneath notice, and the large quantities which remain in situ in the palaces of Beijing have yet to be seriously examined. One imperial patron who has had a certain measure of attention is the remarkable Xiaoqin, most often referred to as the 'Dowager Empress' Cixi (1835–1908). Accounts of her ruthlessly maintained political ascendancy often mention her lavish building projects as evidence of reckless extravagance, especially her rebuilding of palaces looted and burnt by British and French armies, for which she allegedly used funds raised to build a navy. Another interpretation of her actions might see her as a ruler who understood the role of the symbolic in the maintenance of rulership. She attempted to create a public iconography of the ruler for the first time, sitting for her portrait to lady artists of the European diplomatic community, and employing a court photographer to record her private theatricals, in which she delighted to play the role of the bodhisattva Guanyin. She patronized skilled artisans, like the embroiderer Shen Shou, a woman who went on to win medals at the International Expositions which were such an important part of international cultural competition in the late nineteenth century, and in which China had participated since 1873.

The Dowager Empress Cixi also understood the traditional role of the ruler as artistic creator, and was an assiduous calligrapher and painter herself (she also embroidered in her youth), using gifts of her work to win friends in the European community, as well as to reward loyal subjects. Some of these gift pictures may in fact have been executed for the empress by women artists of her entourage, like Miao Jiahui and Ruan Yufen (both active late 19th–early 20th century). This example [40], dated 1897 and painted on paper, is signed with the words 'imperial brush' although that may not of itself guarantee her active participation in its creation. It shows a pine and a kind of fungus called a *lingzhi*, both of which are associated with the notion of 'long life', and which are in this case contorted into a version of the Chinese character *shou*, itself meaning 'longevity'. As such, it is an absolutely typical

presentation picture, but made all the more valuable to its recipient by its emanation from the empress herself.

Four years after the Dowager Empress Cixi's death, China was a republic. The court as centre of patronage had ceased to exist. However, the slow, often squalid and clandestine dispersal of parts of the imperial collection during the fifteen years of 'twilight in the Forbidden City' have shaped many of the collections of Chinese art in North America and Europe, while the ultimate conversion of the bulk of the imperial holdings of art into China's leading museums has ensured the central role of imperial patronage in any subsequent construction of Chinese art, or understanding of China's artistic heritage. The influence of imperial taste, particularly that of the Qianlong emperor, is active in the art market and the art-historical classroom still.

Art in the Temple

3

Early Buddhist Art

Followers of the Buddhist religion, a religion founded on the plains of northern India in the sixth century BCE, began to reach China by the overland and sea routes in the first century CE. The Buddhist missionary known to the Chinese as An Shigao is said to have established himself in 148 CE at the capital city of Luoyang, to minister to the foreign community there and to seek converts at court. The centuries of sophisticated religious, moral, and ethical thought between the life of the Indian prince Sakyamuni or Gautama Siddartha (*c*.563–*c*.483 BCE), later known as the Buddha, and the transmission of his teachings to China had produced an elaborate body of ideas and practices which were to have an incalculable impact on all the cultures of East Asia over the next two millennia. A whole new body of texts, with new claims to authority, new ways of living, such as those led by cloistered and celibate monks and nuns, and new conventions of representing, as well as new objects to represent, and new architectural forms to house them, were accepted into Chinese life. All of these gradually but irrevocably naturalized themselves among all levels of Chinese society.

This was neither a single, nor an evenly occurring process. Rather it was conditioned by factors such as class, gender, and regional religious loyalties which are still very little understood. This was true above all in the area of artistic and material culture practice, where Buddhist elements were first of all appropriated by Chinese makers and users of images in ways which had very little to do with any rigorous understanding of the subtleties of Buddhist religious thought. Typical of this early stage of appropriation of Buddhist artistic motifs into pre-existing contexts is a glazed ceramic jar [**41**], made probably *c*.250–80 CE, in a region of coastal south-east China which formed the state of Wu, one of the Three Kingdoms into which the Han empire disintegrated after 220 CE. It is one of a group of such jars believed to have been used in burials where the physical body of the deceased was not present (a not uncommon occurrence in the third century, as many Chinese families migrated hurriedly to the south to avoid invading peoples from inner Asia). Some of these dwelling places for the soul are

Detail of 55

inscribed, and they are modelled or moulded with figures of the Buddha, identifiable often by a halo of light.

Images of the Buddha had appeared as isolated elements in the decoration of upper-class tombs in widely separated areas of China prior to the making of these jars. In the case of both tomb decoration (whether murals or sculpted reliefs) and of the ceramic jars, it would be unwise to read them as evidence of conversion to exclusively Buddhist beliefs. Rather the Buddha was initially absorbed into existing religious and burial practice on a par with other deities such as the Queen Mother of the West, who are seen for example on the Mawangdui funeral banner [8]. This absorption was particularly fruitful in the south-east, where textual records suggest the first independent Buddha images were made in 193/4 CE (not long after Buddhist sculpture began to appear in India). Here the Buddha, rather than the Queen Mother of the West, protects the soul and guides it in

41
A ceramic jar of *c*.250–80 CE, undecorated except for a small moulded figure of the Buddha, identifiable by a halo of light around the head.

the place of the earlier shamans to the Pure Land of the Buddhist paradise, but this is done in the context of rites involving sacrifice to ancestors and their continued benevolent interest in their descendants, ideas which have no such prominent place in the orthodox Buddhism of India.

In that sense, the jar plays a different religious and artistic role from an image which remains the earliest precisely datable figure of the Buddha from China [**42**]. This gilt-bronze figure of the Buddha seated in meditation is dated 338 CE, and was cast in the territory of the Northern Zhao, an ephemeral polity established by a particularly thuggish warlord, with its capital at modern Luoyang. The risky environment of the court of Shi Luo gave shelter to some of the most distinguished religious figures of the early phase of Buddhism in China. If the soul jars of the state of Wu attest to the reception of Buddhism beyond the highest ruling circles, this small image points to the importance of courts and court circles in allowing what entered China as a religion of foreigners to establish itself as a massively prosperous institution of cultural and artistic patronage. Buddhist masters were highly prized by third-century rulers, operating in an age of constant warfare, as wizards and wonder-workers, and they quickly became a naturalized part of the arsenal of any ambitious prince.

No early Indian sculpture has been recovered in China, but imported images must certainly have been available as models to craftsmen, who could also be directed by monks who were themselves from India and had received advanced religious (including presumably iconographical) training there. The earliest Chinese Buddhist texts describe the Buddha as a golden figure of imposing physique, emitting radiant light, and this, along with the urge to adorn a revered icon with precious materials, may explain the prominence of gilding on figures of this type. This radiance was not necessarily directed towards worshippers. This image should probably be imagined, not on the altar of a temple, but buried as part of a votive deposit, there to protect either

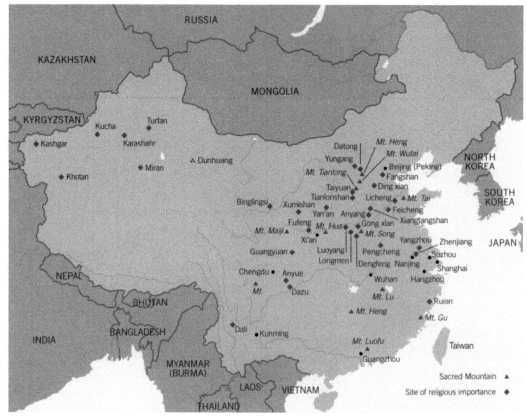

the individual donors or the state and ruler himself. It was meant to *do* things, not to be looked at.

Buddhist Art: *c*.450–*c*.580

The practical function of the Buddha image is seen most powerfully in the huge and impressive group of five caves, known after their initiator as the Tanyao caves, carved and painted out of the rock of a cliff-face at Yungang, near the modern city of Datong, in the years between 460 and 493 CE [**43**]. The idea of a Buddhist cave temple complex on this scale has Indian roots, even though earlier groups of religious rock-carving, perhaps containing Buddhist elements, had been created occasionally in China. But nothing as large as Yungang, or so closely tied to a ruling family's programme, had been attempted previously.

The Tanyao caves were built just outside the capital of the Northern Wei dynasty (420–534), a state of Turkish conquerors who were served by Chinese aristocrats such as Sima Jinlong (see p. 36), and who dominated the north China plain through the fifth and early sixth centuries. Northern Wei rulers of both sexes were great patrons of Buddhism, and under them the religious establishment expanded until there were 13,272 monastic establishments in their empire. Leaders of the Buddhist community responded to this patronage by developing

Figure of the Buddha, in gilt-bronze, dated 338 CE. This image depends closely on imported Indian models, both for formal features of religious iconography like the *usnisa* 'bump' on the Buddha's head, and for the conventions of how to show the folds of drapery in cast metal.

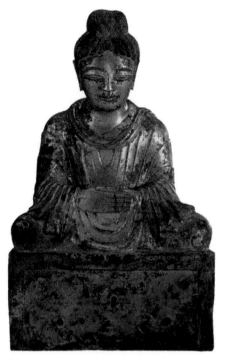

doctrines which equated the ruler with the Buddha himself, and it may well be in support of these doctrines that the five colossal Buddhas of the caves were constructed. A fierce but brief burst of persecution of Buddhism between 444 and 451 had seen imperial decrees which threatened death to any who 'dare to serve the barbarian gods or make images, statues or figures in clay or bronze'. When this policy was reversed on the death of its advocate, the Chinese monk Tanyao suggested as an act of expiation the creation of the caves, explicitly designed to outdo the giant images known from travellers' accounts to exist in India and Central Asia, and to bolster the claims of the Wei ruling house to a central role as patrons of the Buddhist law. Huge economic resources were expended on the project, straining the machinery of revenue-raising to the limit.

The five Buddhas may represent the five emperors of the Northern Wei up to that time, although an alternative theory has been advanced that the whole thing is an elaborate talismanic device for the protection of the Wei state, built to an arcane iconographical programme involving Buddhas of the past, present, and future, which may be of Kashmiri origin (Tanyao was trained by Kashmiri monks).[1] This theory receives some support from the fact that the cliff out of which the caves are carved is directly beneath a fort dominating the main route from the west to the capital city, and also from the general invisibility of the massive Buddha images at the time of their construction. Again, whatever the primary purpose of the images, the designers did not expect them to be seen by a large congregation of the

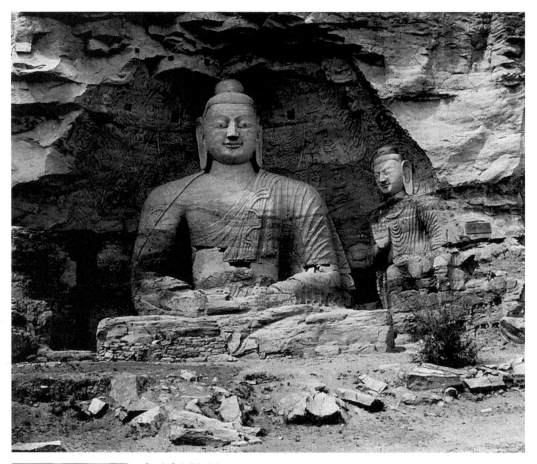

43

The colossal figure of the Buddha Amitabha, from Cave 20 at Yungang, Shanxi province, carved c.460–93 CE. The image has been exposed by the collapse of the original cave front.

faithful. Unlike many other cave temples, it is impossible to circle the images in an act of devotion.

The court may have initiated the work at Yungang, but the site was quickly appropriated by other levels of society. Numerous other caves were worked on in a burst of intense activity lasting less than a decade, from 483 to after 490, creating a site some 1400 m. long with fifty-three greater or smaller caves. An analysis of the 120 donors' inscriptions which have survived from the Northern Wei reveals that 12 per cent refer to religious associations comprising members of both sexes, 33 per cent to nuns and female lay devotees, and 55 per cent to monks and male devotees, including court nobles. The great majority of these people had no connection to the court, and many were of relatively humble status (something suggested by the often considerable numbers who clubbed together to pay for quite modest images). The inscriptions call for blessings on the donors' own families, not on the imperial house. Yungang had become a site capable of satisfying a much broader range of needs, both purely spiritual needs and those for an arena of competition in which women, for example, could play a more prominent role, and where private individuals could

see themselves represented as donors both through permanent inscriptions in the stone and through sculpted groups of donor figures.

We know more, through inscriptions, about who paid for the Yungang Buddhist images than we do about who made them, or indeed how they were made. Before 551, craftsmen like sculptors were technically slaves of the state, who could work for other clients only after fulfilling government commissions. Some further things can be extracted from the evidence of the site itself, for example that it was standard practice to begin work on a cave at the top, and fill the walls downwards as commissions came in. The friability of the soft sandstone meant that breakages often needed to be repaired, and some caves (though not the Tanyao five) were additionally protected by pavilions built out in front of the rock, and mortised into it. Workshops of sculptors may have worked exclusively on the imperial projects, or on smaller caves for private clients, which were turned out in some haste and with a correspondingly more relaxed attitude to the quality of the finish. A variety of styles of image is present at Yungang, and much effort has gone into discerning a formal sequence of stylistic change, or of response to known external stimuli. For example, in 486 the court decreed that all Wei officials were to wear Chinese dress, rather than the distinctive costume of the Tuoba minority, and this has been seen as causing the appearance of Buddha figures wearing Chinese robes tied with ribbons, rather than the draped Indian garments. However recent scholarship on the caves argues that different styles at Yungang do not mean different dates, but rather different types of client and different degrees of interest in strict iconographical correctness.[2] In this model, figures in 'Indian' dress are not a sign of alien influences soon to be replaced by native Chinese artistic genius, but are later, and reflect a more sophisticated audience keener on the outward manifestation of religious orthodoxy.

In 494 the Wei dynasty moved its capital to Luoyang, and work on the Yungang caves effectively ceased. They were neither the first nor the last such complex, even if they were particularly close to the court. Much further from the metropolitan centres of religious, artistic, and political life were the Mogao caves at Dunhuang, far to the north-west in Gansu province. Here a major Buddhist monastery existed in a context of considerable ethnic, linguistic, and religious pluralism. These caves, and the communities of monks who surrounded them, were nevertheless important pilgrimage sites, visited not only by those travelling the land routes between China and western Asia (and which have come to be known in this century as the Silk Routes), but also by those who made the journey in order to worship before images of special efficacy. The pilgrimage was another cultural practice of Buddhism adopted in China which was to have an important impact on artistic creation.

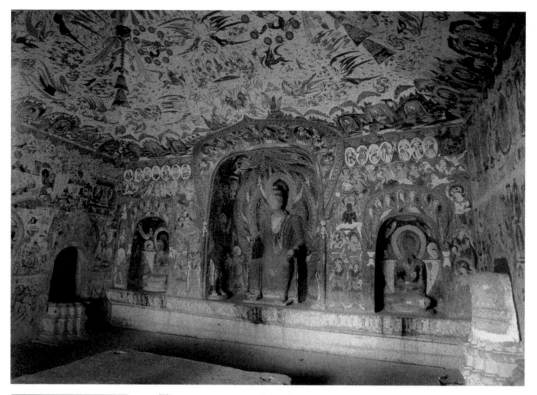

44

The interior of Cave 285 of the Mogao caves, Dunhuang, Gansu province, painted in 538/9 CE. The palette of eleven colours used in decorating the Dunhuang caves includes expensive mineral pigments imported from far away. This testifies to the prosperity of the site in its heyday.

The remoteness of the Dunhuang caves has ensured their survival, and the dry atmosphere has preserved the polychrome painting, here executed on plaster covering the gravel conglomerate of the cliffs and on the predominantly clay sculpture modelled on wooden cores, which certainly once also covered the stone sculptures of Yungang. Work at Dunhuang may have begun almost contemporaneously with that at Yungang, but only one of the 492 surviving caves (out of a possible peak of 1,000) bears a precise date. This is Cave 285, dated by painted inscription to the year 538/9 [**44**]. The elaborate scenes on the walls include solar and lunar heavens, narratives of the life of the historical Buddha, and scenes of the Western Paradise, the Pure Land in which Buddhist devotees could hope to be reborn. It has been claimed that the murals of this cave are the earliest evidence for so-called 'Esoteric Buddhism' in China, the position of deities on the walls being in keeping with elaborate theories of geomancy derived ultimately from the pre-Buddhist Indian religion of the Vedas.[3] Certainly both the main cave and niches or chapels which it contains were used for advanced meditation techniques by monks, and may not have been accessible to lay pilgrims, as many of the other caves were.

The techniques of the Dunhuang mural painters are known to us through the discovery, shortly after 1900, of a cache of miscellaneous items sealed in about 1000. These finds, divided by modern systems of categorization into 'documents' and 'works of art', and hence

physically split between libraries and museums in London, Paris, Berlin, Petersburg, and other European cities, give an unparalleled picture of many aspects of the life of the region, including its artistic life. Some of these documents, dating from rather later than Cave 285, provide evidence for the techniques of the caves' decorators. Stencils or pounces were widely used. These are drawings on thick paper, where the outline of the figures is followed by a line of pinpricks. By laying the stencil on the plaster to be decorated, and dusting it with chalk, the outline on the paper is transferred to the wall, and can then be followed by the painter. This technique speeds up the production of elaborate mural schemes by enabling the same design to be used repeatedly. It would also ensure iconographical precision in the depiction of certain figures.

Although no longer state slaves, painters at Dunhuang in its earlier phases remained hereditary craftsmen whose status was transmitted from father to son, and unpaid labour for the government continued as a form of taxation. In the Tang period (618–906) painters and sculptors became freer to deal with customers of any kind as independent contractors. Painters were paid in cash for small projects like painted banners, while larger projects (and these could take anything up to a year or more) might mean payment in flour or oil as well, the cost depending on the complexity and size of the design. Employers either supplied materials like silk and pigments themselves, or paid extra if the painter supplied them. Dunhuang documents refer to a painter 'and his assistants', though we do not know how big such teams could be. The painters were assisted by monks of the temple involved, though whether as actual artists or as advisers on the specifics of Buddhist iconography is also unclear. Monks certainly inspected sketches and drafts before murals were completed, to ensure ritual correctness.[4] By the ninth century, artists were treated with a certain respect by their employers, even far from the capital.

Religious Art of the Sui (581–618) and Tang (618–906) Dynasties

Visually impressive though they are, the caves of Dunhuang were probably modest in comparison to the splendours of religious establishments in more prosperous parts of the empire, establishments whose architecture, wall-paintings, textiles, and altar vessels are largely lost to us now. Only occasional pieces survive, often preserved by deliberate burial as dedicatory offerings on the occasion of the consecration of a temple, or to protect them from seizure during the intermittent persecutions of Buddhism. The latter is the probable context which has preserved the sculptural group in gilt-bronze, dating from the fourth year of the Kaihuang reign of the Sui dynasty, equivalent to 584, and excavated in 1974 in the suburbs of the great

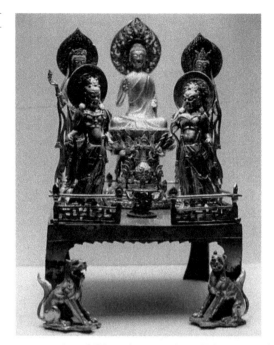

Gilt-bronze figure of the
Buddha Amitabha with
attendants, dated 584 CE.
The architectural setting of
the group, with balustrading
mimicking the wooden
railings of full-scale temples,
links this miniature to the
kind of large sculptural
ensemble which would have
been familiar to devotees.

metropolis of Chang'an, modern Xi' an [**45**]. As the capital of the first dynasty to reunite north and south China after over 300 years, Chang'an was home to a concentration of wealth, aristocratic culture, and political patronage with which the Buddhist religious establishment was closely intertwined. It was the largest city in the world, and over the following centuries was to far outstrip Baghdad and Constantinople, its only near rivals.

The group consists of a central seated figure of the Buddha Amitabha (or Amitayus, though both of these are the Sanskrit, not the Chinese, names), making one of the elaborate repertoire of ritual hand gestures which are so central to the meaning of Buddhist sculpture, and in this case which signifies 'Do not fear'. The Buddha is flanked by two bodhisattvas, perfected beings who have vowed to not enter nirvana themselves, but to remain accessible to the prayers of the world until all have been saved. In front stand two Heavenly Kings, guardians of Buddhism distinguished by their circular haloes, and they in turn are preceded by two snarling lions. An inscription reveals something of the purposes for which this piece was made. It names the donor of the image as a high official named Dong Qin, and calls down blessings on the emperor of the new dynasty and on his family, hoping that they may all 'hear the True Law'. This is followed by a poem which stresses that good deeds and 'compassion to all living beings' are an essential part of the process of rebirth in the paradisiacal Pure Land where Amitabha reigns.

At least one other piece of this type similarly bears inscriptions invoking blessings for the ruling house, thus allowing donors to attest

to both religious piety and political loyalty at one and the same time. Despite being of very similar date, these two shrines from the 580s (the other is in the Boston Museum of Fine Arts) are visibly different in appearance, the figures on the Boston piece being stiff and angular, while the Xi'an figures are more sinuously posed and rounded in their modelling. Such differences may reflect regional traditions of sculpture which had developed in the period of political fragmentation which the Sui emperors brought to a close. The extent to which such questions of style, as opposed to scale, quality of gilding and casting, and iconographical accuracy, were consciously raised as issues by patrons is obscure to us, but is a potentially rich subject for future research. The donor was not a native of Xi'an. However, the attractions of the political capital of a newly centralized and unified empire may have drawn him to the city, just as the extensive programme of temple-building which formed part of the Sui emperors' consolidation of their realm may have drawn the skilled artisan(s) who made the piece.

The cult of Amitabha, the Buddha of the Western Pure Land, began in a monastic environment in the fifth century CE, and only gradually spread to a domestic context to become one of the most potent strands of Buddhist devotion in China. The sutras, or Buddhist scriptures, which describe the Pure Land were among the best known at all levels of society, and Pure Land devotees were to be found in both the court and among the peasantry. Household shrines to Amitabha presumably existed in a great variety of materials and with different levels of artistic competence, this being a luxury example of a very widely disseminated type, created to serve an individual grandee.

Stone sculpture was probably not employed in a domestic context, but was confined to temples, though it linked the home and the temple through the fact that it was usually paid for by lay donors, whose names (often in very large numbers) it sometimes bears. Although stone sculpture could be on a massive scale [44], it is worth remembering that much of it was quite modest, suited to the needs of congregations of limited resources in areas far from the court. A painted stone niche from Changzhi county in Shanxi province [46], which dates from the seventh century, can be taken as fairly typical of a level of Buddhist sculpture much more modest than Dong Qin's gilt-bronze shrine. Clearly they are related in their understanding of what needs to be represented to make a successful and potent image. Here again a seated Buddha figure (this time Maitreya, Buddha of the Future) is flanked by a pair of bodhisattvas dressed in the jewelled garb of Indian princes, though this time the Heavenly Kings are replaced by disciples in monks' robes. Again lions defend the image. But they differ both in the materials employed and in artistic accomplishment, something certainly due to the very different levels of patronage to which they are

46

Limestone image of Maitreya, the Buddha of the Future, flanked by attendants, carved *c.*600–700 CE. The painted decoration has been renewed many times, but gives some idea of how such sculpture was originally coloured.

a response. The Changzhi niche is a 'good enough' image, and one which remained the object of devotion down to very recent times before its transformation into an art object. Its anonymous sculptor(s) by this period worked in a context where regional differences in the appearance of sculpture were diminishing, as the cultural and artistic prestige of a single capital city grew. The repeated repaintings which it has received over the years serve to remind us not only that sculpture in China (as in ancient Greece) was mostly originally decorated in a naturalistic polychrome (and some at least of the paint may be original here), but that the biography of a religious image such as this is bound up closely with questions of local and individual piety, and with the resources available to manifest that piety.

It is easy to think of Buddhism as totally dominating the religious life of China in the first millennium of the Common Era, largely because of the quantities of artistic production which it called into being, and which survive to fill museums and the pages of books about Chinese art. However another tradition was arguably as central to

Daoism (older spelling 'Taoism') is a religion indigenous to China, which takes its name from the word *dao*, 'the way'. It draws in its origins on texts of the late Warring States period (fourth–third centuries BCE), but its formative years were the centuries immediately after the fall of the Han dynasty in 220 CE. Its identity was formed in conflict with the immigrant religion of Buddhism, from which it borrowed much and to which it gave much. It has never had a single centralized hierarchy dictating doctrine, and its canon of texts has been fluid for much of its history.

Daoism offers personal salvation through a number of religious practices, today mostly carried out on behalf of laypeople by trained religious practitioners: these include prayer through the recitation of written texts, alchemy and healing, ritual dance and ceremonial. Practitioners also perform rituals which seek to benefit society as a whole by maintaining cosmic harmony. Daoism offers its devotees the possibility of becoming an 'immortal', deathless beings who dwell in a variety of paradises. Many deities are worshipped in Daoism, but the central figures are a triad known as the Three Pure Ones. As

pic. no. 47

with Buddhism, there are several schools of Daoist practice, which emphasize different strands of the tradition. Daoist practitioners of both sexes have always lived as individuals within the community, as well as inhabiting temples and monastic complexes.

spiritual life, even if its physical traces are much less visible today. This is the religion now known as Daoism (or Taoism, in an older spelling), after the Chinese word *dao*, literally 'path' or 'way'. Although the ideas which underpin it have their origins in the intellectual world of the Warring States period, and draw on the quest for personal immortality and contact with immortals manifested in the burial art of the Han period [**8, 9, 10**], Daoism as a religion developed at the same time as Buddhism was becoming accepted, and the two faiths enjoyed a complex relationship. Often they were overtly antagonistic to one another, in competition for the loyalties and patronage of the same populations and the same rulers. But acknowledged and unacknowledged appropriations of ideas, iconographies, and cultural and religious practices were numerous.

Daoism originally made a point of eschewing images of its deities. Independent and free-standing images of immortals were occasionally made in the era of the Northern and Southern Dynasties, but it is only in the Tang period (618–906) that Daoist sculpture on any significant

Stone sculpture of seated
Heavenly Worthy, one of the
figures of the Daoist pantheon
of immortals, dated 719 CE.
Such a figure would have
originally been flanked by two
standing attendants, making
the similarity with Buddhist
religious sculpture even
more clear.

scale began to be made. The Tang emperors were lavish patrons of both Buddhism and Daoism—particularly the latter, since they claimed descent from Laozi himself, believed to be the Warring States philosopher and mystic, author of the scriptural *Dao de jing* (The Book of the Way and its Virtue), and revered as the deified cosmic hierarch.

A Tang dynasty image [47] of one of the deities known as Heavenly Worthies has clearly appropriated some of the conventions of better developed Buddhist sculpture, indeed was probably carved by someone who also worked on Buddhist projects. From the very fact of having a seated central figure to the manner of representing the folds in the fabric on which he sits, the links with art made for Buddhist temples is clear. Similarly, the style in which the piece is inscribed with the name of a donor, an individual surnamed Zhao, and dated to the tenth day of the eleventh month of the Kaiyuan reign (equivalent to 719) is adapted from that used on Buddhist images. However, the iconography is distinctive; no Buddha has a triple-forked beard, for example, and the feather fan held in the figure's right hand is also an exclusive attribute of immortals of this type. The image was once worshipped in a now-destroyed temple near the modern city of Yuncheng in Shanxi province. It is a relatively modest reminder of what once must have been a very much greater quantity of Daoist sculpture, executed on a grander scale for metropolitan patrons right up to and including the emperors themselves.

Something of the grandeur of a major Tang Buddhist project under direct imperial patronage can be seen at what is, along with Yungang, the largest complex of this type to survive, the cave temples of Longmen, just outside the city of Luoyang in Henan province [48]. These began to be carved as soon as the Northern Wei court decamped to Luoyang in 494, and were worked on continuously from then for about another 400 years. The projects undertaken there by successive ruling houses reflect the changing fortunes of sectarian groupings within Buddhism itself. An analysis of the donor inscriptions has shown a shift in the most popular objects of devotion, from Sakyamuni, the historical Buddha, to Maitreya, Buddha of the Future, and then to Amitabha and Avalokitesvara (known in Chinese as Guanyin), the latter the supremely compassionate bodhisattva who 'hears the cries of the world'. The latter two are particularly associated with Pure Land sects of Buddhism, and with the quest for personal salvation. Doctrinal changes within Buddhism were reflected in new iconographical arrangements. By the seventh century the single, massive figures which dominate Yungang [43] were replaced by the typical group of five figures seen in **45** and **46**, where a Buddha is flanked by bodhisattvas and disciples (in Chinese, *luohan*), symbolizing the doctrine of one Great Vehicle or mode of salvation (in Sanskrit, *Mahayana*) encompassing the Lesser Vehicles. Such

48

Giant figures of a Heavenly King and demon guardian of Buddhism, carved from the rock of the Fengxian temple, near Luoyang, completed 675 CE. By the head of each can be seen the mortises in the stone which once carried the beams to support a roof over the entire 36 m. width of the cave.

doctrinal subtleties may not have been understood at every level of society, but they were certainly widely comprehended by the élites who sponsored large-scale projects. And they had a direct impact on artistic developments, since different sects not only emphasized different elements of the Buddhist pantheon, they had distinctive types of religious practice requiring different types of material culture to service them.

Such a grouping of five dominates the limestone caves of Longmen, in the form of the cave, once-roofed but now open to the elements, called the Fengxian temple. This was completed at court order in 675, under the supervision of three leading religious figures of the capital, and by a team of sculptors whose leaders at least are known by name: Li Junzan, Cheng Renwei, and Yao Shizhi. Though nominally the chief patron was the Tang emperor Gaozong (r. 650–83), he in this as in so many other matters deferred to his formidable wife, the Empress Wu, a woman who had herself spent time as a Buddhist nun, and was an intensely committed patron of religious projects, often with innovative features of her own devising. She was particularly devoted to the Zhenyan, or 'True Word' tradition, distinguished by its highly complex and esoteric rituals, its need for lavish ceremonial and lavish accoutrements, and its complex and arcane ideas available not to a broad congregation but to a circle of initiates only.

The illustration **48** shows not the main figure of the Fengxian temple at Longmen, a colossal (17.4 m. high) figure of the esoteric Cosmic Buddha Vairocana which legend says bears the empress's own features, but the flanking north wall of the cave. On the left a Heavenly King in the full armour of a contemporary military commander, and balancing a votive pagoda on his hand, tramples on a demon, while on the right a guardian figure in a more Indian style of dress tenses his body while making one of the specialized gestures which were so important in Zhenyan Buddhism. Their postures are typical of the religious art of the Tang period, particularly in the way they bend and flex realistically, attempting to capture a sense of bodies in motion, unlike the vertical and unmoving figures of the Buddhist sculpture of an earlier period. Such images of defensive power had more than one purpose. The Longmen temples were explicitly built in response to Tibetan military success in Central Asia, to bring supernatural succour to the Tang armies.

The ceremonies carried out under the vanished roof at Longmen required a whole array of objects now mostly lost to us: textiles, vestments for the priests and to adorn the interior, musical instruments, offering vessels, and ritual implements of all kinds. Only very occasional survivals hint at the splendours which the imagination now has to supply. Objects and images transmitted to Japan at the time, and preserved there since, fill some of the gaps. One such example is a highly elaborate bronze gong, which survives in a temple in Nara, seat of the Japanese emperors, 710–84 [**49**]. A hexagonal pillar rising from the back of a lion supports a pair of male and female entwined dragons, from whom in turn the circular gong, decorated with a lotus pod and petals, is suspended. At one point the gong was accompanied by a now vanished wooden sculpture of an attendant, holding the wooden stick used to beat it, and it also now lacks some final element which stood on the platform held in the dragons' upraised claws. For all these losses, it remains a valuable testimony to the type of craftsmanship of the highest quality deployed in the service of Buddhism, and to a strand of aesthetic appreciation at the period which valued the representation of powerful human and animal musculature, both in movement and in repose.

Esoteric meanings, rather than purely aesthetic criteria, almost certainly attach to the gong's decorative elements, both individually and collectively. Such meanings are also prominent in the case of the most important group of Buddhist objects to be excavated in China in recent years, those from the Famen temple, found in 1987 at Fufeng, west of the Tang capital. A major temple here, completed in 532 under imperial patronage, owed its importance to its ownership of a fragment of the physical body of the historical Buddha, a relic of incalculable spiritual power. This relic was in the course of the Tang dynasty

49

Bronze gong on a stand, dating from the eighth century CE. Only traces of the original gilding remain on the surface. Now in a temple in Japan, where much early Chinese Buddhist art has been preserved from the time of its manufacture.

50

Silver and silver-gilt container for a relic of the body of the historical Buddha, dated 871 CE and presented by the emperor to the Famen ('Gate of the Law') Temple, at Fufeng, Shaanxi province.

removed on several occasions to the imperial palace, and then returned to its home with impressive arrays of gifts, many of them in precious metals, which remained undisturbed in an underground reliquary 'palace' from 874 till the time of excavation.[6]

Secular silverware survives in some quantities from the Tang period. It was widely used by the upper classes, and often adopts shapes and motifs from western parts of Asia, regions with which the Tang empire was in commercial and diplomatic contact. Among the 121 pieces of gold and silver of the Famen Temple deposit are a number of unique pieces, including the relic holder itself, a silver gilt kneeling bodhisattva on a lotus throne [50]. This is inscribed as being presented by the emperor himself, in the year equivalent to 871, with hopes for the sovereign's long life, for numerous progeny, and for the submission of the whole world to his sway. These were by the ninth century pious hopes, as the imperial court of the late Tang was increasingly powerless in the face of independent regional governments, but political frailty was not accompanied by any lessening of devotion to Buddhism, or willingness to spend resources on glorifying and adorning its most sacred relics. It is above all the textiles and the work in precious metals from this site which show for the first time the full range of riches bestowed on an important Buddhist site under court patronage, and which begin to challenge the dominance of the much better preserved

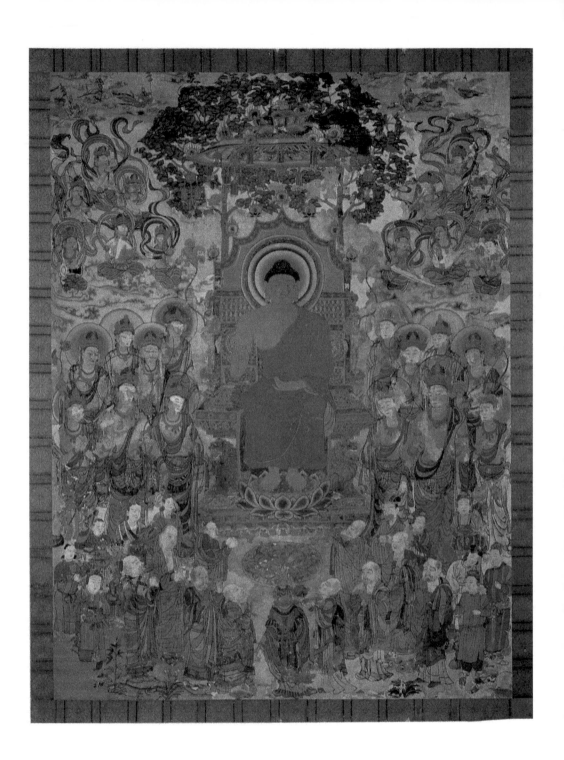

Embroidery on silk showing the Buddha preaching, eighth century CE. No dedicatory inscription appears on the object itself, but the figures in the extreme lower corners probably represent the donors who caused the image to be made.

stone sculpture, and of the important but idiosyncratic Dunhuang deposits in our understanding of Buddhist art.

Given that they were presented by an emperor, it is reasonable to assume that objects of gold and silver stood at the apex of the system of values governing understanding of what we might call a 'hierarchy of the arts' in the field of religious patronage. Materials probably mattered as much, if not more, in asserting the importance of the act of patronage, as did the stylistic features which have generally formed the focus of art-historical study. A silver Buddha was a more pious gift than a bronze one, or a stone one. Difficulty of execution, and the amount of labour involved in making an object, probably also governed its importance as a measure of the donor's piety. In this context, it is worth considering the relative positions of painted and embroidered Buddhist pictures, both of which were found in the Dunhuang deposit, though the former outnumber the latter massively. The embroidered picture shown [51] is not from Dunhuang, though it resembles in technique the most important embroidery found there, but again has been preserved in Japan since the time of its export to that country in the eighth century. It depicts the Buddha seated on an elaborate throne, preaching to an assembly of bodhisattvas, luohans, and disciples. The labour, presumably of professional embroiderers, expended on such a piece was enormous, and it is likely that such objects were above paintings in the hierarchy of esteem, even though as 'textiles' they are now placed in a separate category. Secular embroidery of this period survives hardly at all, but it is known that it was employed as picture-making technique for landscape representations as well.

Preciousness of materials was only one way in which a donor could display piety. Another was by massive multiplication of the number of sacred texts or sacred images put into circulation, and this was to lead to one of the most important technical developments not simply of art and culture in China but of world civilization, namely the invention of printing. Wooden blocks had been used for the printing of multiple pictures from the seventh century, though the earliest surviving piece of printing, involving words only, dates from the eighth century, and comes from Korea. The scale of printing projects is shown by the print-run of 1,000,000 copies of a Buddhist charm, executed between 764 and 770 in Japan at an empress's orders. Not all texts were produced in such numbers, and the earliest surviving complete printed book in the world is known from a single copy. This is a version, printed in 868, of one of the key Buddhist scriptures embodying Pure Land beliefs, the *Diamond Sutra*, which was removed from the Dunhuang deposit in 1907 by the archaeologist Aurel Stein, and which is now in the British Library in London [52]. The bound-book format was not yet standard at this period, and the scripture takes the form of a 6 m. (18′) roll of

八欲讀經先念淨口業真言□過

備唎 備唎

摩訶備唎

備備唎

奉請除災金剛
奉請辟毒金剛
奉請黃隨求金剛
奉請大神金剛
奉請安陳尼金剛
奉請白淨水金剛
奉請赤聲金剛
奉請紫賢金剛
奉請大神金剛

金剛般若波羅蜜經

如是我聞一時佛在舍衛國祇樹給孤獨園與大
比丘眾千二百五十人俱介時世尊食時著衣持
鉢入舍衛大城乞食於其城中次第乞已還至本處

52

Illustrated preface to the *Diamond Sutra*, printed by wood block in 868 CE, and found in the so-called 'sealed library' at Dunhuang, Gansu province. This is the world's earliest printed book.

paper, headed by a picture again showing the Buddha in an attitude of teaching. At the end of the text a colophon reveals that it was printed at the expense of an unidentified individual named Wang Jie, 'for universal free distribution . . . on behalf of his parents'. Monks and laypeople devoted to the Pure Land sects were active as missionaries, seeking conversions at all levels of society, and so it is hardly coincidental that this text should be the first one to survive in a printed form.

Both the script and the picture of the 868 *Diamond Sutra* are accomplished in design and execution, far superior to some of the crude blockprints found at Dunhuang, suggesting that quality of printing as well as quantity of output was an issue for the patron (and presumably reflected in the cost). The continuing unity of drawing in secular and sacred subjects can be seen in this example, as the Buddha is himself shown in a three-quarter perspective view, by contrast with the flatter, more frontally oriented positioning of most images up to that point. The suitability of the woodblock medium of printing in reproducing the technical features of brush drawing in black ink are also visible here, particularly on the torso and legs of the guardian figure to the left of the Buddha, and in the clouds above his head, where the varying thickness of the brush line has been faithfully reproduced in carved wood. It is not known where the *Diamond Sutra*

Hanging scroll on silk from Dunhuang, showing the Guardian King of the North crossing the ocean, tenth century CE. The rectangular cartouche at the upper right has been left blank, possibly showing that an inscription was only added when the painting was purchased.

was printed, or by whom, but it is clearly unlikely to represent the very first attempt at printed images, rather a relatively advanced stage of a process upon whose first steps we can now only speculate.

The kind of brush line being imitated here in print is very visible in a tenth-century painting from Dunhuang, which almost certainly was executed by one of the workshops which clustered round the pilgrimage site [**53**]. This shows one of the four guardian kings associated with the points of the compass, in this case the Guardian King of the North, crossing the ocean in full armour and accompanied by an extensive retinue. This may once have formed part of a set, though donors of modest means might wish to pay for only one of the four. The cartouche in the top right has been left blank, as is the case with a considerable number of the Dunhuang paintings. The reason for this is not entirely clear, though it may suggest that such paintings were produced speculatively by workshops, and inscribed with the names of donors on purchase, rather than being executed as commissions. The motives driving patronage of religious art down to 1000 CE are therefore seen to be various: personal piety above all, but also hopes for offspring, for long life, for the salvation of one's parents, for the maintenance of political power by those who have it, and for association with that power by those who do not. Women and men were equally prominent as donors of images and accessories

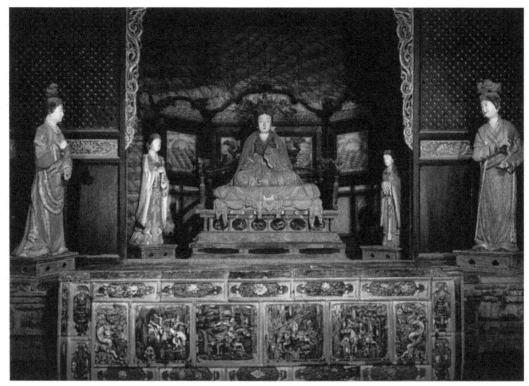

54

Figure of the Sage Mother with her attendants, in painted clay, from the Shrine of the Jin, near Taiyuan, Shanxi province, c.1050 CE. The costumes are modelled closely on those of actual court ladies of the period, and the individualized faces suggest portraits of actual people.

to Buddhist and Daoist establishments, which were patronized by empresses and commoners alike. If we know more about the activities of the former, it is because the objects of their patronage tended to be on a scale and of a permanence to survive down to the present.

Religious Art of the Northern Song Dynasty: 960–1127

One such case, which has been studied with particular success, concerns patronage in the early eleventh century by the imperial family, particularly women of that family, of the Shrine of the Sage Mother, or Shrine of the Jin, near Taiyuan.[7] The highly realistic and naturalistically coloured clay sculpture which is the main focus of worship in the principal hall represents not a figure from Buddhism, nor from the Daoist pantheon developed in competition with it, but an ancient queen, Yi Jiang, wife of King Wu the founder of the Zhou [54]. Recent scholarship has uncovered a complex sequence of shifting and overlapping patterns of patronage on this site, built directly over the three springs that are the source of the Jin River, one of north China's major watercourses. Originally the temple had been dedicated to Tang Shuyu, son of King Wu and Yi Jiang, and founder of the state of Jin, roughly contiguous with modern Shanxi province. Empress Wu of the Tang dynasty, the patron of the Fengxian temple at Longmen, was a native of this very region, and had taken the title Sage Mother for herself, aligning herself with the ancient wife and mother of rulers.

The earliest evidence for worship of the Sage Mother is from 1023, early in the Northern Song dynasty (960–1127), when another native of the region, Empress Liu exercised power on behalf of her still juvenile son, the emperor Renzong (r. 1023–63). It has been argued that the highly lifelike nature of the figures strengthens the association between the living Empress Liu and the ancient Yi Jiang, whose cult, supported by such an august patron, now replaced and eclipsed that of her son. The essentially political message broadcast by the statuary seeks to bolster the empress's power in the face of a male court bureaucracy hostile to her. However, this was a message addressed to a narrow élite, and not necessarily readable by a larger constituency, for whom Yi Jiang was above all a goddess of rain and fertility, presiding over the irrigation resources of the great river. The eight dragons which adorn the pillars on the front of the Hall of the Sage Mother at Jinci are similarly both emblems of the imperial house, and an allusion to the dragon's role in presiding over the life-giving waters and bringing rain. Thus a cult image intended by its élite sponsors to convey a message of loyalty to the Song ruling house (or rather to Empress Liu, its current head) was appropriated for different purposes by a broader audience (and it has kept its role as a pilgrimage site down to the present century). The work done on the Jinci has important wider implications. The same multiple usage of and multiple meanings read on to a single image by different audiences must have taken place at other sites and with regard to other single paintings or sculptures, warning us against privileging any single, oversimplified interpretation, even though equivalently rich evidence is as yet lacking in most other cases.

Southern Song Religious Art: 1127–1279

The developing commercial culture of China in the Song dynasty, with increasing urbanization and population growth on an accelerated scale, brought about an enlarged class of people for whom the patronage of works of art in pursuit of religious goals was a possibility. New forms of art and new ways of producing art grew up together with this clientele. These were often harnessed to doctrinal developments within religion itself, whether the growth of the new Quanzhen or 'Complete Truth' movement within Daoism, or the growing importance of the underworld in Buddhist belief and practice.

The idea of ten hellish kings (themselves derived from deities with a variety of religious and geographical origins), presiding over a bureaucratized Hell to which sinners would be banished, was an innovation in Chinese Buddhism in the ninth–tenth centuries, and quickly became the standard view among many at all levels of society. Importantly, this doctrine has little textual base in the classic Buddhist texts, but instead *visual* means, pictures and sculptures, were used to spread it among the population, and to standardize the imagery of

55

One of the Ten Kings of Hell, hanging scroll in ink and colours on silk, from the workshop of Jin Dashou, Ningbo, Zhejiang province, c.1150–95 CE. The imagery of hell was not confined to the temple context, and paintings like this were used in rituals conducted in homes by Buddhist monks.

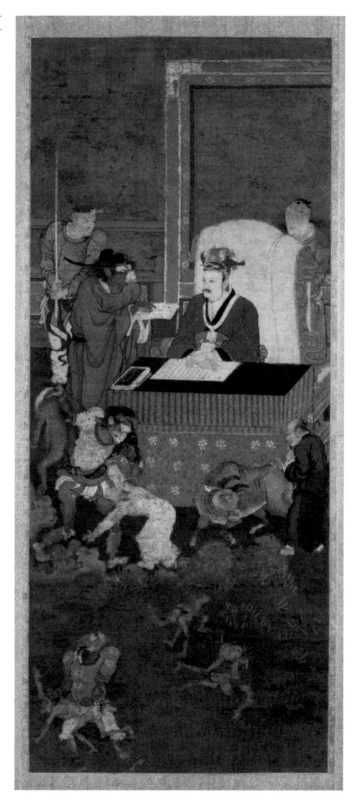

punishers, punishments, and punished. Hell images are attested in temples from as early as the sixth century, and were part of the repertory of Tang court mural artists like Wu Daozi (active *c*.710–*c*.760). As well as acting as focal points for meditative practices by Buddhist monks within the temple, and frightening lay viewers into correct behaviour, such murals were aimed at easing the torments of the souls of relatives of those who commissioned such pictures.[8] Literary sources of this period prove that hell pictures were also used in public by tellers of religious tales, who might gather an audience and unroll a couple of scrolls in the market-place. Finally, an apocryphal Buddhist text (i.e. one not formally adopted into the catalogue, or canon, of scriptures) was created in the tenth century named the *Sutra of the Ten Kings*. This is what is embodied in a hanging scroll [55], one of a set showing sinners' sufferings. Here they are being turned into beasts of burden, in punishment for mistreatment of sentient beings in their previous lives.

The picture was painted *c*.1150–95 in a workshop in the great port city of Ningbo, and is from one of a number of such almost identical sets to survive, often in the Japanese temples to which they were exported at the time of manufacture. The workshops in which they were made clearly employed stencils as a method of speeding up and standardizing production, and these may have passed from shop to shop over a period of at least one hundred years. Another technique of these market-oriented Buddhist images was the laying of paint on both sides of the silk surface—this was used by Chinese painters generally when a particularly bold visual effect was required. Such work could be, and was, bought 'off the peg', rather than being commissioned for a specific religious building. Rather than signatures of individual artists, it bears the inscription or stamp of the workshop, as a guarantee of standards in a growing consumer economy which was coming to expect goods of certain quality to be identified by their maker's name (see p. 174). The Ningbo hell scrolls are also purely visual, they have no accompanying text and are designed to stand independently. They employ an aesthetic of corroborative detail, the minutiae of dress and faces and instruments of torture, to convince their audience of the reality of hell, and of the accuracy of the picture as a representation of it. As such they position themselves very differently from the advanced aesthetic theory, becoming dominant at this very period, in which 'formal likeness' ceased to be an important artistic criterion (see p. 142).

Desire on the part of patrons for Buddhist images which aided, by using realistic modes of representation, visualization of deities of many kinds, appears widespread during these centuries. Such desire was directed in particular at the figure of the bodhisattva Guanyin. Guanyin was the focus of devotional practices aimed at individual

Carved wooden figure of
the bodhisattva Guanyin,
*c.*1200 CE. The costume
depicted is that imagined
by devotees in China as
appropriate to an Indian
prince, with a naked upper
torso, draped scarves, and
richly jewelled head dress.

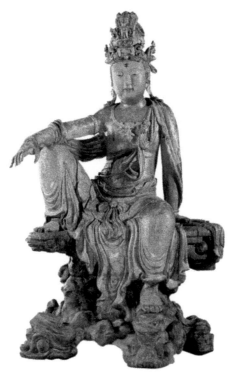

salvation, which continued to increase their adherents in all parts of
China, including those which, from the tenth century, were ruled by
ethnic groups from beyond the traditional frontiers of the empire.
Between the tenth and thirteenth centuries, a new image of this
saviour was established, which developed the types of natural posture
seen at Longmen and other places in the Tang period, and allied them
to a new set of appropriations from the sculpture of other Buddhist
cultures of south and south-east Asia [**56**]. In the wooden example
illustrated, the bodhisattva is carved as seated on a rocky outcrop, with
the right knee raised and the right forearm resting upon it, while the
weight of the figure appears to be braced on the left arm. The posture is
an innovation in the sculpture of this period, and can be shown to be
derived from the imagery of Buddhist and Hindu deities from Sri
Lanka and other places, connected to China by maritime trading
routes. As a saviour particularly to be relied on by those in peril on the
sea, Guanyin was worshipped by many connected with this trade. The
cult of the 'water moon' or 'Southern seas' Guanyin was soon
distributed much more widely than the south coast, and many of the
best surviving examples of this type of image in fact come from the
north, where land connections with India still survived.

The example illustrated is one such case, being made *c.*1200 in the
northern province of Shanxi, as the central focus of a temple's religious
tableau. This would have shown Guanyin seated on the peak of a
sacred mountain, surrounded by attendants, and gazing downwards at

the worshipping throng. Research on this individual figure has shed light on the techniques of the anonymous sculptors of such an image. It is pieced together from separate pieces of the wood of the paulownia tree, and then covered with a layer of clay and animal glue, to provide a smooth ground for highly naturalistic painting. The flesh of the image was painted a reddish-pink, with blue-black hair. The crown and jewellery were gold, and the stole over the shoulders was blue, while the red and green skirt was painted with fine gold designs imitating embroidery. All of this added to the immediacy of the image for worshippers, but it was covered over at some point, probably about 300–400 years later in the Ming dynasty (1368–1644), when it was painted gold in imitation of a gilded metal sculpture. Such an aesthetic change must have gone hand in hand with some change in the understanding of what a successful image ought to look like, a change at the level of both popular belief and the attitudes of religious professionals which is as yet hardly understood.

Buddhist Monks and the Élite in the Southern Song

At no period was there a single coherent 'Buddhist art' in China, just as there was no single centralized Buddhist religious organization, nor a single type of interaction between those engaged full-time in the Buddhist religious life and other members of society. This is evidently so if a comparison is made between a painting like **55**, and another image which also emanates from a Buddhist milieu at broadly the same period, the fragmentary hand scroll, 'Mountain Market in Clearing Mist' by a monk with the name Yujian, whose dates are not known, but who was alive c.1250 [**57**]. More than one monk-painter of this name lived at this period, and controversy exists over the identity of the maker of this particular picture, which is one of thirteen surviving with the signature. It is painted in ink on paper, and depicts one scene from a set of eight landscape subjects known as the 'Eight Views of the Xiao and Xiang Rivers', popular with artists of the secular élite from at least the eleventh century CE. In the thirteenth century, many members of this élite had close personal relations with monks of the Chan and Tiantai schools of Buddhism, to the latter of which Yujian belonged. These relations often involved the creation and exchange of poems and of pictures, which might have explicitly religious subjects, such as images of the patriarchs of the Chan sect, or might more allusively deal with the doctrines of sudden enlightenment through meditative techniques, which were the central contribution of Chan (the Japanese word 'Zen') to Buddhist belief and practice. The latter is the case here, as the image of wanderers ascending in a rain-soaked landscape is paired with an enigmatic poem in which imagery of the dream and of alcohol-induced intoxication is linked to sudden realization of a longing for 'home'.[9] This is not simply an earthly home, but the higher

57

'Mountain Market in Clearing Mist', by the Buddhist monk Yujian (active mid-13th century CE), c.1250 CE. Painted in ink alone on paper, this short hand scroll is now mounted as a vertical hanging scroll.

spiritual one to which the enlightened can aspire. This imagery, emerging from an upper-class poetic culture whose participants knew by heart large quantities of classical poetry dating back over many hundreds of years, is designed to be meaningful only to a few, perhaps fully meaningful only to those present at the time of its creation, or to its original recipients. The very brushwork, with its varying shades of ink, its visible traces of speed of production, and its lack of concern for formal likeness, is used not only in support of secular Chinese élite ideals of the time, but of a Buddhist philosphical disdain for the sensory world, perceived as an illusion. These views permeated each other in a milieu where monks and gentlemen met as social equals. Some Chan painting is distinguished by particularly faint ink brushwork, and was known by the twelfth century as 'ghost' or 'apparition' painting, in view of the unreal appearance of its figures. Nothing is represented completely; roofs and people alike are a few strokes of the brush on the paper, laid on with a spontaneity

which would earn this style the name 'splattered' or 'splashed' ink from later critics.

The poem and the painting are conceived here as a unity, with neither an 'illustration' or 'explanation' of the other, and both ultimately supporting a view of representation itself as limited, contingent, never complete. Although these ideas became the common currency of all explicit artistic theory in China, works like this painting did not in any way enter a canon of masterpieces—quite the reverse, in that painting by Chan monks survives almost not at all in China, but only in Japan, where so many of the surviving examples (including this one) were transmitted by Buddhist pilgrims shortly after they were created. Although the élite continued to patronize Buddhist religious practice, and to have social relations with individual Buddhist monks, these enigmatic images did not find favour with artistic theorists and with collectors in the centuries which followed their flourishing, and it is rarer in later centuries for so many

58

Group portrait of senior
Buddhist monks, painted
on silk by an anonymous
artist *c.*1330 CE. Such
portraits were important in
the Chan school of Buddhism,
as visible testimony to a
legitimate transmission of
religious teachings. The
inscription on this example
was added around 1400 by
a Japanese monk.

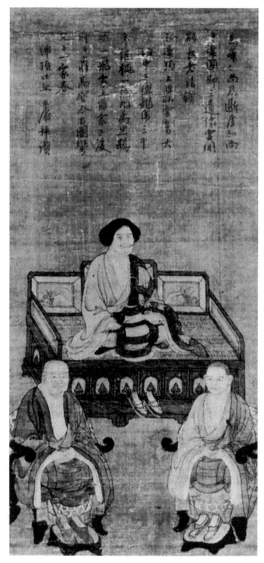

monks to be involved as painters in styles acceptable to the secular
élite.

Another artistic phenomenon which had its roots in Chan
Buddhist monasteries, but has been largely lost in China and preserved
instead in Japan, is that of religious portraiture. Such effigies, which
were often painted but could also take sculpted forms, played an
important role as material testimony of the close personal relations
between master and pupil through which religious mysteries were
transmitted. A revered master was present after his physical death
through these anonymously produced effigies, which sometimes in the
case of clay sculptures contained actual bodily remains within them.
Multiple portraits are known, like the example shown [**58**], today held
by a Japanese Zen temple. It was painted in China and shows three

A volume of the Buddhist canon, printed by wood blocks over a lengthy period, 1225–1322 CE. The text of this volume is dated 1301, although the frontispiece may be slightly later. The 'whirlwind' or concertina style of binding was by this date only used for religious books.

important Chinese monks. The central, slightly larger, figure is Gaofeng Yuanmiao (1238–95), shown with his successor Zhongfeng Mingben (1260–1323) and with Duanya Liaoyi (1263–1334), all leaders of the school of Chan centred on the great monastery at Mount Tianmu in Zhejiang province, to which so many Japanese monks made pilgrimages and from which they brought back pictures like this one. There is a formal realism about these portraits which may at the time have been important also in portraits of secular figures, used in ancestor worship (see p. 49), but which was then becoming marginalized as an aesthetic value among the literate élite. However, the visual culture of the secular and the Buddhist élites never entirely separated, one slight testimony to this being the presence, in the painted panels of the couch on which Gaofeng Yuanmiao sits, of paintings in monochrome ink showing plants and rocks in the newly dominant 'scholarly' style. Zhongfeng Mingben was honoured by the court, but more importantly was a personal friend of Zhao Mengfu (see p. 145), later revered as one of the founding fathers of 'scholar's painting'.

Buddhist Art in the Yuan Dynasty: 1279–1368

The links which Chinese Buddhism had with Japan and Korea in the thirteenth–fourteenth centuries were supplemented by renewed contact, under the Mongol emperors of the Yuan dynasty (1279–1368), with areas of western and central Asia also under their sway. Here Buddhist religious practice and the visual culture associated with it had developed types of image and styles of representing which were to be taken up in China to major effect. From Nepal and Tibet came craftsmen and monks (often they were the same people) who were active at the court in what is now Beijing, and introduced new styles in a variety of media, from painting (which is now largely lost), through sculpture and printing. The most important of these foreign directors of Buddhist artistic projects was a Nepalese named Anige (1243–1306), who was invited to China in 1260.

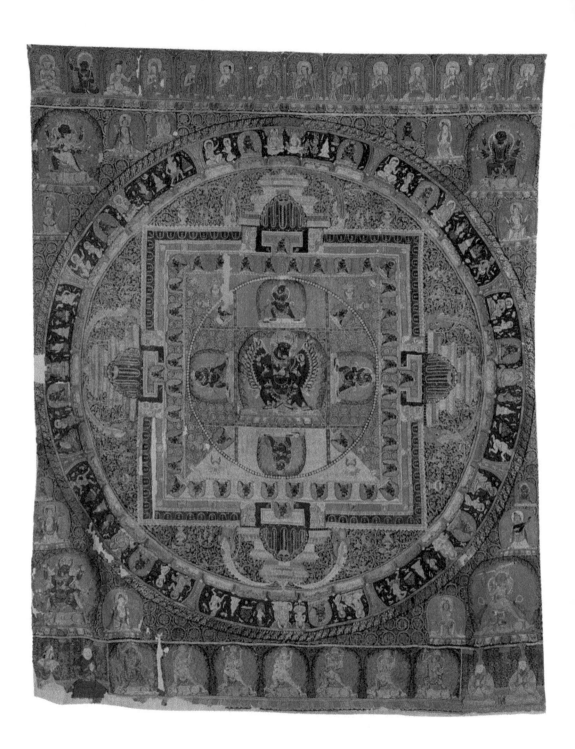

60
Buddhist mandala in woven
silk tapestry, centred on the
deity Vajrabhairava, 1328–9
CE. It was probably woven as
part of an esoteric initiation
ceremony for members of
the Yuan dynasty imperial
family, who are shown in the
lower corners.

Particularly important, by virtue of its dissemination, was a new printed edition of the complete Buddhist scriptures, the *tripitaka*, which took over a century to produce from its initiation under the Song *c*.1225, down to its completion in 1322. It was produced at a monastery on Qisha island, near the city of Suzhou, and the page shown [59] comes from a section printed in 1301, when the adoption of a Tibetan style of imagery, and the presence of Tibetan artists in China, were in their most intensive phase. They may have provided the models, but the evidence is nevertheless that the designers of the frontispiece, like the donors of the funds, were ethnically Han Chinese.

Even more securely within the Tibetan tradition of religious depiction is an immense woven silk hanging [60], which was produced under direct imperial patronage, as it contains in its two bottom corners donor portraits of the Yuan dynasty Mongol emperor known in Chinese as Wenzong (r. 1328–32), with his brother and their wives (the wives are at bottom right, wearing a distinctive type of Mongol women's head-dress). This manner of including patrons in holy pictures goes back to the period of the Dunhuang paintings and beyond, but the image being worshipped is completely new. It is set within a cosmic diagram, or mandala, of a type associated with esoteric or Tantric Buddhism of a specifically Tibetan type. Its arcane programme of deities and saints must have depended on a Tibetan, while the technology of weaving such an object in silk tapestry (*kesi*) was in the hands of artisans from a range of ethnic backgrounds working directly for the imperial court. Relations between Chinese and Tibetan monks, both seeking favour from the Mongol rulers, were often tense. This tension arose from barriers of language and different doctrinal positions, but also from different visual traditions. Tibetan styles of art were to remain prominent in later Chinese Buddhist practice, particularly at the courts of all successive dynasties, for whom good relations with the religious and secular rulers of Tibet remained important.

Religious Painting of the Fourteenth–Fifteenth Centuries

Daoism, as well as Buddhism, was heavily patronized by the Mongol rulers of China, as by all classes of society. In the fourteenth century the Quanzhen movement of Daoism became the dominant one in north China, at the same time as the rise of the cult of the 'Eight Immortals', an originally heterogeneous group of deities who came to be among the most popular and most widely depicted in Chinese art over the last 800 years. One of these immortals (some of them were originally real people) had reputedly been born in the small town of Yongle, Shanxi province, where a temple to him was completed in 1262. In the next century, this temple was decorated with a major cycle of

61

Detail of a wall-painting 'A Celestial Court Audience', c.1325 CE, from the Daoist temple at Yongle in Shanxi province, dedicated to the immortal Lü Dongbin. Painted by a team of artists headed by Ma Junxiang (active early fourteenth century CE).

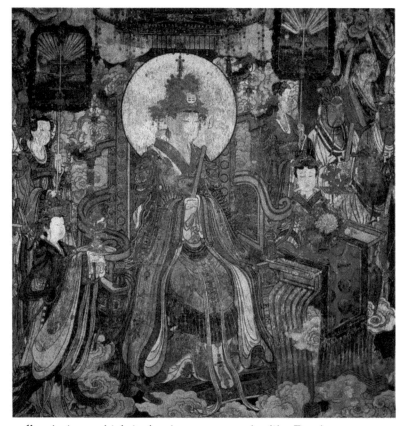

wall-paintings which is, leaving cave temples like Dunhuang to one side, almost the earliest and best evidence for the kind of wall decoration which was common in both religious buildings and palaces, but which does not survive in quantities proportionate to its original importance [**61**]. Shanxi province had long been a centre of mural painting, and the artists at Yongle were heirs to a highly regarded but now vanished tradition. Murals were a major part of any monastery's drawing power, along with its relics and the sanctity of its monks or priests. The mural tradition of Shanxi was associated pre-eminently with the name of the painter Wu Daozi (active c.710–60), whose work carried out for the Tang court and the monasteries it patronized no longer survives, and indeed has probably been lost for many centuries. However, designs attributed to him continued to circulate through the form of copies and rubbings of his images engraved on stone, and were understood to be distinguished for the strength and boldness of their line-drawing (the colouring being done by unnamed assistants). This is the pictorial tradition within which the Yongle temple murals are situated.

The wall-paintings in the main building of the Yongle temple complex were completed in 1325, by a team of professional painters headed by Ma Junxiang and his son Ma Qi from Luoyang. Money for

62

'Former Masters of
Professions and Arts', hanging
scroll on silk, one of a set of
139 images created for the
Buddhist rite of the 'Water and
Land Assembly', and donated
to the Baoning Temple, Youyu
county, Shanxi province, by
the imperial court of the Ming
dynasty in about 1460 CE.

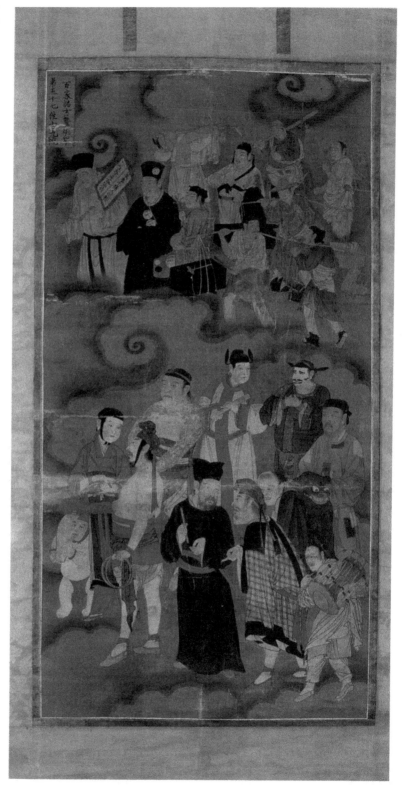

the murals, which cover 430 square metres, was donated by men and women at all levels of society. They show, on all four walls, an assembly of some 286 deities plus their attendants, all of whom are lavishly attired, and who pay homage at the heavenly court of the Three Pure Ones, the central deities of Daoism. The Three Pure Ones are not shown in the murals, but were present in the form of statues. Other halls contained cycles showing the life and miracles of the immortal Lü Dongbin, or of the twelfth-century founder of the Quanzhen tradition, which were used didactically to instruct pilgrims in the sect's history and doctrines.

The largest hall was the site for major Daoist offering rituals of cosmic purification and renewal, rituals carried out by as many as several hundred Daoist priests at any given time, but attended and watched by laypeople. The murals played an important part in these by representing liturgically significant numbers of deities for worship. Their presence was necessary, as it was for them that the central rituals were performed, and they are arrayed precisely in the positions laid down in ritual manuals of the time. The west wall, which is shown, is dominated by the massive figures of one of the six Celestial Lords and two Celestial Empresses, embodiments of constellations of stars.

The active role of painting in religious ritual within the context of the temple is attested further by another set of images also from Shanxi province, dating from just over a century after the Yongle murals. These form the centrepiece of an elaborate week-long Buddhist rite (though happily incorporating elements absorbed from Daoism) known as the Water and Land Assembly [62]. In this ritual, which was elaborated between the tenth and thirteenth centuries, prayers and offerings were said for those countless unfortunates reincarnated as 'hungry ghosts'. Imperial patronage of this ritual dated back as far as the Tang period, often coinciding with natural disaster or defeat in war, and it seems likely that this set of images was made in connection with the considerable losses suffered by the imperial court in battle with the Mongols in 1449, at a place not far from the temple site. A huge pantheon of images was called for, representing the entire hierarchy of beings in the cosmos, from Buddhas and bodhisattvas, through guardian figures, stellar deities, and a host of human types: past emperors and empresses, sages, scholars, alchemists, rustics, and craftsmen. The scroll reproduced represents practitioners of various popular arts, with at top left a fortune teller, an eye doctor, and a public scribe, and in the lower register a troupe of actors and heavily tattooed acrobats and strongmen, including a lion-dancer. An inscription in the upper-left not only identifies the subject, but situates it precisely within the sequence, ensuring it will be hung correctly when the set is brought out for the ritual. Such huge programmes of images are also known from other surviving fragmentary sets in Western museums,

and from wall-painting in the Pilu temple, Shijiazhuang, Hebei province. In both cases their artists are anonymous. The days when the most valued and renowned artists, like Wu Daozi, would themselves take charge of such programmes of decoration were by the fifteenth century firmly in the past. The taste and expectations of élite patrons had changed too. When in the early seventeenth century a great upsurge in Buddhist devotion by the upper classes was reflected in extensive temple refurbishment, bells and gilt-bronze statues were renewed, but there were to be far fewer new murals.

Religious Art of the Ming Dynasty: 1368–1644

Despite the views of aesthetic theorists the service of religious belief continued to be one of the major stimuli to the production of art of all kinds in the later imperial period. Major professional artists produced religious images. They were, for instance, a speciality of Miss Qiu (active c.1550–80), the daughter of Qiu Ying, (see p. 177), and of Chen Hongshou, (p. 188). Accounts of Chinese art which speak of a 'decline' in religious art in later centuries, or even fail to treat of it at all, are really reflecting the priorities of one type of artistic theorist, those whose views dominated writing about painting and who are dealt with in Chapter 4. At the level of popular practice, even at the level of daily life in the households of the élite and at the imperial court, religious practices with their needs for images and paraphernalia of all kinds remained the subject of undiminished fervour. It is at the level of book production, of ceramic sculpture, of textiles, and of carving in a whole range of materials, rather than in painting or monumental sculpture, that the testimony to this depth of faith on the part of men and women will be found.

In the Ming dynasty (1368–1644) fresh religious subjects for art came to the fore. New techniques were marshalled in the service of religious belief, among them the expansion in the sixteenth century of pictorial printing, which could mass-produce images having something of the allure of more expensive paintings. Considered outside the canon of art in China, these images have scarcely survived, one very rare example being a pair of prints dated 1578. The example shown is titled 'The Bodhisattva Puxian coming down from the Mountain', and showing the deity riding on an elephant [63]. The images were designed originally in 1544, and were reprinted at least once before this edition was produced, like the earliest surviving printed text [52], as an act of piety on the part of 'the believer Dong Zhou', to be distributed free.[10] This may possibly have been done in the city of Suzhou, one of the most prominent if not the only centre of fine printing at this time. A single sheet of paper nearly 4′ high bears the impression of five separate co-ordinated wood blocks, the picture being then hand-coloured in at least seven colours to give an effect as

close as possible to that of a painting. We can only assume that these prints are a rare survival of what must at one point have been a very much larger body of religious art, reaching quite humble strata of the population, at least in prosperous urban centres.

It can be assumed that these prints are images for Buddhist devotion in the home, rather than in the temple context. From the sixteenth century onwards a very large number of images in very many media survive for this sort of domestic setting, none in greater numbers than the image of the bodhisattva Guanyin, and particularly in the form known as *songzi* Guanyin, or 'Guanyin the sender of sons'. In this form the deity has taken on a maternal appearance, and is pictured as a stately woman holding a small male child. It has recently been convincingly argued that the very great popularity of this deity in the late sixteenth and seventeenth century owes something to the appropriation by Chinese painters, weavers, embroiderers, and

64

Lacquered and gilded ivory figure of Guanyin as 'the bringer of sons', probably made in Zhangzhou, Fujian province, c.1580–1640 CE.

craftsmen in a number of materials, of the Christian image of the Virgin Mary.[11] These images were brought to China in the course of the Ming dynasty by Catholic missionaries from Spain and Portugal, and had a particular impact on the popular religious art of the south-western littoral. The port of Zhangzhou, in Fujian province, developed an industry centred around the making of congratulatory figures of a number of popular Buddhist and Daoist deities in imported elephant ivory, the maternal Guanyin being one of their most popular lines [64]. The maker of this figure adapted the floating scarves and the piled hairstyles which are part of the Ming ideal of female beauty, and are seen in numerous secular types of representation, to create a goddess who is recognizably part of the real world, approachable and immediately accessible. Her cult, centred on the island pilgrimage centre of Mount Putuo off the coast of Zhejiang, was a particular focus of devotion by women, and it may be that women formed the major part of the clientele for her image. A woman artist like Miss Qiu was renowned for expensive luxury versions of such icons in painted form. Made in a range of materials at a range of prices (the example shown has been lacquered and gilded to resemble gilt metal in a manner reminiscent of the treatment of the sculpture in **56**), these figures show the interplay of commercial and religious changes which was to ensure the continued vitality of Buddhist art at the popular level in the late imperial period, even if the explicit aesthetic programmes of the élite had led to a withdrawal of their patronage.

Although its believers were numerically insignificant before the nineteenth century, the presence of the newly imported religious tradition of Christianity on Chinese soil after about 1600 created new artistic opportunities and problems. These are exemplified in the illustrations to a book [**65**] entitled 'Explanation of the Incarnation and Life of the Lord of Heaven', published in 1637 in the Fujian province city of Jinjiang by the Italian Jesuit missionary Giulio Aleni. Aleni gave his block-cutters the volume of Bible illustrations published in Antwerp in 1595 to accompany the commentary of Geronimo Nadal, and it is these engravings which have been closely copied in this volume by the anonymous Chinese illustrator. The single-point perspective has been effectively imitated, but the very different techniques used in Antwerp engravings and Chinese wood-block printing for showing mass can be seen in particular on the rocks (e.g. those under the horseman's hooves at bottom-left). The cross-hatching which would be found on the copper-plate engraving is here replaced by the parallel lines, ultimately derived from painting techniques, carved on the wooden block in the standard manner of all late Ming book illustration (compare **65** and **98** and **99**). The technical features of European conventions of representation presented few problems of cultural translation. Much more problematic was the

'The Crucifixion', an illustrated page from 'Explanation of the Incarnation and Life of the Lord of Heaven', a book of Christian instruction printed by wood blocks in 1637.

question of subject-matter. It was not simply that the crucifixion, a central moment of human and divine history to the Jesuits, which they had to explain to potential converts, was a distressing scene which Chinese artistic canons refused to admit as a subject of art at all. (The Jesuits therefore tended to stress the image of the Virgin and Child, to the extent that well-informed seventeenth-century Chinese writers 'knew' that the Westerners' God was a woman shown holding a baby). The problem was more a social one. The Jesuits sought to influence the élite of Chinese society, but failed to realize that the dissemination of didactic religious imagery, like this illustrated book with its figures keyed to explanatory texts below, doomed their project to failure in the eyes of that cultural élite. For the Jesuits' ideal audience, the notion of 'didactic art', which was so important in Counter-Reformation Europe, was a contradiction in terms. This had important implications for the social situation of Christianity as an immigrant religion. It never made the breakthrough to Chinese élite patronage achieved by Buddhism so many centuries before, when the understanding of what pictures were for was so entirely different.

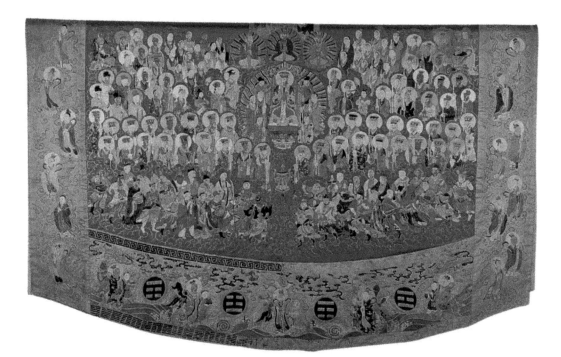

66

Embroidered silk ritual robe for a Daoist priest, c.1650–1700 CE. Some of the figures of deities are identified by their names.

Religious Art of the Qing Dynasty: 1644–1911

Patronage of the manufacture of luxury goods for religious use continued through the late imperial period, aided perhaps by the existence of a growing class of those who had wealth but were outside the cultural ambit of aesthetic theorizing. Such a patron or patrons paid for magnificent pieces of needlework like the Daoist priest's ritual robe [**66**] made sometime between about 1650 and 1700, which in its array of deities and immortals, some of whom have their names written beside them, recalls the murals of the Yongle temple [**61**]. Like them, the number of figures and their positioning almost certainly carries a precise liturgical significance, though in this case research has only just begun the attempt to situate such robes in a context of religious practice.[12] It was almost certainly not actually made in a temple environment, but instead purchased from a professional embroiderer with funds donated by the pious for this purpose. That embroiderer's workshop would have produced all kinds of goods for the secular market also, and this weakening of direct involvement by the religious may possibly have led to more fluid iconographic schemes, less minutely keyed to scriptural details in their execution. Thus even at the popular level, though the quantity of religious imagery being produced in recent centuries and down into our own has been no less than in better studied earlier periods, its centrality to religious practice may have diminished.

The other great source of patronage and production of religious art under the last two dynasties was the imperial court itself, established

Periods Referred to in this Chapter	
HAN DYNASTY	
Western Han dynasty	206 BCE–8 CE
(Usurpation of Wang Mang)	9–23
Eastern Han dynasty	25–220
PERIOD OF DISUNITY	221–589
Three Kingdoms period	221–80
Six Dynasties (in south)	265–589
Western Jin	265–316
Eastern Jin	317–420
Song	420–79
Southern Qi	479–502
Liang	502–57
Chen	557–89
Sixteen Kingdoms (in north)	316–589
Northern Wei	386–535
Eastern Wei	534–50
Western Wei	535–57
Northern Qi	550–77
Northern Zhou	557–81
SUI DYNASTY	589–618
TANG DYNASTY	618–906
LIAO DYNASTY	907–1125
FIVE DYNASTIES	906–60
SONG DYNASTY	960–1279
Northern Song	960–1127
Southern Song	1127–1279
YUAN DYNASTY	1279–1368
MING DYNASTY	1368–1644
QING DYNASTY	1644–1911

since the early fifteenth century in the city of Beijing. Under the Ming (1368–1644) and Qing (1644–1911) dynasties, both Buddhist and Daoist monasteries in the surrounding area received lavish patronage, while ceremonies of both religions were held within the imperial palace itself. Both ruling houses maintained diplomatic contact with Tibet, from where they acquired Buddhist art and ritual objects, as well as Tibetan monks to create more of such art in Beijing itself. Under the Manchu rulers of the Qing in particular, who had themselves acquired their first knowledge of Buddhism from Mongols and Tibetans, these Inner Asian styles of representation were particularly popular in court circles. The imagery of Tibetan and Mongol Buddhism played an important role in the Qing emperors' political and cultural relationships with these territories, where they claimed a greater or lesser degree of overlordship, and fed into a distinctive court culture of

67

Detail of a hand scroll showing an extensive Buddhist pantheon, painted by a team of court artists headed by Li Ming (active late eighteenth century CE), and dated 1792. The section shown depicts the Buddha preaching.

Buddhist art. This then spread to other parts of China, though in unequal measure. A picture which, though not made for a temple context, exemplifies this Qing court Buddhist art, is a very long (over 16 m.) horizontal scroll of Buddhist deities, painted in 1792 by a team of court artists headed by Li Ming [**67**]. It is an explicit and quite close copy of a famous twelfth-century scroll, also then in the imperial collection, which had originally been painted in the independent kingdom of Dali, in south-western China on the borders of Tibet. As such, the transmission of the images it contains is at the same time a work of religious piety and of cultural piety, preserving a work of art and a work of Buddhist merit. The section shown depicts the Buddha preaching to an assembly of bodhisattvas, luohan, and protective deities, the same subject as is seen in **51** and **59**. Here, the central moment in which the Buddhist message is proclaimed to all living beings for the first time is rendered in flat, jewel-like colours, with a lavish use of gold highlights. The pale, sweet faces of the Buddha and bodhisattvas are typical of eighteenth-and nineteenth-century Buddhist art, and indeed many of the stylistic features of this type of painting are now widely spread by the mass media of printing through the Chinese-speaking world today, where Buddhism, like Daoism, is a living faith for many millions. The popular iconography of contemporary Buddhism owes more to styles of painting and other arts patronized by the court under the final centuries of the empire, than it does to those earlier ages when Chinese artists were first creating a vocabulary of styles and images for use in Chinese contexts of worship.

依山築閣見平川夜闌箕斗插屋椽我來名之

Art in the Life
of the Élite

4

Calligraphy as an Élite Art

The most valued of all art treasures in China have historically been examples of the writing of certain aristocrats of the fourth century CE, including casual notes exchanged between them. The process whereby this came about is a lengthy one. It had to do with religious developments in the third–seventh centuries. It was also connected intimately to the role of writing in upper-class life, to notions of the personality, and the visible expression of personality. It depended also upon acts of imperial patronage, the formation of a canon of great masterpieces of writing, and the dissemination of that canon to the wider upper classes. Many factors contributed to making calligraphy, the various forms of writing the Chinese language, the pre-eminent art form in China, pre-eminent in the number of its practitioners as well as in its status to the present. All educated men and women were to an extent participants in this artistic tradition, many more than ever engaged in the production of pictures of any sort.

The earliest forms of the Chinese script date back to the Shang period, at which era the pointed writing brush was already in use. The close relationship between written and pictorial images was already understood in the Zhou period to derive from the 'Book of Changes' (see p. 42), and gave characters a role in the most sophisticated philosophical problems then discussed. The notion of writing as an art form, however, probably does not appear until the early centuries of the Common Era. It is linked to the emergence of the idea of the artist as an individual whose personal qualities allow command of the technical resources to produce work of a higher quality and greater value (in the aesthetic and commercial senses) than that of the common run of writers. It is also associated with the development of less angular forms of the characters, able to be written more quickly, hence often called 'cursive' script in English. These were believed, as early as the second century CE, to reveal more of the writer's moral worth and personal characteristics. Finally, it is connected with the growth from about 100 CE in the use of paper as a medium, its absorbency enabling it to catch every nuance of the writer's touch more effectively than silk or the earlier writing surface of bamboo strips.

Detail of 72

Forms of the Chinese Script

The characters of the Chinese script have been, and continue to be, written in a number of forms. In recent centuries, these have been listed under the following five major groupings:

● Seal script (*zhuan shu*): Historically the earliest form to appear (*c.*1200 BCE), and systematized around 200 BCE under the centralizing Qin dynasty. Used since then chiefly for seals and in other formal contexts of inscription, it revived as an artistic medium in the eighteenth century. Examples in the present book include all impressed seals as well as carved imitations of seals, such as those on 1, 25, 26, 37, 40, and 73. Seal script written with a brush can be seen in 74 (title only) and 89, while the upper register of inscription on 90 is incised into the clay in seal script characters.

● Clerical script (*li shu*): A script developed after *c.*200 BCE, and used initially for bureaucratic record-keeping. Also a formal script used chiefly for inscriptions, but also enjoying a revival for artistic purposes from about 1700. Examples in the present book include 9, 11, and 99 (left-hand text page).

● Regular script (*kai shu, zhen shu,* or *zheng shu*): Developed *c.*200–400 CE, this is still the most widely used script today, and the basis for printed characters. Examples in the present book include 13, 14, 31, 40, 52, 65, 74 (main text), 83, and 92.

Left: Detail of 26. Above: Detail of 92

● Cursive script (*xing shu*): Developed in the fourth century CE, this is one of the major forms of the script used for artistic expression. Examples in the present book include 20, 57, 68, 70 (central section), 82, 91, 101, 102, 109, 113, and 117.

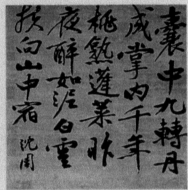

Detail of 101

● Drafting script (*cao shu*): The most rapidly written of the scripts, and the last to develop, becoming current only in the seventh century CE. Examples in the present book include 69, 70 (extreme left-hand section only), and 108 (the inscription at centre-right).

The man revered in later centuries as the greatest calligrapher of all time was Wang Xizhi (303–61), who was taught calligraphy by Wei Shuo, known simply as Lady Wei (272–349). Both of them were aristocrats of the post-Han period of Disunion, living under the Jin dynasty with its capital at Nanjing. The aristocratic ideals of spontaneity and relaxed nonchalance in circulation at this period are captured in the figures shown in **12**. There was also a deeper religious purpose to much writing at the time. Since the Shang dynasty, writing had been understood as a form of communication with higher spiritual powers. In the milieu in which Wang Xizhi moved, it was used as the channel for revelations within the religious tradition of Daoism. Messages from on high were written down in newly developed cursive

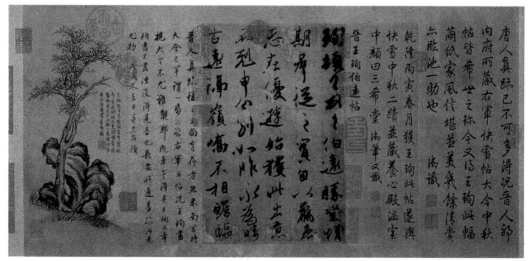

68

'Letter to Bo Yuan', calligraphy by Wang Xun (350–401 CE), done in cursive script on paper. Only the five lines of larger characters are by Wang Xun, the texts in smaller characters are by Dong Qichang (1555–1636), to the left, and the Qianlong emperor (r. 1736–95), to the right. The painting is also by the emperor.

forms of the script, while new ways of talking about calligraphy as an art grew out of the languages of textual criticism necessary to authenticate these sacred texts.

None of Lady Wei's writing survives, but this should not serve as an excuse for ignoring the role of upper-class women in the transmission and development of calligraphy as an art in its early stages. Modern scholarship accepts that none of Wang Xizhi's work survives either, and that the objects revered for centuries as the rare traces of his genius are all at best copies of copies. The same is certainly true for the work of his almost equally famous son, Wang Xianzhi (344–88). Curators of the Palace Museum in Beijing assert that a letter by Wang Xun (350–401), a nephew and childhood student of Wang Xizhi, is the only authentic fourth-century relic of the most prestigious and imitated period of calligraphy, a style which is still practised today by millions in the Chinese-writing world [**68**].

To later connoisseurs, the content of such a piece of writing is immaterial—an ephemeral social note to a friend named Bo Yuan, regretting the writer's inability to meet him on the grounds of ill health. The surviving pieces attributed to Wang Xizhi include the small change of élite social intercourse: comments on the weather, and a note dashed off to accompany a gift of oranges, as well as longer Daoist religious texts and prose pieces commemorating social gatherings. But their very personal nature was felt in later centuries to bring the viewer and the writer closer, and it was this ideal of 'communion of spirit' with a past figure which lay at the heart of calligraphic practice.

So prestigious was the writing of Wang Xizhi and his son (known collectively as the 'two Wang') in later times that it is something of a shock to realize some closer to his own day thought it *too* good. One sixth-century aristocratic writer counselled his sons against developing

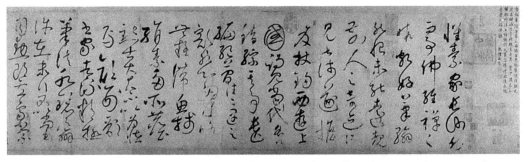

their calligraphy to the point where their literary talents, much more important for social and political advancement, will be ignored, and he lists Wang Xizhi himself as one of the unfortunates to whom this happened.[1] In the Tang period (618–906) imperial support for the Wang style consolidated the process of turning it into the nearest thing to an 'official' style of writing. The emperor Taizong (d. 649, see p. 43) had himself buried with Wang Xizhi's most famous work, the 'Orchid Pavilion Preface' (written 353), thus more or less guaranteeing its ascent to the status of fabled relic. Later courts were to continue as centres for the emulation of Wang's writing, culminating in the possession by the Qianlong emperor of almost all the significant versions of their work (including **68**), their storage in a special room of the palace, and their framing by extensive comments and pictures of his own.

If imperial courts were the settings where calligraphy styles were validated and eventually authorized as norms to be widely imitated, they were not necessarily the milieu where calligraphic work was created. This can be seen in the case of a work which is today as famous as anything by the Wang family, but has been only rarely and intermittently in imperial possession since it was written in the Tang period, the so-called 'Autobiography' of the Buddhist monk Huaisu (active c.730–80) [**69**]. What survives today is only one of an original group of three lengthy scrolls written on paper in 777 in a yet-more rapid script form called 'drafting script' (cao shu). Its authenticity, despite its fame, is not beyond question.[2] Most of Huaisu's life was spent south of the Yangtze River, far away from the Tang court at the modern city of Xi'an, which he did not visit until 772. His extensive reputation in his own lifetime was based on his extreme development of the drafting script into what has been called 'crazy drafting script', valued for a spontaneity which pushes legibility to the very limits. He himself cited inspiration derived from alcohol as fuelling his very rapid and light touch with the brush. Since the rules for the formation of characters are regular and well-known, an educated person is able to retrace imaginatively the process by which this forceful piece of writing was brought into being, and re-enact the very motions of creation.

Clearly, before the era of modern museums, very few people had actually seen Wang Xun's 'Letter to Bo Yuan' or Huaisu's

The long tradition of writing about art in China, plus the practice of adding seals and inscriptions to an object, makes it possible to trace individual pieces over a very long period. Here is what is known of the passage through time of the 'Autobiography' of the Tang monk Huaisu [69], based on the research of He Chuanxing ('Huaisu Zishutie zai Mingdai zhi liuchuan ji yingxiang', *International Colloquium on Chinese Art History, 1991: Proceedings, Painting and Calligraphy* (2 vols., Taipei, 1992), ii. 661–98). From the late tenth century to the early twelfth, the scroll passed by inheritance through four successive generations of high officials of the Su family: Su Yijian (957–95), Su Ji (987–1035), Su Shunqin (1008–48), Su Mi, and Su Yi. By 1096, it belonged to another official named Shao Ye. In 1132, after the fall of the Northern Song capital, it belonged to a man named Lu Bian. Seals indicate that in the late twelfth–early thirteenth century it belonged to the imperial collection of the Jin dynasty (1115–1234), and to the Southern Song statesman Jia Sidao (1213–75), a man reviled in later times for his role in the collapse of that dynasty to the Mongols. The scroll then vanishes from the records for two hundred years.

By the 1470s, it belonged to a man called Xu Tai (1429–79), and then to his heir, Xu Pu. In 1499 Xu Pu died, and the scroll passed successively to collectors named Wu Yan (1457–1519) and Lu Wan (1458–1526). By 1561 it was owned by Yan Song (1480–1565), the richest and allegedly the most corrupt official of the age. It passed from him to Zhu Xixiao (1518–74) on his fall from power. Around 1573, the great collector and art patron Xiang Yuanbian (1525–90) paid the enormous sum of 600 ounces of silver for the 'Autobiography'. It remained in the possession of his heirs after his death. The Xiang family later sold it to a collector from Anhui province named Cheng Jibai (d. 1626) for 1,000 ounces of silver. He sold it to one Yao Hanzhen,

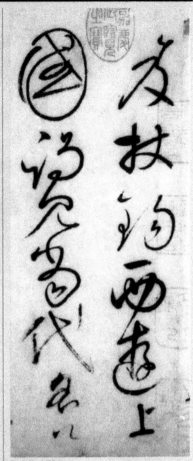

Detail of 69

who in turn sold it in 1693 to Xu Qianxue.

Before 1700, it was bought by An Qi (c.1683–after 1744), a merchant of Korean origin who was possibly the greatest collector of his time. In 1748 his heirs 'presented' it, probably under duress, to the imperial collection of the Qianlong emperor. On the fall of the empire, this art work passed into the possession of the Chinese Republic, and hence to the National Palace Museum situated in Beijing, and subsequently on the island of Taiwan. As well as those of owners, the seals and inscriptions of theorists and artists who saw the work enable modern scholars to study the way it was used and assimilated into the calligraphy traditions of later ages.

A page of rubbings of engraved calligraphy, from the 'Model letters in the Imperial Archives in the Chunhua Era', taken from wooden blocks originally carved in 992 CE.

'Autobiography', so how were they and works like them widely copied, imitated, adapted? Technical processes were developed so pieces of writing could be reproduced in multiple copies. From a very early period, famous works of calligraphy were copied on to wood or stone, often by taking traced copies of the original, and by the sixth century CE at the latest, these stone copies were being used for the creation of ink rubbings. If a sheet of thin paper is placed over the engraved surface, and then tapped gently all over with a cloth pad soaked in ink, an accurate image of the writing, in white on a black ground, will be obtained in all its detail.

In 992, as part of the early Song programme of cultural renewal (see p. 51), the imperial court ordered that 419 notes and letters, mostly by members of the Wang family, be carved on to wooden blocks, from which rubbings were taken [70]. This set of 'Model Letters in the Imperial Archives in the Chunhua Era', in ten volumes, was the first compilation of model calligraphic specimens, and very quickly became almost as rare as the objects it reproduced. The example shown may well be from the original blocks, but was taken from them over a century after they were carved, and reproduces a letter by the Liang dynasty (502–57) official and aristocrat Wang Yun. It may well have been produced in the lifetime of Mi Fu (1051–1107, see p. 60), active as theorist, calligrapher, and painter himself. He carried out extensive research on all surviving works attributed to the 'two Wang', and more than anyone else formed the canon of masterpieces of early Chinese calligraphy. The gendered term 'masterpieces' is used here quite deliberately, since one effect of the Song cataloguing projects was to make the links between artistic prowess and male virtue explicit, and to exclude from consideration work by women.

This set of rubbings was far from the last to be produced under imperial auspices, and similar collections began to be produced by private individuals, fuelling the rapid growth in the Song period of a

connoisseurship of calligraphy, where questions of which (if any) of these precious copies were genuine were hotly debated. The financial value of these objects was considerable, and was related to their authenticity, further reinforcing the already strong associations of calligraphy with the hand of the individual artist. These associations of the work and the maker were also increasingly strong in the case of painting, making the idea of a great, anonymous work less and less possible for the prevailing discourse of art from this point on.

Art and Theory in the Northern Song

The composition of the Song ruling class was not the same as it had been in the Tang period, and their relationship to artistic creation was not the same either. Broadly speaking, an aristocratic ethos, stressing the inheritance of élite status, gave way to one in which moral and cultural cultivation, measured by a system of examinations in the Confucian classics, ensured the right to rule. The attention paid by women and men to Tang aristocratic interests like horses and hunting declined. Nevertheless, it is possible to overstress the difference between the 'scholar' ruling class of the Song and their Tang predecessors. Both depended on land ownership as the source of their wealth, and for both groups access to political power on the national level lay via the imperial state and the dynasty.

Perhaps it was a consciousness of *not* coming from families with ancient antecedents, which led in the eleventh century to a hardening of the theories separating the products of the 'scholar' from those of the 'artisan' in art. We have already seen a suspicion of technical skill, as when Wang Xizhi suffered a disregard of his writings because of his calligraphic skill. A famous anecdote in Zhang Yanyuan's account of Tang artists (see p.45) has the court official Yan Liben (d. 673) so mortified to be summoned suddenly by the emperor to depict a rare bird on a pond, that he cautions his son against practising the art of painting at all. The same author, writing in the ninth century, asserts against all the actual evidence that: 'From antiquity on, those who have excelled at painting have all been nobles with official positions, or rare scholars and lofty-minded men. They awakened the wonder of their times and left behind reputations for a thousand years, which is not something that village rustics could accomplish.'[3] There is indeed evidence that men and women of noble birth engaged in sketching as an elegant pastime as early as the fourth century CE, but it was only in the eleventh century that a general theory of painting was created which elaborated for the first time a distinction between amateur 'scholars' and professional 'artisan' painters.

The principle creators of this theory were a coherent social group around Su Shi (1037–1101), a major and controversial political figure in his own day, who also had a towering reputation as a poet, calligrapher,

and painter. Su was the first person to use the term 'scholar's painting' (*shi ren hua*), and in a context which includes a discussion of the work of his cousin Wen Tong (1019–79) [**71**]. He stresses a number of themes: the relationship between such painting and the élite art of poetic composition, the disinterestedness of the true scholar-painter, who will never work for financial reward, and the superiority of spontaneous creation over laborious technique (an idea which has clear links with Chan Buddhism, see p. 117). He addresses the central question of representation of external reality, of 'likeness of form' versus the capturing of enduring principle, in terms which situate him within the major philosophical debates of his time. Painting theory was a minor part of his writings, and painting for Su Shi was a relatively minor part of a larger cultural project, the central aim of which was to provide men (not women) with a set of practices which would generate morally responsible actions.

The kind of painting Su Shi saw as enabling men to develop is exemplified by his cousin's painting of bamboos, a subject he also treated in his own work. It is done entirely in shades of plain ink, and depends on actual observation of the appearance of growing bamboo, but is at the same time removed in its technique from the manner of painting seen in something like Guo Xi's 'Early Spring' [**20**] with which it is contemporary. The 'scholarly' qualities Su Shi would have praised lay partly in the subject-matter. Later legend associates the origins of bamboo painting in plain ink with a tenth-century noblewoman named Lady Li, but by the Song dynasty the bamboo stood in poetry for the character of the gentleman, 'bending but not yielding', while the handling of the brush, with each leaf rendered in a single stroke, draws closer to the more prestigious art form of calligraphy. By the early twelfth century 'ink bamboo' was listed in painting treatises as a separate branch of art. The contexts in which such art was

71

Album leaf on paper, 'Bamboos' by Wen Tong (1019–79 CE).

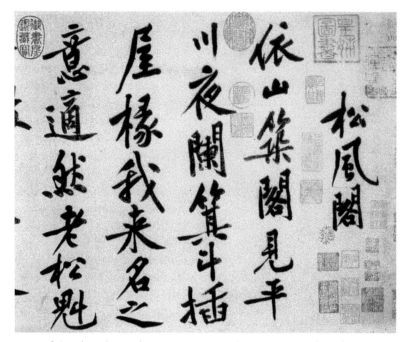

72

Opening section of a hand scroll on paper, containing the sequence of poems 'Pine Wind Pavilion' (*Songfengge shi*), by Huang Tingjian (1045–1105 CE), written 1101–5.

created in the eleventh century were also new: social gatherings of upper-class men, often in the form of excursions, at which painting took its place beside calligraphy and poetry as an art practised spontaneously by artists unbound by obligation to paint and unfettered by vulgar adherence to the actual appearance of the visible world.

This was the ideal. As an ideal, it had immense power over élite Chinese culture for the next 900 years, shaping artistic theorizing and artistic practice equally. But the force with which it is expressed in the writing of Su Shi and his contemporaries should not be taken as making it descriptive of the reality they lived, or of the role of art within that reality, which was much more complex. To take one example, not only were Su Shi and his circle socially and intellectually absorbed in Buddhism, on close terms with many Buddhist monks, but we know that Su Shi's wife was, after her death, the subject of an elaborate 'Water and Land' ritual (see p. 126), in which types of visual representation very different from scholar painting played a central role. Again, relations between Su Shi, his contemporaries, and the imperial court were closer and more convoluted than much later simplistic divisions would prefer. Rather than seeing the scholar ideal in painting as synonymous with 'Chinese art', it may be helpful to see it as only one, albeit socially privileged, type of visuality, coexisting with and interacting with others.

Certainly the links between the arts of calligraphy, poetry, and scholar painting were becoming more closely drawn at this period. It was in the Su Shi circle in the eleventh century that integral 'poem-paintings', works of art where each part was of equal status, were first

produced (see **57** for an early example). In later centuries this progressed to the point where a claimant for scholar-painter status could not be seen as lacking in the other two accomplishments. The reverse was not necessarily the case. A great poet and calligrapher did not have to paint, and this is the case with another member of the eleventh-century generation, Huang Tingjian (1045–1105). One of his most famous works in later centuries was a paper scroll of his own poems entitled 'Pine Wind Pavilion', written between 1101 and his death in 1105 CE [**72**]. It is in the cursive form of the script most closely associated with Wang Xizhi and his family, although here the content is significant, a sequence by the most famous poet of his time. It was created, like all of Huang's work, out of a great self-consciousness. Huang was acutely aware of what traditions (both poetic and calligraphic) he was following, which he was rejecting, and how the effects he sought were achieved through control of the brush. He is known to have had access to Huaisu's 'Autobiography' [**69**], and to have studied a wide range of earlier calligraphy available to him in original pieces, in rubbings, and in the form of stone inscriptions. Only a person of a particular social standing would have been able to gain access to such treasures, and thus the link between status and calligraphic prowess was further reinforced.

The Southern Song (1127–1279) and Yuan (1279–1368)

In the Southern Song period, the ideals expressed by Su Shi and his contemporaries became increasingly normative in élite writing on art, and increasingly influential at the court in Hangzhou. Whether someone like Mi Youren [**25**] is a 'court' or a 'scholar' artist is a question which may not admit of a simple answer, and in fact may simply be the wrong question. The complex context of much Southern Song 'scholar' art is seen in another work produced towards the very end of the dynasty, by a man who in later centuries was very firmly placed in the 'scholar-artist' camp, and is not normally thought of as a 'court artist', but who was in at least occasional contact with a court milieu. The activities of someone like Zhao Mengjian (1199–c.1267), a member of the extended imperial clan, underscore the difficulty, indeed the pointlessness, of seeking to draw a firm line in purely stylistic terms between 'professional' artists of the imperial painting Academy and 'scholars'. His album leaf of c.1260 showing branches of bamboo, flowering plum, and pine is the earliest surviving painting bearing this subject, later known as 'The Three Friends of the Cold Season' [**73**]. It is painted on paper, in the plain-ink technique which by the Southern Song was one of the more prestigious styles available to an artist, and which is closely related to the system of strokes used in the writing of text (see p. 136). It has been customary to associate this subject with the scholarly, non-court tradition, and to read the plants as emblems of

73

Album leaf on paper, 'The Three Friends of the Cold Season', by Zhao Mengjian (1199–c.1267 CE), 1260.

moral male rectitude (the plants being unbowed in the face of harsh weather). These ideas are certainly present in Song poetry. But the meaning of this combination may be at least as much to do with notions of congratulation on the occasion of the New Year, which was always celebrated at court as elsewhere with great festivity. The first example of this subject in any medium in fact appears on the embroidered sleeves of a young woman who was buried in 1243 and it certainly in later centuries becomes associated very closely with courtly objects [**31**, **35**, **36**].[4] Later prejudice against anyone who painted to order would act against any record of involvement on the part of Zhao Mengjian with the court, but the situation may in reality have been more complex.

Similar complexities surround the person of Zhao Mengfu (1254–1322), also a distant descendant of the Song founding emperor. He was already a junior officer of the imperial guard in 1279, when the Mongols captured the capital of Hangzhou, and he spent most of the next ten years living on his estates nearby, studying with several famous scholars in his home town of Wuxing. It was on account of his scholarship in the Confucian classical texts that he was recommended for office in 1287 and visited Beijing. He subsequently had a long and successful administrative career there and elsewhere in China, as well as achieving great fame as a calligrapher and painter who was in his later years close to the court. His courtly connections, production of celebratory paintings to order for the Mongol emperors, and the (to some) dubious fact of transferring his loyalty to a new and alien dynasty do not stop him being seen in later years as one of the great

前朝奉大夫大理

少卿牟巘記誤路

中順大夫楊州

泰州尹薰勸農事

趙孟頫書篆額

妙嚴寺本名順興東際距近日吳

興郡城七十里東南而對涵

徐林東接烏戍南而近

山西傍洪澤北臨洪城

暎帶清流而離絕塵埃

誠一方勝境也先是宗

74

Opening section of the 'Record of the Miaoyan Monastery at Huzhou', hand scroll on paper by Zhao Mengfu (1254–1322 CE), c.1309–10. As early as the fourteenth century, Zhao's style of writing was a model used by the cutters of wood blocks for printing, and it became one of the most common styles in which books were produced.

'scholar-artists'. He was certainly one of the chief beneficiaries in art of the reunification of China under the Mongols. The imperial collections of the Northern Song and the Southern Song were now physically reunited in one place, and it was possible for those with the right connections to see them in Beijing. Travel between north and south was restored, and upper-class artists were now able to see developments which had taken place in the other half of the country over the preceding 200 years.

A famous calligrapher and a major political figure would inevitably be in demand for dedicatory inscriptions of all kinds, and the illustrated example [**74**] is only one of many that Zhao Mengfu would have written out in his lifetime. The text written is 'A Record of the Miaoyan Monastery at Huzhou', and was not composed by Zhao himself, but by a retired Song official named Mou Xian (1227–1311). The text is written on squared paper, making it more like a formal stone inscription. It is a description and brief history of a major Buddhist monastery in Zhejiang province. Both Zhao and his wife

were Buddhist believers, and there is no doubting the genuine piety in such an act, but it was done also partly to express ties of patronage with the monastery, which would be glad to advertise its links with two men of such fame (their titles head the document). Zhao begins with a six-character title written in an ancient form of the script, so-called 'seal script', based on his own study of early stone inscriptions of the fourth–fifth century CE. He then writes the rest in the 'regular script', modelled primarily on Wang family prototypes, for which he was particularly famous.

Zhao was the first theorist to claim explicitly that painting and calligraphy had 'a common origin'. He was at least as renowned himself as a painter, who produced work in a wide range of subject matters and styles, some of which were reworkings of earlier art, often that favoured by the Northern Song court. This was now available again to him through his position in Beijing. Thus there is the paradox that the development of 'scholar' painting in the Yuan, seen in later centuries as an acme of artistic achievement, may have depended on the resources

75
Section of 'Bamboo Groves in Mist and Rain', by Guan Daosheng (1262–1319 CE), dated 1308. This painting is now mounted on a hand scroll together with other works by artists of the Yuan dynasty (1279–1368).

of the court. There is no doubt that the social context of much of Zhao's painting was that of interaction between Chinese members of the élite, in a way which did not depend on the actions or attitudes of their rulers. It is this intersection of the self-conscious adaptation of earlier painting styles (what Zhao called the 'spirit of antiquity', *gu yi*), with the world of élite social intercourse, which above all frames the otherwise nebulous entity called 'scholar painting'.

It was a form of social interaction, and a form of art which was becoming more widely practised in the fourteenth century. And it did give rise to new types of subject-matter, often with personal or literary connections which might be comprehensible only to the very narrow group at which it was originally directed. One novel subject-matter is associated with the name of Guan Daosheng (1262–1319), who was the wife of Zhao Mengfu. She was by no means unique among élite women in her artistic practice, but she is supposed to have been the first to paint what became one of the standard subjects of the repertoire, clumps of bamboo by water [75]. Single branches of bamboo had long been used to symbolize masculine virtue [71], but the allusion here is probably very different, being to the faithful wives of the mythical sage-emperor Shun, whose tears dappled the bamboo on the banks of the Xiang River, into which they flung themselves on his death. Bamboo groves by water thus come to stand for marital fidelity in a general sense, though it is very much in the nature of a painting like Guan Daosheng's that the actual personal meaning for the artist (if any) is not fully recoverable. She and Zhao Mengfu were married late in life, and certainly artistic legend has them as a genuinely devoted couple, who occasionally worked together on the same picture. She has signed and dated the painting, equivalent to the early summer of 1308, and, as was to become standard, makes a brief note of the circumstances of its composition. It was painted on board a boat on Lake Bilang, and is dedicated to the 'Lady of the Kingdom of Chu', another upper-class woman like herself. The picture is therefore above all a gift, expressing not so much the artist's deepest personal feelings, but her ties to a member of her own peer group, the nuances of which are now lost and were probably lost very shortly after the work's

The titles by which Chinese paintings are known today can have several origins. They may be written on the picture itself, sometimes as part of a larger inscription [85]. Sometimes they are written on separate slips of paper, pasted to the outside of the rolled scroll. Such titles are often not original, but arise from the need of collectors and curators to identify individual works. For example, the picture in [75], by Guan Daosheng, is currently titled by the National Palace Museum, Taipei, as 'Bamboo Groves in Mist and Rain'. When it was owned by the eighteenth-century collector An Qi he gave it the name 'Ten Thousand Bamboo Poles in Cloudy Mist'.

Detail of 85

The original title used by the artist is not known, or indeed whether the picture had a formal title at all at that point.

creation. This loss of the original circumstances of the picture's meaning has forced the study of such painting, almost from the time it was made, to concentrate instead on formal questions of style and brushwork.

Guan Daosheng also painted murals in Buddhist temples and wrote calligraphic pieces at the command of the Mongol emperor Renzong (r. 1312–20). However, in her lifetime some members of the upper classes were increasingly involved in the creation of pictures which were only ever intended for a tiny audience, or a single recipient. This was so even for someone like Ren Renfa (1255–1327), who enjoyed a successful administrative career before retiring to his family estates in what is now the city of Shanghai. He is particularly noted for his paintings of horses [76], a subject for which his contemporary Zhao Mengfu also had a reputation. Ren's work was collected by the imperial court, but he did not work explicitly for it. Instead, his pictures were part of the network of élite interconnections, painted to be presented to contacts in the bureaucratic web. As such, they might have iconographical schemes suited to flatter their recipients, in which the judging of horseflesh stood for the judging of talented men, or a thin horse stood for the honest official as against the sleek and corrupt.

The whole question of the meanings embedded in the scholar-painting tradition has only recently come to be a focus of research, replacing an earlier view of these images as one in which representation no longer mattered, and purely art-historical criteria (allusions to earlier styles, displays of personal brushwork manner) dictated the picture's appearance. The political circumstances of the Mongol conquest, in which members of the Chinese élite were often either excluded from political power, or else refused to serve what they

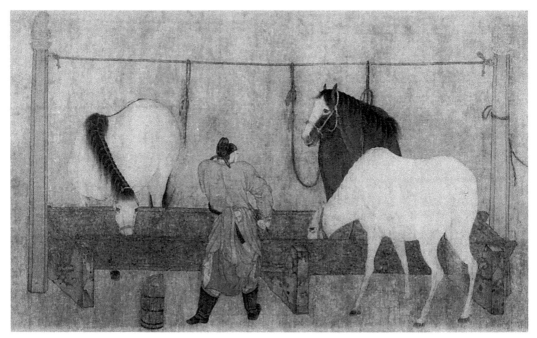

Detail of the hand scroll,
'Nine Horses', in ink and
colours on paper, by Ren
Renfa (1255–1327 CE),
dated 1324. This picture
may have been made for
a family member as a gift,
and remained in the artist's
family until after his death.

regarded as an illegitimate power, have always been seen as crucial to the growth of the scholar ideal in the Yuan period. The role of the disinterested hermit, living in seclusion, was now one adopted by many of the most valued painters. In the eyes of contemporaries, as well as subsequent critics, this was allied to purely formal changes in the manner of making paintings, including a more prominent role for the artist's own inscriptions, and a change in the understanding of visuality to stress the surface of the silk or paper over illusionistic representation of space.

Both of these factors have long been recognized as coming together in a work like the long hand scroll (over 6 m.) on paper by Huang Gongwang (1269–1354), entitled 'Dwelling in the Fuchun Mountains' [77]. Huang was the adopted son of a wealthy family, who after a bumpy official career which ended with his imprisonment, was closely associated with the Quanzhen school of Daoism for the second half of his long life, towards the end of which he painted the scroll. It was painted over a period of three or four years, 1347–1350, for a man named Zheng Wuyong, and has for centuries been one of the most famous of all Chinese paintings (it belonged to Shen Zhou (see p. 155), to Dong Qichang (see p. 160), and the Qianlong emperor). Its depiction of the scenery along the Qiantang River in Zhejiang province is not in any sense a 'pure' depiction of an actually existing landscape. In the first place, such visual reportage was by now in low repute with upper-class aesthetic theorists, including the circle in which Huang moved. Although in his writing on the techniques of landscape painting he advises painters to carry a brush with them to record strange rocks and

trees they come across, this is not an advocacy of drawing from nature as a general principle. The type of rock formations painted, and the manner in which they are represented by a build-up of lots of separate smaller brush-strokes, are above all a cultural landscape, a way of seeing which is privileged by its links with the most valued parts of the tradition of painting. The special brush-strokes used in representing rocks and trees, called *cun* in Chinese, were by the fourteenth century one of the chief focuses of connoisseurly writing. There was an extensive technical vocabulary to describe their forms. They were often named after their putative discoverers; for example, wet horizontal dots of ink were called 'Mi dots' after Mi Fu (see p. 60), even though it is now known they were being used in tomb mural painting as early as the seventh century CE. They provided above all a set of forms painters were supposed to master. Huang associated his own manner of using the brush with two great names of the past, Dong Yuan (d. 962) and Li Cheng (919–67), claiming to synthesize what were to him two entirely separate traditions.

Discussion of a work like this scroll has therefore, in the six centuries since it was painted, concentrated above all on the techniques and effects of Huang Gongwang's brushwork, its antecedents, and its imitators. Little thought has been given to the role of the dedicatee, Zheng Wuyong, or to the precise circumstances of its creation. In recent years it has been demonstrated that the choice of scenes in the 'Fuchun Mountains' scroll contains allusions to a specific hermit of the Han dynasty, and that the true theme of the picture is therefore not the landscape (still less the brushwork in the abstract) but the recluses who inhabit it (even if they are not depicted). The story therefore involves the 'hermit' Huang Gongwang himself, who has rejected political involvement, but is still involved in relationships with the locally prominent. An alternative reading would see the painting as flattering the patron, by associating him with the noble recluses of antiquity. Studies of other Yuan landscape paintings have begun to uncover similar circumstances which help us to relocate these works in the context of élite concepts of landscape and property, as well as in the revolution in representation which separated certain kinds of

78

Hand scroll in ink on paper, 'A Breath of Spring', by Zou Fulei (active fourteenth century CE), dated 1360.

painting patronized by the élite from the continuing bulk of pictorial activity.

There was a distinct geographical focus to the ink-centred 'scholar' painting of the fourteenth century, in the prosperous cities of the lower Yangtze region. Wealthy private patrons in a city like Suzhou could have interactions with many famous artists, at least some of whom were dependent on their support in some way. These relationships are never spelt out in detail, in the inscriptions which were becoming much more common at this time. Huang Gongwang moved in Suzhou circles, as did the other members of the group later known as the 'Four Yuan masters'. So too did Zou Fulei, who painted **78**, and who may have been on social terms with one of these masters, Wang Meng (c.1308–85). Very little is known about Zou himself, but he was a Daoist priest, active c.1360, when the great flowering plum tree which forms 'A Breath of Spring' was painted. The subject-matter of flowering plums depicted only in tones of ink was long established as a separate branch of painting, and like bamboos it has distinct connotations. These involved both the ideals of the secular gentleman and the spontaneous

'Four Great Masters of the Yuan'

The practice of grouping artists together is very common in the literature on Chinese painting. The so-called 'Four Great Masters of the Yuan' is one of the most renowned of these groupings in later critical literature. However, the composition of this group, which is not seen in writing before the Ming period (1368–1644), is not stable. One writer lists as the 'Four Masters': Zhao Mengfu (1254–1322) [74], Wu Zhen (1280–1354), Huang Gongwang (1269–1354) [77], and Wang Meng (c.1308–1385). Another lists Huang Gongwang, Wang Meng, Ni Zan (1301–1374), and Wu Zhen.

Similarly, Shen Zhou (1427–1509) [81], Wen Zhengming (1470–1559) [83], Tang Yin (1470–1523) [82], and Qiu Ying (c.1494–c.1552) [96] are sometimes grouped as the 'Four Masters of the Ming', while the Qing artists Wang Shimin (1592–1680), Wang Jian (1598–1677), Wang Hui (1632–1717) [34], and Wang Yuanqi (1642–1715) [35] are collectively known as the 'Four Wang'. Such groupings are valuable guides to critical thinking about painting, but may be less reliable as guides to actual affiliations and connections between artists.

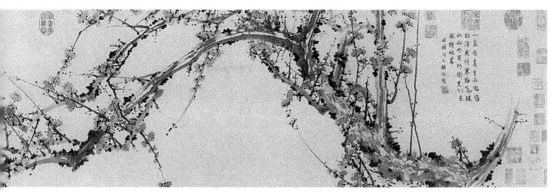

intensity of religious inspiration; the Chan monk Zhongren (d. 1123) was later revered as the creator of 'ink plum' painting. Both Buddhist and Daoist monks continued to interact with the élite, and to be the recipients of works of calligraphy, poetry, and painting. Their monasteries were important sites for upper-class tourism, they were where gentlemen lodged when travelling, and they provided an ambience where the gatherings which so often resulted in artistic activities could take place and be commemorated.

The Ming Dynasty: 1368–1644

The culture of upper-class travel was central to the development of painting in the scholar tradition in the succeeding Ming dynasty (1368–1644). Travel enabled men (women were much more confined to the home) to see the famous paintings of the past held in private collections, and to become familiar with their subjects and styles. It enabled them too to see culturally important sites, often associated with poets and painters of the past, and appropriate these scenes for their own work. For example, the topography of one famous scenic region, Mount Hua in Shaanxi province, was represented in an album by Wang Lü (c.1332–95) [79]. Wang was not solely 'a painter'; the production of paintings did not define who he was. He wrote a theoretical treatise on art, but also ones on medicine (which he practised successfully), and on the sciences of astronomy and geomancy. All of these are underpinned by a common theoretical understanding of the role of 'norms' and 'variants' at work in disparate areas of human experience.

His Mount Hua album may be that genuinely rare item among Chinese painting, a work created principally for himself, outside of patronage networks or the demands of reciprocal gift-giving. It is not simply a series of pictures, but a unity of texts and images which provide an account of Wang's ascent of the sacred mountain in 1381. It is distinguished by its concern with topographical accuracy, Wang arguing that, although it was the expression of ideas, not the representation of forms which made painting art, ideas existed in the

Album leaf on paper,
'Reclining on the Steps in
Front of the Shrine Hall', by
Wang Lü (c.1332–95 CE),
painted after the artist's ascent
of the sacred mountain in
1381. This is one of the
fourteen surviving pictures
from what was originally a set
of forty.

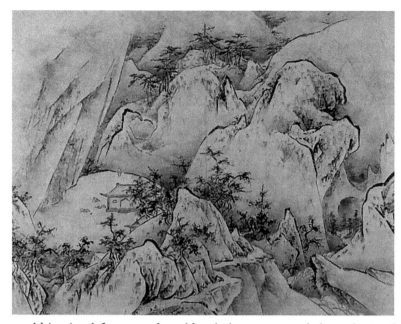

world in visual forms, and could only be represented through visual means. He argued for the importance of the direct engagement with the seen, as against the mediation of existing paintings. His subtle and serious arguments about the nature of representation show that the scholar tradition was not one in which mimesis was rejected altogether, but that it was still possible in the fourteenth century to argue with conviction a role for the primacy of experience over art-historical study, and of 'likeness of form' over pure expression of the painter's 'untramelled spirit'.

The form of the Mount Hua album was a relatively new one, being a suite of pictures designed as a coherent whole. The experience of viewing an album is even more restricted as to the size of the audience than is the hand scroll, and it was therefore suited particularly well to an intimate engagement by one person with the pictures it contained. Servants were needed for one to look at a hanging scroll, but an album could be looked at by one person alone, in an experience of communion with the artist which was more akin to reading a book. It was a form particularly associated with artists in the scholar tradition over the next few hundred years.

Another new pictorial format and subject-matter of the fifteenth century was a type of 'portrait in a landscape', in the form of a short hand scroll which could be taken in in one viewing, i.e. it did not have to be looked at by unrolling successive sections, as did a picture like 'Dwelling in the Fuchun Mountains' [77]. These short scrolls typically showed a gentleman in an outdoor setting, often a representation of the gardens which were being built in increasing numbers after about 1450 in the political capital, Beijing, and in Suzhou, now the unofficial

but uncontested cultural capital of the empire. Such scrolls were created to be presented to the person depicted, put together over a period by a group of his associates, and involving a picture which might be made by a member of the same circle as fulfilment of a social obligation, or might be purchased from a professional's workshop.

The earliest surviving example of the genre is a work by the Suzhou scholar-artist Du Qiong (1396–1474), depicting his brother-in-law Wei Yousong receiving a guest in such a garden setting [80]. Only the picture survives today, to be written into 'art history', but it is really only a fragment of a now-dismembered work which would have included a large title for the scroll, and a number of prose and poetry pieces describing and praising the recipient and his property. The privileging of the picture over the words is not a recent occurrence. In this case, the text had been trimmed off by the late sixteenth century, the subject being much less famous by then than the artist, and the original social impulse which had brought the work into existence being long exhausted. The prestige of the scholar ideal in Ming society, and the growing influence of the commercial market in works of art, meant the rapid appropriation by the market of works which had originally been created as part of the network of gifts, favours, and obligations which bound men of the upper classes together. When that happened, the meaning of the pictures to their subsequent owners was entirely altered.

Du Qiong was probably not paid money to create the picture of his brother-in-law. Similarly, a wealthy Suzhou landowner like Shen Zhou (1427–1509) could not be prevailed upon to create for cash. But this is not the same as saying that their art was a pure outpouring of spontaneous feeling, or that they only ever painted what they wanted to when they felt like it. Shen Zhou certainly fulfilled social obligations with paintings, exchanging them with his peer group for other favours. These might include hospitality, or the writing of an epitaph by a famous calligrapher for Shen's father. The exact circumstances in which he painted his album of 'Twelve Views of Tiger Hill' [81] are lost, but this set of views of the Buddhist monastery just outside the city walls of Suzhou, where the upper classes of both sexes could combine piety with cultural get-togethers, was almost certainly painted *for* somebody or some reason. These reasons are lost today, and were probably lost very soon after the work's creation, there being no need that they be recorded. This leaves later critics, for whom Shen is one of the great figures of what came to be identified as a Suzhou (or 'Wu', after an alternative name for the region) school of painting, to expatiate freely on the characteristics of his brushwork, the sources of the various *cun* (see p. 151) he uses, and the expression of his much-admired personality in his art.

It is quite possible that Shen Zhou's pupil Tang Yin (1470–1524) was

rewarded financially for painting 'Farewell at Jinchang' [**82**]. He
certainly was paid for other paintings and relied on selling his art to
live, but this did not in the eyes of his contemporaries or of later critics
make him a 'professional painter'. His acceptability as a social equal to
a peer group of landowners and government officials was partly due
to his artistic talent, partly to his early success in the imperial
examinations (from which he was subsequently debarred in a scandal
over cheating), and partly to the sense that those who made the rules

were entitled to break them. The Suzhou upper classes among whom he lived were a tightly knit group, intermarried and obligated to one another in numerous interlocking ways. The production of this scroll, presented to an official named Zheng Chuchi on his departure for Beijing, was not a spontaneous gesture on Tang's part, but was brought into being by a group (fifteen figures in official dress bow in farewell as Mr Zheng steps into his boat). The farewell picture was another new format of the fifteenth century, available in all sorts of packages, from signed works by highly prestigious artists as here to formulaic works bought off-the-peg in workshops. Here the artist may have sought to impress both the recipients and the commissioners of the work with a display of brush-strokes associated not with Suzhou but with the other great artistic centre of Nanjing. He paints rocks in longer, wetter strokes of the brush, instead of building them up from lots of little *cun* like his teacher Shen Zhou. Such artistic subtleties were probably not lost on the audience, even if they were secondary to the social role of the painting in forging a tie between the Suzhou élite and a powerful friend at court. It is a mark of Tang's position that the painting is extensively inscribed by him with a poem, his ability to compose verse being one of the things that sustained his scholar status in the face of the unpleasant fact of his economic dependence on his art.

Few such social ambiguities surrounded the austere figure of Tang's childhood friend Wen Zhengming (1470–1559), at least in his native Suzhou. There he was written about as the acme of the scholar ideal, as poet, calligrapher, painter, and man. Yet even he, in the course of his

82

'Farewell at Jinchang', by Tang Yin (1470–1524 CE), hand scroll on paper, painted some time after 1498. The scene of farewell is set at the Jinchang Gate in the west wall of the city of Suzhou. The extensive inscription in the artist's own hand is evidence of his social standing.

brief career in the Beijing bureaucracy of the 1520s, could be insulted by much younger men with the sneer that he was just a 'painter'. Most of the upper classes did not paint. Those who did constantly had to negotiate areas of contested meaning surrounding visual images, proving again and again that their paintings were somehow different from the images which decorated the walls of temples or were bought to be presented to loved parents on their birthdays.

Wen Zhengming had been a pupil of Shen Zhou, and like his master his work was much sought-after in his lifetime. Most of it now circulates shorn of the circumstances which led him to paint it, but a work like 'Cypress and Rock', dated 1550, can still be understood in a richer manner [**83**]. The painting and poem, in Wen's highly regarded calligraphy, are a unity; neither occupies a subsidiary role, even though the context of the present book on art history imposes a reading on this object of 'picture with inscription'. The ideal of a painting and a poem of equal quality was not always realized; in fact literary critics were dubious about the quality of the verse of most famous scholar-artists, but it remained the ideal. They were created in this instance as a gift for a younger friend who lay ill at the time, and urge on him the fortitude of the ancient gnarled cypress (also an ingredient in medicine), at the same time as they quote a line of a Tang dynasty poet to allude elegantly to the young man's promise as a writer. Such a work was almost certainly treasured by its recipient for its personal tone, linking him to a very famous old man. Paradoxically, this very personal nature, the visible traces of Wen Zhengming's brush, made the scroll worth a great deal of money, and hastened its exit from the arena of relationships between known men into the wider, anonymous market-place (see p. 176).

Upper-class artists in the Ming learnt to paint from private tutors, or else from members of their own families. (Wen may have received some early tuition from his mother, Ji Shouduan, praised by Shen Zhou as 'the Guan Daosheng of today'.[5] Family traditions could be sustained over generations, and the Wen family of Suzhou provided the most

striking example of this, with a series of prominent calligraphers and painters stretching down into the seventeenth century. Wen Peng (1489–1573), Wen Jia (1501–83), and Wen Boren (1502–75) were the most famous. Some of the family may effectively have been professional artists, but the lustre of a famous name was still worth something. Wen Zhengming's great-granddaughter Wen Shu (1595–1634) is one of the most interesting cases. Married into an equally distinguished Suzhou family, who were descended from Zhao Mengfu (see p. 145) and hence from the emperors of the Song dynasty, she learnt to paint as one of the accomplishments of an upper-class lady. Most of her surviving work was done after 1626, when her father-in-law died and her family was in reduced circumstances. It seldom carries poems or dedications, suggesting it was done for commercial clients, and that she may have supported the family by painting.

The fan illustrated may have been done for such a client [**84**]. As an arena for small-scale work, which could be produced in a very short time, the folding fan was ideal for the casual or spontaneous gift or commemorative piece, when something larger was not appropriate. Its rise as a format in the sixteenth and seventeenth centuries must have something to do with the growing role of art in élite sociability at this

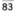

83
Hand scroll on paper, 'Cypress and Rock', by Wen Zhengming (1470–1559 CE), dated 1550. The calligraphy is in 'regular script' *(kai shu)*, for which the artist was particularly famous.

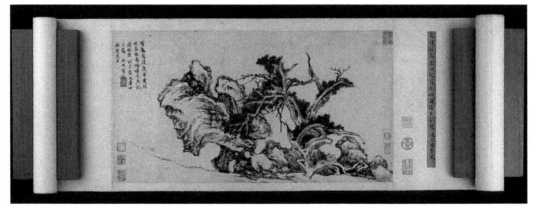

84

Folding fan on gold paper, 'Carnations and Garden Rock', by Wen Shu (1595–1634 CE), dated 1627. The folding fan was almost the last pictorial format to be developed in China, being an import from Japan, and not widely used until the sixteenth century.

time. Fans like this were painted before they were mounted on sticks for use. Some may never have been used, but mounted almost immediately in albums for the enjoyment of art collectors.

The subject-matter, carnations and a garden rock, are typical of Wen Shu and of other late Ming women artists. Just as male scholar-artists were restricted by convention in the range of subjects they might treat, so further unwritten rules operated in the case of women. They rarely painted landscapes, the most prestigious artistic subject, the most common subject being instead flowers and insects. (These were not exclusively female subjects for art, being painted by men also.) In both literature and art the imagery of flowers was capable of being associated with the beautiful lady. In Wen Shu's lifetime a number of educated upper-class women, along with educated courtesans who serviced the male upper classes, were able to deploy this imagery in verse and pictures to create a context for artistic activity by women on a larger scale than had ever been possible before.

The Art and Theory of Dong Qichang: 1555–1636

A scroll or even a fan by a descendant of Wen Zhengming was still a highly desirable thing to many at the beginning of the seventeenth century, but the hegemony of Suzhou as a centre of taste was being openly challenged at this time. The challenge came from a group of upper-class artists and aesthetic theorists associated with the nearby town of Songjiang, of whom the most prominent and most subsequently famous was Dong Qichang (1555–1636). The views of Dong and his circle, and the artistic practice in which he manifested them, have been so influential in all subsequent versions of the history of Chinese painting that it is only recently that the framework he created has been subjected to any real scrutiny.

The theory he advanced about the history of Chinese painting is easy to caricature: since the Tang dynasty at least, two distinct schools of painting have existed, named the Northern and Southern schools.

The Northern school, characterized by meticulous brushwork and intensive use of colour, was sustained largely by professional painters and is inferior. The Southern school, the manner of painting practised by scholar-amateurs, manifests brushwork principally in ink, and is superior. The movement of art is a teleological process, culminating in the achievements of Dong Qichang himself [85]. This is an unfair caricature. Dong's pronouncements, which drew on a long aesthetic tradition of binary opposition between Northern and Southern (these are not geographical terms, but come from two strands within Chan Buddhism) were in reality a lot more subtle, not to say inconsistent, than that. But it contains a certain amount of accuracy about how the theory was *used* in subsequent centuries, sometimes creating a tidy opposition between 'scholar' and 'professional', which is played out in purely stylistic terms. A simplistic opposition of ink and colour, paper and silk, small-scale and large-scale, Yuan dynasty models and Song dynasty models, 'Wu school' (from Suzhou) and 'Zhe school' (from Zhejiang province), realism and self-expression, has arguably done more to cloud than to illuminate the history of Chinese painting. The *theory* is one of the central facts of Chinese art history from the seventeenth century to the twentieth, and must be studied as such. It is less helpful as a guide to everything which went before. In fact it has been demonstrated that Dong very often made mistakes in his own connoisseurship of earlier painting and calligraphy; this introduced further inconsistencies into the theories he wove around them.

Dong Qichang's own artistic practice, as calligrapher and painter, was extremely highly regarded in his own day. He rose to the top in official life, his immense social prestige being intimately related to his artistic activities. His art was a tool in the struggle for prominence, that prominence in turn lending desirability to samples of his writing and to his pictures. He was also extremely rich and owned one of the great art collections of the day, including Wang Xun's 'Letter to Bo Yuan' [68], and Huang Gongwang's 'Dwelling in the Fuchun Mountains' [77]. Meticulous scholarship has uncovered in his case the way paintings were used within the patronage networks of the bureaucracy, given as gifts to cement existing relationships and create new ones.[6] Like many leading scholar-artists, he employed on his staff 'ghost-painters', to make works in his style destined for recipients of lesser importance to him. In this deployment of art within the social realm he was no different from, if rather more intense and committed than, previous men of his class and education who had been involved in similar relationships.

It would be wrong to see Dong Qichang simply as an artistic manipulator. He was deeply learned in the Buddhist tradition, as well as in the philosophical debates of his day, debates in which the question of the relationship of the mind to external phenomena remained hotly

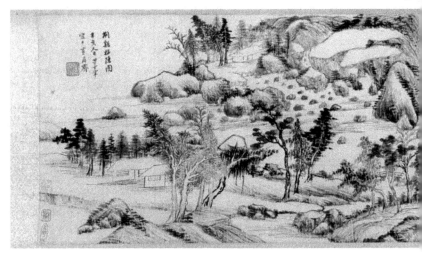

85

'Invitation to Reclusion at Jingxi', by Dong Qichang (1555–1636 CE), dated 1611. Hand scroll on paper. In this case the title is that given by the artist, and written on the picture itself by him.

debated. He was also the most prominent of a group of artists around the beginning of the seventeenth century who took the theoretical rejections of 'form likeness', first articulated by the Su Shi circle in the eleventh century (see p. 142) more seriously than anyone before them. In a painting like 'Invitation to Reclusion at Jingxi', painted in 1611 [85], the middle-aged Dong Qichang has made a landscape which carries the rejection of representation of the observed scene to a new intensity. Quite deliberately, this is not a 'real' landscape, even if Jingxi is a real place. What it is, above all, is 'a Dong Qichang', advertised as such by brushwork identifiable to the educated and art-historically conscious recipient. The man for whom the picture was made in this case was a friend named Wu Zhengzhi (incidentally a previous owner of the 'Fuchun Mountains' scroll). The picture is integral with a written text weighing up the dangers of that friend taking a government post, as opposed to living out the eremitic ideals of the famous recluses of old, which the writer has resolved to do. Both Dong and Wu did take official jobs again, but this does not make either a simple hypocrite. By the late Ming, the interplay of personal wealth, perceived social status, and government position was so complex (and high office potentially so personally dangerous, due to fierce factional politics) that the hermit ideal lost none of its compelling force even for those who served the Ming dynasty in high offices.

The Seventeenth Century and the Ming–Qing Transition

When that dynasty collapsed in the face of peasant rebellion and Manchu invasion in 1644, the social upheaval faced by the upper classes was negotiated by individuals and families in a variety of different ways. Most acquiesced. Some retired. The way calligraphy and painting were used in upper-class life arguably changed very little as a direct result of the change of ruling house. However, the widespread acceptance of Dong Qichang's theoretical positions, the sharpening

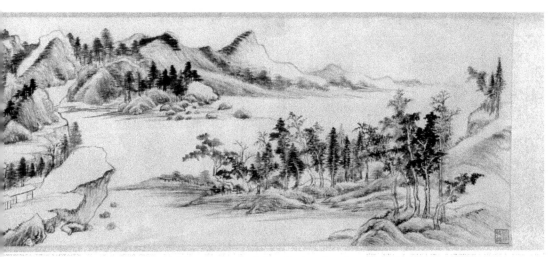

and hardening of the distinction between 'professional' and 'amateur' painters, and the reduction of these categories to simple stylistic equivalents, did throw up new complexities and ironies. Some of the principal, and conscious, upholders of landscape painting in the manner of Dong Qichang were effectively professional artists like Wang Hui (see p. 74). The calligraphy of Dong himself became almost the official style of the Qing dynasty court (1644–1911), copied by the Qianlong emperor himself.

Others who have been seen by art history as admirable 'amateurs' in reality occupied complex social positions. This is particularly true of some of the artists of the seventeenth century who chose lifestyles and developed styles of art in which implicit rejection of the new political order was never very far out of the frame. Several of these were Buddhist monks, men who were in polite society but not of it, and for whom painting was both livelihood *and* means of self-expression. These men characterized themselves often as *yimin*, 'remnants', people left over from the Ming and unable to fully give their allegiance to the Qing.

Shitao (1642–1707) has become since the late Qing dynasty one of the most admired of these monk-artists, the well-attested fact of his selling paintings for cash doing nothing to damage his social standing in the eyes of those for whom this 'eccentric' is one of the great masters of the 'scholar' tradition. His 'Self-portrait Supervising the Planting of Pines' of 1674 [**86**] uses the revival of portraiture as an acceptable genre for the scholar at this time, perhaps to make a more general point about the possible restoration not just of the temple where he was living, but of the Ming ruling house (to which he was related). It is hard to posit a context for the making of such a picture, other than the personal needs of the person who painted it, unless it be for sharing with a very small coterie who understood the deeper meanings the image and its poem contain.

The same is true to an even more extreme degree of some of the

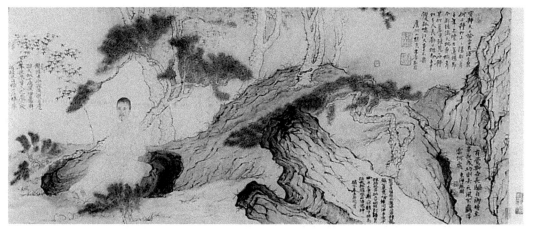

paintings and poetry of Shitao's distant older relative, known to history by the name, adopted late in life, of Bada Shanren (1626–1705). As another man who took to Buddhist monastic life to escape from the Qing conquest, but returned to secular life in the 1670s, Bada led an often marginal existence. Both he and Shitao were the recipients of patronage, not the dispensers of it, unlike Dong Qichang. The social acceptability of those who supported themselves by painting was now so problematic that the most prestigious of those who did so were now tacitly enrolled as 'amateurs' on the basis of their fidelity to certain stylistic norms (and their avoidance of others), regardless of their actual economic circumstances. There were in any case many ways of accepting patronage without seeming to sell work outright, including the enjoyment of lengthy periods of hospitality.

Bada Shanren's highly distinctive work is not quite like anything previously produced by a painter in China, and the extent to which it is the product of extreme mental states continues to be debated by scholars. His scroll of 'Fish and Rocks' [87] was probably painted about 1691, and uses distortions and wrenches of point of view to disorientate the gaze. The poems which are so closely integrated into the layout of the scroll speak enigmatically of the fallen Ming dynasty, and of the fate of its descendant, the painter.[7] Here it does seem fully justified to talk about an art of personal expression, and one which found relatively few admirers among collectors in China before this century, when Bada Shanren has become viewed retrospectively as one of the great painters of the last imperial dynasty. He was also an artist who regularly worked to commission in the last two decades of his life for the élite of his home city of Nanchang, Jiangxi province. Shitao meanwhile had settled in Yangzhou, in Jiangsu, and was similarly engaged as a professional painter. The economic growth of the later seventeenth and early eighteenth centuries led to the rise of a number of new centres of élite culture, where the patterns of art-collecting and art-making in upper-class life, developed in the Suzhou region,

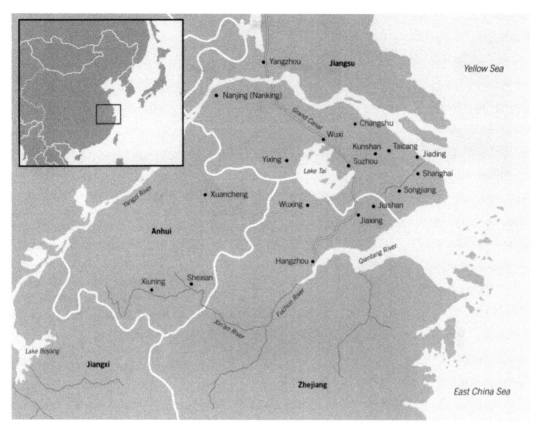

The Lower Yangtze Delta and its Cultural Centres

established themselves over the course of the Qing dynasty. Yangzhou was perhaps the most important of these. One result of this was that artistic styles came to be seen as having regional roots, and are so spoken about in artistic criticism. It is at this time that the opposition between the 'scholarly' artists of Suzhou (the Wu school) and the 'professional' artists from Zhejiang (the Zhe school), hardened into an art-historical commonplace. As a further example, in the seventeenth century a distinct school of painting associated with Anhui province had come to be written of for the first time, one of its most famous exponents being another 'remnant' monk, Hongren (1610–63).

The Qing Dynasty: 1644–1911

It is striking that, although the ideal of the scholar amateur artist was entirely dominant among the upper class of the Qing empire in the eighteenth and nineteenth centuries, very few members of it made or have sustained reputations as painters. Su Shi and Dong Qichang were very important political figures before they were painters; Shen Zhou and Wen Zhengming were independently wealthy members of the gentry who also enjoyed great artistic reputations among their peers. The eighteenth- and nineteenth-century equivalents of these men, as politicians and local magnates, by and large were not so esteemed.

87

Section of a hand scroll on paper, 'Fish and Rocks', by Bada Shanren (1626–1705 CE), painted c.1691.

There were exceptions, often men close to the court, like Wang Yuanqi (see p. 76) and Gao Qipei (1660–1734). As a prominent official with a family history of loyalty to the ruling Manchu house, Gao certainly did not sell his work openly. This was much sought-after as Gao was the leading exponent in the Qing of pictures painted not with the brush but with the fingers (a venerable if minor tradition within painting in China). He clearly painted many of his pictures to give as presents to superiors, equals, or subordinates, the importance of the recipient often being signalled by the presence or absence of a lengthy inscription. His large hanging scroll of 1728 [**88**] showing Zhongkui the queller of demons, a deity associated with the New Year festivities and the Dragon Boat festival in the fifth month, was painted on the latter occasion, clearly as such a presentation piece.

The quantity of upper-class, genuinely 'amateur', picture-making did not decline in the Qing; if anything it increased greatly. However, 'amateurs', in the sense of people who derived no income from art, were not in general the most esteemed painters. Calligraphy too experienced an increasing professionalization, but one which was more closely tied to developments in élite culture in the broader sense. Eighteenth- and nineteenth-century scholarship was distinguished by a deepening scepticism about some aspects of the received classical heritage, which gave rise to intensive investigation of the most ancient written texts. This went together with a revival of interest in the earliest forms of the Chinese script, and an increasing appreciation of the aesthetic value of early, anonymous inscriptions. A piece of calligraphy could now be deemed great even if its writer was unknown. The forms of the 'seal script' had been used in the Yuan and Ming period for specific purposes, such as the titles of hand scrolls [**74**]. New published works on seal script in the seventeenth century had enabled Bada Shanren to copy some of the famous monuments of this type of writing. In the Qianlong reign (1736–95), the publication of the imperial bronzes collection (see p. 81), including the inscriptions cast on the objects, and a number of imperially sponsored philological projects provided resources for writers to learn and use early script forms. A great expansion in the production by private scholars of

88

Hanging scroll, 'Zhongkui, the Queller of Demons', by Gao Qipei (1660–1734 CE), dated 1728. The colouring of such a picture would have been carried out by professional assistants, Gao the scholar and official being responsible for the line-drawing in ink (with his fingers) and the signature and date.

rubbings of early inscriptions on stone and bronze also helped the seal script and the clerical script (see p.136) to become much more widely known and more broadly used by educated writers. A 'stone inscription school' of calligraphy now challenged the 'model letters school' of calligraphy, which looked to the preserved writings of Wang Xizhi and his descendants (see p. 136), for aesthetic hegemony.

One of the most prominent calligraphers of the 'inscription school' was Deng Shiru (1743–1805), among the first writers to produce extensive texts entirely in seal script [89]. On this fourfold screen, the texts are not original compositions by Deng, but ancient texts, suitable for the display of an ancient form of writing. The name 'seal script' derives from the use of this type of script on personal and official seals, its strokes of even thickness and its less abrupt changes of direction making it more suited to carving than forms of writing dependent on rapid movement of a brush. As well as producing calligraphic texts, Deng was in the forefront of a revival of interest in ancient seals, and in the carving of new seals in ancient styles, both of which became prominent gentlemanly pastimes. Seal carving, like the carving of bamboo (see p. 186) escaped the taint of 'craftsmanship', and was accepted as an art rather than a demeaning craft. As with painting at this time, regional affiliations were important, and contemporaries understood there to be distinct regional schools of seal carving centred on Anhui and Zhejiang provinces.

89

Set of four calligraphic scrolls in 'seal script' *(zhuan shu)*, designed to be mounted on a folding screen, by Deng Shiru (1743–1805 CE).

Stoneware teapot, made in the town of Yixing, Jiangsu province, dated 1815 CE. Designed by Chen Mansheng (1768–1822).

Famous in his own time as a figure of the Zhejiang school of seal carving was the official Chen Hongshou, better known as Chen Mansheng (1768-1822). His career as a local administrator at one point gave him authority in the town of Yixing, which since the sixteenth century had had a flourishing ceramic industry, producing a red stoneware which was much appreciated by the élite across the empire. Particularly valued in the Ming and Qing were small pots for tea, often signed by the kind of 'star' craftsman who had come to prominence since the late sixteenth century (see p. 186). Chen Mansheng is believed to have taken an active role in the design of such teapots, having them made for him by a potter named Yang Pengnian, and either inscribing them himself or obtaining the services of other writers to do so. An example dated 1815 [**90**] has calligraphy in the seal script by Guo Pinjia (active late eighteenth-early nineteenth centuries). It demonstrates the involvement of upper-class men in a widening range of artistic practices, as well as the expanding scope for the use of the ancient script forms. Interest in the latter broadened in the nineteenth century, as epigraphy (the study of inscriptions) and the study and collecting of ancient bronzes and jades made possible the rise in the early twentieth century of the archaeological practices which would seem to vindicate the most venerable written accounts of China's past (see p. 18).

The Nineteenth Century

The social world of the nineteenth century in China was not as it had been in the late Ming, when the scholar ideal in art was given its most systematic form. That ideal was available to be appropriated and manipulated in forms of representation which were very different from anything Dong Qichang could have imagined, and by people who occupied social positions very different from his own eminence as landowner and imperial official. Even the geographical centres of cultural production were different, with the rise of commercial cities like Guangzhou (Canton) and above all Shanghai. The artist Ren

91

Hanging scroll on paper,
'Self-portrait', by Ren Xiong
(1823–57 CE), painted in
the 1850s.

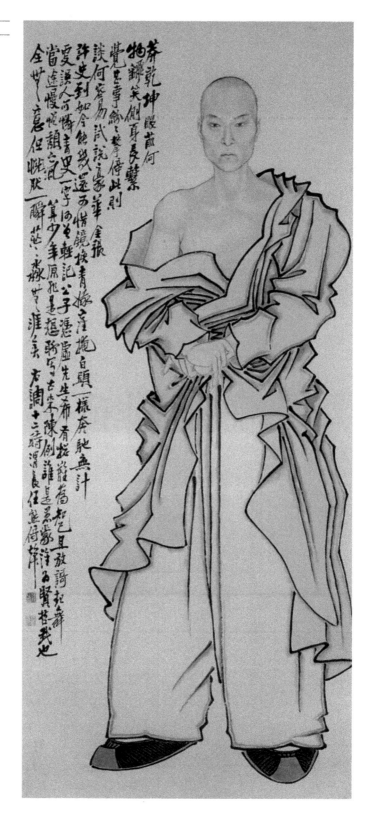

Xiong (1823–57) was unequivocally a professional artist, from a humble background though he was on terms of social familiarity with the rich and politically powerful of the great port. He worked mainly as a portrait painter, a kind of art which had once been held in low esteem by upper-class artistic theorists, but which had revived greatly in the seventeenth and eighteenth centuries, and was an increasing focus of aesthetic writing at that time. His life-size self-portrait [91], probably made towards the end of his short life, is an extremely complex image which has been the object of intense interest within the field of art history over the last decade, and which finally underscores the helplessness of the 'scholar-amateur'/professional distinction in the face of the art actually produced in Qing dynasty China. The unity of visual image with a long, self-composed inscription, the emphasis (in the drapery) on brushwork which asserts the processes of its own production, the notion of art as vehicle for the expression of a self—all these are characteristic of the scholar-amateur ideal as it had grown up over centuries. So too is the sense that the image is not fully readable by an anonymous gazing public. The poem is enigmatic, arguably laden with political references which suggest an ambiguous loyalty to the Qing dynasty, then under assault from the largest of all popular uprisings, the Taiping Rebellion (1851–64). The pose is ambiguous, so is the costume (is the figure dressing or disrobing?), and two different codes of representation govern the depiction of flesh and cloth, person and garment. The garments are in the visible brush-strokes associated with the scholar tradition, while the face is shaded in the manner standard in anonymous commemorative images since the seventeenth century (see p. 188). Ren may additionally have been acquainted with portrait photography, which began to be practised in Shanghai in the 1850s. We do not know why this picture was painted, whether it was intended to be retained by Ren Xiong himself, or presented to a friend or admirer. What can be argued is that, while deploying some very old conventions as to what art is, Ren Xiong here develops the ambiguities inherent in the work of earlier painters like Shitao in a way which marks the final establishment of a new type of subject position and a new type of social role. This is the role of the 'artist' as it came to be understood in the twentieth-century sense of the term.

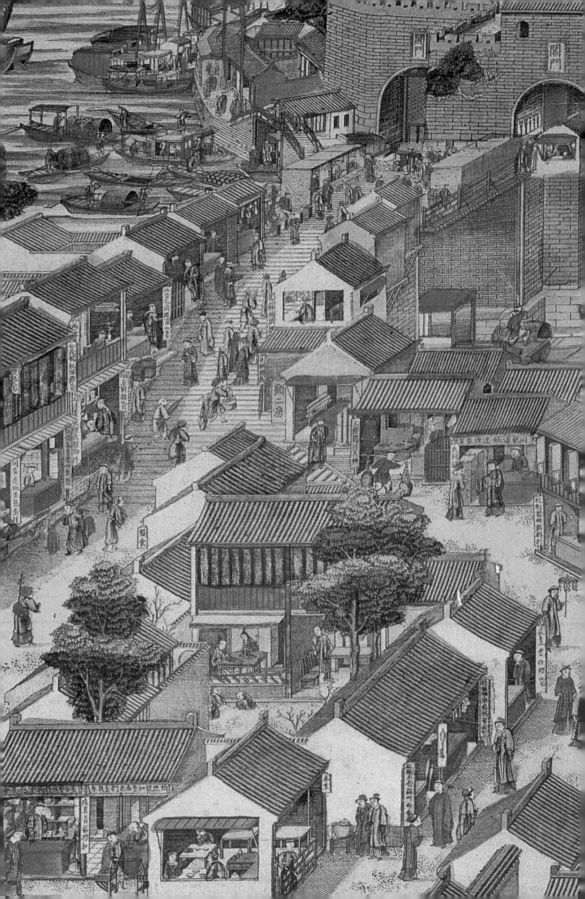

Art in the Market-Place

5

The Song and Yuan Dynasties: 960–1368

Prior to about 1000 CE, very little art in China was made speculatively (that is, without having been ordered by a single or institutional client). Painters generally did not paint, weavers did not weave, carvers did not carve, in the general hope of being able to sell their products to an unknown customer (see **53** for a possible exception). From the Song dynasty, as a developing economy led to the kind of market society in which anonymous relations between seller and buyer were more common, this extended to the fields of artistic production as much as to other types of commodity.

The technology of printing certainly played a role in making it possible for pictures to be sold on to customers who might have no relationship of any kind with their maker: artistic forms and subjects developed in a court or a restricted élite context became more widely available. The one hundred poems and images of flowering plum blossoms published in book form c.1238 by Song Boren [**92**] make up the earliest Chinese illustrated book where the pictures are meant as objects of aesthetic appreciation in their own right (rather than as accompanying a religious or secular text)[1] and take their place in a flourishing publishing industry serving a growing audience. The connoisseurship of plum blossoms (see p. 152) was now available for cash, and the trappings of élite lifestyles increasingly open to all who would pay for them.

Developments in the ceramics industry in the twelfth–thirteenth centuries illustrate the effects of commercialization. A highly diverse range of types was made, at kilns all over the empire. Representations became more common in the decoration of ceramics, some of which are clearly related to the kinds of pictures found in books. Scenes from drama and from prose fiction were painted in particular on objects made in the region then known as Cizhou, in Henan province. As well as vessels made as containers for the alcohol which was the area's other major export industry, the Cizhou kilns produced many ceramic pillows, like **93** decorated with a scene from the heroic historical novel 'Romance of the Three Kingdoms'. The painting techniques used by the decorator are related to more prestigious forms of painting on silk

Detail of 109

92

Page from the printed book,
'Manual of Plum-Blossom
Likenesses', by Song Boren
(active c.1240 CE). First
published in 1238, this book
was successful enough to
require reprinting at least
once, in 1261.

or paper (particularly the strokes used to show rocks), but they are
mediated through printing, which also supplies the format of the
picture, wider than it is high in the manner of book illustrations
occupying the top third of a page. Another innovation of this period,
which attests to the growth of a consumer culture, is the trademarking
of luxury goods. The pillow is stamped 'Made by the Wang family of
Fuyuan', one of a number of such marks known on this type of object.
Similar trademarks appear on paintings (e.g. **55**) and on lacquered
objects at the same period, sometimes with more extensive in-
formation such as the address of the shop where the goods can be
bought. Such advertisement suggests a clientele for whom the name of
the maker is a guarantee of quality which holds good even at a distance
from the point of manufacture.

Cizhou is in the north of China, as were many of the leading
ceramic kilns of the Song period (e.g. **23**). However, by the fourteenth
century a town south of the Yangtze was building a dominance in the
making of fine ceramics which continues to the present day:
Jingdezhen in Jiangxi province, well situated to take advantage of
supplies of the raw materials needed to make the particular type of
ceramic known as porcelain, and well connected by water to markets
elsewhere throughout the empire. It was at Jingdezhen around 1320
that potters mastered the technology of decorating porcelain in a blue
pigment derived from the mineral cobalt, painting it on a white ground
and then covering it with a clear glaze to create the 'blue and white'

93

Ceramic pillow, c.1270–1300 CE, painted with a scene from the historical drama 'Romance of the Three Kingdoms', which also provides the subject-matter for **32**.

which has been one of China's most influential craft achievements in world terms. A wine jar like **94** combines three fourteenth-century innovations. The subject-matter is taken from a new form of drama, the *zaju* (miscellaneous theatre) which flourished in the capital of the Yuan dynasty (1279–1368) at modern Beijing. (In this case the play illustrated is the romantic 'West Chamber'.) The style of depiction comes from illustrated texts of the play, designed for private reading rather than for professional performers. And the blue-and-white colour scheme is used to develop a range of pigment tones from a single colour, much as élite artists claimed to use the tones of ink on paper. Such a picture is outside the bounds of the aesthetic canon being formulated at the time it was made, by artists like Huang Gongwang (see p. 150), and the audience for such an object may well have lain beyond the narrow cultural élite. Alternatively, such representations may have been quite acceptable according to context even by upper-class scholars, who may have applied different criteria to the decoration of a wine jar and the depiction of landscape.

The Ming Dynasty (1368–1644): Painting

By the middle of the Ming dynasty, if not well before that time, all sorts of art objects were commodities, available through the art market. A striking example of this was provided by the excavation in 1982 of the art collection of a wealthy merchant named Wang Zhen (1425–95), at Huaian in Jiangsu province. One piece of calligraphy and twenty-four paintings were mounted together to form two long horizontal scrolls, a highly unusual (but not a unique) possession to be taken to the grave by a proud owner. Most of the paintings are by artists contemporary with the owner's lifetime, including one showing the demon-quelling deity Zhongkui [**95**]. This subject was associated with the New Year festival, when such pictures were given as presents. Like several of the pictures

in the Huaian tomb, this one is by an artist whose work is otherwise totally lost, a shadowy figure named Yin Shan, known to have worked for the Ming court. What the material in Wang Zhen's two scrolls forcibly underlines is the availability through the commercial art market in the fifteenth century of a wide range of art works, plus the fact that, by then the ownership of works of art was an important part of any attempt to claim élite cultural status. This had its risks. Wang Zhen's two paintings purportedly by Yuan dynasty artists (i.e. his only 'old masters') have been judged by modern scholars to be fakes. Faking and copying with dishonest intent are inevitable corollaries of a market in works of art, and the growth of that market in the fifteenth and sixteenth centuries meant a huge expansion in such activities. Suzhou was the centre of such activities. Numerous fake old paintings were produced there, along with fraudulent versions of work by living élite calligraphers and painters such as Shen Zhou and Wen Zhengming (see p. 157)

The opportunities to buy works of art multiplied during the Ming dynasty. Dealers in art existed at all levels, from pedlars by the roadside, through Daoist monks for whom the monastery doubled as a place of business, to gentleman dealers whose commercial activities were heavily camouflaged behind the forms of élite sociability. It was possible to buy the work of commercial artists 'off the peg', as even Japanese visitors to China's ports in the fifteenth-century were

94

Porcelain jar for wine, painted in cobalt blue under the glaze with a scene from the romantic drama, 'The West Chamber'. Made at Jingdezhen, Jiangxi province, c.1320–50 CE.

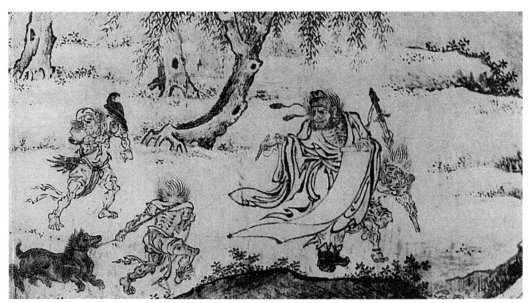

95
Detail of a hand scroll on paper, 'Zhongkui', by Yin Shan (active mid-fifteenth century CE).

provided with farewell pictures analogous to those of a well-connected painter like Tang Yin [**82**], made by workshops in cities like Ningbo. The extension of printing, and of printed pictures either as single sheets or in the form of book illustrations, meant that subject-matters and styles which had hitherto had rather precise references, to courtly, or religious, or élite social contexts, were now much more promiscuously available in a world of images which had to be negotiated on all sorts of levels by all sorts of people.

The grandest professional painters of the Ming period probably continued to work entirely to commission, painting only what they were retained to paint. They might be rewarded in a number of ways, from a straight cash transaction for a single piece, to a prolonged period of residence in the home of a patron, where they received a regular stipend in money or resaleable goods. At the top of the market stood someone like the Suzhou artist Qiu Ying (*c*.1494–*c*.1552), who spent part of his career living with the wealthy merchant and collector Xiang Yuanbian (1525–90), the owner of, among other things, the work shown in **69**. The fact that Qiu's precise dates are not known, at a time

The Commercialization of Technique

In the Ming period (1368–1644), manuals began to be published detailing the techniques of painting. Techniques began to be systematized and classified, an example of this being the 'Eighteen [Types of] Drawing' (Chinese: *shiba miao*), a list of techniques for depicting the lines of garments. First listed by the mid-sixteenth-century critic Zou Dezhong, they were further refined by Wang Keyu (1587–1645) in 1643. Similar listing of types of dots (*dian*) and types of texture-strokes (*cun*) are found in the texts like the 'Mustard Seed Garden Manual of Painting', published between 1679 and 1701, and continuously reprinted since then.

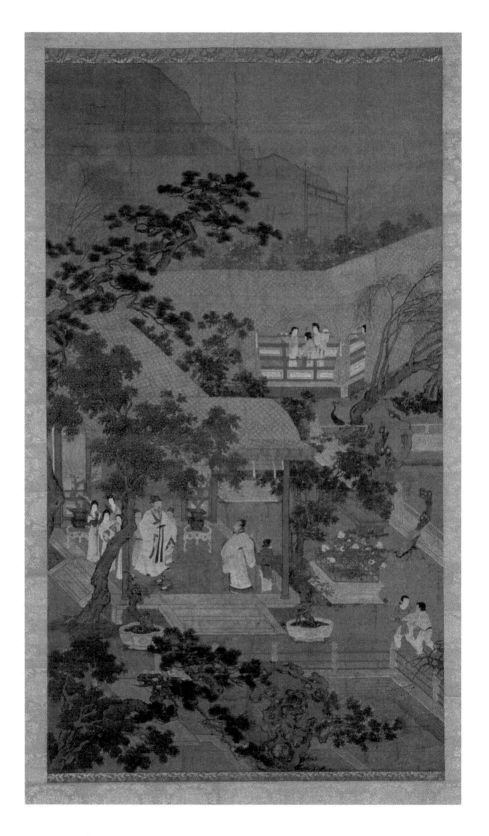

Hanging scroll on silk, by
Qiu Ying (c.1494–c.1552),
traditionally titled the
'Golden Valley Garden'.
First half of the sixteenth
century CE.

The Cost of Art

Preliminary research on the art market in
the Ming period (1368–1644) suggests
that important pieces of calligraphy were
the most expensive works of art. The
record prices of the age, where over 1,000
ounces of silver (a Ming ounce equalled
37.5 g) were paid for a single object,
nearly always involved works of
calligraphy. Important antiquities such
as bronzes, jades, and ceramics were also
in general more valuable than paintings.
The price of a contemporary picture
from a leading professional such as Qiu
Ying (c.1494–c.1552) [96] could be as
high as that of an 'old master'. He was

Detail of 96

paid on one occasion 200 ounces for a
single scroll. This was the price of a
reasonably large house.

when large amounts of writing about art and artists were being
produced, is itself indicative of his status in the eyes of the landowning,
bureaucratic élite of the empire. So is the fact that he left no body of
writings, and never inscribed his work with more than a simple
signature. It seems likely that he was patronized by his upper-class
contemporaries like Wen Zhengming, in both senses of the word. His
own estimation of his social and artistic position is lost to us, as is that
of his less famous customers. It may have been for one of them that he
produced two large hanging scrolls showing scenes from literary
history, both of which take place in gardens, and which have been in
Japan since at least the eighteenth century. One of these [96] depicts a
lavish setting traditionally identified with the 'Golden Valley Garden'
of the third-century CE magnate Shi Chong, although this has recently
been challenged. Undoubtedly there is a precise literary allusion
behind a painting like this, but in the absence of inscriptions it is hard
to pin it down. Such paintings are sometimes known in Ming and
Qing texts as *tang hua*, or 'reception hall paintings', meaning that they
were hung on specific occasions or at specific seasons in the main room
of a mansion, where guests were received. The subject here involves the
greeting of a guest, making it appropriate for such a use. The necessity
to change the *tang hua* according to the occasion, and the general
requirement that paintings hung in a room be seasonally appropriate,
must have had an effect on the total output of the Ming painting
industry as a whole, and also on the styles employed, since what
customers needed were a number of different images, rather than ones
which would be permanently displayed. Hand scrolls too were
produced for special occasions. Qiu was paid the huge sum of 100
ounces of silver for a pair intended as birthday gift for the purchaser's
80-year-old mother.[2]

Qiu Ying's work was faked, both in his own lifetime and sub-

97

Anonymous hanging scroll on silk, showing a scene in a palace garden, mid-sixteenth century CE.

sequently, on a massive scale. In later centuries, his name is attached to almost any work showing a luxurious mansion or palace setting, or involving beautiful women. His production of such pieces is only a very small part of what was in the sixteenth century a much larger output of pictures, from workshops of much less renown catering to a less well-connected body of customers. Very little of this work, excluded from all canonical formations of 'Chinese painting', survives but a few pieces which were exported at the time of their production were fortuitously preserved outside China. Some are in Japan and some even in Europe, with which certain coastal areas of China established commercial relations in the middle Ming. An Austrian archducal collection contains one such picture on silk, probably showing a popular scene from history and literature, the eighth-century emperor Tang Xuanzong accompanied by a group of palace ladies [97]. This was the type of figure scene, with appropriate literary allusions, also painted on Ming dynasty porcelain, and carved on Ming dynasty lacquer. Later legends that Qiu Ying was a lacquer artist or porcelain painter in his youth, though apocryphal, do contain a truth about the close relationship of painting to certain luxury crafts at this time.

The Ming Dynasty (1368–1644): Printing

As a technology of multiple production, printing came, especially after about 1580, to have a greater and greater impact on the possible appropriation of hitherto restricted cultural practices by a wider public. Knowledge, including knowledge about art, which had previously been transmitted orally, came to be available in the form of books. These books provided canonical lists and biographies of major artists (and by their exclusions closed down some possibilities). They catalogued and categorized for the first time in print things like the repertoire of brush-strokes. And they provided, through reproductions, versions of prestigious works of art for copyists and collectors. One of the most ambitious of these books was 'Master Gu's Pictorial Album' (*Gu shi hua pu*) of 1603 [98]. Its 106 (monochrome) versions of paintings by masters from Gu Kaizhi in the fourth century CE, down to the still-living Dong Qichang [85], made available to purchasers of modest means single images which 'fixed' the typical style of all the artists involved. According to the preface, this was done explicitly with the aims of exposing the novice collector to the styles of very rare (and expensive) early masters, and of preventing the purchase of fakes. Knowledge about art, as well as works of art themselves, was now fully in the market-place. Some of *Gu shi hua pu*'s pictures are imaginary (especially with regard to very early artists), but some are taken from actual works, as is the case here, with a precise copy of a section of the Ren Renfa 'Feeding Horses' scroll [76] which the text nevertheless mistakenly attributes to another Yuan dynasty artist, Zhao Yong (1289-1362).

Another consequence of the growth in the market for printed images was the use of printed designs in the arts other than painting. These were often ephemeral, and scarcely survive, although some fragmentary volumes of embroidery patterns are still extant. The technically finest of these pattern books may never have been intended for use, but were rather themselves marketed as collector's items. This was certainly true of two sets of designs produced by two rival firms of ink manufacturers: 'Master Fang's Ink-Cake Album' (*Fang shi mo pu*) of 1589, and 'Master Cheng's Garden of Ink-Cakes' (*Cheng shi mo yuan*) of 1606 [**99**]. Both were based in the merchant-oriented culture of Anhui province, rather far from traditional centres of artistic patronage like Suzhou. They were marketed on an empire-wide scale, and enjoyed an empire-wide reputation, partly in the case of the latter through employing a renowned professional painter, Ding Yunpeng (fl. 1584–1618), to do some of the designs. A highly eclectic collection in terms of subject-matter, *Cheng shi mo yuan* includes images copied from imported Jesuit prints of Christian subjects (see p. 129), as well as

Embroidery on silk, 'Washing a Horse', from an album of copies of Song and Yuan dynasty paintings by Han Ximeng (early seventeenth century CE), dated 1634.

some of the first colour prints produced by the use of a multiple wood-block method (as opposed to inking different areas of the same block with separate colours). Elements taken from these books were heavily utilized in the seventeenth century, to provide motifs which were placed by makers on jade-carving and lacquer work, among other craft forms.

The Ming Dynasty (1368–1644): Textiles and Crafts

Textiles were an area where certain types of production in particular came to be more intimately associated with printing and painting in the sixteenth century (though the reproduction of painting in this medium goes back to the Southern Song, see **27**). Embroidered and woven scrolls were often catalogued by private collectors in the Ming dynasty on the same basis as paintings on paper or silk, although now they tend to be viewed differently by art history, as part of the 'decorative arts'. Questions of gender may have a bearing here, for embroidery in particular was assumed to be a womanly art, with the result, as feminist art historians have shown with regard to Europe, that it has been excluded from the masculine category 'art' altogether. The leading embroiderers of the late Ming were all women, and were highly regarded in their day. The best-documented of these was Han Ximeng, married to a member of the Gu family of Shanghai; it was the (male) family name which was given to the type of work done by Han and her female relatives, 'Gu embroidery' becoming one of the most famous of late Ming trademarks in the luxury crafts. The leaf shown [**100**] comes from an album of eight embroidered copies of Song and Yuan dynasty paintings completed in 1634, done in silk embroidery on a silk ground, such faithful copies of brushwork being the Gu family speciality. Their work was commercially available, as the women of this once degree-holding family plied their needles to support continuing pretensions to an upper-class lifestyle. The blurred boundaries in the early seventeenth century between commercial and purely social forms of artistic production are shown by the fact that Dong Qichang, who did more than anyone to inscribe the amateur/professional divide at the heart of art criticism in China, praised Han Ximeng's work highly, in an inscription written on this album. Recent scholarship has stressed the fluidity of actual gender roles among the seventeenth-century élite, in opposition to the rigid divisions imposed by Confucian social morality. As embroidery enjoyed a rise in status to become an art form, it was then practised by certain men as well. A more important result of the esteem felt by some men for the embroidery practised as art by upper-class women was eventually to install the amateur/professional divide here too. The Gu family did in fact market their work commercially, but it was somehow viewed as all right for them to do so, given their social connections and scholarly background.

101

Woven silk tapestry (*kesi*)
showing Dongfang Shuo
stealing the peaches of
immortality, with a woven
inscription copying calligraphy
by Shen Zhou (1427–1509).
Made by Wu Kan of Suzhou,
late sixteenth–early
seventeenth centuries.

The same may not have been true for another textile copy of a Ming painting [101], a woven silk tapestry (*kesi*) version of a painting with inscription signed by Shen Zhou (see p. 156). The image is of the Han dynasty magus Dongfang Shuo, focus of numerous myths, whose theft of the peaches of immortality from the Queen Mother of the West made him an appropriate subject for birthday present pictures. The highly complex technical requirements of tapestry weave put it outside the grasp of well-born amateurs of either sex, and it is certain that the 'Wu Kan of Suzhou' who signed the work was a professional. What is highly significant is that the work is signed at all. Objects like the porcelain pillow [93] were being stamped with trademarks in the thirteenth century, and carved lacquer was signed in the fourteenth, but it was in the sixteenth that the practice of signing work spread widely into ceramics (where it was first used on Yixing stoneware teapots like **90**), jade-carving, pewter- and bronze-casting, and other luxury crafts. It was a matter of amazement to writers around 1600 that the *name* of the maker could now affect the price, but this was the result of the growth in discrimination between goods attendant on a thriving commercial economy. As with any type of commercial enterprise at this time, succession in the artistic trades tended to be hereditary. Qiu Ying's daughter and son-in-law both were successful as professional painters. Family dynasties of designers and block cutters dominated the printing trade, and similar lineages can be traced in bronze-casting, bamboo-carving, and other crafts.

Typical of the 'star' craft producers of the seventeenth century was the bamboo-carver Zhang Xihuang, famous for his ability to imitate the effects of calligraphy and painting through a technique which involved selectively cutting away the green 'skin' of the bamboo stem, which then dried to a tawny brown [102]. The composition of a mansion among a rocky landscape, seen on a brushpot which prominently bears his signature, is entirely dependent on the conventions of painting, as mediated through printed reproductions like those in *Gu shi hua pu*. Drawn patterns were more widely used as an essential part of a number of manufacturing processes from this time. The use by craftsmen and women of designs with their origins in the art of painting continued throughout the Qing dynasty (1644–1911), and many of the leading makers of the period were famous for what were essentially reproductions of paintings in other media. This domination of painting over other art forms contrasted with the separate visual aesthetic which a craft like, for example, lacquer had employed before that time. No lacquer artist before the eighteenth century produced anything like the set of flat panels [103] in carved lacquer signed by the master carver Lu Guisheng. The technique employed to make them is no different from that used to make the early fifteenth-century table [30], but the use to which the technique is put is entirely different.

The Amateur/Professional Problem in Late Ming Painting

By about 1600 CE, if not before, the notion of a 'professional' painter in China is complicated by the absolute ascendance of the scholar-amateur ideal in key areas of artistic production. Many of those painters who did rely on marketing their work for their economic support, also relied on appearing *not* to do precisely that thing. (Wang Hui is a good example, see p. 74.) However, contexts remained in which such pretensions were either unnecessary or unsustainable. One of these was the production of commemorative portrait images, used among other things in funeral rites for the dead. Ritual demands (it would be disastrous to sacrifice to someone else's ancestors by mistake) meant that accurate delineation of the features of the deceased was extremely important in this context of representation. This fact, taken together with a new fascination on the part of the early seventeenth-century élite with the quirks and obsessions of the individual personality,[3] caused some strikingly 'realistic' portraits to be made at this time. Another possible factor, though this is more controversial, is the exposure of some artists to imported images brought from Europe by Christian missionaries, images whose illusionistic three-dimensionality was certainly remarked on by certain late Ming writers. (At least one imported technical resource was adopted at this time, namely the red pigment known as carmine, which is first attested in China in 1582.) Commemorative portraits were not purely for funerary purposes. Printed portraits of authors were included in books, and the faces of the famous were of interest to a wider circle than immediate family and friends. A surviving album of 'Portraits of Eminent Men of Zhejiang Province' [104] contains twelve head-and-shoulders effigies of luminaries of the day, possibly preparatory sketches for more

102

Bamboo brushpot,
by Zhang Xihuang,
seventeenth century CE.

103

Panel of carved red lacquer,
signed by Lu Guisheng, early
nineteenth century CE.

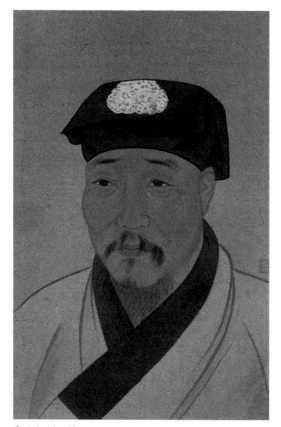

'Portrait of Xu Wei', one of an album of twelve anonymous 'Portraits of Eminent Men of Zhejiang Province', first half of seventeenth century.

finished effigy portraits to be executed later. Most of these are in the full-face posture associated with commemorative funeral effigies, but this portrait of the painter and dramatist Xu Wei (1521–93) is a three-quarter view. All of them are anonymous, a sure sign of their production to order by a professional painter.

Portraiture revived in élite esteem in the seventeenth century, and was taken by some out of the hands of artisans to be reinvested with the discourse of 'art'. One man among several who exploited this change in the hierarchy of genres was Chen Hongshou (1598–1652). He more successfully than any contemporary played 'amateur' and 'professional' as the social roles they essentially were, negotiating between them as occasion demanded. This has caused great debate among subsequent critics, for whom these categories were fixed and immutable, as to whether he was 'really' one or the other. This is not a helpful way to look at it. More intensive scholarship in recent years has demonstrated that he engaged in transactions of both types simultaneously. He came from a bureaucratic and landowning family, and obtained a place on the lowest rung of the ladder of the imperial examination system, the path to political power and social prominence. He spent a brief period at the court in Beijing, where he worked as a copyist of imperial portraits. He engaged in the production of pictures for the types of

105

Hanging scroll in ink and colours on silk, 'Female Immortals', by Chen Hongshou (1598–1652 CE), and his assistant Yan Zhan, second quarter of seventeenth century.

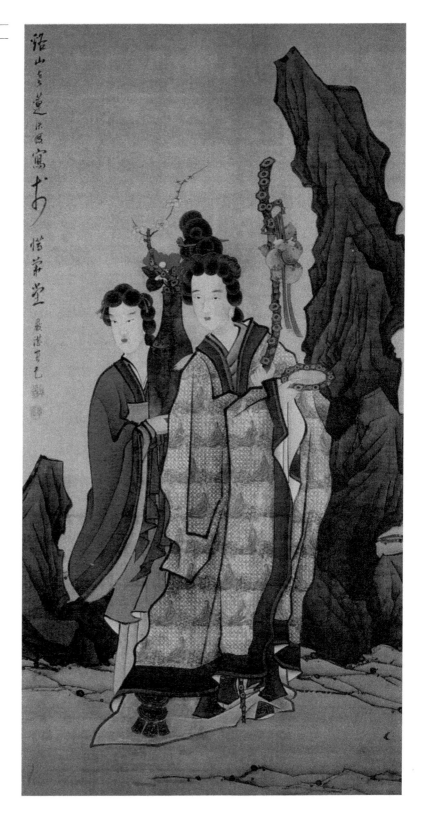

social exchange standard among his class, often elaborate figural scenes of historical significance accompanied by lengthy and erudite inscriptions. But he also, and particularly after the Manchu conquest (1644) destroyed his family's economic position, painted for money. He was active as a designer of prints, both illustrated editions of famous dramas, and the much more ephemeral form of playing cards for use at the gaming table. He also produced pictures like **105**, which bears no inscription other than his name, and the name of the assistant who added the colour to his outline painting of female immortals, a suitable image for display as a *tang hua* on any one of a number of festival occasions. Such an image, which exists in other very similar versions (it is almost part of an 'edition' of images rather than an absolute 'original'), is a product of his workshop, available on a simply commercial basis to a customer whose relationship with the painter is so tenuous that the scroll is not even dedicated to him or her. That customer, by going to Chen's workshop, was not interested simply in purchasing an anonymous goddess image to hang at the New Year, but rather in having a 'real' Chen Hongshou, a work by a professional with all the kudos of the upper-class gentleman.

The categories 'scholar-amateur' and 'artisan-professional', which have dominated the history of Chinese painting since the seventeenth

century, are thus better understood as social roles than as hard and fast descriptions of lived reality. I have chosen to write about Chen Hongshou in this chapter and about Shitao in the previous one (see p. 163), but that is a decision which could easily have been reversed. Nor can a distinction be made between them on purely stylistic grounds, since the spread through printing of works like the 'Ten Bamboo Studio Manual on Calligraphy and Painting' (*Shi zhu zhai shu hua pu*) of 1633, and the 'Mustard Seed Garden Manual of Painting' (*Jie zi yuan hua juan*, the first part was published in Nanjing in 1679) made the components of all previous styles available to anyone who had the skill to master them. These books were merely the systematization and commercialization of the ancient practice of keeping personal sketchbooks of elements from paintings seen and studied (these are *not* sketches taken from the life). This practice was common to artists of every social background, and the example shown [106] is one of forty-six leaves surviving from the originally much larger personal album of a professional painter named Gu Jian-long (1606–84), who spent some time at the imperial court towards the end of his life. It would have been used by Gu and by his students, to enable the brushwork, types of stroke, and compositional form of given earlier masters to be incorporated in his own work.

The Qing Dynasty: 1644–1911
The blurring of social and stylistic distinctions in the Qing period did not mean that any kind of image could be produced by any kind of artist. Signing and inscribing conventions, for example, continued to vary according to the context in which a picture was manufactured and in which it would be viewed. A very large painting on silk [107], depicting a lavish and modish interior in the height of eighteenth-century fashion, is neither signed by its maker nor inscribed in any way. It may once have formed the panel of a standing screen, or else may have been pasted directly on to a wall, a format which was of increasing popularity in the middle of the Qing dynasty. The scene shown is probably from the still-popular romantic drama, 'The West Chamber' (see 94), a subject which was painted on very large quantities of commercially marketed ceramics from Jingdezhen c.1680–1700, and disseminated through the illustrated printed editions of the text. By the standards of official morality at that time, the picture is decidedly charged with eroticism, the degree of physical proximity between the two lovers being enough to make it a picture not suitable to be shown in a domestic setting. It may have been made for display to the male clientele of a brothel or restaurant, and was certainly made in one of the cities of the lower Yangtze region, cities like Yangzhou and Suzhou, where the commercialization of all forms of pleasure, visual pleasure among them, was further intensified in the eighteenth century. The

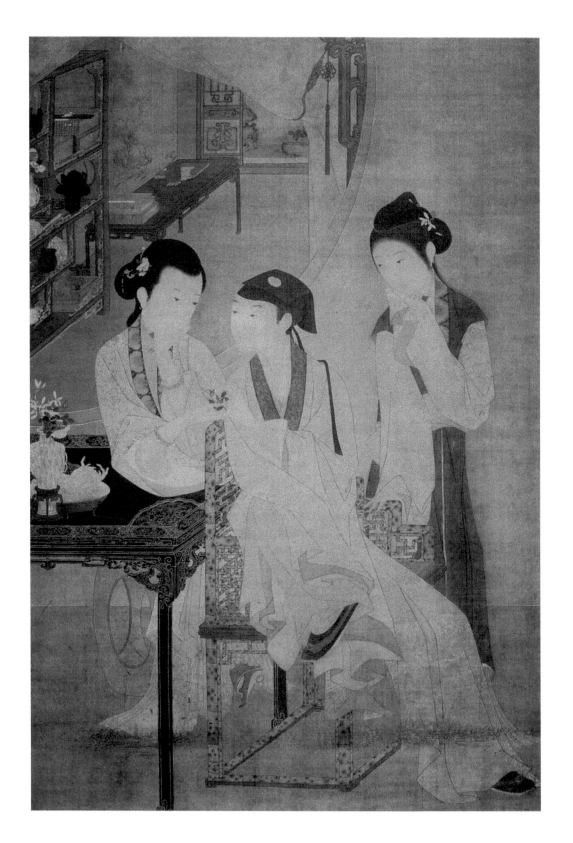

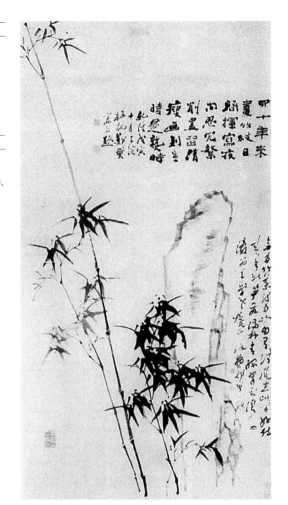

highly detailed rendering of silk garments, expensive furniture, antiques, and even a painting within the painting, evokes a body of (male) customers for such work for whom the women, and the picture of the women, are themselves also luxury commodities.

This would be widely recognized in art-history writing as typical 'professional' painting: figures illustrating a known story, executed on silk, anonymous, highly coloured, and detailed. No less 'professional', however, is an almost contemporary but visually very different painting in monochrome ink on paper of bamboo stems and rocks by Zheng Xie (1693–1765) [**108**]. Although the subject-matter had by Zheng's time long been associated with scholarly ideals of the gentleman's lofty moral character (see p. 142), and although the rapid manner of execution and the close integration of inscription and image fulfil the demands of upper-class amateur aesthetic theory, this picture was made to be sold for cash as surely as the 'West Chamber' illustration. By the mid-eighteenth century, and especially in Yangzhou where Zheng Xie worked and where a body of customers of merchant

background were eager for access to the trappings of high culture, the amateur ideal in art was just one more commodity. Indeed, Zheng Xie was notorious for posting an open price list of his work, emphasizing that, although he had held office and was by Qing standards a respectable 'scholar', he would no longer produce work for reciprocal social favours, but only in return for money. By so blatantly proclaiming himself a professional artist, rather than pretending to be an amateur while in fact deriving his income from art, he may have sought paradoxically to stress his high-mindedness and integrity. A further paradox is that commercial pressures on Zheng and artists like him may have encouraged the adoption of the most 'sketchy' scholarly styles, since a comparison of the materials and labour needed to produce **107** and **108** shows how much more quickly works like the latter could be turned out. Zheng's relatively good income came from the manufacture of large numbers of pictures, sold quite cheaply, rather than from single expensive items. It has been calculated that he would have needed to sell 250 pictures a year to sustain his income of a thousand 'ounces' (*liang*) of silver a year in the 1740s.[4] This may have led, as it certainly did in the case of some of his contemporaries, to the employment of 'substitute brushes', assistants who could reproduce his style of brushwork for the less discerning customer.

Prints and Perspective

One visible difference between **107** and **108**, despite the similar conditions of their manufacture, lies in the conventions of representation which they respectively employ. The drama illustration is distinguished by its adoption of elements of the type of perspective developed in European painting from the fifteenth century, seen even more clearly on a landscape print from 1734, showing one of the gates of the city of Suzhou [**109**]. Although some élite artists had experimented with the imported techniques of fixed-point perspective and the rendering of mass through shading as early as the beginning of the seventeenth century, it was to be professional commercial artists who more fully integrated them into Chinese artistic practice through the course of the eighteenth and early nineteenth centuries. This was done not so much in the realm of painting as in other arts like those of print-making and ceramic decoration. Although Suzhou was no longer the absolute centre of artistic hegemony it had once been, it remained a centre of luxury manufactures, much visited by tourists. It also remained a centre of printing, particularly the production of decorative pictures such as this one, often printed in colour, and often showing scenes of the city and its surroundings. Scenes from drama and literature, as well as images of beautiful women, often in domestic settings, were also popular products. These could be mounted as scrolls, or pasted directly on to the walls, being replaced annually when

109

Colour print from wood blocks, dated 1734 CE, showing Changmen, one of the gates of Suzhou, where the print was published. The presence of an extensive (printed) poetic inscription at the top of the large image testifies to the adoption by commercial artists of the conventions of élite art by this time.

new images were put out by the publishers. As well as being disseminated throughout the Chinese empire, these prints were extensively exported to Japan, where their subjects were taken up by Japanese print artists who, like their Chinese counterparts, served a predominantly urban clientele. However, the idea of the 'star' print artist which became so important in Japan did not originate in China, where upper-class writers on art never displayed enough interest in these pictures to make those who drew them famous.

Although exported, Suzhou New Year prints were not made principally to be sold abroad, and their use of foreign drawing techniques was only one marketing strategy designed to appeal to the taste of Chinese customers for the novel, fashionable, and exotic. There were several potential mechanisms whereby their artists could became familiar with imported European pictures. Immigrant artists at the imperial court were one possibility (see p. 78), although it is unlikely their work was widely seen outside the palace precincts. Catholic missionaries in other parts of the empire presumably also displayed religious paintings and owned illustrated books [65] which were seen not only by converts but by the intellectually curious. Perhaps even more widely available were the quantities of European printed and drawn pictures brought to the southern port city of Guangzhou (or Canton) to act as models for the Jingdezhen ceramic industry's extensive production of porcelain for foreign customers. Western pictures had been copied on to porcelain from the mid-sixteenth century, but the rate of production increased dramatically after 1700. Ceramics with designs ordered by foreign trading companies (principally the Dutch and British but also ships from France, Denmark, Sweden, and after 1784 the USA) were made in very large quantities, but individual pieces were made to special commission, often involving the painting of the objects in enamel

European collections of 'curiosities' included Chinese objects as early as the sixteenth century [97]. From the nineteenth century, museums in Europe and America have consciously included work from China, categorized either as 'art' or as 'archaeology'. Ceramics, which had been exported by the Chinese in large quantities as trade goods, were an early focus of Western collecting, particularly in Europe. Contact with Japanese scholarship in the late nineteenth century led to a growing interest in Chinese painting, more obviously in the USA, with collections such as the Boston Museum of Fine Arts, and the Freer Gallery, Washington.

Political and economic weakness in early twentieth-century China allowed Western museums and private collectors to take out of the country many significant art works, sometimes in controversial circumstances. The principal areas of collecting interest were early bronzes and jades, ceramics, Buddhist sculpture, and painting. Calligraphy was less avidly collected outside China. New York and London have acted historically as centres of dealing in Chinese art, although their dominance is coming to an end at the time of writing. Most major private collectors of Chinese art now once again live in Asia, and new museums in centres like Hong Kong are rapidly expanding.

The international art market creates and services new types of collecting, for example, recently in the West of Chinese furniture or textiles. New types of academic activity often follow in the wake of these commercial developments. The economic value of works of art has led to the establishment of an art market within China itself, but also to the continued illegal excavation and export of many kinds of art work.

Detail of 97

colours over the glaze. This overglaze painting was done in workshops in Canton, as well as in the ceramic city of Jingdezhen, and it was probably in Canton that a workshop painted this bowl [110]. It carries a copy of a print by the English artist William Hogarth (1697–1764), published in London in 1749 and entitled 'The Gate of Calais', as well as the arms of the English aristocratic family of Rumbold for whom it was made. The print (probably a hand-coloured version) was sent out from Britain, but is very unlikely to have been returned with the bowl. Rather it, and literally thousands of images like it, remained in Canton in the eighteenth century, perhaps being destroyed very quickly, perhaps being passed on.

The easy familiarity with Western conventions of representation on

111

'Self-portrait', oil on canvas, by
Guan Qiaochang (Lamqua,
1801–*c*.1860 CE), late 1840s.

the part of Cantonese artisans in all sorts of crafts meant that objects
destined for export, and to suit Western tastes, were manufactured
throughout the eighteenth century. From the second half of the
century these included pictures, often botanical illustrations or images
of birds and animals, but also including views of Canton, scenes of
craft production, and (after about 1770) portraits of European subjects.
As with so many other crafts, transmission of skills was on a hereditary
basis, and one successful lineage of painters has recently been traced
through three generations, beginning with the portrait artist Guan
Zuolin in about 1774. His Western customers knew him by the
nickname 'Spoilum', just as they knew his son (or possibly grandson)
Guan Qiaochang (1801–*c*.1860) by the nickname 'Lamqua' [**111**]. Guan
Qiaochang would have had considerable training as an artist within
the family workshop before becoming, in the 1820s, a formal pupil of
William Chinnery (1774–1852), an Irish artist who had established
himself in the Portuguese colony of Macao, near Guangzhou, in 1825.
Guan later set up as a successful commercial rival of Chinnery, heading
a large workshop producing pictures of many kinds in both Chinese
and European styles for a predominantly foreign audience. He himself
worked mostly in oil paint, exhibiting portraits at the Royal Academy
in London in 1835, and in New York and Philadelphia in 1841 and 1851.
His brother Guan Lianchang ('Tingqua') also headed a workshop
producing watercolours for export, the extensive use of stencils, pattern

books, and production-line division of labour enabling the business to manufacture in bulk images which formed and reinforced European visual stereotypes of China. How these images were construed by the Chinese artists who made them (or any who saw them) is as yet unclear.

Although 'Lamqua' and his Cantonese contemporaries are not generally integrated into the history of 'Chinese painting', they added significantly to the possibilities for visual representation in China, particularly in technical terms. But like his contemporaries in Europe, Guan Qiaochang had to deal with the effects of another new technology of representation, that of photography, which was adopted enthusiastically by professionals, as well as by certain members of the élite, very shortly after its invention. By the late 1840s or early 1850s, photography studios began to be set up in the coastal cities of Xiamen and Guangzhou, and a Chinese photographer travelled to Japan with the American Commodore Perry in 1854. Portraits, for use in commemorative contexts like funerals and in family worship, were the main type of work produced. Necessarily, very early photography in China did not so much initiate a new 'way of seeing', as it appropriated the conventions of painting, in terms of subject and style. The self-portrait made by the Cantonese scholar and scientist Zou Boqi (1819–69) [112], draws on the conventions of élite portraiture, including the kind of painting being executed in oils by artists like Guan Qiaochang at the very same time. The effect of the introduction of photography into the Chinese art scene was to have a much greater impact on professional painters, in particular on effigy painters, than it did on those operating in the more prestigious 'scholarly' styles, since in the latter mimesis, and the transcription of observed forms, were not seen as the central role of art. There was to be no 'crisis of representation' brought about in nineteenth-century China by photography's ability to replicate the thing seen, since such replication was not how the art of painting had been understood for at least several hundred years. An artist like Ren Xiong, operating in Shanghai (see p. 171) may well have seen photography, and there are signs of a response to it in his work, but it required from him no radical rethinking of the basis of his art.

Shanghai in the Nineteenth Century

Demographic changes in nineteenth-century China shifted the patterns of art patronage and artistic production, in particular the growth of Shanghai as the empire's largest and most commercially vibrant city. Professional artists migrated here in search of customers, among whom after about 1870 were a number of Japanese resident merchants, involved in shipping home both contemporary and antique Chinese art. The commercial growth of Shanghai also made available

'Self-portrait', photograph by Zou Boqi (1819–69), one of the earliest photographers working in China who can be identified by name, and who completed his first writings on the new technology in 1844. Taken c.1850–60.

to artists an expanded range of imported pigments, which were enthusiastically adopted.

One of the most admired painters of what was at the time recognized as a distinctive 'Shanghai school', admired equally by Chinese connoisseurs, was Ren Yi, also known as Ren Bonian (1840–96) [113]. The legend has it that he began his career faking the work of the more famous Ren Xiong, and was then taken on as a student by Ren Xiong's brother Ren Xun (1835–93). His painting of a beauty leaning wistfully on a balustrade, by a branch of flowering plum, is typical in employing the brushwork associated with the 'scholarly' tradition in painting to depict a subject more usually found in the immediately preceding centuries in the repertoire of anonymous professionals. Ren himself found many of his customers among Shanghai's business community, rather than among the traditional élites of the bureaucracy or landowning class. Such people may have felt less uncomfortable with the open commercialism of many of the Shanghai artists, who eschewed the social forms designed to camouflage the stigmatized professionalism of their eighteenth-century predecessors, and marketed their work openly through mounting-shops or through known agents. In Shanghai, an artist could be a member of the business community too. The possibilities for building an artistic reputation were increased by the possibility of work as a commercial illustrator, in the periodical press which flourished after the establishment of the *Dianshi Studio Pictorial*, Shanghai's first illustrated magazine, in 1884.

Ren Bonian's daughter, Ren Xia (1876–1920), as well as carrying out work originally commissioned from her father, also made a successful career for herself as a professional, specializing in figure scenes from history and literature. She probably also derived income from tutoring the daughters of the well-to-do in calligraphy and painting. Art education in the late nineteenth and early twentieth century in China was generally on the basis of one-to-one tuition, but within Ren Xia's lifetime a new model of art as the object of public instruction was to provide an additional way of conceptualizing how artists should be trained, and how they might relate to the public which bought their work.

The Republic of China

A certain amount of art and design training was available in the reformed educational system put in place by the imperial government in its last decade down to 1911, particularly in the fields of ceramics and textiles. The initial aim was to produce designers for craft products which would sell internationally, rather than fine artists. Painting in both Chinese and Western styles was taught in government academies as early as 1906, and students were sent to

113
'Young Woman at a Window with Plum Blossoms', hanging scroll on paper by Ren Yi (1840–96 CE), dated 1884. The long calligraphic inscriptions were added in the early twentieth century by two separate writers.

the Tokyo School of Fine Arts in Japan at the same time, where among other things advanced instruction in oil-painting techniques was available; this was the preferred mode of a comfortable majority of the ninety or so Chinese students who studied there in the first half of the twentieth century. They brought back from Japan not simply new techniques but a new conceptual vocabulary, including the word *meishu*, 'art' itself, appropriated from the Japanese term *bijutsu* to describe for the first time a collective set of practices and institutions making up a modern 'art world'.

The overthrow of the Qing dynasty by the Republican revolution of 1911 changed China's political structures, but also accelerated and sharpened debates over 'traditional' culture, which was the object of

114

'Studio by the Water', album leaf on paper by Chen Hengke (1876–1923 CE), dated 1921.

sharp critique and robust defence in the early Republican decades. Visual art formed part of the cultural battleground, becoming a site of struggle between contending visions of China's future. Some proposed total 'Westernization'. Others opposed it vehemently. A widely espoused position aimed at a 'synthesis' of the best parts of what were seen as total artistic entities, and indeed this was the aim of the first dedicated arts school in China, set up privately in Shanghai in 1912 by a precocious teenager named Liu Haisu (1896–1994) All this activity ignored the existence within China of a century and a half of commercially successful art in a Western manner, and no Republican artist was to claim a forgotten figure like 'Lamqua' as a forerunner.

The creation of a category of 'modern' Chinese art implied the creation of its opposite, that of 'traditional' Chinese art. This is the label too often still unthinkingly given to work like a painting [**114**] by Chen Hengke (1876–1923), a figure who maintained into the Republican period the practice that important practitioners of painting in China were also its principal theorists. Chen's 'Studio by the Water' is in a format (the album leaf), and in a medium (ink and colour on paper) which had a very long history in China. Its subject matter is similarly one which had engaged artists in China for centuries. But it is only a 'traditional' Chinese painting in the sense that Pablo Picasso's 'Demoiselles d'Avignon' (1907) is a 'traditional' European painting, given that the latter depicts the nude female form in oils on canvas, a

centuries-old practice. In style, Chen's unpretentious image is not that of a work of the eighteenth century, or the sixteenth (compare **80** for example). And it does not represent an unthinking conservatism, or a simple resistance to modernity, rather a conscious and sophisticated awareness of what modernity might be in pictorial terms. In the same year in which he painted this picture, 1921, Chen published an important theoretical essay entitled 'The Value of Literati Painting', written in the new standard vernacular Chinese language (Chen had been a student roommate in Japan of modern Chinese literature's most distinguished writer Lu Xun (1881–1936)). In the essay, he displayed an awareness of the changes taking place in art outside China:

Western painting can be described as extremely faithful to form. Since the nineteenth century, in accordance with the principles of science [Western painting] has meticulously rendered objects with light and colours. Lately, however, postimpressionism has run counter to that course; it de-emphasizes the objective, and focuses on the subjective, and is joined in its revolutionary performances by cubism and futurism. Such intellectual transformations are sufficient demonstrations that verisimilitude does not exhaust the good in art and that alternative criteria must be sought.[5]

Chen was able to use his awareness of post-impressionism, cubism, and futurism to argue that there were within Chinese painting itself the elements of subjectivity and self-expressionism which made it intrinsically 'modern' art, without the necessity of mechanically acquiring the representational canons of European painting. The 'spirit resonance' (*qiyun*) of Xie He's venerable and revered 'Six Laws' (see p. 46) was now understood by such as Chen Hengke, and fellow members of groups like the 'Chinese Painting Research Society' to provide a charter for the individuality and subjective expression which were a necessary part of a 'modern' form of art.

Chen was associated, as a teacher of painting, with the leading intellectual centre of the Chinese Republic, Peking University. In the years before his early death, he would have encountered there a younger artist who took a very different tack in his response to the creation of art that was both 'modern' and 'Chinese'. This was the name most closely associated today with the project to make a self-consciously 'new' Chinese art by blending East and West, that of Xu Beihong (1895–1953). Despite his subsequent canonization as a 'founding father' of modern Chinese art, he was not, as we have seen, the first person to make oil-paintings in the Western academic manner, nor was he the first Chinese artist to study in Europe. Fang Junbi, daughter of a wealthy family settled in France, attended the École des Beaux-Arts in Paris from 1917, and another upper-class lady named Jin Zhang followed some courses at the Slade School of Art in London as early as 1900–5. But Xu was the first person to study art in Paris and Berlin on a (rarely paid) Chinese government scholarship, from 1919–25. It was the prestige he gained from this, coupled with his own artistic and self-presentational skills, which gave him such a

prominent position in certain artistic circles. He owed his start to an artist of an older generation, Gao Jianfu (1879–1951), who in 1915 spotted him producing cheap fan paintings aimed at the bottom end of the Shanghai art market. Gao Jianfu, his brother Gao Qifeng (1889–1935), and a third artist named Chen Shuren (1883–1949) were all from Guangzhou, had studied in Japan, and been active participants in the 1911 revolution.

Their 'Lingnan' (from an alternative name for Guangdong province) school of painting was closely associated with members of the Nationalist Party (Guomindang), dominant in China's confused Republican politics after 1927. Their art therefore came close to being an officially approved 'national' style, increasingly described using the term *guohua*, or 'national painting'. In the late 1920s, Gao Jianfu in particular often incorporated into his *guohua* practice as an artist images of modernity such as motor cars, tanks, and aeroplanes [115], the latter in particular being a popular icon of Republican modernity, found on contemporary postage stamps and other pieces of official imagery. Lions, eagles, and horses were also popular subjects, often inscribed with texts which made explicit their role as symbols of the struggles of the 'new' Republican regime. The technique in which these works are painted in ink and colours on paper is one which Gao had mastered in Japan, his type of perspective being closer to the Western conventions as assimilated there, and his washes (as opposed to the use of *cun* texture strokes, see p. 151) being also visibly related to the style of contemporary 'Japanese painting', or *Nihonga*.

Gao Jianfu was chief organizer of China's first government spon-sored national art exhibition, held in 1929. This put in place the last piece in the network of art institutions in the country, together with art education in state colleges and universities. The Guomindang regime understood the value of art patronage in sustaining its claim to safeguard China's heritage as well as its future, opening museums (including the former imperial palace in Beijing), and allowing many of the most important objects from the former imperial collection to

115
'Flying in the Rain', hanging scroll on paper by Gao Jianfu (1879–1951 CE), c.1920–30. Gao's deliberately hard-to-read calligraphy was a distinctive feature of his painting at this time.

travel to London in 1935 for an exhibition which raised the profile of ancient Chinese art in the West at the same time as it subverted any notion of the possibility of 'modern' Chinese art in the eyes of Western critics. To them 'Westernization' in the arts meant not creative appropriation (as when Picasso was supposedly influenced by 'primitive' art), but sterile imitation, the loss of the essence of the Chinese tradition. Such views were widely held by conservative theorists of the 'national essence' within China also, conditioning the climate in which the Lingnan school artists worked.

This growing polemical opposition of 'Westernization' and national 'tradition' was felt even more keenly by the young Xu Beihong, who nevertheless espoused in the 1920s and early 1930s an extreme position with regard to the necessity of fitting representational techniques from the West to the matter of Chinese art. He aimed to develop the history painting which was at the heart of the French academic tradition in which he was trained (a tradition effectively moribund in France itself by the time he studied there), with huge oil-paintings like 'Tian Heng and his 500 Retainers' (1928) and 'Awaiting the Deliverer' (1930–3) [116]. The subject is drawn from an ancient Chinese text, regarding the common people's desire for a just ruler, and has explicit references to contemporary politics. The marketing of such work was difficult, and Xu depended more on his position as a teacher in various art academies, and as a portrait painter in the Western manner, to earn his living. He also developed a certain reputation outside China, as impresario of an exhibition of contemporary Chinese painting which toured Europe in 1933.

116
'Awaiting the Deliverer', oil
on canvas, by Xu Beihong
(1895–1953 CE), painted
1930–3.

Xu Beihong's deployment of the most conservative available resources of European painting was only one response of artists in China to the enlarged art market of the Republican period. Well-born amateurs continued to learn and paint in contemporary versions of earlier scholarly styles, while calligraphy remained at the centre of the self-image of the well-educated person in many families. Painters in what was increasingly coming to be seen as the 'traditional' manner continued to sell their work very successfully to private collectors, often using art-materials shops as intermediaries.[6] In the major cities, most particularly Shanghai, a tiny self-conscious avant-garde chose a different mode of expression, with commercial and critical success in inverse proportion to the passion and commitment of the artists who formed it. The 1929 National Exhibition was the occasion of a bitter exchange of polemics between partisans of these modernists and Xu Beihong, in which the latter caustically maintained that 'Manet is mediocre, Renoir is vulgar, Cezanne is shallow, Matisse is inferior'. The poet Xu Zhimo (1895–1931, and no relation), responded that 'The truthfulness or falsehood of art can be gauged neither by empirical experience nor by intuition; and art must be granted its own autonomy from which 'the genuine independent spirit' emanates.'[7] This 'art for art's sake' position owed much to Xu Zhimo's links with the Bloomsbury Group in interwar Britain, but something too to the long history of Chinese painting as an art not focused on realistic transcription of observable phenomena.

'Nude', oil on Canvas, by Lin Fengmian (1900–91 CE), c.1934.

Although occasional collectors, often themselves returning students from France, were appreciative of the modern movement in art (one collected an impressive group of early Picassos), a modernist artist like Lin Fengmian (1900–91) was just as dependent as Xu Beihong on a teaching post. Economic liberation for most painters in Republican China did not go together with artistic freedom. The market for their work simply was not there, and consequently some would-be modernist artists found jobs in the commercial graphics industry, contributing in Shanghai to a vibrant plurality of styles in advertising, and in book and periodical illustration.

Lin Fengmian had also spent time as a student of painting in France, but had there engaged much more deeply than many of his Chinese contemporaries with the work of the modernist and anti-academic styles and 'isms', favoured by the contemporary Parisian art market, and by wealthy collectors: Post-impressionism, Fauvism, and Primitivism. He may well have studied the work of Matisse and Modigliani in particular, and on his return to China in 1927 to take up a teaching post, continued to work in styles and media which owed a lot to his Paris experiences. His 'Nude' [117], painted in about 1934, was effectively a work for which there was no public, or at best only a tiny public, in China at that time. He kept it in his studio for over ten years, finally finding an American buyer for the painting. This unsaleability was due both to the manner of representation and to the subject-matter. The nude human body, centrepiece equally of conservative and avant-garde Western art for centuries, was a subject which audiences in China did not automatically equate with high culture. Attempts to introduce the Western academic practice of drawing from nude models met with considerable resistance in China's art colleges.

The professional artists who were most successful at finding a public for their work in the decades of the Chinese Republic (1911–49) were probably those who maintained what were now seen as 'traditional' styles and subjects, although these were not necessarily unthinking conservatives. The effect of the introduction of mass media, cinema, and journalism, and the growth of an urban middle class in cities like Shanghai and Guangzhou, for whom an interest in cultural questions was a sign of enlightened modernity, led to a highly polemical climate among artists. Explicit statements of principle and artistic position multiplied on all sides. The inscription on a landscape scroll by Huang Binhong (1864–1955) [118], probably made towards the end of his very long life, is not a dedication or a poetic accompaniment to the image. It is functionally quite different from the inscription which forms an integral part of art works like 83 or 91. It is a miniature essay which stresses the philosophical and spiritual roots of painting in this style, picking up on the themes developed earlier in the century by Chen Hengke, and which significantly finishes with the words: 'Recently scholars from Europe

118
'Landscape', hanging scroll
on paper by Huang Binhong
(1864–1955 CE), probably
painted in the 1940s.

have maintained that artistic creation starts with an appreciation of the spiritual. Gentlemen study the ideal, common people study matter…' Huang may seem here to be reaffirming purely traditional Chinese élite understandings of the non-representational role of painting, but he is doing so with new terminology, the opposition of 'idealism' and 'materialism' translated into Chinese from the work of European philosophical writers like Hegel. His allusion to another opposition, that of a materialist West and a spiritual East, was also part of an international intellectual discourse which owed much to the writings of the Indian poet and philosopher Rabindranath Tagore (1861–1941), who visited China in 1924, and whose work was widely admired. Despite his choice of media and forms of painting which owed little to how he understood 'the West', Huang did much to alter the patterns of artistic production and appreciation in China. He was from 1907 the editor of a series of albums which were the first books in China to reproduce paintings photographically. In 1911 he began to edit a series of historical texts on art, *Meishu congshu*, which vastly improved the possibilities for research on many aspects of the cultural heritage. He taught extensively in the new art schools, maintaining the cultural life of Beijing during the brutal Japanese occupation of 1937–45. What he and his contemporaries were doing was now invariably classified as 'Chinese painting', in the hierarchy of cultural categories advanced by the global hegemony of the West, where the regional tradition of Europe was simply 'painting' in an unqualified sense.

Some of the complexities which were developing in the mid-twentieth century around what was 'Chinese' and what was foreign in art ('Western' being only one of those foreign possibilities), as well as the increasing impact of political developments in the arts, can be seen in the career of the photographer Lang Jingshan (1892–1995). His extremely long life spanned over a century, from the China of the Qing dynasty to that of the 1990s. Born into an élite family, and trained in the

119

'Roaring Lion', photograph from composite negatives by Lang Jingshan (1892–1995 CE), 1941.

arts of calligraphy and painting from an early age, he worked initially in the new cultural industries of journalism and the media. By 1920 he was showing photographic work publicly in Shanghai, and in 1928 he was one of the founder members of the 'Chinese Photography Society' (*Zhonghua sheying xueshe*), dedicated to seeing the new technology as an artistic medium. The following year he was a judge of the 'art photography' included in the First National Art Exhibition, referred to above. In 1931 he began experimenting with the composite negatives [119] which are his most distinctive images, and for which he became renowned in the years leading up to the outbreak of the Sino-Japanese War in 1937. So it was natural that he should use this technique for a blatantly patriotic image like 'Roaring Lion', created in 1941 and supplied to an exhibition in the allied nation of Britain, where he was made an honorary fellow of the Royal Photographic Society. The technology of photography is itself an index of modernity here, and it is deployed to create an image—the lion roaring its defiance of the aggressors against the splendours of the land of China—which harks back to the 'national painting' of painters such as the Gao brothers, irrespective of the fact that animal themes such as this owe a great deal to the Chinese appropriation of themes within 'Japanese painting' (*Nihonga*), the art of the national enemy. Lang Jingshan's most internationally successful images are therefore bound up with the appalling violence of China's mid-twentieth century history, just as his personal life was dictated by one of its most decisive turning points, the final victory of the Communist party over Chiang Kai-shek's Nationalists in 1949. Lang was one of those artists and intellectuals who followed the defeated Chiang in that year to the Republic of China on Taiwan, and whose subsequent career was shaped by its ideology of imminent return to repossess the mountains and rivers he continued to make the focus of his work.

Art in the People's Republic of China

The victory of the Communist party in 1949, after years of civil war and resistance to Japanese invasion, affected the visual arts in China in a number of profound ways, but it did not change everything at once. As well as those artists like Gao Jianfu and Lang Jingshan, often associated with Guomindang politics, who relocated to the island of Taiwan, some moved to the British colony of Hong Kong, or to elsewhere within an increasingly global Chinese diaspora. Others, including Lin Fengmian, continued to teach within the newly established People's Republic of China, but were increasingly the object of political criticism on the grounds of 'inappropriate' subject-matter or 'reactionary' styles in their work. Some artists who were either already members of the Communist party, or identified as sympathetic enough to its programme (such as Xu Beihong), were instructed to erect the structures of a new, socialist art world. This involved the closure of private art

schools, and the restructuring of art education on lines which owed much to the pattern of the Soviet Union, the effective end of the commercial art market, and of private patronage for artists on any significant scale. (Some work was still sold from public exhibitions, and bought by individual customers, including senior government and party officials, many of whom were in particular, themselves enthusiastic calligraphers.) The 'Talks at the Yan'an Forum on Art and Literature', delivered by the Communist party leader Mao Zedong (1893–1976) in 1942, became the guiding principles of party policy, above all in their employment of the Marxist model of ideology and culture as a reflection of underlying economic and class realities. Art for art's sake, the early twentieth-century view of the artist as a romantic free spirit, was no more acceptable to Communist party thinking than was the much older view of art as the expression of a spiritually noble nature.

Some senior figures of the art world, including Xu Beihong and Huang Binhong, were left largely alone by the government after 1949, simply being encouraged to avoid certain subject-matters and to concentrate on others; for example, Xu drew a series of revolutionary military heroes and heroic workers, while Huang was told to concentrate his art-historical researches on figure-drawing. They, along with world-famous figures like Qi Baishi (1864–1957), a venerable painter in *guohua* style who additionally benefited from an impeccably modest class background, were seen as ornaments of the regime, testimony to its ability to marshal the best part of the cultural heritage in the service of 'new China'.

Throughout the first twenty or so years of the People's Republic, the polarity between 'Chinese painting' (*guohua*) and 'Western [oil] painting' continued to structure much of the debate within professional artistic circles, concentrated in the reformed and enlarged art schools, and in the national and provincial artists' associations, from which approved painters, sculptors, and graphic artists drew a regular salary. Additionally, a new validity was given to forms derived from what was construed as 'folk art', in particular the graphic prints sold widely to audiences of modest standing in the countryside from which the Communist revolution had drawn its greatest strength. Even before 1949, artists living in the party's base in the town of Yan'an had experimented with removing the popular religious content of these 'New Year prints', and replacing it with exhortatory material more in line with their aims. Some of these, like Jiang Feng (1910–82), had also engaged with modernist styles of print-making in Shanghai in the 1930s.

After 1949, all artists lived in a context where changes in party policy could and did render certain styles politically suspect in an unpredictable manner. The inconsistencies and uncertainties of the party line in the 1950s meant that the art produced at this period is not simply uniform, and some degree of individual choice did remain in the field of style (though less in that of subject-matter). The relatively

'Conquer Every Difficulty;
Build Socialism', poster
designed by Yu Yunjie
(1917–92 CE) and Zhao
Yannian (b. 1924), dated
1955.

large resources placed by the state behind the arts, by comparison
with the neglect of the Republican era, also meant an enlarged audi-
ence for what had once been types of art with very small audiences,
confined to a few major cities. The major beneficiary of this was oil-
painting, which through the medium of posters, and other forms of
reproduction, reached much larger and more diverse audiences than
the small numbers who would have been familiar with its conventions
prior to the Sino-Japanese War, making it for the first time a familiar
(if not always a popular) style. Some hint of these new audiences can
be gleaned from a surviving poster based on a painting by the artists
Yu Yunjie (1917–92) and Zhao Yannian (b. 1924) [**120**]. These are

both artists typical of the generation born after the establishment of the Republic, who had the opportunity for professional training within China itself. Yu was trained at the National Central University in the Republican capital of Nanjing, while Zhao had trained in both oil painting and *guohua* in Shanghai in the late 1930s, and had also been involved with the making of woodcut prints; by the 1950s both held teaching posts within an expanded art education system, Yu in Suzhou and Zhao in the art academy based in Hangzhou, Zhejiang Province (now the prestigious Central Academy of Fine Arts), where he would have been a colleague of Lin Fengmian [117]. This poster, with the slogan, 'Conquer Every Difficulty—Build Socialism', was produced in 1955 in Shanghai, in an edition of 35,000 copies. Although perfectly acceptable in terms of the canons of the approved 'socialist realist' style, which in 1953 had been proclaimed as the most acceptable form of contemporary art, it still retains touches of what might seem like more modernist, or expressionist, handling of oil-paint, particularly in the muted tones and greenish tints of the torrent and the mountains, at which the dauntless builder of socialism swings with his pickaxe. This copy of what must have been a fairly ephemeral item carries dedicatory inscriptions in ink, giving us an insight into the context in which it was possibly viewed. In terms which mimic the dedicatory inscriptions found on Chinese painting for centuries, these inscriptions read (at top right); 'Souvenir of the wedding of Comrades Peng Jing and Liu Shengjie', and 'From all the comrades in the laboratory, [19]56'. Whatever the Freudian subtext of this image as a wedding gift, the inscription places it in the context of the scientifically educated technocrats of the early People's Republic, many of whom would have had contact with the supposedly advanced practice of the Soviet Union, then China's chief ally and mentor. This was true in the arts no less than in the sciences, and during the years of the mid-1950s, when the alliance with the Soviet Union was most vigorously pursued, high prestige was accorded to oil-painting, with the Russian expert in the social-realist style Konstantin Maksimov (b. 1913) teaching in China from 1955–7, and with certain promising students being sent to Moscow for advanced training. Yu Yunjie was himself one of Maksimov's advanced students in Beijing, despite already being active as a teacher himself.

During these years of close alliance with the USSR, 'national-style' Chinese painting was under a degree of suspicion as a remnant of the feudal society which had to be swept away, particularly for its resistance to new subject-matter. In the years of the late 1950s, when party policy veered in a more nationalist direction, and relations with the USSR became strained, oil-painting was constructed as essentially a 'foreign' art form, associated with the capitalist enemy. Individual artists' fortunes rose and fell with these policy changes, facing the

121

'This Land So Rich in Beauty', ink and colours on paper, by Fu Baoshi (1904–65 CE) and Guan Shanyue (1912–2000 CE), 1959. The calligraphy is not by either of the painters, but by the Chairman of the Communist Party, Mao Zedong, on one of whose poems the image is based.

real personal risk of becoming involved in the factional politics of the age, and the galling necessity of suppressing or even repainting work which no longer met the party's current requirements. Those without regular salaries made very poor livings by selling their work through exhibitions, or sometimes by painting large quantities of cheap fans or lanterns for export, a kind of production which had been the support of many Shanghai artists since the nineteenth century.

Party control of the arts went together with party patronage, and visual artists were involved in major cultural projects of the 1950s, including the decoration of government buildings on an unprecedented scale. In 1958–9, the so-called 'Ten Great Buildings' were erected in Beijing; and a huge campaign of sculpture and painting both in Chinese styles and in oils was undertaken; 345 (often huge) artworks were commissioned at this time. One of the most highly praised by contemporaries was an immense collaborative painting [121], produced for the Great Hall of the People, the setting for major political and government ceremonies and meetings. Entitled 'This Land So Rich in Beauty', it was painted by Fu Baoshi (1904–65) and Guan Shanyue (1912–2000). Both men had been involved with the Lingnan school in the 1930s, when Guan Shanyue had been a student of Gao Jianfu, and Fu had written in praise of him as a 'modernizer' of Chinese art (though Fu himself studied in Japan, 1933–6). Only very recently has it become possible for scholars outside China to reconstruct in detail the processes by which a commission such as 'This Land So Rich in Beauty' was executed.[8] The subject was not of Fu and Guan's choosing, but was specified to them as an illustration of Mao Zedong's poem 'Ode to Snow', the basic composition being suggested by the then Foreign Minister, Chen Yi. The red sun rising in the east, a common visual symbol by this time of the Communist party's ascendancy (and of the growing personality cult of Mao himself), was included on the instructions of Guo Moruo (1892–1978), another leading figure in the regime's cultural politics. A first version was painted between May and September 1959, but rejected as too small, and the whole thing was painted again in about a fortnight. Collaborative work had occasionally been undertaken in centuries past by upper-class artists, but it was more typical of professional workshop practices, as was the close adherence to a patron's programme. However, the innovative features of this work outweigh its dependence on any type of picture-making in China which had preceded it. For one thing, its enormous scale (5.5 × 9 m.) made it one of the largest works ever painted on paper in China, while its format as a framed, permanently exhibited work separated it from the hanging scrolls and hand scrolls of earlier painting. The scale and permanence depended on assumptions by those who commissioned it about the nature of the audience for the work of art which were quite different from what had gone before. Its placing in the building meant that it

was (and continues to be) used as a backdrop for group photographs of important people, often foreign visitors, who are thus placed 'in China'. As a landscape so rich in particular symbolic features, and in the association of the landscape with idealistic notions of 'the nation', it represents a break with, not a continuation of, much of the landscape painting of the preceding 200 years, although arguably it reasserts types of meaning in landscape which existed at a much earlier period of painting in China (see p. 55). Technically, too, it breaks with the kind of conservative landscape painting still being practised in the 1950s by artists of an older generation like Huang Binhong, in that it does not depend for its forms on the repertoire of *cun* 'texture strokes', but on washes and on fixed-point perspective. The latter in particular was originally an imported technique, by then fully appropriated into the making of 'national painting' in China. Many of the traditional techniques of Chinese painting were phased out of art schools in the 1950s, with the result that later artists working in the 'national painting' manner were in fact using very different types of brushwork from those employed prior to the mid-twentieth century. There was also in art schools a new emphasis on drawing from life, rather than mastering the styles of earlier artists.

From the middle of the 1960s, in the years of political and social upheaval known as the 'Great Proletarian Cultural Revolution', artists no less than the rest of the population were caught up in often agonizing personal and professional dilemmas. This era of history in China still remains for many too painful and too recent for dispassionate analysis, and it is easier to bear witness to the sufferings and tragedies than it is to recapture the motivations of those who embraced it enthusiastically, such as the art students and teachers of the Central Academy of Fine Arts who in 1966 smashed the school's entire collection of instructional plaster casts. Although seen by many who lived through it as a cultural wasteland, there is no denying the fact that visual images were produced in the Cultural Revolution, were distributed in huge quantities, and played an important role in fixing and structuring ideological positions, rather than merely representing what was happening in a chaotic society. Posters, cartoons, and above all portrait images of Mao Zedong himself were ubiquitous in the public and private spaces of Chinese life in the period 1966–76 (when the official end of the Cultural Revolution was declared). One of the iconic images of this period is 'Chairman Mao goes to Anyuan', by Liu Chunhua (b. 1944), painted in 1967 for the exhibition 'The Brilliance of Mao Zedong Thought Illuminates the Anyuan Worker's Movement', held at Beijing's Chinese Revolutionary Museum to commemorate a 1921 miners' and railway worker's strike seen as one of the key moments in the birth of socialism in China. Single sheet prints of the work were distributed in July 1968

with two leading newspapers and the party's main theoretical journal, and two months later it formed the cover of the mass-circulation 'China Pictorial' [122]; the figure of 900 million copies of the image produced in total is often repeated. The inscription the printed versions carried at the time was, 'Collectively created by the students of the Beijing [art] academies; executed by Liu Chunhua and others', a formula which reflects the party's unease with the notion of individual as opposed to collective creativity, seen as far back as the 1950s (both [120] and [121] were also collective creations). Since the 1990s at least, authorship of this iconic image has been ascribed solely to Liu Chunhua, who in 1967 had visited Anyuan to prepare the creation of what was originally intended to be a heavily populated history painting, in a vein descending ultimately from the work of Xu Beihong [116]. But the factional struggles of the period made Anyuan an unsafe working environment, and on his return to Beijing Liu reportedly sought inspiration in Mao's romantic and classical-style poetry, as chiming with the 'revolutionary romanticism' which was the main aesthetic position championed at the time by Jiang Qing (1914–91), Mao's wife and the leading cultural arbiter of the day. Whether or not the composition was (as the artist has later suggested) inspired by a Raphael Madonna, it gave effective visual form both to the cult of Mao as a titan dominating the landscape of China, and to the notion that youth and willpower were the answers to every problem.

122

'Chairman Mao Goes to Anyuan', by Liu Chunhua (b. 1944), oil-painting of 1967, as reproduced on the cover of the September 1968 issue of 'China Pictorial'.

By the 1970s, when strict central government control was reasserted in all areas of culture, and the Mao cult became slightly less all-pervasive, many pictures became richly symbolic, their slightest iconographic detail readable by a sophisticated audience for significance within the larger discursive frames of party policy. This policy often involved down-playing the value of work by trained 'professional' artists (such as Liu Chunhua) in favour of work supposedly produced by less expert but much more 'red' (i.e. politically committed) members of 'the masses'. It is now known that much of the supposedly amateur art of the period was in fact produced, or at least reworked, by academically trained painters sent to the rural areas for that purpose, and this is certainly true of the most vigorously promoted body of work of the early 1970s, that of the 'peasant painters' of Huxian, in Shaanxi province. A work like 'Old Party Secretary' [123] was widely disseminated through reproduction from 1973 on, while other Huxian paintings were toured extensively in Asia and Europe in the 1970s, as the Chinese government used cultural diplomacy to rebuild its image abroad. The idealized image of the veteran local leader, grown grey in the service of the revolution, who pauses from arduous physical labour only to make marginal notes in his copy of one of the Marxist classics, is a representation of the party to itself and to the world.

But by far the most consistently propagated artistic image of the 1960s and early to mid-1970s remained that of Mao Zedong himself, not only

123

'Old Party Secretary', ink and colours on paper, by Liu Zhide (b. 1939), painted c.1973. The artist was himself described as the Communist party secretary of a production brigade in a Shaanxi village.

Statue of the seated Mao Zedong in white marble, carved for the Chairman's mausoleum in Beijing in 1976 by Ye Yushan (b. 1935).

in the form of paintings and their reproductions in print and poster form [122], but also in monumental sculptures, and small busts and statuettes in porcelain (the latter were widely used as wedding presents at the time). The portrait-sculpture tradition was a relatively recent innovation in China, though sculptors like Zhang Chongren (1907–98), trained in Brussels, began to work and teach after 1949. When Sun Zhongshan (Sun Yat-sen), the father of the Chinese Republic, died in 1925, the government had brought in Polish and Japanese sculptors to make the marble effigies for his public mausoleum in Nanjing. As with painting, the 1950s had seen Soviet sculptural techniques transmitted to Chinese students, and large statues of Mao were ubiquitous by the late 1960s. In accordance with the party policy on artistic creativity, the original designers of these multiple images were generally anonymous, or else like [122] they were ascribed to a collective of unnamed artists. The example shown [124] is probably among the last to be made, and differs from the tens of thousands elsewhere in China in that it shows the Chairman seated, instead of standing with hand flung out towards the Communist future. This sculpture was carved for his mausoleum in Beijing, erected immediately after his death in 1976, and a focus for governmental art commissions on a scale not seen since the Ten Great Buildings of the late 1950s. In line with the general dismantling of Cultural Revolution orthodoxies, the mausoleum works were no longer ascribed to collectives or to amateur peasant artists, but were acknowledged as the work of individual professionals, products of the art schools which had begun to reopen in 1973. In this case the sculptor was Ye Yushan (b. 1935), who had been carving Mao images since the early 1960s, as well as working on the team which in 1973 reworked a series of life-size figures, in a remaking of the tableau entitled 'Rent Collection Courtyard'. This sculptural ensemble had been originally produced in 1965 by a group of sculptors at the Sichuan Academy of Arts, and was to portray the evil ways of pre-Liberation landlordism as part of 'class education'; it was one of the most widely publicized works of the Cultural Revolution period, singled out for praise in February 1966 by Jiang Qing herself.

Art in China since the 1970s

The relative relaxation of political control following Mao's death in 1976 probably had its greatest effect on the arts simply by allowing young urban intellectuals to return to their home cities from the countryside. Many students had spent years there as part of a political project to 'learn from the peasants'. Older artists like Guan Shanyue [121] often returned to subject-matters of their earlier careers; he painted c.1980 a large standing screen of flowering plum blossoms for the Beijing Hotel which was very much understood at the time as symbolic of returning spring after a harsh (political) winter. But for the younger

125
'Idol', Carved wood sculpture by Wang Keping (b. 1949), made in 1979 for the first unofficial exhibition of the Stars group in Beijing.

126
'Father', oil on canvas, by Luo Zhongli (b.1950), 1980. Originally titled 'My Father' by the artist, the work was renamed with the more monumental title 'Father' by the jury of the National Youth Art Exhibition, where it won first prize in 1981.

generation of returnees, beginning to be exposed through publication to art produced outside China for the first time in their lives, new subjects, new media, and new methods of reaching a public seemed more compelling. In September 1978, a group of amateur artists, their name usually translated as 'Stars', though 'Sparks' gives a better sense of their incendiary aims, showed their work outside the Chinese National Art Gallery, in competition with an official exhibition taking place inside. Although they had some tacit support from the art bureaucrat Jiang Feng, this event was effectively entirely outside the official structures of art in the People's Republic, structures to which the members of the Stars group were explicitly opposed. None of the artists had art related jobs at the time of the show. They positioned themselves as dissident artists, who sought no official approval for their work, and instead embraced direct confrontation with the police. Some of the art shown was formally unlike anything seen in China since the Shanghai modernism of the pre-war period, and some of it was explicitly political in an oppositional sense. Wang Keping's (b. 1949) wooden sculpture, 'Idol' [125], was potentially particularly sensational in its appropriation of Mao's familiar features.

The art of the Stars group was seen by very few people in China itself, although some of it was subsequently published in specialist art journals, but it attracted considerable media coverage outside China in North America and Western Europe. An artistic controversy which was more visible inside China itself was that over the mural painted in 1979 for the new Beijing airport by Yuan Yusheng (b. 1937). In the immediate post-Mao era, artists often chose subjects from among the national minorities of China's borders, such as Dai or Tibetans and Mongols, using the realist gaze in the service of a sort of 'internal orientalism', these colourfully costumed peoples acting as the exotic Other of the Han Chinese ethnic majority. Entitled 'Water Splashing Festival—Song of Life' Yuan's mural depicted folkloric scenes of life among the Dai minority of the far south of China, and included a number of nude female figures. Opposition to the public display of these came from various quarters; from political and cultural conservatives (reigniting a controversy over the legitimacy of the nude in art going back to the 1910s), and from representatives of the Dai themselves, contesting their reduction to stereotypes of tropical sensuality. The mural was covered over in 1981, and the painter in disgust emigrated to America, a path increasingly open to artists as formerly strict controls on movement in and out of China were relaxed.

Another work which generated immense debate inside the country, among artists, critics, politicians, and a wider public of intellectuals, was the huge oil painting 'Father', by Luo Zhongli (b. 1950), exhibited officially in 1981 [126]. Using his familiarity with the work of the American Photorealist painter Chuck Close which he saw in

a magazine, and deliberately parodying the scale of the monumental Mao portraits which hung everywhere in China through his youth, Luo created this image of the peasant as mute witness to and stolid survivor of China's modern history. The obvious poverty and backwardness of the subject, after thirty years of socialist transformation, troubled many official critics in China, and the story goes that the principal of Sichuan School of Fine Arts insisted on the inclusion of the ballpoint pen behind the figure's left ear, to give the picture a more 'modern' feel.[9] Controversy did not prevent the picture being bought by the Chinese National Art Gallery nor inhibit this kind of photographic realism from being one of the most widely practised art-school styles of the late 1970s and 1980s.

Artists working on Taiwan, where Chiang Kai-shek's Republic of China established itself after 1949, faced fewer obvious stylistic constraints than those on the mainland, and a vigorous pluralism has existed there for the past forty years. A number of artistic personae and lifestyles have similarly been available, with a figure like Zhang Daqian (1899–1983) successfully portraying himself as the 'last of the literati', selling work extensively on an international scale. The search for a synthesis of East and West has occupied some artists, often aware of the progress of New York-based modernist art movements like Abstract Impressionism. By contrast, Lo Ch'ing (Luo Qing, b. 1948), for example, received a training in painting from one of the dispossessed scions of the last imperial ruling house, but has used it to make pictures which aim to subvert expectations of 'traditional Chinese painting.' His 'A Postmodern Self-portrait—China Deconstructed' of 1989 [127] assumes an audience for whom intellectual constructs, like semiotics and post-modernism itself, are familiar terms. It uses the artist's seals as the 'sign' of his presence, not so much synthesizing Western with Eastern as recognizing the arbitrary nature of the things signified. Work like this sold for relatively modest prices to a professional clientele of the under-45s in Taiwan itself (in 1990 his prices ranged from £3,200 to £4,000, then about $5,000 to $6,000), to doctors, architects, and lawyers who felt at ease with the explicitly intellectual content of the art they owned.[10] He is unusual among modern Chinese artists in enjoying an equally wide reputation as a poet, the ideal combination of the scholar tradition but one very rarely achieved in the past any more than at present. He has staged his rejection of the tradition of the scholar-recluse both through his art, and through a lifestyle which openly accepts the professional teaching job, the one-man exhibition, the fellowships, grants, and visiting professorships abroad, which are the material underpinning of so much art in the current international market place.

It was only in the latter part of the 1980s that the international art market began to impinge upon China itself. Political and economic

127

'A Postmodern Self-portrait—
China Deconstructed', by Luo
Qing (Lo Ch'ing, b. 1948),
hanging scroll in ink and
colours on paper, 1989.

liberalization reduced the direct interest of the state in what art was produced, at the same time as the state lost interest in how artists made a living. Many artists began to show work in temporary gallery spaces, sometimes within the confines of foreign embassies, or the apartments of diplomats.[11] The interest these events created was out of proportion to the number of buyers for avant-garde contemporary art (indeed for art of any type) at that time. After 1990 work which had originally been produced for exhibitions in China began to be toured outside the country, often remaining there—as did many of the artists who produced it. One of these is Xu Bing (b. 1955), whose installation 'A Book from Heaven' (or 'from the Sky') [128] was first shown in Beijing in 1988. In this particular work Xu employed the finest surviving craftsmanship in traditional woodblock book

'A Book from Heaven',
installation by Xu Bing
(b. 1955), created 1987–91,
as shown at the Elvehejm
Museum of Art, University
of Wisconsin-Madison,
in 1991–2.

production to generate huge quantities of texts in entirely imaginary and unreadable characters, invented and carved by himself. For those literate in Chinese, the work hovers constantly just beyond the edge of readability, as if the past itself had become meaningless. The installation was reassembled for a major 1989 Beijing exhibition entitled (in English) 'China Avant-Garde', when 186 mostly young artists from all over China staged an unprecedented manifestation of new and controversial art forms, including performance pieces and installations. The show was closed twice by the police in its two-week run, and although no very serious consequences followed immediately for the artists involved, the edginess around the event was part of the febrile atmosphere in Beijing which led up to the events of 4 June of that year. The Communist party demonstrated forcefully that there remained distinct limits to political freedom in China, by violently suppressing student and worker protests held in the symbolic heart of the capital. These tragic events impacted on the art that was produced by Chinese artists, and often too on where they chose to produce it. Xu Bing was one of many whose work in the 1990s was much more visible in the USA, Japan, and Hong Kong than in his homeland. Another was Huang Yongping (b. 1954). His 1987 conceptual artwork, 'The History of Chinese Art' and 'A Short History of Modern Art' after Two Minutes in the Washing Machine', reduced two art school textbooks to a pulpy and undifferentiated sludge, in an act of simultaneous cleansing and destruction. As a participant in a controversial 1989 Paris exhibition entitled *Magiciens de la Terre*, he was among the first of the post-Mao Chinese avant-garde to achieve a degree of international fame.

An entirely different use of the past from that of Xu Bing and Huang Yongping, and one much more immediately commercially successful in the 1990s, was seen in the realist canvases produced by Chen Yifei (1946–2005). His 'Lingering Melodies from the Xunyang River' [129], painted in 1991, became the most expensive ever piece of contemporary art by a living Chinese artist when it was sold at auction in Hong Kong in that same year for 1,375,000 Hong Kong dollars (then £102,000 or US $177,878). Trained in Shanghai College of Art before the Cultural Revolution, Chen commanded a kind of realist oil-painting technique which very few contemporary fine artists could match (although it remains widespread in graphics and the international advertising industry). His work became immensely popular with collectors in Hong Kong, as well as in the USA and Japan, often representing beautiful women in historical dress. It is at one and the same time an imagining of the nineteenth-century salon oil-painting China might have had if the 'Lamqua' tradition had been sustained by Chinese patrons, and a sort of auto-orientalism, the very stereotype

129
'Lingering Melodies from the Xunyang River', oil on canvas, by Chen Yifei (1946–2005 CE), dated 1991.

of the passive but available Asian woman. It was also a visual counterpart of the literary and cinematic movement of the late 1980s and early 1990s known as the 'search for roots', a recuperation of China's past from Communist party disdain, which has found its most luscious expression in the internationally successful costume dramas of the director Zhang Yimou (b. 1950), with films like 'Raise the Red Lantern' (1991). In 1996 the 'Homecoming of Chen Yifei' exhibition at the Shanghai Museum marked his triumphant return, largely validated by commercial success in the USA, to display his work in a major Chinese museum. Before his early death, he established a highly successful fashion and design practice, choosing to blur the boundaries between high art and commerce in the manner of an Andy Warhol (1928–87) or a Jeff Koons (b. 1955). His work was seen by some as a clever marketing gimmick, foisting kitsch in defunct European styles on an unsophisticated collecting public.[12] Certainly it did not match its commercial success with any degree of international critical esteem, in contrast to more avant-garde contemporaries like Xu Bing. The

latter was much more assimilable into the international exhibition and grant giving circuit. Yet artists of the avant-garde, even those living by now in New York or Paris, initially found it just as hard as those whose subject-matter was more 'traditional', to shake off the label 'Chinese artist', with all that that implies for Western audiences and critics. Their work through the 1990s was still bought outside China, if at all, by museums or museum departments of 'Oriental' art, and published in journals devoted to Asian subjects. Although intellectual discourse internationally might talk of 'post-colonial' hybridity as an established fact, the practices of the art market and exhibiting institutions with which Chinese artists had to live still clung tenaciously to the ideal of 'Chinese art'.

At the same time as Chen Yifei was establishing himself commercially outside China, and while Liu Chunhua was selling (in 1995) the oil-painting 'Chairman Mao Goes to Anyuan' [**122**] to a Chinese bank's private collection for a large sum, a less visible body of artists was laying the groundwork inside the country for what by the end of the twenty-first century's first decade would be a global boom in 'contemporary Chinese art'. In self-consciously bohemian and marginal artistic enclaves like Beijing's 'East Village', a generation for whom the Cultural Revolution was only a childhood memory (if it was a memory at all) was trying out the limits of public and personal toleration for artistic innovation. In the 1994 performance piece '65 kg' [**130**]

131

'Venice's Rent Collection
Courtyard', installation of
clay figures by Cai Guoqiang
(b. 1957), as exhibited at
the Venice Biennale, 1999.

Zhang Huan (b. 1965) suspended himself in metal chains from the
ceiling of an East Village hut, while his blood dripped from a cut on
to a heated metal bowl below. The number of people present at this
performance of extreme macho abjection (only one of several forms
of masochistic self-torture in Zhang's work) was tiny. Its rapid global
fame depends on the photographs of the event by Ai Weiwei (b. 1957);
only a year after the performance they were being seen in exhibitions
in Germany and then in Japan and the USA. The naked, bound and
gagged male body of '65 kg' is very different on one level from the tri-
umphant nature-conquering male body of [120] or [122], but perhaps
there are similarities too, not least in the implied (but contested) cul-
tural invisibility of female agency in the Chinese art world.

Growing international success for China's contemporary artists was
sealed in 1999 when for the first time one of them won the prestigious
Golden Lion at the Venice Biennale. Chinese artists had been shown
in this international festival of contemporary art since 1993 (and Chi-
nese film at its accompanying Venice Film Festival from 1991). The
controversy over the triumph of Cai Guoqiang (b. 1957) was immedi-
ate and telling; his work 'Venice's Rent Collection Courtyard' [131]

remade (with the help of at least some of the original craftsmen) the iconic Cultural Revolution installation. This appropriation was immediately and intensely resented by many within China, not least by the original makers at the Sichuan Academy of Arts, who instigated legal action against what they described as 'an overseas Chinese artist domiciled in Japan'.[13] The problem was compounded by the fact that Harald Szeemann, German curator of the Venice Biennale, had as early as 1972 tried to bring the 'original' version of 'Rent Collection Courtyard' to another exhibition of contemporary art in the very different political and cultural climate of that year. Issues of authenticity (cultural, legal, personal) and intellectual property rights (then a hot topic in China's commercial relations with the rest of the world) swirled around the controversy, demonstrating at the very least that China was no longer a place where the litigiousness of other parts of the art world was unknown. Resentment at Cai Guoqiang's use of a 'Chinese' work to achieve fame and success in 'the West' pointed to issues of nationalism and the location of the artist which have only become sharper in succeeding years.

The enormous diversity, the commercial success, and the high exhibiting profile of contemporary art made in China, or by artists educated there, or by artists of Chinese heritage worldwide, make it impossible to summarize current trends, or provide a satisfying conclusion to this book. By 2006, Sotheby's had a turnover in its Hong Kong auction house of $21.9 million (£11 million), in the field of contemporary Chinese art, and twenty-four Chinese artists appeared among the global top-selling one hundred, where there had been none ten years previously.[14] Much of the most successful art in terms of prices achieved was painting, in genres variously defined as 'political pop' or 'cynical realism'. In the same year, the work of the Russian Konstantin Maksimov and his Chinese pupils formed the focus of an exhibition in Shenzhen, as a now historicized socialist realism was re-evaluated by an audience too young to remember its first flourishing. The framework of 'Chinese art', now rather more than a century old, increasingly no longer encompasses contemporary practice with any degree of satisfactoriness, as painters and sculptors, video and installation artists from China come more and more to be exhibited in frameworks which do not necessarily stress their nationality or cultural specificity, but see them as part of a globalized contemporary art world. China is now represented at the Venice Biennale by its own 'national' pavilion, as the government appreciates the prestige participation in such a forum can bring. The pace of change within China matches that in other areas of the economy; between 2004 and 2007 the number of nationally based galleries exhibiting at the major Beijing contemporary art fair doubled.[15] The most successful artists

132
'No Snow on the Broken Bridge', film installation, 35 mm film on eight screens, by Yang Fudong (b. 1971), with music by Jin Wang. First shown in 2006.

receive individual shows in prestigious contemporary art venues, exhibitions like 'No Snow on the Broken Bridge', held in London in 2006, for which Yang Fudong (b. 1971) created the haunting film/ installation work of the same name [**132**]. Accompanied by music by Jin Wang, it envelops the viewer in eight screens, on which play loops of 35 mm film in black and white. Scenes of flirtation, reverie, and inconsequential searching are played out by actors dressed in the costumes of the 1930s, a focus for nostalgia in contemporary Chinese popular culture, as an imagined alternative modernity which manages to be authentically 'modern' and 'Chinese' at the same time. The film constantly undercuts expectations of narrative coherence; it is no soap opera, though it visually resembles elements of popular television historical drama. It is a form of art unrepresentable in a book, and as such it could be said to share formal features with the long hand scrolls of premodern painting in China, which cannot be viewed by a single static gaze. Created for and first shown at an exhibition in Britain, it challenges the validity of the category 'art in China', with which this book sought to avoid the flattening effect of 'Chinese art' (it was subsequently shown again in other venues, including Shanghai). Whether viewers of 'No Snow on Broken Bridge', and in turn readers of this book, choose to emphasize the 'Chineseness'

of the work, its linkages back in time to something like the equally monochrome painting of Dong Qichang [77] or whether they stress instead the contemporary nature of its technology, its maker and its global audience, is fundamentally a political question which has no easy, or indeed no definitive, answer.

Notes

Introduction

1. V. Segalen (tr. E. Levieux) *The Great Statuary of China* (Chicago and London, 1978).
2. E. J. Laing, 'Women Painters in Traditional China', in M. Weidner (ed.), *Flowering in the Shadows: Women in the History of Chinese and Japanese Painting* (Honolulu, 1990), 81–101 (p. 81), based on Yu Jianhua, *Zhongguo meishujia renming cidian* (Beijing, 1981).

Chapter 1

1. R. W. Bagley, 'Changjiang Bronzes and Shang Archaeology', in *International Colloquium on Chinese Art History, 1991, Proceedings: Antiquities, Part 1* (National Palace Museum; Taipei, 1992), 209–56.
2. R. W. Bagley, 'What the Bronzes from Hunyuan Tell Us about the Foundry at Houma', *Orientations* (Jan. 1995), 46–54.
3. L. Ledderose, *Ten Thousand Things: Module and Mass Production in Chinese Art* (Princeton, NJ, 2000).
4. Wu Hung, 'Art in a Ritual Context: Rethinking Mawangdui', *Early China*, 17 (1992), 111–44.
5. L. Ledderose, 'The Earthly Paradise: Religious Elements in Chinese Landscape Art', in Susan Bush and Christian Murck (eds.), *Theories of the Arts in China* (Princeton, 1983) 164–83.
6. Wu Hung, *The Wu Liang Shrine: The Ideology of Early Chinese Pictorial Art* (Stanford, 1989).
7. The 'Admonitions' scroll has been reproduced and discussed many times, most fully now in S. McCausland, *First Masterpiece of Chinese Painting: The Admonitions Scroll* (London, 2003) and S. McCausland (ed.), *Gu Kaizhi and the Admonitions Scroll* (London, 2003). An important reassessment of the artist is provided in A. Spiro, 'New Light on Gu Kaizhi', *Journal of Chinese Religions*, 16 (1988), 1–17.

Chapter 2

1. E. J. Laing, 'Notes on Ladies Wearing Flowers in their Hair', *Orientations*, 21/2 (Feb. 1990), 32–9.
2. J. Cahill, *Three Alternative Histories of Chinese Painting* (The Franklin D. Murphy Lectures, 9; Lawrence, 1988), 43–6.
3. S. Bush and Hsio-yen Shih, *Early Chinese Texts on Painting* (Cambridge, Mass., and London, 1985), 168–9. On the reworking of 'Early Spring' see J. Stanley-Baker, 'Looking Beneath the Surface: Some Notes on Retouching', in *International Colloquium on Chinese Art History, 1991: Proceedings, Painting and Calligraphy* (2 vols., Taipei, 1992), ii. 849–72.
4. W. Fong, *Beyond Representation: Chinese Painting and Calligraphy, 8th–14th Century* (Princeton Monographs in Art and Archaeology, 48; New York, 1992), 264–75. J. Hay, 'Ch'ien Hsuan and Poetic Space', in A. Murck and W. C. Fong (eds.), *Words and Images: Chinese Poetry Painting and Calligraphy* (New York, 1991), 173–98 (p. 181).
5. J. C. Y. Watt, *Chinese Jades from the Collection of the Seattle Art Museum* (Seattle, 1989), 65.
6. Na Chih-liang, *The Emperor's Procession: Two Scrolls of the Ming Dynasty* (Taipei, 1970), 127.
7. H. Lovell, *An Annotated Bibliography of Chinese Painting Catalogues and Related Texts* (Michigan Papers in Chinese Studies, 16; Ann Arbor, 1973) 49–58.
8. Zhu Jiajin, *Treasures of the Forbidden City* (Harmondsworth, 1986), 214–17.

Chapter 3

1. J. C. Huntington, 'The Iconography and Iconology of the "Tan Yao Caves" at Yungang', *Oriental Art*, NS 32/2 (Summer 1986), 142–60.
2. J. O. Caswell, *Written and Unwritten: A New History of the Buddhist Caves at Yungang* (Vancouver, 1988), 48.

3. Jao Tsung-yi, 'The Vedas and the Murals of Dunhuang', *Orientations*, 20 (Mar. 1993), 71–6.

4. Zhang Gong, 'Painters of the Tang Period in Dunhuang and Turfan', in Frances Wood (ed.), *Chinese Studies* (British Library Occasional Papers, 10; London, 1988), 108–13.

5. Helmut Brinker and Roger Goepper, *Kunstschätze aus China* (Zurich, 1980), catalogue no. 44 discusses the excavated piece.

6. Zhu Qixin, 'Buddhist Treasures from Famensi: The Recent Excavation of a Tang Underground Palace', *Orientations* (May 1990), also Roderick Whitfield, 'Esoteric Buddhist Elements in the Famensi Reliquary Deposit', *Asiatische Studien*, 44/2 (1990), 247–66.

7. The interpretation here follows A. McNair, 'On the Date of the Shengmudian Sculptures at Jinci', *Artibus Asiae*, 49 (1988–9) 238–53. However this has been convincingly challenged in Tracy Miller, *The Divine Nature of Power: Chinese Ritual Architecture at the Sacred Site of Jinci* (Cambridge, Mass., and London, 2007).

8. S. Teiser, *The Ghost Festival in Medieval China* (Princeton, 1988), 193–4, discusses public reactions to wall painting.

9. The painting and poem are discussed in Luo Qing, *Shui mo zhi mei* (Taipei, 1991), 66–77.

10. R. T. Paine Jr., 'Wen-shu and P'u-hsien: Chinese Wood-Block Prints of the Wan-Li Era', *Artibus Asiae*, 24 (1961), 87–91.

11. By Derek Gillman, in W. Watson (ed.), *Chinese Ivories from the Shang to the Qing* (London, 1984), 35–50.

12. V. Wilson, 'Cosmic Raiment: Daoist Traditions of Liturgical Clothing', *Orientations*, 26/5 (May 1995) 42–9.

Chapter 4

1. A. C. Soper, *Textual Evidence for the Secular Arts of China in the Period from Liu Sung through Sui (A.D. 420–618), Excluding Treatises on Painting* (Artibus Asiae Supplementum, 24; Ascona, 1968), 11–13.

2. P. C. Sturman, 'The "Thousand Character Essay" Attributed to Huaisu and the Tradition of *Kuangcao* Calligraphy', *Orientations*, 25/4 (Apr. 1994) 38–46.

3. S. Bush and Hsio-yen Shih, *Early Chinese Texts on Painting* (Cambridge, Mass., and London, 1985), 86–7.

4. M. Bickford, 'The Painting of Flowers and Birds in Sung-Yuan China', in

M. K. Hearn and J. G. Smith (eds.), *Arts of the Sung and Yüan*, papers prepared for an international symposium organized by the Metropolitan Museum of Art in conjunction with the exhibition *Splendors of Imperial China: Treasures from the National Palace Museum, Taipei* (New York, 1996), 293–307 (289–9).

5. E. J. Laing, 'Women Painters in Traditional China', in M. Weidner (ed.), *Flowering in the Shadows* (Honolulu, 1990), 93.

6. W. Ho (ed.), *The Century of Tung Ch'i-ch'ang 1555–1636* (2 vols.; Seattle and London, 1992), 413–15.

7. Wang Fangyu and R. M. Barnhart, *Master of the Lotus Garden: The Life and Art of Bada Shanren (1626–1705)* (New Haven, 1990), 128–9, stress the continuing opacity of Bada Shanren's poetry, with the words, 'We are by no means certain we understand it now'.

Chapter 5

1. M. Bickford, 'Stirring the Pot of State: The Sung Picture-Book *Mei-Hua Hsi-Shen P'u* and Its Implications for Yüan Scholar Painting', *Asia Major* Third Series 6.2 (1993), 169–223.

2. E. J. Laing, 'Ch'iu Ying's Three Patrons', *Ming Studies*, 8 (Spring 1979), 49–56.

3. J. Zeitlin, 'The Petrified Heart: Obsession in Chinese Literature, Art and Medicine', *Late Imperial China*, 12/1 (June 1991), 1–26.

4. J. Cahill, *The Painter's Practice* (New York, 1994), 58.

5. Translated in A. Y. Wong, *Parting the Mists: Discovering Japan and the Rise of National-Style Painting in Modern China* (Honolulu, 2006), 65.

6. Their essays are translated in J. Birnie Danzker, K. Lum, and Zheng Shengtian (eds.), *Shanghai Modern: 1919–1945* (Munich, 2005), 373–7.

7. J. K. Murray, *Last of the Mandarins: Calligraphy and Painting from the F. Y. Chang Collection* (Cambridge, Mass., 1987), 12.

8. J. F. Andrews, *Painters and Politics in the People's Republic of China 1949–1979* (Berkeley, 1994), 229–36.

9. Yuejin Wang, 'Anxiety of Portraiture: Quest for/Questioning Ancestral Icons in Post-Mao China', in Liu Kang and Xiaobing Tang (eds.), *Politics, Discourse and Literary Ideology in Modern China* (Durham, NC, 1993), 243–72.

10. S. J. Checkland, 'Contemporary Image: The New China Syndrome', *The Times* (7 July 1990).

11. N. Jose, 'Notes from Underground, Beijing Art, 1985–89', *Orientations*, 23/7 (July 1992), 53–8.

12. A. Chang, 'A Personal View on Contemporary Chinese Oil Paintings', *Orientations*, 26/4 (Apr. 1995), 82.

13. Wu Hung (ed.), *Chinese Art at the Crossroads: Between Past and Future, Between East and West* (London, 2001), 52–5 prints the relevant documents.

14. J. Watts, 'Once hated, now feted—Chinese artists come out from behind the wall', *Guardian* (11 April 2007).

15. Ling-yun Tang, 'Beyond Selling Art: Galleries and the Construction of Art Market Norms', *Yishu: Journal of Contemporary Chinese Art* (Dec. 2007), 34–43.

List of Illustrations

For help with the location of illustrations, as well as for bibliographic aid and comments on earlier drafts of the text, the author would like to thank: Tim Barreh, Maggie Bickford, Helmut Brinker, Cao Yiqiang, Christie, Manson & Woods Ltd. (New York, Hong Kong), Educational and Cultural Press Ltd. (Hong Kong), R. H. Ellsworth Ltd., Guo Oliver Moore, Sidney Moss Ltd., Jessica Rawson, Reaktion Books, Textile and Art Publications, Robert L. Thorp, Christer von der Burg (Han-Shan Tang Books, London), Evelyn Welch, Roderick Whitfield, Verity Wilson, Fangfang Xu, Hong-xing Zhang.

The publisher would like to thank the following individuals and institutions who have kindly given permission to reproduce the illustrations listed below

1. Jade tablet of the neolithic period, *c.*2500–2000 BCE. 30.5 × 7.2 cm (not including wooden stand). National Palace Museum, Taiwan.
2. Bronze standing figure from Sanxingdui, *c.*1200 BCE. Excavated in 1986. H. 262 cm/H. of figure, 172 cm. China Cultural Relics Promotion Centre, Beijing.
3. Ivory beaker inlaid with turquoise, From the tomb of the Shang dynasty queen Fu Hao, *c.*1200 BCE. H. 30.5 cm. Museum of Chinese History, Beijing/photo Cultural Relics Publishing House.
4. Bronze vessel for wine, dated 964 or 962 BCE. 28.7 × L. 38 cm. Zhouyuan Fufeng Cultural Relics Office/photo Cultural Relics Publishing House, Beijing.
5. Bronze jar and basin, *c.*430 BCE, from the tomb of Yi, Marquis of Zeng. H. of jar, 33.1 cm/H. of basin, 24 cm. Hubei Provincial Museum, Wuhan/photo Cultural Relics Publishing House, Beijing.
6. Detail of an embroidered silk shroud, *c.*300 BCE, from Mashan, Hubei province. Size of repeat, 29.5 × 21 cm. Hubei Provincial Museum, Wuhan/photo Cultural Relics Publishing House, Beijing.
7. View of Pit no. 1, part of the 'Terracotta Army' surrounding the tomb-mound of the First Emperor of Qin, d.210 BCE. Average H. *c.*180 cm. China Photo Library, Hong Kong.
8. Funeral banner from Tomb no. 1, Mawangdui, *c.*168 BCE. 205 × 92 cm. Hunan Provincial Museum, Changsha/photo Cultural Relics Publishing House, Beijing.
9. Incense burner of gilt silver, the property of the Han dynasty imperial princess Yangxin, *c.*153–106 BCE. H. 58 cm. Shaanxi History Museum, Xi'an/Educational and Cultural Press, Hong Kong.
10. An immortal on horseback from the site of the tomb of the Han dynasty emperor Zhaodi, about 70 BCE. White jade. 7 × L. 8.9 cm. Xianyang City Museum, Shaanxi Province/photo Cultural Relics Publishing House, Beijing.
11. Stone slab from the Shrine of Wu Ban, *c.*147 CE. 78 × 197 cm. Percival David Foundation of Chinese Art, London, from E. Chavannes, *Mission Archaelogique dans la Chine Septentrionale* (Paris, 1909), plate LIII, no.109.
12. Rubbing of tomb walls *c.* 380–420 CE, from Xishanqiao, near Nanjing. 80 × L. 240 cm. Nanjing Museum.
13. Screen painted in lacquer on wood, from the tomb of Sima Jinlong, d. 484 CE. 80 × 20 cm. Datong City Museum (on loan from the Shanxi Provincial Museum)/photo Cultural Relics Publishing House, Beijing.
14. Limestone coffin of Lady Yuan, d. 522 CE (Episode from Stories of Filial Piety). Engraved grey limestone. 64 × 225 cm. The Nelson-Atkins Museum of Art, Kansas City, MO (Purchase: William Rockhill Nelson Trust, 33–1543/2).
15. A mythical protective beast *(qilin)* guarding the tomb of the Liu Song dynasty emperor Wendi, d. 453 CE. 275 × L. 295 cm. Photo Ann Paludan.

16. One of the six war horses of the Tang dynasty emperor Taizong, d. 649 CE. Limestone. H.173 cm. University of Pennsylvania Museum, Philadelphia (c. 395).

17. Detail of the unfinished murals from the entrance passage of the tomb of Li Zhongrun, Prince Yide, c.700 CE.176×115 cm. Shaanxi History Museum, Xi'an/Educational and Cultural Press, Hong Kong.

18. *Ladies Wearing Flowers in their Hair,* hand scroll on silk once attributed to Zhou Fang (c.730–c.800 CE), but probably 10th century CE. 46×L.180 cm. Liaoning Provincial Museum, Shenyang.

19. Anon: *One of the Empresses of Song Renzong,* c.1040–60 CE. Hanging scroll on silk. 172.1×165.3 cm. National Palace Museum, Taiwan.

20. Guo Xi: *Early Spring,*1072 CE. Ink on silk. 158.3×108.1 cm. National Palace Museum, Taiwan

21. Anon: *Landscape,* from the second half of the 10th century CE. Hanging scroll painted on silk 154.2×54.5 cm. Liaoning Provincial Museum, Shenyang.

22. Attributed to the Song emperor Huizong: *Auspicious Cranes,* 1112 CE. Hand scroll on silk. 51×L., including colophons, 138.2 cm. Liaoning Provincial Museum, Shenyang.

23. Porcelain bowl of 'Ru ware', named after Ruzhou, the place where it was made in c.1100–20 CE. Diameter 16.7 cm. Percival David Foundation of Chinese Art, London (PDF3).

24. Ma Hezhi: *Odes of Chen,* c.1150 CE. Hand scroll on silk. 26.8×L.187 cm. © Trustees of the British Museum (Brooke Sewell Bequest OA 1964.4-11.01 Add. 338).

25. Mi Youren: *Cloudy Mountains,* painted in the 1140s. Hand scroll, ink on paper. 27.3×57 cm. The Metropolitan Museum of Art, New York, Ex coll.: C. C. Wang Family, Purchase, Gift of J. Pierpont Morgan, by exchange, 1973 (1973.121.1). Image © The Metropolitan Museum of Art.

26. Ma Yuan: *Moments of the Flowering Plum: A Fine Moon.* Album leaf painted on silk. Each leaf, 20×7.3 cm. Collection of Yvonne, Mary, and Julia Chen/photo Yale University Art Gallery, New Haven, CT.

27. Embroidered silk fan, c.1250 CE. 25.4×27.4 cm. Liaoning Provincial Museum, Shenyang.

28. Anon: *Hunting Falcon Attacking a Swan,* 13th–14th centuries CE. Hanging scroll laid down on panel. 152.5×106.1 cm. Nelson Atkins Museum of Art, Kansas City, MO (Purchase: William Rockhill Nelson Trust, 33–86).

29. Wang Zhenpeng: *Vimalakirti and the Doctrine of Non-Duality,* detail, 1308 CE. Hand scroll in ink on silk. 39.5×217.7 cm. Metropolitan Museum of Art, New York, The Dillon Fund Gift, 1980 (1980.276). Image © The Metropolitan Museum of Art.

30. Table of carved red lacquer on a wood core, made in the Xuande reign of the Ming dynasty (1426–35 CE). H. 79.2 cm. © V&A Images, The Victoria and Albert Museum, London (FE.6–1973).

31. Porcelain bowl, made for the Ming imperial court in the Xuande reign (1426–35 CE). Diameter at mouth rim, 29.5 cm. Percival David Foundation of Chinese Art, London (PDF B619).

32. Shang Xi: *Guan Yu Captures an Enemy General.* Hanging scroll on silk. 200×237 cm. Palace Museum, Beijing.

33. Anon: *The Jiajing emperor of the Ming dynasty (r.1522–66 CE) in his state barge,* c.1536–8 CE. Detail of hand scroll on silk. 97.6×L. 2995.1 cm. National Palace Museum, Taiwan.

34. Wang Hui: *The 'Southern Tour' of the Kangxi emperor.* Detail of hand scroll on silk. 67.8×L. 2227.5 cm. Palace Museum, Beijing.

35. Wang Yuanqi: *Three Friends of the Cold Season,*1702 CE. Hanging scroll done in ink on paper. 85.1×47 cm. Nelson-Atkins Museum of Art, Kansas City, MO (Purchase: William Rockhill Nelson Trust, 51–77).

36. Anon: Porcelain teapot, decorated in enamel colours and underglaze blue with a design of 'Three Friends of the Cold Season', Yongzheng reign of the Qing dynasty (1723–35 CE). H.13.8 cm. Percival David Foundation of Chinese Art, London (PDF A798).

37. Giuseppe Castiglione (known in China as Lang Shining): *Assembled Auspicious Objects,* 1715 CE. Hanging scroll on silk. 173×86 cm. National Palace Museum, Taiwan.

38. Craftsmen working for the imperial court of the Qing dynasty: *Yu the Great Taming the Waters,* completed in 1787 CE. Jade carving. 224×96 cm. Palace Museum, Beijing.

39. Anon: *The Daoguang emperor (r.1821–50) with his children,* 1840s CE. Horizontal scroll painted on silk. 111×294.5 cm. Palace Museum, Beijing.

40. Dowager Empress Cixi: *Pine and Auspicious Fungus,* 1897 CE. Hanging scroll on paper. 122.5×60.9 cm. Royal Ontario Museum, Toronto (1921.1.169).

41. A ceramic jar of about 250–80 CE. H. 12.6 cm. Percival David Foundation of Chinese Art, London (PDF A200).

42. Figure of the Buddha, 338 CE. Gilt-bronze. 39.4 × 24.5 cm. Asian Art Museum, San Francisco (Avery Brundage Collection, B60.B1034).

43. The colossal figure of the Buddha Amitabha, from Cave 20 at Yungang, Shanxi province, c.460–93 CE. H. of central figure, 1370 cm. Werner Forman Archive, London.

44. The interior of Cave 285 of the Mogao Caves, Dunhuang, Gansu province, painted in 538/9 CE. 430 × max. W. 640 × D. 630 cm. © NHK Publishing (Japan Broadcast Publishing Co.). Photo Seigo Otsuka, published, *DUNHUANG, Caves of the Singing Sands; Buddhist Art from the Silk Road* (London: Textile and Art Publications Ltd., 1996), vol. i, p. 41.

45. Figure of the Buddha Amitabha with attendants, 584 CE. Gilt-bronze. H.41 cm. Shaanxi Province Cultural Relics Office, Xi'an/photo Helmut Brinker, Zürich.

46. Image of Maitreya, the Buddha of the Future, flanked by attendants, c.600–700 CE. Limestone. 102 × 56 cm. Shanxi Provincial Museum, Taiyuan/photo Don Hamilton, Spokane, WA.

47. Seated Heavenly Worthy, 719 CE. Stone sculpture. H. 305 cm. Shanxi Provincial Museum, Taiyuan/photo Cultural Relics Publishing House, Beijing.

48. Giant figures of a Heavenly King and demon guardian of Buddhism, completed 675 CE. Rock carving. H.1030 cm. Photo Cultural Relics Publishing House, Beijing.

49. Bronze gong on a stand, dating from the 8th century CE. H. 96 cm. Kofuku-ji Temple, Nara/photo Askaen.

50. Container for a relic of the body of the historical Buddha, 871 CE. Silver and silver gilt. H. 21 cm. Shaanxi Tourism Press/photo Ma Lingyun.

51. The Buddha preaching, 8th century CE. Embroidery on silk. 208 × 158 cm. National Museum, Nara/photo Johnouchi.

52. Illustrated preface to the *Diamond Sutra*, 868 CE. Printed by wood block. 23.7 × 28.5 cm (picture only). © British Library Board. All Rights Reserved (Or.8210/p.2).

53. *The Guardian King of the North crossing the ocean*, 10th century CE. Hanging scroll on silk. 61.8 × 57.4 cm. © Trustees of the British Museum (OA 1919.1-1.045).

54. Figure of the Sage Mother with her attendants, c.1050 CE. Painted clay. H. of seated figure, 228 cm. Photo Cultural Relics Publishing House, Beijing.

55. Jin Dashou: *One of the Ten Kings of Hell, c.*1150–95 CE. Hanging scroll in ink and colours on silk. 111.8 × 47.6 cm. Metropolitan Museum of Art, New York, Rogers Fund, 1929 (30.76.290). Image © The Metropolitan Museum of Art.

56. The bodhisattva Guanyin, c.1200 CE. Carved wooden figure. H.114.2 cm. © V&A Images, The Victoria and Albert Museum, London (A.7-1935).

57. Buddhist monk Yujian: *Mountain Market in Clearing Mist, c.*1250 CE.Ink on paper. 30.3 × 83.3 cm. Idemitsu Museum, Tokyo.

58. Anon: *Group portrait of senior Buddhist monks, c.*1330 CE. Painted on silk. 91.1 × 44.7 cm. Shofuku-ji Temple, Fukuoka City, Japan.

59. A volume of the Buddhist canon, 1301 CE. Printed by wood blocks. 24.7 × 11 cm (page size, closed). © British Library Board. All Rights Reserved (Or.80.d.25).

60. Buddhist mandala centred on the deity Vajrabhairava, 1328–9 CE. Woven silk tapestry. 246.1 × 208.3 cm. Metropolitan Museum of Art, New York, Purchase, Lila Acheson Wallace Gift, 1992 (1992–54). Image © The Metropolitan Museum of Art.

61. Ma Junxiang: *A Celestial Court Audience, c.*1325 CE. Wall-painting. H. 400 cm. Photo Cultural Relics Publishing House, Beijing.

62. *Former Masters of Professions and Arts, c.*1460 CE. Hanging scroll on silk. 119 × 24.5 cm. Shanxi Provincial Museum, Taiyuan/photo Don Hamilton, Spokane, WA.

63. *The Bodhisattva Puxian coming down from the Mountain,*1578 CE. Colour print from wood blocks. 118.4 × 61.9 cm. Photograph © 2009 Museum of Fine Arts, Boston, Gift of Robert Treat Paine (55.989).

64. Figure of Guanyin as 'the bringer of sons', c.1580–1640 CE. Lacquered and gilded ivory. H. 32 cm. © V&A Images, The Victoria and Albert Museum, London (A. 15–1935).

65. *The Crucifixion*, an illustrated page from *Explanation of the Incarnation and Life of the Lord of Heaven*, a book of Christian instruction, 1637 CE. Printed by wood blocks. 23.8 × 14 cm. Bibliothèque Nationale de France, Paris (Chinois 6750).

66. Embroidered silk ritual robe for a Daoist priest, c.1650–1700 CE. 127 × 208.7 cm. © V&A Images, The Victoria and Albert Museum, London (T.91–1928).

67. Li Ming: detail of a hand scroll showing an extensive Buddhist pantheon, 1792 CE. 34.8 × 1656.5 cm. Liaoning Provincial Museum, Shenyang.

68. Wang Xun, Dong Qichang and Qianlong emperor: *Letter to Bo Yuan*. Calligraphy done in cursive script on paper. 25.1 × 17.2 cm (colophons not included). Palace Museum, Beijing.

69. Buddhist monk Huaisu: the opening of the *Autobiography*, 777 CE. Drafting script on paper. 28.3 × 755 cm. National Palace Museum, Taiwan.

70. The *Model letters in the Imperial Archives in the Chunhua Era*, 992 CE. Rubbings of engraved calligraphy taken from wooden blocks. Each double leaf, 25.5 × 43 cm. Private Collection/photo Christie's, New York.

71. Wen Tong: *Bamboos*. Album leaf on paper. 31 × 48.3 cm. National Palace Museum, Taiwan.

72. Huang Tingjian: *Pine Wind Pavilion (Songfengge shi)*, written 1101–5 CE. Hand scroll on paper. 131.8 × L.1119.2 cm. National Palace Museum, Taiwan.

73. Zhao Mengjian: *The Three Friends of the Cold Season*, 1260 CE. Album leaf on paper. 32.2 × 53.4 cm. National Palace Museum, Taiwan.

74. Zhao Mengfu: *Record of the Miaoyan Monastery at Huzhou*, detail, c.1309–10 CE. Hand scroll, ink on paper. Calligraphy, 34.2 × 364.5 cm/colophons, 34.2 × 206.7 cm. Princeton University Art Museum. Bequest of John B. Elliott, Class of 1951/photo Bruce M. White (1998–53).

75. Guan Daosheng: *Bamboo Groves in Mist and Rain*, 1308 CE. Hand scroll. 23.1 × 113.7 cm. National Palace Museum, Taiwan.

76. Ren Renfa: *Nine Horses*, detail, 1324 CE. Hand scroll in ink and colours on silk. 31.2 × 262 cm. Nelson-Atkins Museum of Art, Kansas City, MO (Purchase: William Rockhill Nelson Trust, 72–8).

77. Huang Gongwang: *Dwelling in the Fuchun Mountains*, detail, 1347–50 CE. Hand scroll, done in ink and colours on paper. 33 × 639.9 cm. National Palace Museum, Taiwan.

78. Zou Fulei: *A Breath of Spring*, 1360 CE. Hand scroll in ink on paper. 33.7 × 218 cm. Freer Gallery of Art, Smithsonian Institution, Washington, DC (Purchase, F. 1931.1).

79. Wang Lü: *Reclining on the Steps in Front of the Shrine Hall*, 1381 CE. Album leaf, ink and colour on paper. 34.7 × 50.6 cm. Palace Museum, Beijing.

80. Du Qiong: *Befriending the Pines*. Hand scroll on paper. 29.1 × L. 92.3 cm. Palace Museum, Beijing.

81. Shen Zhou: *The Thousand Buddha Hall and the Pagoda of the Cloudy Cliff Monastery* from the album *Twelve Views of Tiger Hill*. Album leaf, ink and slight colour on paper. 31.1 × 40.2 cm. © Cleveland Museum of Art, Leonard C. Hanna Jr Fund (1964.371.7), Cleveland, OH.

82. Tang Yin: *Farewell at Jinchang*, after 1498 CE. Hand scroll, ink on paper. 28.5 × 126.1 cm. National Palace Museum, Taiwan.

83. Wen Zhengming: *Cypress and Rock*, 1550 CE. Hand scroll, ink on paper. 26.1 × 144.8 cm. Nelson-Atkins Museum of Art, Kansas City, MO (Purchase: William Rockhill Nelson Trust, 46–8).

84. Wen Shu: *Fan Painting: Carnations and Garden Rock*, 1627 CE. Ink and colours on gold paper. Fan, 16.5 × 54 cm. Honolulu Academy of Arts, Gift of Mr Robert Allerton,1957 (HAA.2306.1)/photo Tibor Pranyo.

85. Dong Qichang: *Invitation to Reclusion at Jingxi*, 1611 CE. Hand scroll, ink on paper. 28.4 × 120 cm. Metropolitan Museum of Art, New York, Gift of Mr and Mrs Wang-go H. C. Weng, 1990 (1990.318) Image © The Metropolitan Museum of Art.

86. Shitao: *Self-portrait Supervising the Planting of Pines*, 1674 CE. Hand scroll, ink and colour on paper. 40.2 × 170.4 cm. National Palace Museum, Taiwan.

87. Bada Shanren: *Fish and Rocks*, c.1691 CE. Hand scroll, ink on paper. 29.2 × 157.5 cm. © Cleveland Museum of Art, 1995, John L. Severance Fund (1953.247), Cleveland, OH.

88. Gao Qipei: *Zhongkui, the Queller of Demons*, 1728 CE. 149 × 67 cm. Hanging scroll. Liaoning Provincial Museum, Shenyang.

89. Deng Shiru: Set of four calligraphic scrolls in 'seal script' (*zhuan shu*), designed to be mounted on a folding screen. Each panel, 179.8 × 56.8 cm. Shanghai Museum.

90. Chen Mansheng: Stoneware teapot,1815 CE. H. 7 × diameter 11.8 cm. Hong Kong Museum of Art (Flagstaff House Museum of Tea Ware), C81.496/ Photo Hong Kong Museum of Art.

91. Ren Xiong: *Self-portrait*, painted in the 1850s CE. Hanging scroll on paper. 177 × 79 cm. Palace Museum, Beijing.

92. Song Boren: *Manual of Plum-Blossom Likenesses*, first published 1238 CE. Page

from the printed book 15.5 × 21 cm (open). Shanghai Museum.

93. Ceramic pillow painted with a scene from the historical drama *Romance of the Three Kingdoms*, c.1270–1300 CE. White slip. H.12.5 × W. 38.8 × D.17.8 cm. Seattle Art Museum (Eugene Fuller Memorial Collection), 47.114/photo Susan Dirk.

94. Porcelain wine jar painted with a scene from *The West Chamber*, c.1320–50 CE. H. 35.9 cm. © V&A Images, The Victoria and Albert Museum, London. (C.8–1952).

95. Yin Shan: *Zhongkui*, mid-15th century CE. Detail of a hand scroll on paper. 24.2 × L.112.8 cm. Huai'an County Museum, Jiangsu Province.

96. Qiu Ying: *The Golden Valley Garden*, first half of the 16th century CE. Hanging scroll, ink and colours on silk. 224 × 130 cm. Chion-in Temple/photo Kyoto National Museum.

97. Anon: *Scene in a palace garden*, mid-16th century CE. Hanging scroll on silk. 171 × 105 cm. Schloss Ambras, Innsbruck/photo Kunsthistoriches Museum, Vienna (KK. 8913).

98. *Master Gu's Pictorial Album*, showing a reproduction of a section of the 'Nine Horses' scroll by the Yuan dynasty artist Ren Renfa (pl. 76), published in 1603 CE. Page from the printed book. 27 × 19 cm. Percival David Foundation of Chinese Art, London.

99. *Master Cheng's Garden of Ink-Cakes*, published in 1606 CE. Page from the printed book. 31.5 × 16 cm (page size). Percival David Foundation of Chinese Art, London (PDF B 169).

100. Han Ximeng: *Washing a Horse*, 1634 CE. Embroidery on silk 33.4 × 24.5 cm. Palace Museum, Beijing.

101. Wu Kan of Suzhou: Woven silk tapestry (*kesi*) showing Dongfang Shuo stealing the peaches of immortality, with a woven inscription copying calligraphy by Shen Zhou. Late 16th–early 17th centuries CE.152.7 × 54.6 cm. National Palace Museum, Taiwan.

102. Zhang Xihuang: Bamboo brushpot,17th century CE. H.30 cm. Photograph © 2009. Museum of Fine Arts, Boston, Marshall H. Gould Fund and partial gift of Judge and Mrs Matthew Brown in Memory of their Son, Ronald Goodrich Brown (1977.22).

103. Lu Guisheng: Panel of carved red lacquer, early 19th century CE. Each panel, 50 × 55 cm. Sydney L. Moss Ltd., London.

104. Anon: *Portrait of Xu Wei*, first half of 17th century CE. 40.3 × 25.6 cm. Nanjing Museum.

105. Chen Hongshou and assistant Yan Zhan: *Female Immortals*, second quarter of 17th century CE. Hanging scroll in ink and colours on silk. 172.5 × 95.5 cm. Palace Museum, Beijing.

106. Gu Jianlong: Page from a book of sketches. Each album leaf, 30.2 × 18.8 cm. Nelson-Atkins Museum of Art, Kansas City, MO (Purchase: Nelson Trust), 59–24/45.

107. (formerly *The West Chamber*) *Amorous Meeting in a Room Interior* from the mid-18th century CE. Hanging scroll or screen panel painted in colours on silk. 198.5 × 130.6 cm. Freer Gallery of Art, Smithsonian Institution, Washington, DC., Gift of Charles Lang Freer (F.1916.517).

108. Zheng Xie: *Bamboos*, 1759 CE. Hanging scroll done in ink alone on paper. 171 × 91 cm. Shanghai Museum.

109. Colour print from wood blocks, dated 1734 CE, showing Changmen, one of the gates of Suzhou, where the print was published. 108.6 × 56 cm. Ohsha'joh Museum of Art, Hiroshima.

110. Porcelain punch bowl, painted in overglaze enamels with a copy of William Hogarth's print, *The Gate of Calais*, and with the arms of the English family of Rumbold. The enamelling was done in Guangzhou (Canton), c.1750–5. Diameter 40.5 cm. © V&A Images, The Victoria and Albert Museum, London (Basil Ionides Bequest), C.23–1951.

111. Guan Qiaochang (Lamqua): *Self-portrait*, late 1840s CE. Oil on canvas. 27.3 × 23.2 cm. Peabody Essex Museum, Salem, MA.

112. Zou Boqi: *Self-portrait*, c.1850–60 CE. Photograph.

113. Ren Yi: *Young Woman at a Window with Plum Blossoms*, 1884 CE. Hanging scroll on paper. 92 × 42.6 cm. Liaoning Provincial Museum, Shenyang.

114. Chen Hengke (1876–1923), *Studio by the Water*, dated 1921. Album leaf, ink and colour on paper. 33.7 × 47.6 cm. Metropolitan Museum of Art, New York. Gift of Robert Hatfield Ellsworth, in memory of LaFerne Hatfield Ellsworth, 1986 (1986.267.104). Photo © 2000 The Metropolitan Museum of Art.

115. Gao Jianfu: *Flying in the Rain*, 1932 CE. Hanging scroll, ink and colour on paper. 46 × 35.5 cm. Art Museum of the Chinese University of Hong Kong (73.831).

116. Xu Beihong: *Awaiting the Deliverer*, 1930–3 CE. Oil on canvas. 230 × 318 cm.

Liao Jingwen (Xu Beihong Memorial Hall, Beijing).

117. Lin Fengmian: *Nude*, *c.*1934 CE. Oil on canvas, laid on board. 80.7 × 63.2 cm. Christie's, Hong Kong.

118. Huang Binhong: *Landscape*, *c.*1940s CE. Hanging scroll, ink and colour on paper. 81 × 142 cm. Huang Binhong Memorial Museum, Hangzhou.

119. Lang Jingshan (Long Chin San, 1892–1995), 'Roaring Lion', 1941. Photograph, bromide, 42 × 19 cm. The Royal Photographic Society Collection at the National Museum of Photography, Film and Television, Bradford Science and Society Photo Library.

120. Poster, 'Conquer Every Difficulty; Build Socialism' designed by Yu Yunjie (1917–92) and Zhao Yannian (b. 1924), 1955. © Copyright The Trustees of the British Museum, London (2006.5–1.072).

121. Fu Baoshi and Guan Shanyue: *This Land so Rich in Beauty*, 1959 CE. Ink and colours on paper. 550 × 900 cm. Guan Shanyue/China Photo Library, Hong Kong.

122. Liu Chunhua (b. 1944), *Chairman Mao Goes to Anyuan*, 1968, oil on canvas, as reproduced on the cover of the September 1968 issue of the journal *Renmin huabao* (*People's Pictorial*). © British Library Board. All Rights Reserved (15532.a.21).

123. Liu Zhide: *Old Party Secretary*, *c.*1973 CE. Ink and colours on paper. Huxian City Art Museum, Xi'an.

124. Ye Yushan: *Statue of the seated Mao Zedong*, 1976. White marble. H. 350 cm. Ye Yushan/Hulton Getty Picture Collection Ltd., London.

125. Wang Keping: *Idol*, 1979. Carved wood sculpture. Wang Keping.

126. Luo Zhongli: *Father*, 1980. Oil on canvas. 240 × 165 cm. Luo Zhongli.

127. Luo Qing (Lo Ch'ing): *A Postmodern Self-portrait—China Deconstructed*, 1989. Hanging scroll in ink and colours on paper. 69.5 × 141 cm. Lo Ch'ing/Private Collection.

128. Xu Bing: *A Book from Heaven (Tianshu)*, 1987–91. Movable-type prints and books. Installation as shown at the Chazen Museum of Art (formerly Elvehjem Museum of Art), 1991–2, University of Wisconsin-Madison.

129. Chen Yifei: *Lingering Melodies from the Xunyang River*, 1991. Oil on canvas. 130 × 149 cm. Chen Yifei.

130. Zhang Huan (b. 1965), *65 kg*, 1994, performance, Beijing. Photograph by Ai Weiwei. Zhang Huan Studio, New York.

131. Cai Guoqiang (b. 1957), *Venice's Rent Collection Courtyard*, installation, 1999. Cai Studio, New York.

132. Yang Fudong (b. 1971), installation view of *No Snow on Broken Bridge*, 2006, 35 mm film on eight screens, music by Jin Wang. Courtesy Marian Goodman Gallery, New York.

The publisher and author apologize for any errors or omissions in the above list. If contacted they will be pleased to rectify these at the earliest opportunity.

Bibliographic Essay

This is not a full bibliography on art in China, but is intended as a guide to some of the English-language sources of this book, and indications of further reading. It is arranged by chapters although some works will have relevance to more than one section.

General

R. L. Thorp and R. E. Vinograd, *Chinese Art and Culture* (New York, 2001) addresses the same span of time as this book, with many different examples. Three surveys which take context of use as their ordering principle are: R. L. Thorp, *Son of Heaven: Imperial Arts of China* (Seattle, 1988), R. Kerr (ed.), *Chinese Art and Design* (London, 1991), and J. Rawson (ed.), *The British Museum Book of Chinese Art* (London, 1992). The reference materials and bibliographies at the end of this latter volume are particularly useful. Specialist English language journals which cover art in China include *Archives of Asian Art, Artibus Asiae, Arts of Asia, Oriental Art*, and *Orientations*, the latter title being distinguished for its colour reproduction, frequent publication of new research from China itself, and by important thematic issues on topics like Dunhuang, or the collections of major museums.

An essential bibliographic tool on Chinese painting, which is also a valuable survey in its own right, is J. Silbergeld, 'Chinese Painting Studies in the West: A State-of-the-Field Article', *Journal of Asian Studies*, 46 (1987), 849–97. An equally essential collection of translated source material is S. Bush and Hsio-yen Shih, *Early Chinese Texts on Painting* (Cambridge, Mass., and London, 1985), more accessible than W. R. B. Acker, *Some T'ang and Pre-T'ang Texts on Chinese Painting* (Leiden, 1954).

S. Bush, *The Chinese Literati on Painting: Su Shih (1037–1101) to Tung Ch'i-ch'ang (1555–1636)* (Harvard Yenching Studies, 27; Cambridge, Mass., 1971) contains less translation and more commentary, still of considerable use but now looking rather in thrall to the viewpoint of its sources.

R. Barnhart (ed.), *Three Thousand Years of Chinese Painting* (New Haven and London, 1997), is the richest single volume history. Not yet fully superseded as a guide to technical aspects of the art is R. H. van Gulik, *Chinese Pictorial Art as Viewed by the Connoisseur* (Rome, 1958; repr. New York, 1981). However, Yu Feian, *Chinese Painting Colours: Studies of their Preparation and Application in Traditional and Modern Times*, tr. Jerome Silbergeld and Amy McNair (Hong Kong and Seattle, 1988) is very valuable and detailed, but is mostly unillustrated, while So Kam Ng, *Brushstrokes: Styles and Techniques of Chinese Painting* (San Francisco, 1993) has many more pictures, and is an excellent short introduction.

Still well worth studying are Benjamin March, *Some Technical Terms of Chinese Painting* (Baltimore, 1935), and J. Silbergeld, *Chinese Painting Style: Media, Methods and Principles of Form* (Seattle and London, 1982). There is nothing comparable devoted to techniques of sculpture in China, but A. Paludan, *Chinese Sculpture: A Great Tradition* (Chicago, 2007) is a thorough survey; J. Larson and R. Kerr, *Guanyin: A Masterpiece Revealed* (London, 1985) shows what a close study of one object (**56** in the present text) can reveal.

Almost all the objects in this book have been published before, and discussed in the context of different approaches to the subject. For example, S. W. Goodfellow

(ed.), *Eight Dynasties of Chinese Painting: The Collections of the Nelson Gallery-Atkins Museum, and the Cleveland Museum of Art* (Cleveland, 1980) discusses **14, 28, 35, 76, 81, 83, 87, 106**, while its introductory essays by themselves provide an overview of Chinese painting written round two of the major American collections.

A number of volumes of essays treat themes central to this book. S. Bush and C. Murck (eds.), *Theories of the Arts in China* (Princeton, 1983) opens up the field of aesthetics within which the visual arts are situated, while A. Murck and W. C. Fong (eds.), *Words and Images: Chinese Poetry, Painting and Calligraphy* (New York, 1991) deals with the interrelationship between key élite art forms. C. Clunas, *Pictures and Visuality in Early Modern China* (London, 1997) attempts to relate painting to other forms of picturing in one period, that of the Ming. The pieces in C. Li (ed.), *Artists and Patrons: Some Social and Economic Aspects of Chinese Painting* (Lawrence, Kan., 1989) mark the beginning of the serious study of the relationship between makers and consumers of painting. Another revisionist survey which provides essential orientation for the new student is J. Cahill, *The Painter's Practice: How Artists Lived and Worked in Traditional China* (New York, 1994), also his *Three Alternative Histories of Chinese Painting* (The Franklin D. Murphy Lectures, 9; Lawrence, Kan., 1988).

Perhaps the major change in the field of the last twenty-five years has been the extensive publication of material held in Chinese collections, which could not be covered in earlier surveys. Major series like *Zhongguo meishu quanji* (Complete Arts of China), published variously in Beijing and Shanghai, have begun to make available bodies of material to supplement those of the National Palace Museum, Taipei, and of collections outside China, which have formed the inevitable backbone of all English-language literature until the 1980s.

1: Art in the Tomb

The pace of excavation within China is so intense that standard accounts quickly become out of date. R. Thorp, *China in the Early Bronze Age: Shang Civilisation* (Philadelphia, 2006) covers the first securely known dynasty, while L. von Falkenhausen, *Chinese Society in the Age of Confucius (1000–250 BC): The Archaeological Evidence* (Los Angeles, 2006), is the best

recent synthesis on the Zhou dynasty, to set alongside an exhibition catalogue like W. Fong (ed.), *The Great Bronze Age of China* (New York, 1980).

G. L. Barnes, *China, Korea and Japan: The Rise of Civilization in East Asia* (London, 1993) is a rich synthesis which is strengthened by studying China in a regional context. The journal *Early China* carries reports on recent finds, and usually the first analysis of them too. On early jade J. Rawson, *Chinese Jade from the Neolithic to the Qing* (London, 1995) replaces previous accounts. The Sanxingdui finds are discussed in R. W. Bagley, 'A Shang City in Sichuan Province', *Orientations* (Nov. 1995), 52–67, and in J. Rawson (ed.), *Mysteries of Ancient China: New Discoveries from the Early Dynasties* (London, 1996).

The Tomb of Fu Hao is discussed in Thorp and in R. W. Bagley, *Shang Ritual Bronzes in the Arthur M. Sackler Collections* (Washington, DC, and Cambridge, Mass., 1987), while the importance of studying sets rather than individual pieces is underlined in J. Rawson, 'Ancient Chinese Ritual Bronzes: The Evidence from Tombs and Hoards of the Shang (*c.*1500–1050 BC) and Western Zhou (*c.*1050–771 BC) Periods', *Antiquity*, 67 (1993), 805–23, which also touches on the 'ritual revolution'. Taken together with E. Shaughnessy, *Sources of Western Zhou History: Inscribed Bronze Vessels* (Berkeley, Calif., 1991) and J. Rawson, *Western Zhou Ritual Bronzes from the Arthur M. Sackler Collections* (Cambridge, Mass., 1990), these also provide accounts of the technical processes of making and the role of inscriptions. J. Rawson, *Chinese Bronzes: Art and Ritual* (London, 1987), is less comprehensive but more portable, while L. Nickel, 'Imperfect Symmetry: Re-thinking Bronze Casting Technology in Ancient China', *Artibus Asiae*, 66.1 (2006), 5–39, provides a wholly new explanation for how the decoration on bronzes was cast.

Both sides of the debate about the meaning of early decoration on bronze vessels are aired in R. Whitfield (ed.), *The Problem of Meaning in Early Chinese Ritual Bronzes* (London, 1992) and recapitulated in L. Kesner, 'The Taotie Reconsidered: Meanings and Functions of Shang Theriomorphic Imagery', *Artibus Asiae*, 51/1–2 (1991), 29–53. A useful summary of the issues is L. von Falkenhausen, 'Issues in Western Zhou Studies: A Review Article', *Early China*, 18 (1993), 139–226.

Changes in the understanding of tombs are clearly explained in Wu Hung, 'From Temple to Tomb: Ancient Chinese Art and Religion in Transition', *Early China*, 13 (1988), 83–6, and in Wu Hung, *Monumentality in Early Chinese Art* (Stanford, Calif., 1996).

The best synthesis on the 'terracotta army' is provided by J. Portal (ed.), *The First Emperor: China's Terracotta Army* (London, 2007). L. Kesner, 'Likeness of No One: (Re)presenting the First Emperor's Army', *Art Bulletin*, 77/1 (Mar. 1995), 115–32, presents one argument about the figures' purpose, while L. Ledderose, *Ten Thousand Things: Module and Mass Production in Chinese Art* (Princeton, NJ, 2000), situates them in a much broader context. The literature on Mawangdui is now very extensive, but an excellent starting-point is Wu Hung, 'Art in a Ritual Context: Rethinking Mawangdui', *Early China*, 17 (1992), 115–32. The same author's *The Wu Liang Shrine: The Ideology of Early Chinese Pictorial Art* (Stanford, Calif:, 1989) is essential reading, to be supplemented by the equally important M. J. Powers, *Art and Political Expression in Early China* (New Haven, 1991), and now (in a new twsit to an old controversy) by C.Y. Liu, M. Nylan and A. Barbieri-Low (eds.), *Recarving China's Past: Art, Archaeology and Architecture of the 'Wu Family Shrines'* (New Haven and London, 2005).

The Nanjing 'Seven Sages' tombs are the focus of A. Spiro, *Contemplating the Ancients: Aesthetic and Social Issues in Early Chinese Portraiture* (Berkeley, Calif. 1990), which ranges as widely as its title suggests. A typically stimulating discussion of this and other monuments of the period appears in Wu Hung, 'Three Famous Stone Monuments from Luoyang: Binary Imagery in Early Sixth Century Chinese Pictorial Art', *Orientations*, 25/5 (May 1994) 51–60. The standard account of spirit roads and their sculpture is A. Paludan, *The Chinese Spirit Road: The Classical Tradition of Stone Tomb Statuary* (New Haven and London, 1991).

2: Art at Court

A. C. Soper, *Textual Evidence for the Secular Arts of China in the Period from Liu Sung through Sui (A.D. 420–618), Excluding Treatises on Painting* (Artibus Asiae Supplementum, 24; Ascona, 1968) repays close reading. M. Sullivan, *The Birth of Landscape Painting in China* (Berkeley, Calif:, and Los Angeles,

1962), remains the standard account, though there is little published accessibly which discusses the important Yemaotai scroll adequately.

The religious dimensions of early landscape painting are discussed in S. Bush, 'Tsung Ping's Essay on Landscape Painting and the "Landscape Buddhism of Mt. Lu" ', and L. Ledderose, 'The Earthly Paradise: Religious Elements in Chinese Landscape Art', both in S. Bush and C. Murck (eds.), *Theories of the Arts in China* (Princeton, 1983), and in K. Munakata, *Sacred Mountains in Chinese Art* (Urbana, Ill., and Chicago, 1991).

Guo Xi's writings are translated in S. Bush and Hsio-yen Shih (eds.), *Early Chinese Texts on Painting* (Cambridge, Mass., and London, 1985), while Northern Song court art can be approached generally via W. Fong, *Beyond Representation: Chinese Painting and Calligraphy, 8th–14th Century* (Princeton Monographs in Art and Archaeology, 48; New York, 1992), written around the collections of the Metropolitan Museum, New York, and with extensive bibliography. Both as patron and artist, Huizong is now fully treated in P. B. Ebrey and M. Bickford (eds.) *Emperor Huizong and Late Northern Song China: The Politics of Culture and the Culture of Politics* (Cambridge, Mass., 2006). See also the fine article by P. C. Sturman, 'Cranes above Kaifeng: The Auspicious Image at the Court of Huizong', *Ars Orientalis*, 20 (1992), 34–68.

Serious students of the Northern Song will need to engage with P. Bol, *This Culture of Ours: Intellectual Transitions in T'ang and Sung China* (Stanford, Calif., 1992), which is highly relevant to many artistic issues. A useful brief summary on early imperial collecting is L. Ledderose, 'Some Observations on the Imperial Art Collections in China', *Transactions of the Oriental Ceramic Society*, 43 (1978–9), 33–46. The important topic of engraved calligraphy at the Song court is the subject of A. McNair, 'The Engraved Model Letters Compendia of the Song Dynasty', *Journal of the American Oriental Society*, 14/2 (1994) 209–25.

The 'Odes' scrolls have been studied in exemplary fashion in J. K. Murray, *Ma Hezhi and the Illustration of the Book of Odes* (Cambridge, 1993), while Southern Song and Yuan art are discussed in W. Fong, *Beyond Representation* (above). Much of the material in M. Bickford (ed.), *Bones of Jade*,

Soul of Ice: The Flowering Plum in Chinese Art (New Haven, 1985) is also Southern Song. It is a real lack that there are not more in-depth studies of individual subject-matters to accompany this fine example. Both Fong and Weidner (eds.), *Latter Days of the Law* (below) discuss the Wang Zhenpeng Vimalakirti scroll.

The study of Ming imperial art has been revolutionized by Richard Barnhart, *Painters of the Great Ming: The Imperial Court and the Zhe School* (Dallas, 1993), but Ming court culture is still less well-researched than is that of the Qing, covered by many important recent articles including S. Heilesen, 'Southern Journey', *Bulletin of the Museum of Far Eastern Antiquities*, 52 (1980), 89–144, Wei Dong, 'Qing Imperial "Genre Painting": Art as Pictorial Record', *Orientations*, 26/7 (July/Aug. 1995), 18–24, and Yang Boda, 'The Development of the Ch'ien-lung Painting Academy', in A Murck and W. C. Fong (eds.), *Words and Images* (New York, 1991). Three exhibition catalogues: H. Zhang (ed.), *The Qianlong Emperor: Treasures from the Forbidden City* (Edinburgh, 2002); C. Ho and B. Bronson (eds.), *Splendors of China's Forbidden City: The Glorious Reign of Emperor Qianlong* (London, 2004); E. S. Rawski and J. Rawson (eds.), *China: The Three Emperors, 1662–1795* (London, 2005) now give excellent coverage of the eighteenth century.

An entire issue of *Orientations* (19/11, Nov. 1988) is devoted to Castiglione, including Yang Boda, 'Castiglione at the Qing Court: An Important Artistic Contribution', pp. 44–51. A number of significant Qing court paintings are well treated in H. Rogers and S. E. Lee, *Masterpieces of Ming and Qing Painting from the Forbidden City* (Lansdale, Pa., 1988). The July/Aug. 1995 issue of *Orientations* is again devoted to Qing court art, including Wu Hung, 'Emperor's Masquerade—"Costume Portraits" of Yongzheng and Qianlong', *Orientations*, 26/7 (July/Aug. 1995), 25–41 and Yu Hui, 'Naturalism in Qing Imperial Group Portraiture', *Orientations*, 26/7 (July/Aug. 1995), 42–50.

Later court art is covered in J. Chou and C. Brown, *The Elegant Brush: Chinese Painting under the Qianlong Emperor* (Phoenix, 1985) and in C. Brown and J. Chou, *Transcending Turmoil: Painting at the Close of China's Empire* (Phoenix, 1992). The best coverage of Dowager Empress Cixi as an artist is in the catalogue, M. Weidner, E.J. Laing,

I. Y. Lo, and J. Robinson, *Views from Jade Terrace: Chinese Women Artists 1300–1912* (Indianapolis and New York, 1988).

Decorative arts at court have been better catalogued than analysed in English. R. L. Thorp, *Son of Heaven: Imperial Arts of China* (Seattle, 1988) and R. Kerr (ed.), *Chinese Art and Design* (London, 1991) both attempt surveys. Two good recent points of entry into the huge literature on ceramics are S. G. Valenstein, *A Handbook of Chinese Ceramic*, revised 2nd edn. (New York and London, 1989), and S. Vainker, *Chinese Pottery and Porcelain: From Prehistory to the Present* (London, 1991). A range of imperial objects, including the 'Yu the Great' jade boulder, is illustrated in Zhu Jiajin, *Treasures of the Forbidden City* (Harmondsworth, 1986).

3: Art in the Temple

There are comprehensive 'state-of-the-field' articles on Chinese religions, with exhaustive bibliographies, in *Journal of Asian Studies*, 54/1 (1995), 124–60 (to the end of the Han) and 54/2 (1995), 134–95 (Post-Han). The *Journal of Chinese Religions* carries articles on artistic subjects from time to time.

The earliest phase of Chinese Buddhist art is treated in Wu Hung, 'Buddhist Elements in Early Chinese Art (2nd and 3rd Centuries A.D.)', *Artibus Asiae*, 47/3–4 (1987), 263–316, and at much greater length in S. Abe, *Ordinary Images* (Chicago, 2002), a book whose modest title hides its major importance, and which casts productive doubt on the entire category of 'Buddhist art'. A. C. Soper, *Literary Evidence for Early Buddhist Art in China* (Antibus Asiae Supplementum, 19; Ascona, 1959) is an invaluable compendium of sources, but is unillustrated, as is J. O. Caswell, *Written and Unwritten: A New History of the Buddhist Caves at Yungang* (Vancouver, 1988) which is notwithstanding the best text on Yungang. A significantly different interpretation is advanced in J. C. Huntington, 'The Iconography and Iconology of the "Tan Yao Caves" at Yungang', *Oriental Art*, NS 32/2 (Summer 1986), 142–60. R. Whitfield and A. Farrer, *Caves of the Thousand Buddhas: Chinese Art from the Silk Route* (London, 1990) is more descriptive than analytical, and could profitably be read in tandem with the articles in *Orientations* (Mar. 1989), which is devoted to Dunhuang. Issues of patronage and style are covered in S. K. Abe, 'Art

and Practice in a Fifth-Century Buddhist Temple', *Ars Orientalis*, 20 (1991), 1–31, and more fully in S. E. Fraser, *Performing the Visual: The Practice of Buddhist Wall Painting in China and Central Asia, 618–960* (Stanford, Calif., 2004). Another important monograph on Buddhist art, a flourishing field at present, is E. Wang, *Shaping the Lotus Sutra: Buddhist Visual Culture in Medieval China* (Seattle, Wash., 2005).

M. Weidner, *Latter Days of the Law-Images of Chinese Buddhism 850–1850* (Lawrence, Kan., and Honolulu, 1994) is a magnificent survey, which rescues later Buddhist art from undeserved oblivion, and which discusses several of the works in this book in detail. It integrates an understanding of Buddhist religious belief with the art in a way which has thankfully now begun for Daoism too, with a major exhibition catalogue; S. Little (ed.), *Taoism and the Arts of China* (Chicago, 2000). What a scholar who fully understands the religious context can achieve is shown by S. F Teiser, ' "Having Once Died and Returned to Life": Representations of Hell in Medieval China', *Harvard Journal of Asiatic Studies*, 48/2 (1988), 433–64. On the Jinci sculptures, A. McNair, 'On the Date of the Shengmudian Sculptures at Jinci', *Artibus Asiae*, 49 (1988–9), 238–53, delivers very much more than the title suggests, but its central interpretation (adopted here) has now been convincingly refuted by T. Miller, *The Divine Nature of Power: Chinese Ritual Architecture at the Sacred Site of Jinci* (Cambridge Mass., and London, 2007).

The development of Guanyin imagery is well covered in Weidner, *Latter Days of the Law*, and also in D. Gillman, 'A New Image in Chinese Buddhist Sculpture of the Tenth to Thirteenth Century', *Transactions of the Oriental Ceramic Society*, 47 (1982–3), 33–44. The former treats Buddhist portraiture rather briefly, and can be supplemented by an older survey, J. Fontein and M. L. Hickman, *Zen Painting and Calligraphy* (Boston, 1970), as well as by two pieces by H. Brinker, 'Ch'an Portraits in a Landscape', *Archives of Asian Art*, 27 (1973–4), 8–29, and 'Body, Relic and Image in Zen Buddhist Portraiture', *International Symposium on Art Historical Studies, vi: Portraiture* (Society for International Art Historical Studies; Kyoto, 1990), 46–61. However, the received wisdom on this topic (including Brinker's views) is trenchantly attacked in a very important article by

T. G. Foulk and R. H. Sharf, 'On the Ritual Uses of Ch'an Portraiture in Medieval China', *Cahiers d'Extrême Asie*, 7 (1993–4), 149–219, which art historians will need to digest.

P. Katz, 'The Function of Temple Murals in Imperial China: The Case of the Yung-lo Kung', *Journal of Chinese Religions*, 21 (1993), 45–68, is excellent on the religious context of the Daoist murals of Shanxi, while N. S. Steinhardt, 'Zhu Haogu Reconsidered: A New Date for the ROM (Royal Ontario Museum) Painting and the Southern Shanxi Buddhist Taoist Style', *Artibus Asiae*, 48/1–2 (1997), 11–16, explores some of the stylistic issues of related murals now outside China. M. Weidner, *Latter Days of the Law* (above) provides material on the 'Water and Land Assembly' cycles, which are the focus of D. M. Stevenson, 'Text, Image and Transformation in the History of the *Shuilu fahui*, the Buddhist Rite for Deliverance of Creatures of Water and Land', in M. Weidner (ed.), *Cultural Intersections in Later Chinese Buddhism* (Honolulu, 2001), 30–72.

The Guanyin cult in its domestic setting is treated in W. Watson (ed.), *Chinese Ivories from the Shang to the Qing* (London, 1984) which also deals with a range of small religious images in a number of materials. The literature on early Christian art in China requires updating, but a compelling account of the Jesuits' view of their own project is contained in J. Spence, *The Memory Palace of Matteo Ricci* (London, 1985). On Ming and Qing court religious art, the starting-point is again inevitably M. Weidner, *Latter Days of the Law*, but there is now also the outstanding study by P. Berger, *Empire of Emptiness: Buddhist Art and Political Authority in Qing China* (Honolulu, 2003).

4: Art in the Life of the Élite

One of the clearest accounts of the Wang tradition of calligraphy is provided by L. Ledderose, *Mi Fu and the Classical Tradition of Chinese Calligraphy* (Princeton, 1979), which should be supplemented by the same author's 'Chinese Calligraphy: Its Aesthetic Dimension and Social Function', *Orientations*, 17/10 (Oct 1986), 35–50, and 'Some Taoist Elements in the Calligraphy of the Six Dynasties', *T'oung Pao*, 70 (1984), 247–78. R. C. Kraus, *Brushes with Power: Modern Politics and the Chinese Art of Calligraphy* (Berkeley, Calif., 1991)

is admirably lucid and demystifying, and ranges much more widely than its title would suggest. It is an excellent introduction to the problems of script as art. P. C. Sturman, *Mi Fu: Style and the Art of Calligraphy in Northern Song China* (New Haven and London, 1997) is a monograph on one of its most important practitioners, while R. E. Harrist and W. Fong, *The Embodied Image: Chinese Calligraphy from the John B. Elliott Collection* (New York, 1999) is a fine overview with excellent illustrations.

J. Hay, 'The Human Body as a Microcosmic Source of Macrocosmic Values in Calligraphy', in S. Bush and C. Murck (eds.), *Theories of the Arts in China* (Princeton, 1983), has been highly influential on many recent interpretations, not only of calligraphy. There is much less in English on rubbings and engraved calligraphy, but an excellent start is made in A. McNair, 'Engraved Calligraphy in China: Recension and Reception', *Art Bulletin*, 77/1 (1995). 106–14.

The aesthetic theories of the Su Shi circle, and the birth of 'scholar' painting are well covered in S. Bush and Hsio-yen Shih (eds.), *Early Chinese Texts on Painting* (Cambridge, Mass., 1985), 191–240, also S. Bush, *The Chinese Literati on Painting* (Cambridge, Mass., 1971) and W. Fong, *Beyond Representation* (New York, 1992). There is rich material too, in P. Bol, *This Culture of Ours* (Stanford, Calif., 1992), and K. Smith Jr., *et al.*, *Sung Dynasty Uses of the I Ching* (Princeton, 1990). J. Cahill, *The Painter's Practice* (New York, 1994) provide a wealth of cautionary tales against mistaking these theories for accounts of practice, particularly as regards the separation of the 'scholar' artist from mundane concerns. The same author's much earlier essay, 'Confucian Elements in the Theory of Painting', in A. E. Wright (ed.), *The Confucian Persuasion* (Stanford, Calif., 1960), 115–40, still repays study.

Standard works on Yuan painting include J. Cahill, *Hills Beyond a River: Chinese Painting of the Yuan Dynasty, 1279–1368* (New York, 1976). The works by Bush and Shih, Bush, and Fong also bear upon the scholar artists of the Yuan, while Zhao Mengfu's calligraphy is covered additionally in F. W. Mote and H. Chu, *Calligraphy and the East Asian Book* (Boston and Shaftesbury 1989). On the question of meaning in their work, a crucial article is R. Vinograd, 'Family Properties: Personal Context and

Cultural Pattern in Wang Meng's *Pien Mountains* of 1366', *Ars Orientalis*, 13 (1982), 1–29. Other studies are noted in the survey article by Silbergeld (above). A complex but rewarding reading of the changes in Yuan painting is J. Hay, 'Boundaries and Surfaces of Self and Desire in Yuan Painting', in J. Hay (ed.), *Boundaries in China* (London, 1994), 124–70.

On women élite artists from Guan Daosheng on, and including Wen Shu, the invaluable exhibition catalogue M. Weidner, E.J. Laing, I. Y. Lo, and J. Robinson, *Views from Jade Terrace: Chinese Women Artists 1300–1912* (Indianapolis and New York, 1988) is supplemented by the several important essays in M. Weidner (ed.), *Flowering in the Shadows: Women in the History of Chinese and Japanese Painting* (Honolulu, 1990), especially those by Shen C. Y. Fu on 'Princess Sengge Ragi: Collector of Painting and Calligraphy', and E. J. Laing, 'Women Painters in Traditional China'.

The Mount Hua album of Wang Lü has been the subject of an exemplary monograph by K. M. Liscomb, *Learning from Mt. Hua: A Chinese Physician's Illustrated Travel Record and Painting Theory* (Res Monographs on Anthropology and Aesthetics; Cambridge, 1993), which shows how the close study of one artwork can illuminate the whole field. The Ming genre of the 'portrait in a landscape' is discussed in C. Clunas, *Fruitful Sites: Garden Culture in Ming Dynasty China* (London, 1996). Tang Yin and Wen Zhengming have both been the subject of monographs by A. Clapp, *The Painting of T'ang Yin* (Chicago, 1991) and *Wen Cheng-ming: The Ming Artist and Antiquity* (Artibus Asiae Supplementum, 34; Ascona, 1975), and both are well covered in J. Cahill, *Parting at the Shore: Chinese Painting of the Early and Middle Ming Dynasty, 1368–1580* (New York, 1982). A sceptical eye on the poetic talents of both men is cast by J. Chaves, ' "Meaning beyond the Painting": The Chinese Painter as Poet', in A. Murck and W. C. Fong (eds.), *Words and Images* (New York, 1991), 431–58. C. Clunas, *Elegant Debts: The Social Art of Wen Zhengming, 1470–1559* (London, 2004) examines in detail the social relationships which conditioned the artistic practice of one of these major Ming painters.

On the late Ming, J. Cahill, *The Distant Mountains: Chinese Painting of the Late Ming Dynasty 1570–1644* (New York, 1982) is now

supplemented by the monumental study of the central figure of the period, W. Ho (ed.), *The Century of Tung Ch'i-ch'ang 1555–1636*, 2 vols. (Seattle and London, 1992). The compelling essay therein by C. C. Reily, 'Tung Ch'i-ch'ang's Life', pp. 385–458 is the fullest account we have in English of the interplay of social and artistic strategies for a given élite artist of the imperial period. There are important essays on late Ming culture in C. Li and J. C. Y. Watt (eds.), *The Chinese Scholar's Studio: Artistic Life in the Late Ming Period* (New York and London, 1987). The complexities of the seventeenth century are covered in J. Cahill, *The Compelling Image: Nature and Style in Seventeenth-Century Chinese Painting* (Cambridge, Mass., 1982), while the dangers of taking dynastic boundaries for stylistic ones are underlined in J. Hay, 'The Suspension of Dynastic Time', in J. Hay (ed.), *Boundaries in China* (1994), 171–97. The recovery of portraiture as a genre at this period is the central theme of R. Vinograd, *Boundaries of the Self: Chinese Portraits 1600–1900* (Cambridge, 1992). The definitive monograph on Shitao is J. Hay, *Shitao: Painting and Modernity in Early Qing China* (Cambridge, 2001), and on the artist formerly known as Bada Shanren there is Wang Fangyu and R. M. Barnhart, *Master of the Lotus Garden: The Life and Art of Bada Shanren (1626–1705)* (New Haven, 1990). Regional schools of the seventeenth century are well covered in several of the essays in C. Li (ed.), *Artists and Patrons* (Lawrence, Kan., 1989).

On Gao Qipei see K. Ruitenbeek, *Discarding the Brush: Gao Qipei (1660–1734) and the Art of Chinese Finger Painting* (Amsterdam, 1992). The revival of interest in early calligraphy in the Qing period is one of the themes of Bai Qianshen, *Fu Shan's World: The Transformation of Chinese Calligraphy in the Seventeenth Century* (Cambridge, Mass., 2003), and also of the article by A. McNair, cited above, as well as J. Kuo, *Word as Image: The Art of Chinese Seal Engraving* (New York, 1992), more general than its title would suggest.

The life-size self-portrait by Ren Xiong has become one of the most studied of all Chinese pictures over the last decade. See Vinograd, *Boundaries of the Self* (above) and (for an example of the application of recent developments in cultural theory to this and other works of portraiture), A. Zito, 'Silk and Skin: Significant Boundaries', in A. Zito and T. E. Barlow (eds.), *Body, Subject and Power in China* (Chicago, 1994), 103–30.

5: Art in the Market-Place

On printing and illustrated books see M. Bickford, *Bones of Jade, Soul of Ice: The Flowering Plum in Chinese Art* (New Haven, 1985), also, J. Needham, *Science and Civilization in China*, v/1: Tsien Tsuen-hsin, *Paper and Printing* (Cambridge, 1985), S. Edgren, *Chinese Rare Books in American Collections* (New York, 1985), Mote and Chu, *Calligraphy and the Chinese Book*, and H. Kobayashi and S. Sabin, 'The Great Age of Anhui Printing', in J. Cahill (ed.), *Shadows of Mt. Huang: Chinese Painting and Printing of the Anhui School* (Berkeley, Calif., 1991).

On ceramics, see the works by Valenstein and Vainker (above). The collecting activities of Wang Zhen are analysed in K. Liscomb, 'A Collection of Painting and Calligraphy Discovered in the Inner Coffin of Wang Zhen (d. 1495)', *Archives of Asian Art*, 47 (1994), 6–34. On collecting, and the market in works of art, see C. Clunas, *Superfluous Things: Material Culture and Social Status in Early Modern China* (Honolulu, 2004).

Qiu Ying is covered in J. Cahill, *Parting at the Shore* (above), and in E. J. Laing, 'Ch'iu Ying's Two Garden Paintings Belonging to the Chion-in, Kyoto', in *International Colloquium on Chinese Art History, 1991: Proceedings, Painting and Calligraphy* (2 vols., Taipei, 1992), 331–58, which challenges the traditional identification of the 'Golden Valley Garden'. The Schloss Ambras pictures are the subject of R. Whitfield, 'Chinese Paintings from the Collection of Archduke Ferdinand II', *Oriental Art*, 22 (1976), 406–16.

Analytical work on the role of textiles as an art form is only now beginning, but there is some interesting material in Weidner (ed.), *Jade Terrace*, and in D. Ko, *Teachers of the Inner Chambers: Woman and Culture in Seventeenth Century China* (Stanford, Calif., 1994), especially pp. 172–6. The role of signatures in craft manufacture in the Ming is a theme of Clunas, *Superfluous Things*. Professional effigy portraiture is discussed in R. Vinograd, *Boundaries of the Self* (Cambridge, 1992), and in J. Cahill, *Parting at the Shore*, but the fullest treatment is now J. Stuart and E. Rawski, *Worshipping the Ancestors: Chinese Commemorative Portraits* (Stanford, Calif., 2001). Its connections

to the art of physiognomy are sensitively explored in M. Siggstedt, 'Forms of Fate: An Investigation of the Relationship Between Formal Portraiture, Especially Ancestor Portraits, and Physiognomy (*xiangshu*) in China' in *International Colloquium on Chinese Art History, 1991: Proceedings, Painting and Calligraphy* (2 vols., Taipei, 1992), 713–48.

The elusive character of Chen Hongshou is effectively pinned down, and the ambiguities in his deployment of social roles well explored, in A. Burkus-Chasson, 'Elegant or Common? Chen Hongshou's Birthday Presentation Pictures and His Professional Status', *Art Bulletin,* 26/2 (June 1994), 279–300. The same artist is discussed in Cahill, *Restless Landscape,* and Vinograd, *Boundaries of the Self.*

There is no single overview of Qing painting on a par with Cahill's volumes on the Yuan and Ming. But the two catalogues Chou and Brown, *The Elegant Brush* and *Transcending Turmoil,* collectively repair the gap to an extent. The nineteenth century remains under-researched, at least in English, and there is nothing to compare with the polemically titled Wan Qingli, *Bing fei shuailuo do bainian: shijiu shiji Zhongguo huihua shi/The Century was not Declining in Art: A History of Nineteenth-century Chinese Painting* (Taibei, 2005), although W. C. Fong, *Between Two Cultures: Late-Nineteenth-and Twentieth-Century Chinese Paintings from the Robert H. Ellsworth Collection in The Metropolitan Museum of Art* (New York, 2001) covers some of the ground.

On export art, surveys include C. Clunas (ed.), *Chinese Export Art and Design* (London, 1987), and C. L. Crossman, *The Decorative Arts of the China Trade* (Woodbridge, 1991). Photography has still not been adequately discussed in English, and only work in Chinese, principally Chen Shen *et al., Zhongguo sheying shi* ('A History of Chinese Photography', Taipei, 1990) reproduces an adequate range of early Chinese practice, as opposed to that by visiting Europeans or Americans, which is better studied. Patronage in nineteenth-century Shanghai is dealt with by S. Y. Lee, 'Art Patronage of Shanghai in the Nineteenth Century', in C. Li (ed.), *Artists and Patrons* (Lawrence, Kan., 1989), 223–31.

There has been a large expansion of writing about twentieth-century Chinese art over the last ten years since the first edition of this book. An overview is provided in M. Sullivan, *Art and Artists of Twentieth-century China* (Berkeley, Calif., 1996), by the first western scholar to take the subject seriously, who has championed it for well over a half-century. Another survey, putting Chinese art in a wider framework, is J. Clark, *Modern Asian Art* (North Ryde, NSW, 1998), while J. F. Andrews and Kuiyi Shen (eds.), *A Century in Crisis: Modernity and Tradition in the Art of Twentieth-Century China* (New York, 1998) is the catalogue of a major survey exhibition. The cultural politics of *guohua* painting are subtly explored in Aida Yuen Wong, *Parting the Mists: Discovering Japan and the Rise of National-Style Painting in Modern China* (Honolulu, 2006), while one specific school of such painting is the focus of R. Croizier, *Art and Revolution in Modern China: The Lingnan (Canton) School of Painting, 1906–1951* (Berkeley, Calif., 1988). The volume of essays edited by Kao Mayching, *Twentieth-Century Chinese Painting* (Hong Kong, 1988) extends the coverage. On Xu Beihong see *The Art of Xu Beihong* (Hong Kong Museum of Art, Hong Kong, n.d.). The lost history of modernism in China is beginning to be exhumed, a good example being R. Croizier, 'Post-Impressionists in Pre-War Shanghai: The Juelanshe (Storm Society) and the Fate of Modernism in Republican China', in J. Clark (ed.), *Modernity In Asian Art* (Broadway, NSW, 1993), 135–54. The catalogue of a major exhibition, J. Birnie Danzker, K. Lum, and Zheng Shengtian (eds.), *Shanghai Modern: 1919–1945* (Munich 2005), not only illustrates many rare works but translates key documents of the interwar period. On this period see also M. K. Hearn and J. G. Smith (eds.), *Chinese Art Modern Expressions* (New York, 2001)

A work of pre-eminent quality on the politics of artistic production under Communist party rule is J. E. Andrews, *Painters and Politics in the People's Republic of China 1949–1979* (Berkeley, Calif., 1994). There is still much useful material in J. L. Cohen, *The New Chinese Painting 1949–1986* (New York, 1987), and E. J. Laing, *The Winking Owl: Art in the People's Republic of China* (Berkeley Calif:, 1988). Laing has the advantage of dealing with sculpture, and graphic design, as well as painting. Kraus, *Brushes with Power,* deals entertainingly with the special case of calligraphy in the PRC. The Cultural Revolution is only now beginning to receive scholarly attention,

one major contribution being H. Evans and S. Donald (eds.), *Picturing Power in the People's Republic of China: Posters of the Cultural Revolution* (Oxford, 1999).

Andrews, Cohen, and Laing bring the story as far as the 'Stars' group, but since 1997 analysis of contemporary developments has exploded in quantity, and it would be impossible to list all the exhibition catalogues and artists monographs which have been published. Good starting-points are: J. Noth, I. Pohlmann, and I. C. Reschke (eds.), *China Avant-Garde* (Berlin, 1993), Gao Minglu, (ed.), *Inside Out: New Chinese Art* (Berkeley, 1998), and Wu Hung, *Transience: Chinese Experimental Art at the End of the Century* (Chicago, 1999). J. F. Andrews and Gao Minglu, 'The Avant-Garde's Challenge to Official Art', in D. Davis, *et al.* (eds.), *Urban Spaces in Contemporary China the Potential for Autonomy and Community in Post-Mao China* (Cambridge, 1995), 221–78 is an excellent short introduction. More extensive discussion can be found in G. R. Barme, *In the Red: On Contemporary Chinese Culture* (New York, 1999), and C. Huot, *China's New Cultural Scene* (Durham and London, 2000), while Wu Hung (ed.), *Chinese Art at the Crossroads: Between Past and Future, Between East and West* (London, 2001) is a highly useful compendium of documents and statements by foreign and Chinese artists and critics. The artists discussed individually in the text all have extensive personal websites: www.yifei.com; www.zhanghuan.com; www.caiguoqiang.com; www.yangfudong.com. The journal *Yishu: Journal of Contemporary Chinese Art* is now essential for anyone attempting to keep up with developments, as is its website, www.yishujournal.com.

Museums and Galleries

There are important museum collections of Chinese art all over the world, with major museums in every Chinese provincial capital and in many other places and historic sites. Outside China, important collections are dispersed very widely, and the following list is only a selection, limited principally to those museums with significant websites in English. The Society for East Asian Archaeology website, http://www. seaa-web.org, includes a comprehensive list of museums and websites.

ASIA

China National Museum of Fine Arts (China Art Gallery)
1 Wusi Street,
BEIJING 100010,
CHINA
Mostly a venue for temporary exhibitions, but also holds the leading collection of twentieth-century Chinese art.

Hong Kong Museum of Art
10 Salisbury Road,
Tsim Sha Tsui,
Kowloon,
Hong Kong SAR
http://www.lcsd.gov.hk/CE/Museum/Arts/english/intro/eintro.html

National Museum of China
16, East Chang'an Street,
Dongcheng District,
BEIJING 100006,
CHINA
http://www.nationalmuseum.cn/en/index.jsp
Principally a historical museum, but its collections contain many important and less well-known pieces.

National Palace Museum
221 Chih-shan Rd., Sec. 2; Shih-lin,
Taipei, 11143,
TAIWAN
http://www.npm.gov.tw/
Part of the former imperial collection, contains many of the most-reproduced works of pre-twentieth-century Chinese art.

Palace Museum
4 Jingshan Qianjie,
BEIJING,
CHINA
http://www.dpm.org.cn
Housed in the former imperial palace in Beijing, the broadest and most significant single collection of pre-twentieth-century Chinese art.

Shanghai Museum
201 Renmin Dadao,
SHANGHAI 200003,
CHINA
http://www.shanghaimuseum.net/en/index.asp

Tokyo National Museum
13-19 Ueno Park,
Taito-ku,
TOKYO 110-8712
JAPAN
www.tnm.go.jp/en/index.html

EUROPE

The British Museum
Great Russell Street,
LONDON,
WC1B 3DG,
UK
www.britishmuseum.org
Collections strongest in early Chinese art, contains part of the Stein collection of

Buddhist art from Dunhuang and other sites.

Victoria and Albert Museum
South Kensington,
LONDON,
SW7 2RL,
UK
www.vam.ac.uk
Major collection of decorative arts and craft, including textiles and furniture.

Musée nationale des arts asiatiques Guimet
6, place d'Iéna,
75116 PARIS,
FRANCE
www.museeguimet.fr

Museum of Asian Art Berlin
Takustrasse 40,
14195 BERLIN (DAHLEM),
GERMANY
www.smb.spk-berlin.de/smb/

Museum Rietberg
Gablerstrasse 15
CH-8002 Zürich
SWITZERLAND
www.stadtzuerich.ch/internet/
zuerichkultur/home/institutionen/home/
redirect_mr/museum_rietberg/home.html

Museum of Far Eastern Antiquities Stockholm
Tyghusplan,
Skeppsholmen,
Stockholm,
SWEDEN
www.ostasiatiska.se/smvk/jsp/polopoly.
jsp?d=124

NORTH AMERICA/AUSTRALIA

Asian Art Museum of San Francisco
200 Larkin Street,
San Francisco, CA 94102,
USA
www.asianart.org/index.html

Museum of Fine Arts, Boston
479 Huntington Avenue,
Boston MA 02115-4401,
USA
www.mfa.org

Cleveland Museum of Art
11150 East Boulevard,
Cleveland OH 44106,
USA
www.clevelandart.org

Freer Gallery of Art and Arthur M. Sackler Gallery Smithsonian Institution
Jefferson Drive at 12th Street, SW,
Washington, DC 20560,
USA
www.asia.si.edu

The Nelson-Atkins Museum of Art
4525 Oak Street
Kansas City, Missouri 64111-1873
USA
www.nelson-atkins.org

Minneapolis Institute of Arts
2400 Third Avenue South
Minneapolis, MN 55404
USA
www.artsmia.org

Metropolitan Museum of Art, New York
1000 Fifth Avenue,
New York, NY 10028-0198,
USA
www.metmuseum.org/toah
Strong Chinese painting collection, also early art. See also the 'Timeline of Art History' on this site.

Royal Ontario Museum
100 Queen's Park,
Toronto, Ontario,
M5S 2C6,
CANADA
www.rom.on.ca/index.php
Early Chinese art, decorative arts and sculpture.

Art Gallery of New South Wales
Art Gallery Road,
The Domain,
Sydney NSW 2000,
AUSTRALIA
www.artgallery.nsw.gov.au/

Websites

Arts of China Consortium
http://www.nyu.edu/gsas/dept/fineart/html/chinese
Extremely useful site, with many links.

Bibliography of Contemporary Chinese Art
http://www.stanford.edu/dept/art/china/index.shtml
Research tool on the literature about modern Chinese art.

China 5,000 years – Electronic exhibition of modern section
http://kaladarshan.arts.ohio-state.edu/exhib/gug/intr/china.html
Illustrates and discusses the twentieth-century exhibits from a major exhibition held at the Guggenheim Museum in New york.

China Institute
http://www.chinainstitute.org/
Important venue for temporary exhibitions, and for the study of all aspects of China.

Chinese Posters 1937– Present
http://www.chineseposters.net
Propaganda and advertisng posters from the Republican era onwards.

Hefner Collection
http://www.hefnercollection.com/hefnermuseum/index.asp
Private collection of modern and contemporary Chinese painting.

International Dunhuang Project
http://idp.bl.uk
Devoted to the Buddhist caves of Dunhuang, and other Buddhist sites in China and Central Asia.

Internet Guide for Chinese Studies
http://www.sino.uni-heidelberg.de/igcs
Contains sections on 'Culture and art' and 'Archaeology', with many useful links.

James Cahill
http://jamescahill.info
The website of one of the leading scholars of Chinese art, with much unpublished material relating to the study of Chinese painting, and to debates within the field.

Morning Sun—A Film and Website about Cultural Revolution
www.morningsun.org
Contains many images relating to the art of the Cultural Revolution period.

Society for East Asian Archaeology
http://www.seaa-web.org
Includes comprehensive list of museums and websites.

Stefan Landsberger's Chinese Propaganda Poster Pages
http://www.iisg.nl/~landsberger/
Site maintained by a leading scholar of Chinese political imagery.

Twentieth-century Chinese Oil-Painting Exhibition
http://cn.c12000.com/art100/index_en.htm
Site of the Chinese Oil Painting Association, illustrates work in the medium from the early twentieth-century onwards.

Ullens Center for Contemporary Art
http://www.ullens-center.org/english/object.html
Beijing-based contemporary arts centre.

University of Chicago Center for the Art of East Asia Scroll Archive
http://scrolls.uchicago.edu
Interesting project designed to use technology to make more effective reproduction of Chinese scroll painting.

University of Westminster Poster Collection
http://www.wmin.ac.uk/china/home.htm
Important collection of political posters.

	7000 BCE	6500 BCE	6000 BCE	5500 BCE	5000 BCE
Political	Neolithic Cultures from *c.*7000 BCE				
Cultural	● *c.*7000 Beginnings of agriculture				
Artistic			● *c.*6000-5000 First evidence of jade working.		

4500 BCE	4000 BCE	3500 BCE	3000 BCE	2500 BCE	2000 BCE
			● Liangzhu (Zhejiang/ Jiangsu/Shanghai) *c.*3300–*c.*2250 BCE ● Longshan (Shandong) *c.*3000–*c.*1700 BCE		● Xia dynasty (disputed, traditional dates) 2205–1818 BCE
			● *c.*3000 Lacquer first used as an adhesive and sealant.		

	1500 BCE	1000 BCE	500 BCE	50 CE
Political	**Shang dynasty** ● c.1500–1050 BCE	**Zhou dynasty** ● Western Zhou c.1050–770 BCE ● Spring and Autumn Annals period 770–475 BCE	**Han Dynasty** ● Western Han dynasty 206 BCE–8CE ● Warring States period 475–221 BCE **Qin dynasty** ● 221–207 BCE	● (Xin dynasty, usurpation of Wang Mang) 9–23 CE ● Eastern Han dynasty 25–220 CE
Cultural	● c.1500–1300 Beginnings of bronze technology. ● c.1400–1200 First evidence of the Chinese script, from the Shang capital at Anyang.	● c.900 'Ritual revolution' affects the use of bronze vessels. ● c.900–600 Composition of the 'Book of Songs'	● 551–479 Life of 'Master Kong' ('Confucius'). ● c.500 First coinage. ● c.400–200 Composition of the Daode jing, 'Classic of the Way and its Power'. ● c.300 Silk first used as painting and writing surface. ● c.220 Chinese script systematized under the Qin dynasty.	● c.0–100 Changing beliefs about the afterlife lead to the creation of stone tombs as the focus of ancestral cults, and to the first large-scale stone sculpture.
Artistic		● c.1200 Ritual deposit of bronzes at Sanxingdui, Sichuan [2]. ● c.1200 First evidence of wall painting on plaster. ● c.1200 Tomb of Queen Fu Hao, Anyang [3].	● c.430 Tomb of Yi, Marquis of Zeng [5] ● c.201 Tomb of the First Emperor of Qin, the 'Terracotta Army' [7], Lintong, Shaanxi province ● c.168 Tomb No 1, Mawangdui, Hunan province [8]	

Period of Disunity
220–589 CE

● Eastern Jin
317–420 CE

'Three Kingdoms period'
220–280 CE

● Shu (Han)
221–263 CE

● Wei
220–265 CE

● Wu
222–280 CE

Six Dynasties
(in south)
265–589 CE

● Western Jin
265–316 CE

Sixteen Kingdoms
(in north)
316–589 CE

● Northern Wei
386–535 CE

● c.100 Invention of paper.
● c.100 First dictionary of Chinese, the 'Explanation of Writing' (Shuo wen).
● c.100 Buddhism established in Chinese capital.

● 175 Confucian classics carved in stone by imperial order, forming a state-supported ideological canon.
● 184 'Yellow Turban' rebellion, millenarian movement inspired by Daoist texts.

● 193 Earliest written evidence for Buddhist images in China.

● 360–74 The 'Mao Shan Revelations', transmission of Daoist sacred texts.

● c.147 Shrines of the Wu family, Shandong province [11].

● 309–c.365 Wang Xizhi, Jin dynasty calligrapher.
● 338 Earliest dated Buddha image in China.
● 344–88 Wang Xianzhi, Jin dynasty calligrapher.
● c.345–c.406 Gu Kaizhi, Jin dynasty painter.

● 350–401 Wang Xun, Jin dynasty calligrapher [68].
● c.380–420 Tomb of the 'Seven Sages and Rong Qiqi' relief, Xishanqiao, Jiangsu province [12].

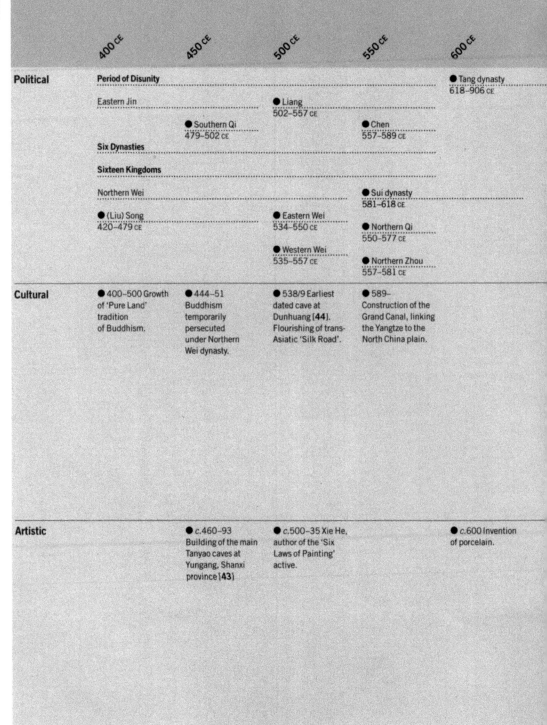

	400 CE	450 CE	500 CE	550 CE	600 CE
Political	Period of Disunity				● Tang dynasty 618–906 CE
	Eastern Jin		● Liang 502–557 CE		
		● Southern Qi 479–502 CE		● Chen 557–589 CE	
	Six Dynasties				
	Sixteen Kingdoms				
	Northern Wei			● Sui dynasty 581–618 CE	
	● (Liu) Song 420–479 CE		● Eastern Wei 534–550 CE	● Northern Qi 550–577 CE	
			● Western Wei 535–557 CE	● Northern Zhou 557–581 CE	
Cultural	● 400–500 Growth of 'Pure Land' tradition of Buddhism.	● 444–51 Buddhism temporarily persecuted under Northern Wei dynasty.	● 538/9 Earliest dated cave at Dunhuang [44]. Flourishing of trans-Asiatic 'Silk Road'.	● 589– Construction of the Grand Canal, linking the Yangtze to the North China plain.	
Artistic		● c.460–93 Building of the main Tanyao caves at Yungang, Shanxi province [43]	● c.500–35 Xie He, author of the 'Six Laws of Painting' active.		● c.600 Invention of porcelain.

● Five Dynasties
907–960 CE

● Liao dynasty
907–1125 CE

● 730 Definitive catalogue of the Buddhist canon.
● 749 Daoist canon distributed by imperial order.

● c.750 Beginnings of woodblock printing.
● c.750 'The Classic of Tea', by Lu You, promotes tea-drinking as an aesthetic experience.
● c.750 High point of classic poetry, poets Li Bai (701–62) and Du Fu (712–770) active.

● 837 Confucian classics carved in stone in Imperial College.
● 845–7 Buddhism temporarily persecuted.

● 874 Sealing of the underground repository at Famen Temple, near Xi'an, Shaanxi province [50].

● 673 Death of Yan Liben, Tang dynasty court artist.
● 675 Completion of the Fengxian Temple, Longmen, Henan province [48].

● 699–759 Wang Wei, Tang dynasty poet and artist.
● c.710–60 Wu Daozi, Tang dynasty court artist, active.

● c.730–80 Huaisu, Tang dynasty monk/calligrapher [68]
● c.730–c.800 Zhou Fang, Tang dynasty painter

● 847 Zhang Yanyuan writes, 'Records of Famous Paintings of all the Dynasties.'
● 868 Printing of the 'Diamond Sutra' [52].

● 919–67 Li Cheng, Five Dynasties painter.

	950 CE	1000 CE	1050 CE	1100 CE	1150 CE
Political		● Southern Song 1127–1279 CE			
				● Jin dynasty 1115–1234 CE	
	Liao dynasty				
	Song dynasty 960–1279 CE ● Northern Song 960–1127 CE				
Cultural	● c.950 Cult of the 'Ten Kings of Hell'. ● 953 First printed edition of the Confucian classics. ● 983 First printed edition of the Buddhist canon. ● 997–1124 A majority of those entering the bureaucracy examined in the Confucian classics.	● c.1000 'Library' at Dunhuang sealed. ● c.1020 Introduction of new strains of rice makes two crops a year possible in the south. ● c.1025 Explosives first used in warfare.	● 1050– Development of the idea of 'scholar painting.'	● 1127 Capital relocated to Lin'an (modern Hangzhou) after Jin conquest of North China.	● 1130–1200 Zhu Xi, writer and philosopher.
Artistic	● 962 Death of Dong Yuan, Five Dynasties painter. ● 984 Official founding of Song Imperial Painting Academy. ● 992 Printing of the 'Model Letters in the Imperial Archives in the Chunhua Era' [70].	● c.1000 Paper first used as painting surface. ● c.1000–c.1090 Guo Xi, Song dynasty painter and theorist [20] ● 1019–79 Wen Tong, Song dynasty painter [71]. ● 1037–1101 Su Shi, Song dynasty calligrapher, painter, and theorist. ● 1045–1105 Huang Tingjian, Song dynasty calligrapher [72].	● 1052–1107 Mi Fu, Song dynasty calligrapher, painter and connoisseur. ● 1074–1151 Mi Youren, Song dynasty painter and connoisseur [25]. ● 1082–1135 Emperor Song Huizong, painter and collector [22].	● c.1130–90 Ma Hezhi, Song dynasty court painter [24].	● 1166 Earliest illustrations to the Confucian classics. ● c.1190– after 1225 Ma Yuan, Song dynasty court painter.

● Ming dynasty
1368–1644 CE

● Yuan dynasty
1279–1368 CE

● c.1200–
Chan
('Meditational')
School of Buddhism
flourishes.

● 1300–
Strengthened
cultural relations
with Tibet and Nepal
bring new forms of
Buddhism to China.
● 1300–
Quanzhen
movement of
Daoism flourishes
in North China.

● c.1350
Development of
drama in Yuan
capital, now Beijing.
Texts such as 'The
West Chamber'.

● 1450–
Suzhou flourishes
as cultural centre.

● 1225–1322
Printing of the Qisha
version of the
Buddhist canon
[59].

● c.1250 Yujian,
Song dynasty
monk/painter
active [57].
● c.1250–1300
Invention of carved
lacquer technique.
● 1254–1322
Zhao Mengfu, Yuan
dynasty calligrapher
and painter [74].
● 1255–1327
Ren Renfa, Yuan
dynasty painter
[76].
● 1262–1319 Guan
Daosheng, Yuan
dynasty painter
[75].

● 1269–1354
Huang Gongwang,
Yuan dynasty
painter (pl.77).
● c.1280–1329
Wang Zhenpeng,
Yuan dynasty court
painter [29].
● c.1320
Jingdezhen
established as
major centre of
luxury ceramics.
● c.1325 Daoist
murals of the Yongle
Temple, Shanxi
province, painted.

● 1396–1474
Du Qiong, Ming
dynasty painter
[80].

● 1427–1509
Shen Zhou, Ming
dynasty calligrapher
and painter [81].

● 1470–1524
Tang Yin, Ming
dynasty painter
[82].
● 1470–1551
Wen Zhengming,
Ming dynasty
calligrapher and
painter [83].
Ancestor of
several prominent
Ming artists.
● c.1494–c.1552
Qiu Ying, Ming
dynasty painter
[96].

	1500 CE	1550 CE	1600 CE	1650 CE	1700 CE
Political	Ming dynasty			● Qing dynasty 1644–1911 CE	
Cultural	● 1514 Portuguese reach China by sea.	● c.1550– Cult of Guanyin as 'Bringer of Sons' flourishes. ● 1550 Economic growth, fuelled by imports of silver from the Americas.	● 1636 Manchus adopt the dynastic name 'Qing'.	● 1669 Official prohibition of Christianity.	● 1700– Yangzhou flourishes as cultural centre. ● c.1720– European trade flourishes at Guangzhou, Western visual materials begin to circulate.
Artistic		● c.1550–80 Miss Qiu, Ming dynasty painter. ● 1555–1636 Dong Qichang, Ming dynasty calligrapher, painter, and theorist [85]. ● 1595–1634 Wen Shu, Ming dynasty painter [84]. ● 1598–1652 Chen Hongshou, Ming dynasty painter [105].	● c.1600–30 Han Ximeng, Ming dynasty embroiderer active [100]. ● 1603 'Master Gu's Pictorial Album' [98]. ● 1606–84 Gu Jianlong, Ming/ Qing dynasty painter [106]. ● 1626–1705 Bada Shanren, Qing dynasty painter [87].	● 1632–1717 Wang Hui, Qing dynasty painter [34]. ● 1642–1707 Shitao, Qing dynasty painter [86]. ● 1642–1715 Wang Yuanqi, Qing dynasty painter [35]. ● 1679 'The Mustard Seed Garden Manual of Painting'. ● 1683– Revival of imperial patronage of the visual arts.	● 1688–1766 Giuseppe Castiglione (Lang Shining), Qing dynasty court painter [37]. ● 1693–1755 Zheng Xie, Qing dynasty painter [108]. ● 1740s– Major catalogues of the imperial collections compiled.

1750 CE	1800 CE	1850 CE	1900 CE		1950 CE

- People's Republic of China 1949–

- Republic of China 1911– (on Taiwan after 1949)

● 1759 Qing empire achieves its maximum extent with the conquest of Xinjiang.	● 1791 Publication of the novel 'The Dream of the Red Chamber', or 'The Story of the Stone'.	● 1840–2 First Opium War, British invasion of China. ● c.1850 Photography first practised in China. ● 1851–64 Taiping Rebellion devastates South China. ● 1884 Dianshi Studio Pictorial, China's first illustrated journal, published in Shanghai.	● 1912 Abdication of last emperor of the Qing dynasty. ● 1919 '4th May Movement' promotes the vernacular language as written standard. ● 1921 Founding of Chinese Communist party. ● 1927 Chiang Kai-shek establishes national capital at Nanjing. ● 1942 'Talks at the Yan'an Forum on Literature and Art' delivered by Mao Zedong.		● 1958–9 'Ten Great Buildings' project in Beijing. ● 1966–76 'Great Proletarian Cultural Revolution', ends with death of Mao Zedong. ● 1985– Economic liberalization and relaxation of state control of culture in China.
● 1743–1805 Deng Shiru, Qing dynasty calligrapher [89]. ● c.1750 Ready-made colours for painting commercially available.	● 1801–c.1860 Guan Qiaochang ('Lamqua'), Qing dynasty painter [111]. ● 1819–67 Zou Boqi, pioneer of photography [112]. ● 1823–57 Ren Xiong, Qing dynasty painter [91]. ● 1840–96 Ren Yi, Qing dynasty painter [113].	● 1864–1955 Huang Binhong, Qing dynasty/ Republican period painter [117]. ● 1879–1951 Gao Jianfu, Republican period painter [114]. ● 1895–1953 Xu Beihong, Republican period painter [115].	● 1900–91 Lin Fengmian, twentieth-century painter [116]. ● 1904–65 Fu Baoshi, twentieth-century painter [118]. ● 1905 China's first public museum opened. ● 1906 Creation of first art departments within government academies. ● 1907 First photographic reproduction of paintings in Chinese.	journals ● 1911 Meishu congshu series of art-historical texts begins publication. ● 1912 Establishment of China's first private art school. ● 1924 National Palace Museum opened in Beijing. ● 1929 First government sponsored art exhibition.	● 1950 Nationalization of all art schools, following Communist victory in 1949. ● 1965 National Palace Museum opens in Taipei. ● 1979 Unofficial 'Stars Group' exhibition shown in Beijing. ● 1989 'China/ Avant-Garde' exhibition shown in Beijing. ● 1999 Cai Guoqiang becomes first Chinese artist to win Golden Lion at Venice Biennale.

Index